**MONUMENTS
AND MEMORY**

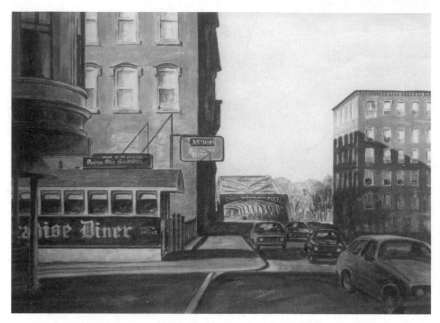

The Bridge Street Bridge by Vassilios "Bill" Giavis. (Courtesy The Brush Art Galleries and Studios, Lowell, Massachusetts)

MARTHA
NORKUNAS

Monuments and Memory

HISTORY AND REPRESENTATION
IN LOWELL, MASSACHUSETTS

Smithsonian Institution Press
Washington and London

Production editor: Robert A. Poarch
Designer: Brian Barth

Library of Congress Cataloging-in-Publication Data
Norkunas, Martha K.
 Monuments and memory : history and representation in Lowell, Massachusetts /
Martha Norkunas.
 p. cm.
 Includes bibliographical references and index.
 ISBN 1-58834-085-6 (cloth : alk. paper) — ISBN 1-58834-030-9 (pbk. : alk. paper)
 1. Monuments—Massachusetts—Lowell. 2. Public sculpture—Massachusetts—
Lowell. 3. Lowell (Mass.)—Buildings, structures, etc. I. Title.
NA9350.L68 N67 2002
730'.9744'4—dc21 2001057784

British Library Cataloguing-in-Publication Data is available

Manufactured in the United States of America
08 07 06 05 04 03 02 5 4 3 2 1

♾ The paper used in this publication meets the minimum requirements of the American
National Standard for Information Sciences—Permanence of Paper for Printed Library
Materials ANSI Z39.48-1984.

CONTENTS

ACKNOWLEDGMENTS

This project took a great deal of time and commitment from many people. I would like to begin by thanking my funders. The Lowell Historic Preservation Commission provided initial survey funds and, during my summer in Lowell in 1996, provided computers and office support. The National Trust for Historic Preservation provided funds to continue the survey and their early endorsement was important to the project. The L. G. Skaggs and Mary C. Skaggs Foundation provided a grant at a critical time that allowed me to hire a research assistant. I am grateful to them and Mr. Philip Jelley for their interest. The Theodore Edson Parker Foundation provided funds for research and for travel to Lowell; again I am most grateful for their support. A University Cooperative Society Subvention Grant was awarded by the University of Texas at Austin, which allowed me to include the many photographs in this book, and I am thankful to them. The American Council of Learned Societies awarded me a fellowship in 1996 so that I was able to work on the project for six uninterrupted months. I do not know which was more important to the project, the funds or their belief in the value of this work. I am deeply grateful to them for both.

The Lowell Parks and Conservation Trust served as the fiscal agent for this project for six years. Special thanks to them, and especially to Jane Calvin and Steve Conant. Grateful acknowledgment is given to the Lowell Historical Society for publishing "The Lowell Monuments" brochure and to Joan Ross and Jim Higgins for photography and brochure design, Linda Peterson for editorial work, and Lew Karabatsos for brochure project management. Jim and Joan also opened their home to me on one of my trips to Lowell, and I thank them for that as well.

I would like to thank the many people in Lowell who discussed the project with me, and provided information, and support. At the former Lowell Historic Preservation Commission: Peter Aucella, Chuck Parrott, Chris Briggs, Rachael McManus, Jamie Brown, Lance Kasparian, and Donna Spellissey. At the Lowell National Historical Park: Sue Leggat, Audrey Ambrosino, Rich Rambur, Gray Fitzsimons, Chris Wirth, and Marty Blatt. At the city of Lowell: Tom Bellegarde, Joe Duceau, Ed Trudell, Bob Malovich, Steve Stowell, Bill Kelley, Frank Grady, Brian Martin, Rick Johnson, Bill Flanagan, Peter Alexis, Mary Jo Christian, and the other women at the city of Lowell Clerks Office. At the University of Massachusetts Lowell: President Bill Hogan, Robert Wagner, and their administrative assistants (especially Donna), Martha Mayo, Janine Whitcomb, and Patricia Rowe. I would also like to thank Susan Karabatsos, Richard Scott, Mehmed Ali, Adrian Luz, Pauline Golec, Marie Sweeney, Paul Sheehy, Bill Giavis, George Merritt, Carol McMahon, Helen Whiting, the late Father Kirwin, Mary Noon, Barbara Palermo, Sister Madeleine Gagnon of the Franco-American School, David McMckean, Betty Cleary, the lunchtime regulars at the Sac Club, and the many other people interviewed by project researchers. Writer and poet Paul Marion discussed many of the ideas in this book with me, and I appreciate his insights. Thanks go to the various people who provided research assistance for The Lowell Monuments Project: Erica Lehrer, Richard Leach, Karen Shopoff, Anne Welcome, and Millie Rahn. Special thanks to the many Lowell people whose families were commemorated in bronze and stone, and who graciously allowed me, and project researchers, to interview them.

Thanks to Mike Frisch, Linda Shopes, and Roger Abrahams for reading drafts of my funding proposals, and to John Bodnar and Dick Bauman for writing many reference letters for this project. John Bodnar discussed ideas in the project with me, suggesting references and offering ideas on directions. Roger Janelli also suggested literature for this work. Vivien Rose, Liza Stearns, and Barbara Irvine sent information and suggested ideas for the

chapter on gender. Thanks to Patricia Melvin-Mooney for sharing with me her material on monuments to labor. Many thanks also to Kirin Narayan for talking with me about writing.

I would like to thank a number of people in Austin. Damon Scott designed the File Maker Pro database for the project, Martha Russell assisted with that program, the technology assistants at the University of Texas Computer Instructional Technology Center, especially Wei Yeh, taught me Photoshop, and Mike Widener sent me relevant articles. I would also like to thank my Austin colleagues who discussed various aspects of this book with me as I was writing it and who, I imagine, will be as delighted as I am that it is done. Marjorie Payne, Linda Peterson, Sheree Scarborough, Emily Socolov, Francoise De Baker, and Roger Renwick discussed various chapters with me. My deepest thanks to each of them. Sheree Scarborough also helped me select images for the book. Deborah Kapchan and Jan Dawson read the chapter "The Gender of Memory," and I am grateful for their input.

As always, I am very grateful to my friends and colleagues Lew Karabatsos and Bob Weible. They answered countless questions, gave help when it was needed, encouraged me to go forward, criticized me when they saw it was needed, and offered valuable insights.

Thanks to everyone who kindly answered the hundreds of emails I jettisoned out. I imagined my colleagues, particularly my Lowell colleagues, coming in to the office in the morning to see my barrage of email questions, and summarily deleting anything with my return address in it. But they did not do this: instead they patiently answered my questions, month after month.

I would like to thank my Aunt Dorothy and my cousin, Walter, for letting me stay with them when I was in Lowell, and my cousins, Colleen and Danny McHale, for later opening their home to me. Special thanks to my cousin, Ann Dempsey King, for the wonderful tours we took of our past in Lowell together both on the streets and in our memories. My Aunt Lil Cleary accompanied me on several research excursions, measuring the monuments, and talking with me, and I thank her for her time and words.

Several of my friends and colleagues in the Boston area walked the monuments with me and shared ideas about them: Kathy Neustadt, Tom Rose, Robin Winslow, and Millie Rahn. Shelley Fitzgerald collected archival information, assisted in research expeditions, read drafts of chapters, and provided housing, transportation, and friendship far beyond the confines of this book.

Suzy Seriff took the time to read two drafts of the entire manuscript, each time making insightful recommendations that helped me to reorganize and

reshape it. Regina Bendix shared ideas, wrote letters of support, and encouraged me throughout this project. They were both enormously important in bringing this work to completion, and I can't thank them enough.

Special thanks to Mark Hirsch, formerly the senior editor for American studies at the Smithsonian Institution Press, for his interest in publishing this work and his guidance through the process. I would also like to thank the two readers for this manuscript. Both provided thoughtful, detailed comments that encouraged me and offered me opportunities to improve aspects of the manuscript before publication. Thanks to Robert A. Poarch, production editor, for his careful reading of the text and his many helpful editorial changes. I would also like to thank Emily Sollie, Caroline Newman, and Janice Wheeler at the Smithsonian Institution Press for their help with this manuscript.

As with my other projects, my husband and colleague, Yildiray Erdener, has been unflagging in his commitment to my completing this work. He has assisted in countless ways, financially, intellectually, and emotionally, and knows how grateful I am to him. Our children, Jasmine, Emre, and Ayla, have made varying contributions to this work. Jasmine discussed one chapter with me in her bright, forthright manner, in the process clarifying certain issues, and did major amounts of filing for the project. Emre's emerging humor often relieved stress, and Ayla, with her own single-minded determination, served as a model. Our children's drive, their earnestness, charm, and competence in negotiating their own complicated social and intellectual worlds, are a source of pleasure and inspiration to me.

"Climbing the Tenement Stairs," from *French Class: French Canadian-American Writings on Identity, Culture, and Place* by Susan April, Paul Brouillette, Paul Marion, and Marie Louise St. Onge (Loom Press, 1999), was reprinted with permission of Paul Marion. Grateful acknowledgment is given to artist Peter Gorfain for permission to use an image of his *Stele for the Merrimack* for the cover photo.

Versions of several chapters were given as talks at the University of Texas Folklore and Expressive Culture Series, the American Folklore Society Meetings, the National Council on Public History Meetings, and the University of Texas Center for Women's Studies Series, "Women, Leadership, and Policy."

Finally I have several in memorium messages. Ed Harley was my Lowell teacher. I met him in 1982 when he was the librarian for the Lowell National Historical Park. Over the years he found Lowell images and articles for me, researched items, took me on tours of neighborhoods, and answered my

endless questions. I don't think I ever did research in Lowell without seeking his input. I was nearly done with this book, and looking forward to talking over some of my conclusions with him, when he died.

My Aunt Doris Cleary went on research excursions with me, measured monuments, and took notes. We had wonderful talks about her life in Lowell and our family. After the death of my mother, Doris became my friend, and we grew closer with each of my visits to Lowell. Just before this book went to press she died at home, surrounded by the people she loved.

I lost many beloved members of my family during the years I worked on this project: my mother, Kathleen Cleary Norkunas, my Uncle Walter Dempsey ("Big Walter"), my Uncle Jack Cleary, and my Aunt Dorothy Dempsey. With them went so much of the memory of my family's life in Lowell. I miss them with all of my heart. May this book serve as my monument to them.

MONUMENTS
AND MEMORY

INTRODUCTION

❧❧ ❧❧

ASKING QUESTIONS

In 1996 a series of small granite sculptures, a work of public art funded by the Lowell Historic Preservation Commission, was dedicated to those Yankee women who formed a part of the Lowell Female Labor Reform Association in 1840. Fifty yards away a *Winged Victory* statue rises up before the obelisk dedicated to the first two Lowell soldiers to die in the Civil War. Behind that is the city hall, with monuments to Lowell's Franco Americans and Lowell's Polish Americans prominently placed on the front lawn. Still within sight is Cardinal O'Connell Parkway with a large pedestal and bust of the cardinal, and monuments to the Irish and Greek communities of Lowell defining opposing ends of the small greenway. Nearly every five blocks there is a monument with the names of members of Lowell's ethnic communities, the war dead, politicians and priests, civil servants, coaches, athletes, volunteers, donors, children, or women.

Bearing witness to the multiple collective memories of this old industrial city, the creation of these monuments describes ideas about the rise of American industrialism, the good citizen, and the heroic death. The ques-

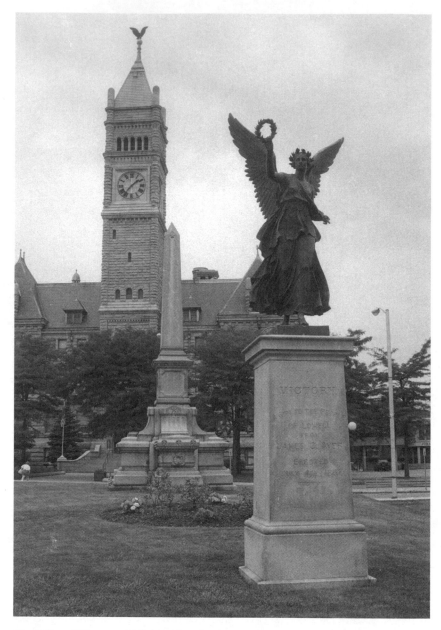

The *Winged Victory* and the Ladd and Whitney Monuments in front of Lowell city hall, summer 1996.

tion of the meaning of America is constantly being raised in specific places, wrote Edward Linenthal in *American Sacred Space*. In Lowell, Massachusetts, the creation, placement, and design of monuments raise questions that resonate throughout America, questions about the connections between gender, ethnicity, power, space, and narrative, about the relationship between the living and the memory of the dead, and about the uncertain intersections between memory and history.

WHERE AND WHO

What is now called Lowell was once inhabited by members of the Pennacook Confederacy who fished the salmon beneath the great Pawtucket Falls and grew crops in the fertile lands between the Merrimack and Concord Rivers. English farmers came to Lowell and Chelmsford, and industrialists built factories along the Concord River in the eighteenth century. Early in the nineteenth century the Boston Associates chose Lowell to be the home of their textile manufacturing empire, drawn to the city by the possibility of generating power from the thirty-two-foot drop of the Pawtucket Falls. Hoping to avoid the creation of a permanent industrial proletariat, as had happened in industrialized England, the Boston Associates brought in young Yankee women from New England farms to work in the factories for periods of several years. Other people were also brought to Lowell as laborers. Irish men dug the intricate system of canals used to power the many mill complexes. After the potato famines in Ireland, waves of Irish began to arrive in Lowell, and they slowly replaced the Yankee women as factory workers. Later Greeks, French Canadians, Lithuanians, Poles, and some Italians immigrated to Lowell, and later still Portuguese, Puerto Ricans, and Colombians settled in Lowell. In the late twentieth century the ethnic makeup of the city changed once again as up to 25,000 Cambodians resettled in Lowell. These ethnic groups followed classic patterns of immigration, establishing their churches, schools, and stores within strongly ethnic enclaves, working in the mills and later factories, and remaining isolated from other groups for up to two generations. Each group experienced the ethnic discrimination that all newcomers to Lowell had come to know. Over time, members of the groups intermarried.

After the textile mills began to close in the 1920s, Lowell experienced a depression that lasted for decades. For a period in the 1980s it seemed that a computer company, Wang Laboratories, which relocated its national head-

quarters to Lowell, would save the city. Like other industries before it, however, Wang went bankrupt. The city then hoped that tourism might become a new economic base. Through a series of astute political initiatives, Lowell was chosen as a National Park site to tell the story of the American industrial revolution. Since the 1970s tens of millions of federal dollars have poured into the city to create museums, restore buildings, and build new structures. Many of the mill complexes have been renovated, a major hotel, arena, and performing-arts park were built in the downtown, and tours are offered of the canals, the museums, and the city itself.

HOW AND WHY: STAGE ONE

From 1989 to 1994 I was the cultural affairs director for the Lowell Historic Preservation Commission, a sister agency to the Lowell National Historical Park. As a part of my job I worked on the Lowell Public Art Collection. Artists from around the country were invited to Lowell to develop artworks that interpreted some aspect of the city's past. While these artists were constructing their pieces, I began to see, for the first time, that there were other sculptural forms on the Lowell landscape. There were polished granite stones, boulders, bronze plaques, and iron and metal signs on poles in addition to these public art pieces. I wondered how the outsider public art pieces differed from the nearly unnoticed locally constructed monuments. Who had constructed these local monuments and why? How many were there? How did they function in the life of the community? Suddenly, I realized the tremendously rich, and previously untapped, potential for investigating issues of memory and history through the local, or vernacular, monuments and the federally funded public art pieces and waysides. While other scholars had examined particular kinds of monuments across the United States, no one to my knowledge had before studied the entire array of monuments in one community. In 1993, with grants from the Lowell Historic Preservation Commission and the National Trust for Historic Preservation, I began to systematically document the monuments.

First, however, I had to find them. I looked in the various departments in city hall for a list of monuments on city lands or created with city funds, or for written records about their locations, their texts, or background on who or what they commemorated. The city engineer's office had some file cards in an old cabinet that listed the names of some of the squares in Lowell and referred to handwritten record books indicating when and how the squares

were named. Their records did not include 90 percent of the monuments. I went to the city solicitor's office, hoping that there was some legal research on the naming and, more importantly, the renaming of public spaces, but there was not. The planning department did not have written records. The city clerk, I had hoped, would have paperwork prepared for city councilors when proposed monuments were to be voted on by the full council, but I was unable to locate such written records. Finally, I went to the Lowell Department of Parks, Recreation, and Cemeteries. I interviewed the commissioner, Tom Bellegarde, who described in detail how current monuments were nominated and dedicated. Again, there were few written records. I contacted the Massachusetts Historical Commission to ask if they had an index of monuments in Lowell. They did not. No record of the monuments existed, or, besides my own, currently exists, at the city, state, or national level. I have since learned that few records exist of vernacular monuments in other cities and towns, although nearly every community in America has monuments.

I began doing windshield documentation, that is slamming on the brakes whenever I noticed an uncharted monument. Gradually my methods became more sophisticated as I realized that many of the monuments were located in public parks. With the assistance of grant funds, I was able to hire research assistants, and we obtained a list of the city's public parks and visited each one. We created a process for doing background research about each of the monuments. I designed forms to record information about the location, social context, text, plantings, and appearance of each monument (see Appendix 1). By spring 1994 I had a list of approximately 140 monuments and estimated that there were about twenty more.

I spent the summer of 1996 intensively documenting the monuments and conducting interviews.[1] I hired researchers to look for documentary evidence about the monuments in the city archives and in the local newspaper, and to do interviews. My goal was to establish dedication dates for each monument, obtain newspaper accounts of the dedication ceremonies, identify the death date of the persons commemorated, and retrieve obituaries for each person named on a monument—all in an effort to discover who was memorialized and why. In the process we uncovered other related information, including city documents about the parks system, walking tours, and resolutions from the Parks Board of Commissioners and from the Lowell City Council.

When I left Lowell in 1996, my list of monuments had reached 190. I returned to Lowell in October 1996, the summer of 1997, and December 1997,

and visited all the monuments, noted any new monuments, and again photographed them. I interviewed family members of those named on the monuments, people present in the parks, and local historians. I conducted informational interviews with my former colleagues at the Lowell National Historical Park and with former staff members of the Lowell Historic Preservation Commission, asking about the historic waysides and other public plaques they had been involved in creating. In subsequent trips to Lowell (May 1999 and May 2000), I concentrated on specific monuments. At the end of 1999 I decided to stop documenting any new monuments. By that time I had files on 252 monuments. The sheer quantity of information sometimes seemed overwhelming.

The research process was extremely detailed. There were instances where it took several years to identify the person commemorated on a given monument. The monuments sometimes included a date, but it was not always clear what the date meant: was it the monument's dedication date, the death date of the person, the retirement date of the person, or the date of the event being remembered? I created a system to monitor the dates, locations, and information needed to search newspaper files. I assigned each monument a number in my cataloging system, and created a file for each one. The files contained the informational forms I designed, newspaper articles about the dedication of the monument, obituaries, interview transcripts or notes, correspondence, and other related material. I eventually created a searchable computer database for the project. I also indexed the more than one thousand images I had taken of the monuments over a six-year period. Rather than appending to this book an 100-page catalog of the monuments, I hope to create a Web site with images and text about each of the monuments.[2]

Finding information about a monument that was moved was often serendipitous: I discovered a newspaper article or photograph indicating a prior location, or someone remembered that a monument had once been located somewhere else, or a clue appeared on the monument itself (Crotty Circle, for example, now stands in the corner of a park but must have once been located in a circle). The early waysides were as difficult to research as the more locally constructed monuments, for there was little written about them and no maps of their locations.[3]

Each time I returned to Lowell, I was able to ask better questions about the monuments. After the *Boston Globe* printed an article about the project, local people knew why I was asking certain kinds of questions and why I was standing around in public parks with a notebook and measuring tape.[4]

In 1997 a brochure I wrote about the monuments was published by the Lowell Historical Society. It outlined the major genres of monuments and included sample photos and text.[5]

Initially, I was interested in the relationship of monuments and power. I connected power with money, assuming that there was a correlation between the financing of the monuments and the ability to commemorate on public lands. As my work progressed I saw that wealth per se does not confer the authority to have monuments created. The equation is more complicated than that, with power derived from sources that go well beyond money.

From early in the project I was interested in the symbolic significance of siting. This began from a practical concern: where were the monuments? Once I had found them and began to document them, I thought about the meanings of their locations. Certain monuments tended to be in certain kinds of spaces. I was also concerned with the visibility of the pieces—how easily they could be seen and read. It struck me as curious that so many of the monuments in Lowell, as in other communities, are placed where it is difficult, if not impossible, to read the text, so one cannot tell what the monument commemorates. To the extent that I could, I tried to assemble information about changes in the location or siting of monuments, which led me to think about how the value of a monument changes when it is resited. On occasion a monument did not move, but the importance of the park where it was located changed. Once again, the value of the monument changed when the space around it changed. All these factors affect the relationship between the social creation of value, siting, and memory and its obverse—social devaluation, resiting, and forgetting.

The siting of the monuments was a larger bird's-eye-view of the system of monuments. I was also interested in a more detailed analysis that zeroed in on the space immediately surrounding individual monuments. As I identified patterns in the design of the areas around the monuments—the plantings and the stone itself—I saw how much they had borrowed from the vocabulary of cemetery design. This led me to explore the creation and location of Lowell's cemeteries in relation to the community. From there I pondered the differences between the actual cemeteries, which contained the bodies of the deceased, and the monuments in civic spaces, which did not contain any remains. I questioned why, if each of the deceased had a headstone in the cemetery, there was a need to place a second stone monument in a more public space.

I had assumed in the beginning that there was a relationship between history, memory, and the monuments. The monuments seemed to me to be an

expression of memory. Many were, literally, in memoriam. Yet others seemed more explicitly tied to history, particularly the waysides, which described some past event or activity that had occurred at a particular site. What, then, was the difference between history and memory, and were these differences articulated in the system of monuments? Cultural theorists postulated great ruptures in the organic nature of memory, first in the modern era, and again in the postmodern period. Could Lowell be a postmodern city, and did the monuments reflect the rupture of memory associated with postmodernity?

I wondered what kind of typology of monuments existed in the city, and if that typology described the city's values. In other words, what gets marked and what does not? Initially, my typology was somewhat straightforward and literal. Over time I looked for more abstract patterns and was able to see associations between seemingly unrelated commemorative pieces. I searched for any possible connection between the typologies and the ability to express ideas on the landscape. As so many of the monuments were literal expressions of ethnicity and so many others were veiled ethnic expressions, I wanted to know how ethnic groups had used monuments as a form of expression and a form of power.

I was struck by the paucity of monuments to women despite their rich presence in the community and began to ask additional questions about the monuments as systems of representation. A core question became, "Why are there so few monuments to women?" This led me to feminist literature concerning the association of public space with males and private space with females, and the ways in which space, gender, and power intersect. I looked at the gendered nature of public spaces in Lowell and at the monuments as a part of this patriarchal landscape.

HOW AND WHY: STAGE TWO

If the project physically began for me in 1993 with the documentation of the monuments, it intensified intellectually and creatively in 1996. Propelled by the question "Why are there so few monuments to women?" I turned the lens of inquiry inward. I asked how the generations of women in my family, all from Lowell, remember and are remembered. Where is the intersection of women's memory, monuments, and the history of Lowell? I went to my family's sites of memory alone, with my aunts, and with my cousins. What I saw and what I did not see on the landscape changed me. Ultimately, it changed the way I wrote this book.

There was no commemorative evidence anywhere on the landscape of the women in my family, though they had lived their entire lives in Lowell. They existed only in the intersection of my memory, my cousins' memories, and the sites we visited. Together with my cousin, Ann Dempsey King, I visited many sites in the summer of 1996. They are sites that are physically present in Lowell, sites we traveled to in our shared memories of the past, and sites that were created for us through the stories of my grandmother Nana, my mother, and my Aunt Dorothy (Ann's mother).

I realized that it would not be possible for me to write about Lowell as an objective observer. My emotional attachment to the city extends over time and space. The first of my Irish relatives came to Lowell in 1847. My Irish American grandmother, a beloved person in my extended family, was born and raised in Lowell. With the exception of my mother, all six of my grandmother's children lived their lives in Lowell, and even my mother returned for the last seven years of her life. My parents met and married in Lowell, moved away, and, after their divorce, my mother moved to a nearby town so that she could be close to her family. I discovered strange and wonderful coincidences when I perused the city directories: my Irish grandfather's uncles lived on Lawrence Street in Lowell in the 1880s; my Lithuanian grandparents lived on Lawrence Street in the 1930s; my mother lived in an apartment on Lawrence Street in the 1970s; and when, in 1990, my husband and I bought our first home, it was on Lawrence Street. In a city where family and neighborhood memory goes back generations, these coincidences are a part of everyday life.

I began to see my story as integral to the building of ideas about memory sites, to the discussion of gendered memory, and, finally, to the description of the culture of Lowell. Other historians and ethnographers have made similar choices. Carolyn Kay Steedman created a portrait of her childhood and her mother's life as a working woman and a single parent. Then she searched for a way of theorizing their lives, not to say that all working-class childhoods were the same, "but so that the people in exile, the inhabitants of the long streets, may start to use the autobiographical 'I,' and tell the stories of their life." She ultimately sought to unmask the processes of historical writing, to step into the landscape and see herself there, as well as see herself watching.[6] Ruth Behar called for the anthropologist to write herself back into her work, to become a "vulnerable observer."[7] When Karen McCarthy Brown wrote about Haitian Voodoo practitioners, she left her theorizing embedded in stories; Kirin Narayan wrapped her ethnography around the sto-

ries of a Hindu religious figure; and Katie Stewart used the form of the story
to theorize about culture and place.[8] Absent a paper trail in local archives,
absent monuments on the landscape, such stories are all I had to remem-
ber Lowell women.

Each chapter in this book thus begins with my family's stories about Low-
ell and the ways that I have come to understand the city, moves into a pres-
entation of the ideas central to the themes of the chapter, and, finally, ends
with a discussion of how monuments illuminate ideas about memory, his-
tory, power, class, ethnicity, and gender. My own memory, therefore, is the
raw data of an ethnography that describes the culture of Lowell and sets the
context for understanding the monuments. But it also stands on its own, as
a gendered form of memorializing women. My narratives are a part of the
discussion of monuments, memory, and history, as well as a form of mem-
ory becoming history. I hope that one day women's memory will not be a
distinct realm apart from history, but will merge so seamlessly as to appear
to have always been that way.

I believe that blurring the lines between memoir, ethnography, and the-
ory is itself a gendered form of writing. Women learn so much of what they
know through stories and through personal examples. Women readers may
linger on the stories in this text, relating them back to their own family nar-
ratives. Some men may move quickly to the more explicitly analytical sec-
tions of each chapter. Both genders might sense that the stories are an al-
ternative kind of monument. Unlike the many physical monuments on the
landscape, "a material shrine for bodies buried elsewhere, [the narratives]
are an unfolding tapestry of the memory sites, living and breathing the ways
in which we ultimately experience memory."[9]

It is controversial: does the "I" belong so strongly in an intellectual work?
I think it does, in certain instances, when the writer is inextricably linked to
a place over periods of time, where roots run deep, and when experience so
informs all that the writer sees that there can be no observation apart from
it. Maintaining the "I" also allowed me to examine the dialectic between in-
sider and outsider, which is a strong undercurrent throughout this work.
Who has the authority to speak in public is a question constantly posed by
the monuments. Who has the authority to reconstruct history, to decide
local cultural issues, or to claim knowledge derived from insider status are
issues I lived with daily when I worked at the Lowell Historic Preservation
Commission.

In the end this book is about the intersections of the personal and the

public, the singular and the collective, memory and history. I am always asking where my personal memory connects with the history of the city. Where do my memory, the memory of the mill workers, and the history of the city intersect? Where do male and female memory intersect, if they do, in public space? Where is the connection between narrative, memory, history, and space? Where too is the intersection between the idea of place and the physical place itself? Do my family's memory sites exist only in the link between my knowledge of their meaning and their presence on the landscape, or could they one day describe the history of this one extended family and so the untold history of twentieth-century working-class ethnics? Where does the memory of the deceased, as it is expressed in the cemetery, intersect with the memory of the deceased as it is displayed throughout the city in the form of monuments on public lands?

In one of the many drafts of this book I analyzed the monuments as artifacts on a landscape, removed from the particularities of Lowell. I realized that this was a mistake, for these monuments are not just anywhere—they are in *this* city. I wanted to mesh the monuments with the complex, sometimes messy, details of their context, which is Lowell. These are not monuments in some anonymous place. But I think the issues this city raises are illustrative of issues in many other places. They speak to the differences between history and memory, about the impact of federal constructions of history upon local memory, about the ways ethnic groups negotiate power relationships and express them in physical form, about ethnic groups and women who are denied the right to speak in public, about ideas of gender, power, patriarchy, and representation on the landscape. Just as Lowell serves as the case study for a National Park examination of the industrial revolution, so too does it serve as an excellent case study for an examination of the role of monuments in American culture. Many of the issues in the book resonate well beyond the boundaries of Lowell. Lowell was one of the first cities to be industrialized, and one of the first to be abandoned by industrialization. It was one of the first to become interested in historic preservation issues and one of the first National Historical Parks. Throughout all of this Lowell has kept its ethnic, local flavor. While other places may suffer from a sense of being homogenized by chain stores and mass culture, Lowell has retained its own identity. You know when you are in Lowell—it is not like any other place.

In Chapter 1, "Inside the Memory of Class and Ethnicity," I describe how my understandings of class and ethnic identity were derived from my fam-

ily's stories. Then I go on to discuss how my conception of the city changed after I was hired as an ethnographer to document other cultures in Lowell, and finally I look at my role in the creation of Lowell's past as an employee of the Lowell Historic Preservation Commission. Class and politics impact everything in Lowell, and the National Park's presentation of the past is no exception. I consider the two models of culture that guided the transformation of Lowell to a National Park, and how cultural theories about memory in the modern and postmodern city do and do not fit Lowell. Lastly, I turn to the monuments—the waysides, the historical texts created by the National Park, the ethnic monuments surrounding city hall, the ethnic monuments that were not allowed to be built, and the veterans' monuments around the Lowell Memorial Auditorium—to explore ideas about the negotiation of power, loyalty to the nation, and ethnic identity.

In Chapter 2, "The Gender of Memory," I again begin with my family stories to show how I developed an understanding of gender. I discuss gender as an issue in the early construction of the space and culture of Lowell. Then I reflect on the few monuments to women nationally and how women's bodies have so often been used not to represent an actual woman, but to stand for the nation or male heroism. By looking at the monuments to women in Lowell, I question what the city's shared civic identity would be like if women were more fully represented on the landscape. Can narrative and space intersect in a particular way for women? I try to answer this question by offering ideas about how gender, memory, and history intersect and how women's memories of the past and their actions in the present are somewhere between private and public, memory and history.

In the third chapter, "Relocating the Memory of the Dead," I start with my family's relationship with the cemetery and with the dead. I discuss cemeteries in Lowell and their relationship to the town. I end with a discussion of the monuments I have documented outside the cemetery. I believe that, through the monuments, the dead have been relocated back into the center of the city and the neighborhoods, absent the pestilence of the actual corpse. The issue of relocating memory back into the heart of the city follows a part of the growing literature in the Western world about the location and relocation of cemeteries from the middle of the city to its outskirts and back, bespeaking changes in the relationship between the living and the dead.

"The Changing Relationship of Memory and Place," Chapter 4, begins with my conception of Lowell as a series of memory sites relating to my family history. I review how the meaning of certain sites changed over time

as my relationship to Lowell changed. I look at the "pre-leap" landscape of industrialism and how the National Park has used that landscape, and created new sites, to describe the past. I address the significance of where the monuments are located, what their locations mean, and how their meanings and the memory they represent alter as they are moved or their sites change. So much of the relationship between the past and the present is evoked by sites of memory and sites of history. As these sites change over time, so too does our contemporary understanding of the past.

WHAT

Between 1993 and 1999 I documented 252 monuments in Lowell. I include in the term *monument* free-standing inscribed stones, both boulders and the more polished cemetery stones; inscribed bronze and metal plaques, both free standing and mounted on buildings, on bridges, in sidewalks, on fences; inscribed brick sidewalks, sculptural forms identified as public art; and waysides; or historical texts either mounted on buildings or free standing.

The first of the monuments that I discovered was erected in 1865. There were six monuments erected before 1900, three from 1900 to 1910, six between 1910 and 1920, and approximately ten each decade from 1920 to 1970. There were more than thirty monuments created in Lowell from 1970 to 1980, more than sixty-five between 1980 and 1990, and between 1990 and 2000. Approximately seventy-five of the monuments are in public parks, twenty-five in schoolyards, fifty in the historic district, thirteen on bridges, and eleven on churches. There are approximately thirty-five waysides, most erected by the National and State Parks, 110 boulders and cemetery stones, and ninety plaques. Of the 252 monuments only forty-nine are to war (four to the Civil War, if one counts a Civil War cannon and the Lincoln Monument; one to the Spanish-American War; nine to World War I; twelve to World War II; two to the Korean War; six to the Vietnam War; three to the Persian Gulf War; nine to all wars; and three to soldiers who died while in service but not in a war). Twenty-nine of the monuments are to sports figures (coaches and athletes), seven to children, fourteen to religious figures (thirteen priests and one minister), fifteen to overtly political figures, eighteen to civic figures (former city employees), and nineteen are what I call autocommemoration (the plaque honors the people who were in power when a project was completed or who donated land or funds).

Approximately thirty of the monuments are to someone who died young,

unexpectedly, or in an accident, and sometimes one person has multiple monuments.[10] Two monuments are specifically dedicated to peace. Eighteen monuments mention labor. Eight of the 252 monuments are to individual women, although women are referenced in some way on twenty additional monuments ("to all the men and women in the war," for example). One-fourth to one-half of the monuments, depending on how one reads them, are ethnic. Five of the monuments mention fire. More than thirty monuments reference water. Water plays a significant role in the memory and history of Lowellians. Water is a major theme marked in the various waysides, and, surprisingly, it is one of the major themes of the local monuments. Many of the local monuments mark sites associated with water (power plants, water-processing stations, and reservoirs), and employees of the water department are marked more often than other city workers.

I created two typologies to help me organize my thinking about the monuments. The literal typology includes monuments honoring European ethnic groups, Native Americans, priests, civil servants, and civic leaders (particularly those concerned with the use of water), politicians, children, sports figures (especially baseball coaches), volunteers, veterans (including ethnic and neighborhood veterans), donors, workers, and women. In a second, more interpretive typology, I divided the monuments into four categories: those grappling with the randomness of death; monuments to an ill-defined but deeply felt sense of service to the community and to the nation; monuments to the elements of nature, particularly fire and water, and human efforts to control it; and monuments through which the voices of ethnic Americans speak to the larger nation.

I have not explicitly defined what I mean by memory and what I mean by history. This work is an exploration of those meanings and of the places where they intersect.

WHO

My grandmother, Catherine Barrett Cleary, was born on May 10, 1882, on Marion Street in the Acre section of Lowell. She died at the age of eighty-six in St. John's Hospital on December 31, 1968. She lived at 834 and 848 Bridge Street for almost fifty years. Her father immigrated from Ireland via England to Lowell in 1878, and her mother in 1879. She married Edward Cleary on October 11, 1911, in Lowell. They had seven children: Edward (October 15, 1912), my mother, Kathleen (June 4, 1914), Dorothy (August 16, 1916),

a stillborn boy (1918), Jack (January 20, 1921), Frank (January 4, 1923), and Raymond (May 24, 1926).

My mother, Kathleen Cleary Norkunas, graduated from St. John's Hospital School of Nursing in 1936 and worked as a registered nurse off and on throughout her life. She married Stanley Norkunas on August 10, 1942, in Lowell. They had five children: Billy (September 5, 1944), Stanley (April 19, 1946), Patty (March 17, 1951), me (February 3, 1955), and Kathy (March 26, 1957). Although she was born and died in Lowell, my mother lived much of her life in other parts of New England. My mother died in her apartment in Lowell on November 1, 1993.

My Aunt Dorothy Cleary Dempsey married Walter Dempsey on June 29, 1940. They had four children: Little Walter (April 1, 1942), Jack (May 14, 1944), Ann (June 5, 1947), and Brian (September 18, 1953). Dorothy lived all of her life in Centralville, on Bridge Street and Seventh Street. Occasionally working as a nurse's aide, she was a homemaker for most of her life and the hub of the immediate and extended family. Dorothy died in the D'Youville Nursing Home on May 27, 1999.

A WORD ABOUT THE NOTES

I wrote this book for both academic and general audiences, and there are many notes. Somewhere I read that a reader so enjoyed a particular author's notes that she looked forward to reading them almost as much as the text. I do not know if my notes are quite that engaging, but I have included them as a way to give further evidence for a particular point, to offer additional in-depth text, and to refer readers to other writers' ideas on a topic. For readers who do not want to be bothered with the notes, I have three words of advice: don't read them.

I

INSIDE THE MEMORY

OF CLASS AND

ETHNICITY

In the summer of 1996 my cousin Ann and I lay in twin beds at my Aunt Dorothy's house, as we had so often done as children, and moved in our memories through each of the rooms in Nana's apartment. There was Nana's green, scratchy couch in the living room, her rocking chair, the chair that only Grandpa sat in when he was alive, the spare bedroom where all the dolls were kept, and the picture of Jesus with the eyes that followed me across the room. We remembered the huge windows in the kitchen that filled it with sunlight, the newspaper-plastered walls in the attic, and the claw-footed bathtub. After Grandpa died, Nana lived alone in that apartment for twelve years. "I miss Eddie," she would say. Later, when most of her friends had died, she got ready herself: "I wish the good Lord would take me. I'm the only one left." Ann often brought dinner to Nana, carrying the food up the long flight of stairs, or picked her up to spend a few days at Dorothy's house.

We decided to go to the actual building where Nana had lived. We stood in front of the apartment with our bodies in the present and our minds in the past of our childhoods. Suddenly the door of Nana's apartment opened and someone came out. We realized we could ask the woman if we could

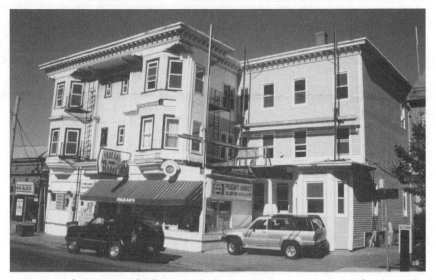

Over Fruean's Store was the Dempsey's three-room apartment on Bridge Street. In the summer of 1996 it was being renovated.

go in, explain to her that we had last seen the inside of the apartment in 1968 when Nana lived there, tell her how much it would mean to us. But we did not approach the woman. I could not go in. I was afraid that my memory of the place, which I had varnished over time, and Ann and I had lovingly added details to, would be forever disturbed.

We continued down Bridge Street, past Eleventh Street where Uncle Edward used to live, past Shedd Street where Nana had briefly lived, and past the Shell gas station where my brother, Billy, still pictures Grandpa sitting out front with the other men, to Fruean's, the corner store. Above Fruean's was a large tenement building. Ann, her three brothers, and her parents lived in a three-room apartment there for twenty-one years. The building was being remodeled. To our amazement, it was open. Ann decided to go in. It had been thirty years since Ann walked up these back stairs. I began to travel back in time through Ann's memory. There was a kind of wonder on her face. We entered the first room, a small entryway with a slight closet to the side where Dorothy kept the coats. In the main room Ann described where their furniture had been, where the Christmas tree stood, and where Nana and Uncle Jack had sat. She pointed to where the pullout couch had been that Dorothy and Big Walter slept on. We went into the small adjacent bedroom. Ann said, "There was a big bed that Walter and Jack shared, and Brian

and I had the bunk beds. I looked out the window at all the trees and the houses next door." Next was the kitchen, so small that a stove and table barely fit. "That window! One day we jumped from our roof to that roof right next to us." The tiny bathroom completed their living space.

What Ann saw was meaning and memory in a place that represented happiness. I had few memories of the place, for I was little when we used to come visit. But I remembered my mother's and brothers' stories of coming to visit, how much they looked forward to it, and how happy they were when they stayed in the apartment. The stronger image for me was the literal place I saw that day. I saw it in terms of class, a poor, cramped space where six people lived for twenty-one years. Was my family that poor? I could not reconcile memory and physical place. I had been to the Lower East Side Tenement Museum in New York, which portrayed the difficult life of working-class immigrants forced into tiny, often unventilated tenements. My heart had ached for them. This apartment was smaller. I knew that this space was lying to me, just as it would lie to an outsider, conveying poverty and hardship, when it had wondrous meaning for my family. If this apartment were to become a part of the historical representation of Lowell, whose interpretation of the site would prevail? Would we be remembered as struggling Irish Americans, the working classes forced into this pitiable space? Could our humanity and humor and tremendous connection to each other, our memory of the space beyond class, be incorporated into an historical analysis of life in Lowell? I hoped that history would not condemn us to forever feel the burdens of class, something that memory's emotions allowed us to forget.

We went through the other apartments in the building, and in each one Ann excitedly spoke about the person who lived there. Some were one-room apartments, others were just two tiny rooms. Here, she said, was where My-My lived, who told Ann stories in the evenings, and here was where Mr. Buckley lived, who used a wheelchair. Until that moment, Ann never realized that Mr. Buckley had lived in one room. She stopped in front of the landing where the bottles of milk were delivered every morning. It was a world, a culture, full of life, visiting, relationships, and friendships. We ran to Dorothy's house to get Ann's brother, Little Walter, so he could see the building. In the entryway, and in each of the rooms, Ann turned to Little Walter, saying "Look Walter, do you remember?" We went to the apartment where Dorothy's best friends had lived. After they moved away, they always wrote to Dorothy. (I remember my mother telling me that they moved

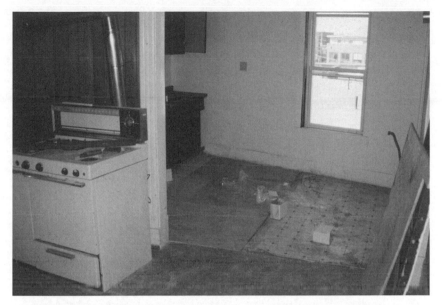

The inside of the Dempsey's apartment as I saw it in the summer of 1996.

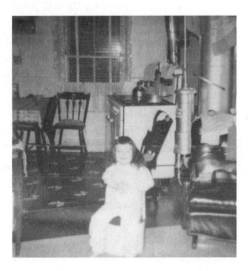

The inside of the Dempsey's apartment, as Ann saw it, and as it appeared in a photograph of Ann, circa 1950.

quickly, because they could not afford the rent. When they were better off, that story was never mentioned.) Later, back at Dorothy's, still stunned, I asked Dorothy if she ever felt the apartment was small. "No, it was okay for us," she said. "Remember Ann, the landlord would come around every Friday afternoon and collect the rent—$2.50 each week." It was not their tenement—it was their home.

My mother attended the public high school, Lowell High School, for one day. She thought it was big and confusing, and she came home upset. The next day she went to Immaculate Conception High School, a private Catholic girls' school. She was happy there, but she also faced some difficult class issues. Through the stories of her high school days, I learned about the social stratification of Lowell. The school was located in Belvidere, the section of Lowell once developed for the mill agents with huge homes and landscaped yards. Many of the girls at Immaculate Conception High School came from prominent business or political families. They took dancing and piano lessons and were in all of the school plays. My mother did not have lessons, which is why, years later, she made it a point to enroll us in dancing, piano, sewing, and swimming lessons. My grandmother did not understand why she needed piano lessons: "I have enough noise around here without listening to any banging on the piano." So, my mother could only watch the other girls perform. It seemed that in high school my mother began to develop a sense of class consciousness. She wanted to be a part of the middle or upper-middle class and to have not only what money could buy but also the status and prominence that money could only imply.

After she finished high school, my mother decided to attend the St. John's Hospital School of Nursing in Lowell. This was the same school that Nana's sister, Aunt Nan, had attended, and Aunt Nan had spoken to someone to help my mother get in. Forty years later someone from the third generation in my family, my sister, Kathy, worked at St. John's as a nurse. My mother graduated as a registered nurse in the midst of the Great Depression. She wanted to go to college and complete her bachelor of science degree, but Nana told her no. "There are four others behind you, Kathleen," my grandmother said. "I can't afford to send you to college. I sent you to nurse's training. Now, I have to help the others." There were no scholarships for college then to assist with financial constraints. Instead, she got a nursing job at St. John's and later at the Veterans Administration Hospital.

What I knew of my father's family came through my mother's stories. My

Catherine Barrett Cleary (Nana), Kathleen
Cleary (my mother), and Edward Cleary
(Grandpa), circa 1936.

father's parents came from Lithuania in 1917, perhaps, I learned from inter-
viewing another Lithuanian family, to avoid conscription in the Russian
army.[1] They settled first in Lawrence, Massachusetts, and then in Lowell in
the Lithuanian district, just off Lawrence Street, not far from St. Joseph's
Church, the Lithuanian church. Nana Norkunas had worked as a midwife,
and maybe as a mill worker. She adored my father, her youngest child and
only son. He had three sisters, one of whom died in Lowell of a ruptured ap-
pendix on the fourth of July when she was twelve. After Grandpa Norkunas's
death in 1940, my father worked every day after school at a shoe store in
downtown Lowell to help support his family. When he was denied a five-cent
raise, he went across the street and got a job at the Thom McCann Shoe
Store. One of his coworkers was going out with a friend of my mother's.
When my mother wanted to go to a dance, her friend fixed her up on a blind

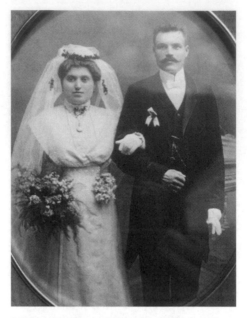

Martha Norkunas (Nana Norkunas) and
Joseph Norkunas, circa 1910.

date with my father. I learned by talking with other Lowell women that many
of them met their husbands at dances. Nana Norkunas never felt completely
comfortable with English and was distrustful of my mother because she did
not speak Lithuanian. Although both of my parents were Catholic, neither
the Lithuanian nor the Irish churches would marry them, because in 1942 in
Lowell it was considered a mixed marriage and frowned upon. My mother's
Uncle Jack performed the ceremony in the Immaculate Conception Church
in Lowell. When I was a little girl, my mother often went to a hairdresser in
Lowell that I believe was near the courthouse. I have a picture of Hurd Street
in my head, but it is dark, perhaps because my mother only went after work.
As an adult, I understood for the first time why she went to that particular
shop. The hairdresser had grown up next door to my father's family, and she
told my mother many stories about my father's past.

My Uncle Edward used to tease my mother about marrying outside the
ethnic fold. When they drove through the Polish section of Lowell, he would
say to her, "Look at the Polish kids with no shoes. Kathleen's kids will never
have to worry about shoes." My mother would correct him, "My husband is

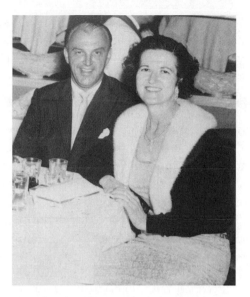

My father, Stanley Norkunas, and my
mother, Kathleen Cleary Norkunas, at the
Copacabana nightclub, New York City, 1960.

Lithuanian, not Polish." Ironically, my father was in the shoe business his
whole life, and we had shoes in every color.

My parents married in 1942, just as my father was drafted into the army.
When he returned from the war, my father resumed his former job at Thom
McCann's in downtown Lowell. It was not long before he was promoted, and
the family moved away from Lowell. My father was a hard-working and tal-
ented shoe designer and salesman. The promotions came regularly and with
each one the family moved. My mother was not unhappy to leave Lowell. It
was a time when many were leaving. In the early 1950s people wanted to es-
cape the city's depressing economic climate. Nana's children were successful
by the definition of her class and times: civil servants, office workers, and
state employees. My mother dreamed of a wealthier lifestyle, and, with my
father's increasing success, she found it. Eventually my father had an office
in New York City, and we bought a house in New Jersey. My parents went
to plays in New York City and dined at the Copacabana, and we had cars,
clothes, and maids to help in the house.

In the early 1960s my parents legally separated, and my mother's status
in the class structure became murky. Her lifestyle and many of her ideas were

now upper-middle class, but suddenly her income plummeted. After the separation we moved back to Massachusetts to be near Nana, Dorothy, and my mother's brothers and her sisters-in-law. There, in the small rented house, my mother would reweave the past. Now there were stories about me entering the small Massachusetts house and asking my mother, "Where is the recreation room? And where are the other bathrooms—I can only find one." Most often she used the stories as a way to untangle the events in her own life. She described the week that we moved from our big house in New Jersey. At first we thought we would move into Nana's attic on Bridge Street. Then, two days before we were scheduled to leave, Dorothy called and said, "I found you a house." She remembered the last moment on Rugan Drive in New Jersey—the huge moving truck packed with the designer lamps, the china dishes embossed with the sheaf of wheat, the furniture she had so lovingly chosen—and the enormous pain of leaving that lifestyle behind. "It is easy to improve your station in life," she would tell us, "but it is very difficult to go back."

My mother returned to the Lowell area a single, working mother, a rare social position in our circle of family and friends, and for many years she lived in a nebulous zone between the classes, retaining the vision of our family as sophisticated, cultured, and bourgeois, although she never used any of these terms. We were to be well read and well traveled, within her new economic means. Each year she took us to New York City to attend Broadway plays, to visit the Metropolitan Museum of Art, to tour the United Nations, and to shop on Fifth Avenue. But on most weekends we went to the Giant Store in Lowell to have dinner at the lunch counter, a far cry from Fifth Avenue. She wanted us schooled in what she felt were middle-class towns, Chelmsford and Bedford, so that one day we could lead the life that she had aspired to and had begun to live in New Jersey. We believed that in our new circumstances we were temporarily misplaced in class, although it was the culture of our working-class family that now sustained us. At the age of forty-eight, my mother began, once again, an effort to move from the working class to the middle class, but this time there would be no delight in it, only a driving determination for her children.

When my mother and father were separating, Nana rode the bus from Lowell to New Jersey to visit, never staying more than two weeks. My mother said Nana missed Lowell, and that she could not be away from it for too long. It was as though Nana had brought Lowell to us with crayons, coloring books, a pound of sugar, a pound of coffee, and some tea bags. Years later I

too packed a pound of sugar in my suitcase to bring to my mother, as a memory of Nana. The idea of Nana's gifts of sugar and flour cause me to ache. They were offerings from a loving working-class woman to her daughter who had risen far above her financially, and who received the flour and sugar into her designer home as an act of love. "Nana was very wise," my mother said. She told me about the advice that Nana gave her during those sad times. As a child I did not understand Nana's words, but in them my mother sensed something meant to comfort her, to instruct her, and to bring an acceptance of all the changes she had to face: "It's a long road, Kathleen, that has no turn."

After my mother moved back to Massachusetts her family folded itself around her, acting as a source of moral and physical support. In working-class Lowell, no one called for appointments to visit or to say, "I hope everything is going well." Instead, they were there to take some of the children for the weekend, to hang curtains in the new house, to make dinner for the family, to pick my mother up when her tire went flat, to check on the kids in the afternoon before my mother came home from work, and to help her make decisions that faced her, large and small. "Thank God for my family," my mother often said. Nana, Dorothy, and my mother's brothers and sisters-in-law—they were her social world, but more than that they were the people she trusted and depended on. As time passed, she too performed a thousand small services for each of them. The obligations and assistance were understood. When my mother died so many years later, her brother turned to me at the wake to say, "You have no idea what your mother did for us over the years. So many times she was there for us. You have no idea." I did not know exactly what he meant, but I understood what he said in terms of their interdependence, of their being physically ready to help each other.

I had always known that there were other ethnic groups in Lowell besides the Irish. There was my father's Lithuanian family, and my Aunt Doris's family was Franco American. When we drove through Lowell my mother pointed out the different ethnic sections. Sometimes we went to the Portuguese bakery on Back Central Street. But it was not until I was grown and living apart from Lowell that I saw the city intellectually rather than emotionally. In the 1980s I developed a new relationship to Lowell's culture and geography.

In graduate school I received a grant to make a documentary videotape about women in Lowell, and I spent a summer interviewing twenty-two dif-

ferent women. For the first time I came to know different sections of the city. I learned of other Irish neighborhoods near the Sacred Heart Church, the Polish area around High Street, the Lithuanians off Rogers Street, and the Franco Americans in Pawtucketville and in the place that was once Little Canada. I walked in the Acre section where the Irish and Greeks had once lived, although I was warned of its danger, and through the small streets off Back Central Street around St. Anthony's Portuguese Church. I wondered that I had never been in these neighborhoods, did not know the streets, or did not know how to judge danger or comfort. I wondered that the women I interviewed had rarely been outside of their own neighborhoods, and how they, and my family, had all lived in such small spaces without feeling crowded. I wondered that I had never seen *Centralville* written, and had only heard it spoken—*Cenavul.* Until one afternoon, during an interview, I had always been associated with the Irish Cleary family in Lowell. Sitting in the home of an elderly Lithuanian woman, her husband came in. "Look who it is," she said to him, "It's Joe Norkunas's granddaughter." They knew my father's father. In turn I understood myself, in that moment, as a part of the Lowell Lithuanian network.

In 1987 I was back in Lowell doing research, this time collecting ethnographic data for the American Folklife Center of the Library of Congress. The center was creating a folklore archive, and I was documenting events so different from those I had known as a child in Lowell: a Portuguese procession circling the boundaries of the neighborhood, a Franco American afternoon of music, bingo in the church halls, and the Buddhist temple created by the newly arrived Cambodians. I did not know there were boxing clubs in Lowell or arranged marriages, and I had never been to the Portuguese Holy Ghost Park. Other ethnographers on the project went to Cambodian wedding ceremonies and Latino festivals, and they heard stories of swimming in the canals, accidents in the mills, and local politics. Based in part on my research, my colleagues began to associate me with Lowell, and, when asked where I was from, I started to respond, "From Lowell." I thought of the great irony of my mother fleeing the city's depression, of her efforts to school us in the towns around Lowell, and how I was now both identifying with and identified by my connection to Lowell.

In graduate school I came to value the stories that Nana and my mother had told me. I saw them for the first time not only as the story of my family, but as belonging to the great repertoire of family and ethnic narratives

Our working-class home on Lawrence Street, February 1991.

that folklorists were interpreting. They were an ethnic art form practiced by immigrant families across America. I also came to see my upbringing in and around Lowell as something both uniquely personal and as structured by ethnic and class culture. I was nearly fluent in the Anglo American and Irish working-class cultures and constantly passed between them. My ethnic and working-class background, so linked in America, became not identities to be disavowed, but badges of honor. Colleagues who did not have strong ethnic backgrounds began to wonder if they had identities at all.

I moved to Lowell in 1989 when I accepted the position of cultural affairs director at the Lowell Historic Preservation Commission. I was married with three young children. Buying a house in the city, declaring that my roots were deep, was an unofficial requirement of my position. We purchased our first home on Lawrence Street. The house became a site of memory for our nuclear family, the incongruous sound of the Concord River rushing over the rapids deep in our ethnic, industrial neighborhood and the lily bulbs that continued to bloom years after we planted them and years after we departed. It was mine from the moment the real estate agent first took me inside. As I entered there was the aroma that had once greeted me when I opened the downstairs door to Nana's apartment. The neighborhood is a place of Portuguese, Polish, Irish, and Cambodian cultures. We could stretch our arms out the window and touch Mrs. Roger's house next door. It was an old working-class neighborhood with houses built for the people who once worked in the nearby mills or in the bleachery up the hill, now the spaghetti factory. It was in this house that we colored Easter eggs, that we made a snowperson in the front yard, that we had our own big family party, and that I made my daily calls to my mother "just to check in."

Mrs. Rogers was eighty-seven and I was thirty-five when I moved next door. She left school after the eighth grade; she and her husband had been mill workers. They had lived in that house in part of the old Irish section of the neighborhood for more than forty years. Looking out the window, she waited for me to pull my car into my spot on the street, for no one had driveways and they carefully protected their spot on the street, and then step outside to visit with me. It was on the steps that she talked about her children and grandchildren, the neighborhood, and her love of flowers, and that I told her about my family, events downtown, my mother's cancer, and my husband's job. Together we shared the hurricane, the robber Mrs. Rogers threw out of her house, and the enormous flowering rose bush (which later I took a cutting of and planted in yet another house in another state as a daily re-

minder of Mrs. Rogers). On these steps she asked how my mother was doing, and I told her that I believed my mother was dying.

I loved that house and our relationship with our neighbors, yet I sensed my mother's class admonitions: we should have lived in Belvidere or high on Christian Hill. Would having a different address, I wondered, have advanced my advocacy of certain projects? I wondered if my access to power and my address were connected. The neighborhood, or pockets of it, had a reputation of being dangerous, although we never felt in danger. I sensed that we were not who we could have been because of the house. We were not living in a place my mother had once envisioned for herself and later for me. At one point, a friend and colleague came to visit us. "What are you doing here?" he bluntly asked. "You should be living in a much better house than this." I was not offended by his speaking the truth. In certain ways, however, the house had value, not economic value certainly for it was too working class, but the value of residing deep in the heart of one of the older Irish neighborhoods in Lowell. My connection to the house went deeper than I could have imagined. We owned the house for years after we moved away from Lowell. Its value had dropped. It could not be sold. Only the houses in Belvidere sold quickly.

Did marrying outside the fold, I wondered, impact how certain people in Lowell viewed me? My husband was born and raised in Turkey. He was a true stranger to my relatives. Over a period of many years they came to know and cherish him, but he had to prove himself first: through his humor, through his devotion to my mother, through his kindness to the older members of my family, and through his constancy. He remained a stranger to my professional Lowell colleagues, never having the opportunity to become their friend. The large Greek and Armenian communities in the greater Boston areas created a certain atmosphere of hostility toward Turks, even those far removed from the politics in Turkey. Once, when introduced to a Greek woman who sat on the Lowell Historic Preservation Commission's board of directors, she stepped back away from him as they shook hands. Later she told me that although I was married to a man from Turkey, "You and your family will still be welcome in my home." These were quiet pressures, and I was never certain how they affected our roles in the city.

As the cultural affairs director I came to know a network of people who I had known before only through the stories of my aunts and my mother. I was now no longer a visitor to the city, if that is what I was before, or the objective ethnographer, or the child of my large extended family. I was now a

part of the history, and hence the politics, of Lowell. I do not know if I was—or am—an insider or an outsider. Early on I sensed that my authority and my ability to negotiate successfully depended in part on my being an insider, and I frequently referenced my family's long ties to the city, the purchase of a house in an old Lowell neighborhood, and my various family connections. Yet I had not gone to Lowell schools, nor had I ever actually lived in Lowell before 1989. The stranger in a community is someone who comes today and stays tomorrow. If the stranger does not go away, one has to establish if he or she is a friend, which is different from accepting that person as one of the community, a process that may take years or never happen. The stranger is, ultimately, the person whose coming is an event in history, rather than a fact of nature, who was not a part of the community from the beginning of time.[2] I was an event in time in Lowell, not a part of the natural landscape, and so in that sense I was a stranger. Still, as often as I went away, I could be counted on to return, which made me a friend. I could trace my lineage in Lowell and build upon associations.

Lowellians refer to certain people as "blow-ins." A blow-in may have lived in the city for years, but remained in some sense a stranger. They are not thought to be of the city, but only in it; just as they had blown in, so too could they blow out. Their commitment to Lowell is questioned. Such a city, often described by the press as "gritty," is not always an easy place to live. Young professionals choose Cambridge or Boston, with their cafés, book-stores, and vintage shops. Yet the struggle, sometimes daily, gives Lowell a quality one colleague could only describe as soul. Like the Puritans who re-fused to settle in warmer climates and instead endured the harsh New Eng-land winters in order to prove their worth to God, Lowellians feel a sense of machismo in triumphing over the struggle.

Lowell is a place where one is known, and one's family is known. I have attended many meetings that began with people introducing themselves by stating their names and professional titles, and then describing their ethnic backgrounds and how their families came to America and to Lowell. Peo-ple here earn their authority to advocate ideas through loyalty to the city, longevity, and ethnic associations. It takes a commitment to live in Lowell that involves generations of family, of being related to others in the city, of having politics in your blood, of developing a hide tough enough to navi-gate the political waters, and of valuing the cultural life that takes place in-side the three-room tenement.

With each childhood visit and my eventual move to Lowell, I was enfolded back into my huge family and its complicated network of rules and expectations. The rules of my family are drawn from the rules of Lowell, which guided what to wear, how far to push the teasing, when to visit, what to bring, when to touch or kiss, and when to refrain, how to ask for favors, and how to reciprocate when a favor is asked. When my mother was alive she strictly enforced these rules within the family.

Once I started working at the Lowell Historic Preservation Commission, my mother outlined for me the rules for succeeding in the social and political spheres of Lowell. She encouraged certain connections and relationships, told me what events to attend, and spoke for and about me to her own social and political network. In this way she protected me, if protection was occasionally needed, and quietly made known my connections to certain powerful people. These were not formal lessons, but parts of daily conversations drawn from my mother's knowledge of power, class, and politics in Lowell. She also had a tremendous drive and drove us. I think she wanted me to abandon the cloak of invisibility many women wore and sit at the table with the power brokers. On occasion she would phone me, demanding to know why my photo had not been in the *Lowell Sun*'s coverage of a cultural event. "That's not my job, Mum," I would tell her. "My job is to administer the cultural program." But I would ask myself later, "Was she right?" Over time I developed my own network of associations and trusted colleagues, and my own methods of reaching people in positions of power. I learned the rules well enough to stay afloat. Looking back and seeing myself as naive, I had thought my job was about history, ethnic culture, and the arts, but I learned that it was about politics, just as everything in Lowell is about its unique brand of politics.

Politics is the lifeblood of Lowell. On Tuesday evenings, everyone regularly watches the city council meetings broadcast on the local television station and discusses who supports what and why. Reading the *Lowell Sun*, particularly the local news, is an absolute necessity. What is talked about at the latest meeting, who supports which position, flies over telephone lines. News is a form of power, and the joke around town is "Been gone for fifteen minutes? Must be out of the loop." I learned that who supported a position was as significant, if not more so, as the position itself. This complicated the pathways linking people: "Didn't I know that so-and-so was her uncle?" and "Didn't I know that X's father and Y's father worked in city hall together, so

of course he would support the proposal?" Power is exercised overtly through job positions and control over budgets, and covertly through networks of long-held relationships. Those, particularly women, with low- and mid-level positions know how to exercise great behind-the-scenes power through their relationships. I eventually learned never to equate someone's title with power. At work, for example, one of my colleagues had years ago served on a board with a woman who was now on our board, and one phone call from her was all that was needed to begin lobbying votes.

Each weekday morning the editor of the *Lowell Sun*, certain city officials and city councilors, the radio call-in host, and other power brokers had breakfast at Brigham's Restaurant. My Aunt Doris was a waitress there, and she told me this. Aware of the rules of discretion, she never talked about what they discussed. Over lunch, people told me stories in hushed tones. There was the man who brokered agreements between organizations and financed projects and never wrote anything down. There were men who lost their jobs and resurfaced in other appointed positions. One man awoke on a Sunday morning to read in the *Lowell Sun* that he had "resigned." Often it was clear how people came to occupy certain positions by being the godchild or niece of someone currently or once in power. At other times the avenue to power was less visible, like old connections through relatives or campaign contributions.

Ethnic loyalties ran deep. Each ethnic group had one or several cultural organizations, and their people could be counted on to donate funds to the organization. They could also be counted upon to support particular positions, acting as a lobbying group, jokingly referred to as the Greek Mafia, the Irish Mafia, or the Franco American Mafia. When estimating how a vote would go on a particular cultural matter, my more seasoned colleagues said, "So and so will vote with so and so. They served together on the Hellenic cultural board years ago."

I became an actor in the life of the city, both a part of its memory—the institutional memory of the Lowell Historic Preservation Commission and the Lowell National Historical Park—and an agent in the creation of its history. I was a part of so many of the projects that transformed the face of the city, although how much a part—2 percent or 70 percent—can never be said. The outdoor performing-arts park, public art pieces, exhibits, books, plays, conferences, waysides, and media productions—I assisted, in some way, in them all, and yet few knew that I had played any role. I see myself in each of these new additions to the landscape of the city, but can I be seen in any of

them? So thoroughly was my new identity fused with my position, that I was never Martha when I was downtown. I was always the cultural affairs director. On occasion I asked a long-time colleague to speak to me as the person they knew before I became the cultural affairs director, but I always had to ask. Responsible for overseeing a three-million-dollar budget, I had to be an objective evaluator of project proposals and yet be politically savvy enough to imagine how the final vote would go and who would support certain positions. Though I was a federal employee, I was also part of the fabric of Lowell. Emotionally, it felt like I was in two different worlds, although intellectually I knew they were supposed to be conjoined. In some ways I was the quintessential insider/outsider, traveling between the realms of interpretations of the past, the living culture of Lowell, and the powerful memories of my family's life in the city.

My status as a Lowell insider/outsider was written by my constantly going away and coming back, my ability to be a part of the city and to be able to document it and create its history, and my evolving relation to the people I came from. I did not live in Lowell until I was a grown woman with my own family. I came to Lowell then, as I now see that I had always come to Lowell, with my father's Lithuanian name and my mother's Irish identity, belonging at once to more than one social class. My mother had also lived apart from Lowell for much of her life, so perhaps she too experienced a sense of being an insider and outsider at the same time. Certainly, she lived in and through many social classes. She had moved so often in her life, and, like me, she returned to Lowell again and again. Her final move was not just to Lowell, but to Centralville, the part of the city where Nana had always lived, where my Aunt Dorothy lived, and where many of my aunts, uncles, and cousins now live. Her last home, it turned out, was in the very neighborhood where she was born. I wonder where my last home will be.

Class divisions and ethnic separatism were born with the first breaths of Lowell. When the corporate investors needed manual labor in their mills, they imported Irish laborers to dig the 5.6 miles of canals and housed them in a mosquito-ridden acre of land separated from the mills. Prohibited from working in the mills next to the young Yankee farm women, the Irish were known as "the coloreds." The memories of discrimination die slowly. One day as my mother and I were driving down West Sixth Street, she pointed out a house. "See that house? I remember, as a young girl, a sign on it that said, FOR RENT, NO IRISH NEED APPLY." Over time new immigrants filled the

mills, and the White Anglo Saxon Protestant face of the city changed in the nineteenth century, like much of the industrial north, to immigrants living in enclaves within the city and marrying within their own ethnic groups for up to three generations.[3]

Imagining my ancestors' entry into Lowell and the discrimination they faced, I thought a lot about the then recently arrived Cambodians. If I struggled with feelings of being both an insider/outsider, what must the experience of establishing a home in Lowell be like for them? It would take years before they could build an ethnic lobbying group or they could create the kind of political network needed to advance their ethnic interests. At the Mogan Cultural Center's "Working People" exhibit, I stood in front of the video monitor as a Cambodian man described his first impression of Lowell. He had landed in the United States in winter, wearing only a thin shirt. When he saw the apartment he was to occupy in Lowell he was confused because there was no place to grow his vegetables or keep his chickens.[4]

As a member of the Lowell Historic Preservation Commission, I attended meetings with newly emerging Cambodian American leaders. At one dinner meeting in Lowell I was the only non–Cambodian American present. As the guest, everyone waited for me to begin eating, but I did not know the proper etiquette for serving myself or which foods to select.[5] I saw how difficult it would be to bridge the gap between Lowell and Cambodian culture. I encouraged the Preservation Commission to take an active interest in the Cambodians.[6] The Preservation Commission funded a number of initiatives between 1989 and 1994 that presented, interpreted, and celebrated Cambodian culture in Lowell and assisted the Cambodians in developing a meaningful connection to the city. Among the projects were a Cambodian television program, a play about the Cambodian holocaust, a children's art exhibit based on their experiences in the holocaust, a Lowell-Khmer classical dance troupe, a book on Cambodian youth, a book of poetry from the Cambodian community, and a performance of a classical dance troupe from Cambodia.[7]

In the early 1990s I attended a Lowell showing of a recently completed film about the Cambodian experience in America, *Rebuilding the Temple: Cambodians in America*.[8] At the end of the film, there was a discussion with the audience. Three Cambodian American teenagers wearing denim shirts and jeans, surprised the audience with their eloquent articulation of the difficulties of integrating into American culture. They spoke of the teachings of Buddha, which stressed the good of the community and a passive approach to the winds of fate, and how that philosophy conflicted with the American

emphasis on individualism and an aggressive, activist approach to life. They wondered aloud how they could continue to be Buddhists in America, and Lowell in particular.

A Puerto Rican colleague from the Coalition for a Better Acre, an advocacy group for low-income families, once commented to me that Lowellians thought that the Puerto Ricans, and also the Cambodians, would go away. It took Lowellians a long time to realize that Lowell was now home to Puerto Ricans and Cambodians too. Lowell, although a city of immigrants, was having difficulty accepting this newest group of immigrants. Today, however, Cambodians are a major presence in Lowell. As one foundation director noted, "They are making themselves felt, culturally and politically. Someone told me recently that they now make up over 40 percent of the population of Lowell. The latest census figures indicate a much lower percentage—around 18 percent—but it feels like 40 percent."[9]

The ethnic neighborhoods or sections of the city have been named by locals but are unmarked and their boundaries are fluid. They have existed for generations, designating space as well as ethnicity and class, and are clearest to Lowell insiders. Little Canada, for example, was once the area inhabited by Franco Americans. Pawtucketville is largely, although not exclusively, known as a Franco American neighborhood to this day. Swedeville was a small area not far from the cemeteries where many Swedish immigrants lived. The Hale-Howard area was the Jewish section, while other, smaller neighborhoods were called Little Italy, Oaklands, the Bleachery, and Ayer City. Middlesex Village is the name of a section of Lowell that was once an early Anglo Saxon community. The Acre was originally settled by the Irish and referred to as the Paddy Camps or the Holy Acre; when the Greeks lived there, it was called Little Athens or Greektown. Later it became a mix of Cambodians, Puerto Ricans, Colombians, and other new immigrants. Back Central is known as a Portuguese section, and many Poles live around High Street. Centralville is ethnically mixed, although it had, and to some extent still has, strong ethnic pockets and is clearly derived from the French *ville* (city). In South Lowell, the Grove and the Flats had significant Irish populations.

These neighborhood designations are very much a part of how people define themselves and their families. A woman I interviewed said that she could not answer one of my questions about Centralville because she "wasn't from there." Although born in Lowell, she had only moved to Centralville forty-seven years earlier.[10] Sections of the city once associated with older immigrant groups are increasingly associated with class. Belvidere was once the

neighborhood of the wealthy Yankee mill owners and agents. It is now ethnically mixed but remains upper-middle class. It is prestigious to live on or near Andover Street in Belvidere. The Highlands was once a middle- and upper-middle-class area, but in the 1980s and 1990s has come to be more of a working- and middle-class neighborhood with large concentrations of Cambodians and Irish. The area around Middlesex Street is also populated primarily by Cambodians. There is a pagoda atop a Cambodian American mall in this neighborhood. I would not be surprised if one day it becomes known as Little Cambodia.[11]

Lowell's intensely Catholic history is reflected in the descriptions often given to neighborhoods as parishes. Interethnic conflict within the American Catholic church led to the development of ethnic-language churches, and Lowell had many. The Irish churches were ethnically homogenous, and older non-Irish Lowellians tell stories of feeling unwelcome in them. The Franco Americans had several French-speaking churches in Lowell, the Holy Trinity was the Polish-language Roman Catholic church, and St. Casimir's the Polish Catholic church. St. Joseph's Church had masses in Lithuanian, and St. Anthony's is still a Portuguese-language Catholic church. In the 1970s a number of the churches began to lend their basements to Spanish-speaking Catholics for mass, and St. Patrick's, the oldest of the Catholic churches in Lowell and once the sole province of the Irish, has a significant Vietnamese congregation. There were also four Greek churches in Lowell. People described themselves as coming from a parish, which was synonymous with belonging to a particular ethnic neighborhood. "I'm living over in the Sacred Heart parish" meant that the person was Irish and lived in the Grove or South Lowell area.

It was argued that Lowell was the appropriate place to tell the story of the American Industrial Revolution because so much physical evidence of industrialism remained on the landscape. The story of the early female labor force was also compelling. Finally, ethnic mill workers still lived in Lowell, and their memories could inform the narrative of the late nineteenth- and early twentieth-century industrial city. The legislation that established the Lowell National Historical Park in 1978 also created the Lowell Historic Preservation Commission as a sister agency to the National Park. The brainchild of then Massachusetts Senator Paul Tsongas, a Lowell native, the Preservation Commission was, at the time, a unique federal agency. Unlike the National Park, the Preservation Commission could disperse federal

funds as grants, and it could engage in historic-preservation projects and cultural programs to enliven the historic district. The Preservation Commission's central theme was "to tell the human story of the Industrial Revolution in a nineteenth-century setting by encouraging cultural expression in Lowell."[12]

At the Preservation Commission we funded local cultural organizations and individuals in the city that wanted to produce exhibits, plays, books, radio and television programs, documentation and research projects, and a host of other projects related to the themes of labor, ethnicity, industrialization, and the history of Lowell. We created an outdoor performing-arts park, a public art collection, and a folklife center. We also assisted community groups in developing temporary exhibits about themselves in the National Park's "Working People" exhibit. Many of the ethnic groups in Lowell created exhibits, as did cultural and social service organizations. Most applicants had never before produced an exhibit. After the organization shaped the story they wanted to tell, the Preservation Commission assisted them with technical expertise. Most groups depended on their members' memories to construct the narrative script for the exhibit. They collected artifacts from people's homes and conducted interviews with community members about their lives in Lowell. All groups produced brochures documenting their history in Lowell, as they saw it.[13]

Many of these projects were designed to bring the story of nineteenth-century Lowell into the present so that the interpretation of Lowell would be ongoing. The commission worked closely with the National Park in creating the Boott Cotton Mills Museum, the Patrick J. Mogan Cultural Center, the outdoor trail of waysides, and many other interpretive projects. Through this work, it was clear that the identity of the people of Lowell was deeply connected to their past and that the physical preservation of Lowell's industrial landscape was critical to telling the story of that past. But it was also clear that the story could not be told through buildings alone. The meanings of the buildings and the meanings of the past could only be articulated through cultural programming, which was sometimes celebratory, sometimes reflective, sometimes interpretive, but always sought to find the intersections between memory and history.

The need to create the Lowell Historic Preservation Commission can be explained in part by exploring the tension that existed in the city between insiders and outsiders. The National Park, while valued for infusing millions of federal dollars into the city and creating a feeling of hope for the future

and pride in the past was also carefully monitored because it was filled with outsiders who did not necessarily understand the ways of Lowell, although, in fact, many local people worked at the National Park. The National Park was to be balanced by the Preservation Commission, which had a board of directors comprised of local people and a staff of predominantly local people, although many outsiders worked at the Preservation Commission. These agencies worked cooperatively, but sometimes also competitively, with the Preservation Commission laying claim to the insider's perspective and the insider's politics. When conflict came to a head, the underlying questions were always: Whose vision of the past—outsider or insider—will prevail? and Who has the right to decide what will happen in the city? The perspective that outsiders "just don't get Lowell" was contrasted with the idea of outsiders representing a more balanced, less provincial, less politically motivated vision of the city's past and its potential future. In some sense the two agencies balanced the principle conflicts so that there was constant negotiation between memory and history, the personal and the abstract past, and, of course, insiders and outsiders.

With the designation of Lowell as a National Historical Park, reconstructing the city's history became a task of national as well as local interest. Texts by professional historians served as the basis of the narratives in the National Park visitor's center, the "Working People" exhibit, the Boott Cotton Mills Museum, and, later, as the outline of the waysides trail. The National Park primarily focused on Lowell during the American industrial revolution. As with most scholarship, the narrative was created out of available material. Historian Thomas Dublin did some of the most important early research in Lowell on the female factory workers employed in the early and mid-1800s. Dublin thoughtfully analyzed "mill girl" letters, their bank accounts, payroll records from the Hamilton Manufacturing Company, genealogical records, census records, the women's writings in the *Lowell Offering*, and textile mill management correspondence—in short, all available written documentation. With the publication in 1979 of *Women at Work*, Dublin established the fundamental script for early women's work in the textile mills in Lowell. Dublin later authored the official National Park handbook *Lowell: The Story of an Industrial City* in 1992. His work was the basis for the detailed re-creation of the mill girl boarding-house at the "Working People" exhibit in the Mogan Cultural Center. While the history of the Yankee women in the textile mills was well told, documenting the ethnic workers proved more difficult to research, interpret, and present.

Detail of the "mill girl" display at the
"Working People" exhibit, Mogan Cultural
Center, April 1992.

The exploration of the mill girls in Lowell was not locally contested. In fact, there had not been more than a passing local interest in these women prior to the advent of the National Park. When the National Park and the Preservation Commission started to examine the city's more contemporary history, curators, Lowellians, and national historians entered into discussions, and sometimes confrontations, over the meaning, ownership, complexity, and interpretation of the recent past.[14] A strong interest in community history projects began in the 1970s in Lowell. Mary Blewett, a professor of history at the University of Massachusetts at Lowell, then the University of Lowell, used Lowell as a teaching tool in her classroom, encouraging and working with her students to study various aspects of the city's past labor and social conditions.[15] According to Blewett, her work, together with others, culminated in the rejuvenation of the local historical society, the publication of a bicentennial history of the city, and the development of a local history museum, as well as a number of oral-history interviews with mill workers.[16] The edited oral histories were published in *Surviving Hard Times* in 1982.[17]

Some of the new social historians who worked at the Lowell National His-
torical Park and who were charged with reconstructing Lowell's past wanted
to use oral-history interviews to document the ethnic past, because they rec-
ognized that local memory was critically important to the people of Lowell
and that it had to be taken seriously. One of the first projects undertaken
by the National Park was an oral history of Lowell textile workers. From 1979
to 1981 Judith Dunning worked for the National Park, gathering oral histo-
ries of Lowell mill workers. The results of this project served as the basis of
one of the exhibit islands in the Lowell National Historical Park's visitor's
center.[18] I spent the summer of 1983 interviewing women who had worked
in Lowell's mills. Based on their oral histories, I made a documentary, *And
That's How We Did in the Mill: Women in the Lowell Textile Mills*, which the
National Park uses on a regular basis.[19] From 1984 to 1986 the National Park
undertook another oral-history project with its own oral historian as well as
with Blewett and her students. The results of the second project were to be-
come a part of the National Park's major exhibit on textile industrialization
at the Boott Cotton Mills Museum. Ultimately, however, four oral-history
stations were created in the Boott museum based on a set of entirely new in-
terviews of male and female mill workers by a professional video company.
In the thirty-three minutes of video, workers describe the conditions inside
the mills.[20] Some in Lowell were disappointed that the ethnic workers, who
had lived and worked in the city for more than one hundred years, were not
made a more central part of the exhibit.[21] When Blewett "discovered that the
exhibit designers for the Boott mills planned to use very little" from the nar-
ratives she and others had collected, she "became determined to write" *The
Last Generation,* an edited collection of the oral histories of the ethnic men,
women, and children who once worked in Lowell's textile mills.[22] It seemed
possible to collect the memories of Lowell's ethnic textile workers, but less
clear how those memories would influence the writing and presentation of
the history of Lowell.

There were no plans to include the story of the ethnic communities of
Lowell in the major National Park–sponsored "mill girl" exhibit at the
Mogan Cultural Center. Local interpreters, represented by the Preservation
Commission, mounted a successful campaign to change the exhibit so that
ethnic working people would be represented. The exhibit that resulted ex-
emplified the battles over national versus local scripts (replaying the in-
sider/outsider tension) and over history versus memory. While the Yankee
women are well interpreted, the immigrant section of the exhibit, created

from local memory alone, lacked a context and an interpretive framework. It is more of a collection of artifacts, photographs, and quotations than an interpretation of the ethnic history of Lowell. It was criticized as evidence of the "contested terrain between amateurs and professionals with competing interpretations of the past and different views of how to present it to a wider audience."[23] Nonetheless, local people felt they had won a battle by having their memories included in the final National Park exhibit.[24] The then historian at the National Park, Robert Weible, wrote in defense of the exhibit that the people from the National Park and the Preservation Commission who were involved in the project had strong community sensitivities. He said, "They genuinely felt that the local and visiting public's historical awareness would be better served by presenting history from the point of view of those who remembered their past firsthand rather than by forcing interpretations to fit a detached, abstract, and academic mold."[25] Battles over what constituted memory and what constituted history in Lowell were fought repeatedly. Excising memory from the "historical" exhibit script was viewed as an attempt to remove ethnic history from the portrayal of the past. Yet the inclusion of material based on memory alone—ethnic, twentieth-century life—was never given the prominence that the documentary material received—the early, primarily Yankee, industrial period in Lowell. Memory that did not pass through the filter of interpretation was not the equal of history.

Yet the living memory of the past had a hold on the imagination of many of the people creating exhibits and programs about Lowell. One of the most interesting ideas introduced at the time the National Park was created was that Lowell should be the museum, not segregated from the representation of history, but an active, integral part of the presentation of its own past and present. The National Park was not to be located in a distinct area of town separated from the life of the city or to represent a distinct and distant time period, but fully integrated into the city's present activities. A visitor could view the twenty-minute orientation slide show "Lowell: The Industrial Revelation" at the visitor's center on the first floor of the renovated Market Mills and then walk across the street for lunch at the Athenian Corner or the Dubliner, both local restaurants. They had to walk through downtown Lowell to reach the park's other major exhibits at the Mogan Cultural Center and the Boott Cotton Mills Museum. Visitors could ride the renovated trolley to a National Park boat and spend the afternoon touring the canal system.[26] National Park visitors could attend a live performance on immigration at the local theater, go to the Brush Art Gallery to see the work of Lowell

artists,[27] or attend a reenactment of the dedication of the Ladd and Whitney Civil War Monument. At the same time, there were stories and reports in the news of drugs and prostitutes in the Acre neighborhood, and Hispanic and Asian gangs in Lowell. Press reports about Lowell often centered on crime, and many middle-class tourists feared going too deep into the working-class neighborhoods.

Two Lowell men represent the two different visions of what the city was and how it would present itself. Patrick J. Mogan, known as the Father of the Lowell National Historical Park, was a proponent of tying the identity of Lowell to the ethnic cultural traditions of the working-class people. As an educator, he argued against attempts to gentrify the city and encouraged the documentation and presentation of local culture as a core function of the Lowell National Historical Park. One of his central ideas was to develop ethnic gardens along the canalways; another was to highlight ethnic culture through festivals. Mogan believed that the living culture of the city would be a core element in any interpretation that brought the Lowell story into the present.

Paul Tsongas saw gentrification as a way of improving Lowell's image, drawing tourists and a new middle class to the city and ultimately creating a new economic base. It was Tsongas who developed the Lowell Public Art Collection, which brought in artists from around the country to interpret the history of Lowell through art.[28] His goal was to "raise the sightlines" of Lowellians by placing major works of public art in their midst, thus bringing culture into the city.[29] The artists created sculpture related to the industrial city: men's labor, women's labor, waterpower, and textile production. Sensing the fear of the middle-class tourists, Tsongas looked for ways to market the working-class city. He sought to transform the downtown into an area with nineteenth-century style buildings and upscale shops and restaurants. His last two projects in the city were the building of an arena and a semiprofessional baseball field.[30]

Both Mogan and Tsongas had a huge impact on the city, and their seemingly contradictory visions could also be complementary. The Lowell Folk Festival, for example, began as a way to showcase the best in local ethnic culture. It now draws several hundred thousand middle-class tourists to the city to see folk artists and performers from around the country. Mogan created a working-class model of Lowell based on celebrating a city's indigenous culture and the living memory of its ethnic citizens. Tsongas created a middle-class model for Lowell meant to transform the economy and culture of the

city to reinfuse the old city with new life. Tsongas's model sought to bring culture into Lowell and to create history out of its nineteenth-century past, while Mogan argued that the city was already brimming with ethnic culture. Both visions of Lowell were reflected on the landscape with the physical changes of the downtown aligning more with Tsongas and the ethnic stores and churches in the neighborhoods representing Mogan's ideas of what Lowell was and how it should present itself.[31]

M. Christine Boyer wrote that cities at different points reflect different stages of capitalism. In the 1960s and 1970s, Boyer argued, the city landscape began to be circumscribed by structures of consumption, overflowing with marketplaces and commodities for sale. The state began to treat urban growth and decline—empowerment and impoverishment—as natural events responding to market demands that recycled and revalued parts of the city or displaced and recentered different residential groups. Cities lost their manufacturing base and white-collar employment was expanding, so public/private coalitions were used to produce residential, work, and leisure space within the city in order to appeal to their white-collar base. Tax incentives spurred the gentrification of inner-city neighborhoods, and city governments invested in leisure-time space like arenas, convention centers, and upscale marketplace complexes while they advertised safer neighborhoods, good education, shops, and history.[32] Although Boyer was not writing specifically about Lowell, she could have been, for her description closely matches many of the changes envisioned for Lowell by Tsongas.

Cultural theorists created models to explain how cities move through various stages of development, both economically and culturally. Cities progress through modernism, closely associated with the industrial period, and then into a postmodernist, postindustrialist phase. Those that study cities assume that many of the social changes brought on by industrialization accelerate in the period of postindustrialization. One of the great changes that they outline is the change in memory.

The influential French thinker Maurice Halbwachs described memory as a social, or collective, function. The past is recalled by time periods and by situating ideas, images, or patterns of thought within the context of a social group. Memory is a dynamic process that orients the individual by linking him or her to family experiences, traditions, class, and place. It is personal and changing, but, most importantly, it is intimately tied to everyday experience. As the uninterrupted line of thought or imagination in the commu-

nity, memory presented past and present on an equal plane, at times making no distinction between them. Memory has the ability to see time as a continuous flow rather than as a series of oppositions between past and present. There is no such thing as individual memory, Halbwachs argued, because each person can only remember within his or her social group, and it is the group that gives meaning to the remains of the collective past. As long as memory stays alive in a group's collective experience, there is no need to write anything down.

Halbwachs wrote that collective memory seeks material reality in an image, like a monument, or a concrete place, like a house. It looks for a symbol that binds it to this place. This sense of memory, which is alive in a group, of personal relationships and of a meaningful sense of place defined both physically and by the community of people who live there, is what anthropologist Marc Augé called *anthropological place*. In the anthropological place memory is closely connected with tradition. Anthony Giddens wrote of tradition as a form of repetition that involves ritual and that is based on a moral content.[33] Thus the anthropological place is full of personal relationships, of traditional activities based on content that is meaningful to local people, and it has a long, collective memory that people refer to in guiding present activities and as a way of understanding the past.

History, according to Halbwachs, is quite different from memory. It is an abstraction and an intellectualized reordering of the past to fit into a coherent framework. History begins only at the moment when collective memory stops and the distance between the enactment of the past and the recall of the present is too great.[34] Cultural theorist Walter Benjamin located what he called a "crisis of memory" in the late nineteenth century when oral tradition began to rupture. Remembrance had begun to sever ties with everyday experience and had stopped functioning as a collective. Instead of memory, which was like an epiphany, Benjamin wrote, people had history, an official linear sense of events. As a result, modern life was transformed into a series of fragmented and privatized events. The city, once a place embedded with collective memories, had become a series of shock experiences, and the continuum of traditional experience, once located in the city, was impoverished beyond recognition. It could only be resuscitated synthetically in frozen city landscapes.[35] In the postmodern world, action is divorced from tradition and has become nothing more than a serial pattern devoid of meaning. Tradition, once the glue holding the community together, has lapsed into custom or habit, an empty routine now separated from moral

authority.[36] The result is a series of what Augé calls *non-places*, which are the very opposite of the known anthropological place. Non-places, such as freeways or chain stores, characterize the postmodern world with their lack of tradition and their absence of collective memory.

Lowell exhibits many of the trends noted by the cultural theorists. The city has transitioned economically from industrialization, with a large immigrant population engaged in manual labor and strong ethnic communities, to one of deindustrialization, with an uncertain economic base and neighborhoods with a mixture of class and older ethnic ties. In the 1970s Lowell tried to base its economy on a postmodernist idea of tourism, marketing its past to outsiders through history, programs, and a reconstructed landscape. In terms of historic preservation, Lowell is consistent with the cultural theorists, creating a landscape of the past by restoring twentieth-century buildings to look old and constructing new structures that resemble nineteenth-century buildings. New stores and buildings were created in the downtown historic district to support an economy based on leisure and gentrification. Lowell borrowed from national models with artsy shops and small specialty stores.[37]

Yet in many important ways Lowell defies the model of the city described by cultural theorists. It has not experienced the concomitant fracture of memory, tradition, and community. There is no crisis of memory in the class-based ethnic communities. Even if the city has, to some extent, moved into the middle class economically, it has retained much of the culture of the working class. Identity is dependent on memory, what subgroup you belong to, and what place (neighborhood) you come from and identify with. The great difficulty of being an outsider in Lowell is testimony to the strength of the insider's local collective memory. The city continues to function primarily as an oral culture. The local newspaper, rather than fragmenting that oral culture, operates in conjunction with it, so that news moves fluidly from word-of-mouth to the newspaper and back. Email, the ultimate middle ground between the oral and the written, fits in perfectly in Lowell. In this way the memory of the past is alive, changing, and what Halbwachs, Giddens, and Augé would call organic, anthropological memory.

The neighborhoods are still the most important units in the city, now bound as much by class as by ethnicity, although ethnicity is never far from one's consciousness in Lowell. Each neighborhood retains deep memories of its own past. Childhood associations, knowledge of people over generations, and the belief that the way of life will go on as it is: all of this speaks

to collective memory.[38] Even what should be non-places in Lowell—small chain grocery stores, for example—are personalized as neighborhood men make them into meeting places to drink coffee and exchange local news.[39] Memory is transmitted through generations. Much of the political culture in the city relates in some way to associations between people and memory. When I phoned to ask if there was a booklet explaining who the Lowell schools were named for, the woman in the superintendent of schools office was surprised and mildly annoyed by my question. She said, "A booklet? No, no, we don't have that. Everyone knows who the people are." Lowell remains the essence of the anthropological place.

As a political tool, history can be used to marginalize class and ethnic groups in order to limit their access to power.[40] Without an acknowledged physical trail to prove their historical presence—paper documents, monuments, and waysides—many groups in the society are left voiceless. When memory, as expressed through oral history, became a part of the recovering of the past, new, previously marginalized groups came closer to joining official history. With oral history as a legitimate method of reconstructing the past, the differences between memory and history are less clear. Some historians continued the call for corroborating oral documents with documentary evidence. Nonetheless, oral testimony was assuming an authority it had not once had in historical circles. Of course, many local cultures, and nearly all families, understood their pasts only through oral history. For them, the differences between memory and history were nonexistent—without memory there was no history for them.

Some saw social historians in Europe and the United States in the 1980s as turning away from history as truth to history as a collection of multiple narratives, each with a particular perspective, but none as authoritative, thus erasing differences between history and memory.[41] Saul Friedlander questioned the opposition between memory and history, and the view that memory was antithetical to the writing of history. At one end of the spectrum, he wrote, historians once saw public-collective memory and at the other end a "dispassionate" historical inquiry. Public-collective memory was made manifest in a set of commemorative rituals and dominant symbolic systems referring to the past of a group (street names, monuments, and museums), while dispassionate historiography was distant in time and situated in those periods that had lost an immediate ideological relevance to the present. But the past that Friedlander investigated, the Jewish Holocaust, made the distinctions between history and memory less clear. The generalized record of

the past and the past of one's own life was for Friedlander a twilight zone, whose length and fuzziness vary—a no-man's-land of time. "When past and present remain interwoven, there is no clear dichotomy between history and memory."[42] Yet as Edward Linenthal demonstrated when the National Holocaust Museum in Washington, D.C., was created, it was ultimately only the Holocaust survivors who had the moral authority to establish when and whose memory would be considered history.[43]

Despite the new social historians' efforts to establish a relationship between past and present in Lowell, there remain differences between history and memory. These differences are reflected in the exhibits at the National Park. The oral histories they collected from local people who had worked in the textile mills were not as fully integrated into the presentation of the past as the documentary evidence. These differences are also reflected in the emphases placed on nineteenth-century Lowell, a past just outside of most of present-day memory. They are reflected in the absence of ethnic women from much of the discussion of the city's past.

The differences between history and memory are also reflected in the two approaches to the past that distinguish the waysides, many of which were erected by the State and National Parks, and the more locally constructed monuments.[44] The waysides are a series of text plaques that describe significant sites and events in the city's past. They focus on nineteenth-century buildings, technology, industrial processes, and workers. Few mention the names of individuals. The monuments built by the city and by private citizen groups are not on sites where an event took place but in sites of power, and mark not aspects of the industrial past but the political power of ethnic groups. The waysides presuppose no familiarity with Lowell; the monuments rely almost entirely on local memory. The waysides are the result of documentary research, interpretation, and carefully selected summary texts; the monuments are the result of collective action by local ethnic groups to physically mark their presence in Lowell or to express ideas about their identity.

The first of the extant waysides in Lowell was created in the 1930s by the Massachusetts Bay Colony Tercentenary Commission, which describes the preacher John Eliot and his work in converting the native people to Christianity. The Daughters of the American Revolution also erected at least one freestanding wayside, which describes the Pow-Wow Oak Tree, as well as several monuments, likely in the 1930s.[45] These early waysides describe Native Americans from an Anglo perspective. There was a set of waysides created

in the early 1970s that no longer exists. Although no written records remain of their texts, local historians recall about five kiosks, with one located outside of city hall, in various spots around the downtown.[46] They contained summaries about Lowell's past.

There are reminders of an effort to mark sites of history throughout Lowell. On the wall outside St. Joseph the Worker Shrine in downtown Lowell is a small wayside from the bicentennial era. Numbered 46, the wayside indicates that this Romanesque church was built in 1850, was once Universalist, and was bought by Father Garin and converted into the first French church in the Roman Catholic Archdiocese of Boston. Erected as a part of a bicycle-and-walking-trails project, the wayside was funded by the Massachusetts Bicentennial Commission, with assistance from local organizations and the National Cultural Park Program. The date and sponsorship of the wayside reveals that it was erected in the mid-1970s, that the Lowell National Historical Park was originally envisioned as a cultural park, and that there was enough local interest in marking sites to create a walking and bicycle tour. The number 46 indicates that there were at least forty-six waysides although most of the other sites no longer have markers.[47] The *Lowell Sun* described the unveiling on March 1, 1977, of sixty-five "Spindle City Historic Markers" at the city's 151st birthday. The markers outlined the history of selected landmarks in the city's historic districts, and were accepted by Mayor Leo Farley "as a first step toward the Lowell National Cultural Park."[48] The marker tells the alert viewer as much about the period when it was erected as it does about the historic period it describes.[49] Focusing on nineteenth-century Lowell, the sixty-five markers contained information about the homes of the elite, churches, canals, city and company buildings, and the textile mills.[50] The markers make no mention of twentieth-century Lowell.

By far the greatest number of waysides were created by the State and National Parks in Lowell. At least thirteen waysides were erected by the Lowell Heritage State Park and the Lowell National Historical Park between 1976 and 1985.[51] The first of these was the wayside to Charlie Sampas, a local personality and newspaper columnist. It was dedicated in front of an outdoor stage, the Sampas Pavilion, in the fall of 1976 as part of the bicentennial celebrations. Arthur Fiedler and the Boston Pops played at the dedication. The last of the waysides was "The Worker," which describes the men who dug Lowell's canals. Richard Scott, superintendent of the Lowell Heritage State Park, wrote the text for "The Worker." This series, many of which are still standing, were placed along the Merrimack River, adjacent to the canals, and

The Worker

In 1821 Hugh Commisky led a band of laborers on a trek from Charlestown to Lowell. With muscle and sweat they dredged canals in the soil of rugged farmland. As others joined in their toil a complex waterpower system evolved, creating a new era of textile production. When one generation had endured and the clamor of manufacturing increased, immigrants came by the thousands seeking labor and a better life. This fountain celebrates workers and their contribution to industrial and human heritage.

LOWELL HERITAGE STATE PARK
LOWELL NATIONAL HISTORICAL PARK

The Worker statue and the wayside text, Market and Shattuck Streets in downtown Lowell, December 1992.

in the downtown historic district. While three of the waysides tell the story of men (Sampas, Michael Rynne, who was a policeman and athlete, and "The Worker"), the remainder focus on buildings, technology, and water. All concern the nineteenth century.[52]

The set of sixteen waysides created in the 1990s by the Lowell National Historical Park refer to a mixture of social history, architecture, and technology.[53] Social and cultural historians working in Lowell at the time, me among them, were concerned that the waysides be as much about the human story as about the wonders of the city's technology. There was a serious effort to make 50 percent of each wayside address the social history of Lowell people.[54] Care was taken that the story of Lowell should not evolve or devolve into one concentrating on the city's technological and engineering achievements. The waysides describe the often bitter social history of industrialism. While the majority of the waysides focus on nineteenth-century Lowell, many include text about the mills closing, the reuse of the mill buildings, and technological changes that bring the narrative into the twentieth century. Unlike locally erected plaques in other places, which are site specific and focus on the concrete, these waysides are abstract in nature and discuss ideas about working and housing conditions, child labor, industrialism versus nature, and the difficult conditions of the industrial worker.[55]

Ninety-five percent of the waysides in Lowell focus on some aspect of the nineteenth century, sometimes concentrating solely on that time period and sometimes bringing it into the twentieth century. As Paul Litt observed when analyzing the waysides in Ontario, Canada, if a Martian were to learn an area's history through its waysides, they would think that people had been hyperactive in the nineteenth century, creating more history then than at any other time.[56] While the first set of waysides, erected in 1976 for the bicentennial, concentrate on sites and the significant males who once inhabited them, the initial set of State and National Park waysides takes a different approach to the past. The focus is more clearly on the early industrial technology and buildings of the city. The third set of waysides, created in the 1990s, reflects the concerns of the new social historians. While the text consistently begins in the nineteenth century, it often moves the story into the twentieth century, and insists on both the innovation of industrialism as well as the harsh social price it exacted from workers. For the most part, biographical information about individuals, the culture of the city, and the events of the twentieth century are absent, for this is when history has moved into memory.

In writing about public memory, commemoration, and patriotism, John Bodnar described public memory as a product of complex discussions about the existence of a society—its organization, structures of power, and the meaning of its past and present. He said that public memory functions to mediate competing restatements of reality offered by divergent groups in the society. These groups use the symbolic language of patriotism because it "has the capacity to mediate both vernacular loyalties to local and familiar places and official loyalties to national and imagined structures." Bodnar found that it is the "local and personal past that is incorporated into a nationalized public memory rather than the other way around," and that the dominant meaning is nationalistic, stressing the desirability of maintaining the social order and existing institutions, the avoidance of dramatic changes, and the dominance of citizen duties over citizen rights. Accounts of fundamental change, such as industrialization, were usually reinterpreted in ways that fostered patriotism and made them seem inevitable and desirable, while the exploits of immigrant pioneers were told as a story of nation building and valor rather than uncertainty and death.[57]

The ethnic voice in Lowell found a ready local constituency. Surrounding city hall, the major seat of civic power in the city, is a careful balancing of ethnic monuments. Building ethnic monuments in the most politically powerful space in the city was testimony to the authority of certain local groups to assert their ethnicity in the context of being Americans. They are proclamations of ethnicity, but they are also statements of allegiance to the nation state, and they use the language of patriotism to assert the power of the ethnic group. Those ethnic groups who were able to create monuments adjacent to city hall—the Franco Americans, Polish, Irish, Greeks, and Italians—could do so because they had achieved a degree of political power in Lowell by the 1970s. Once erected, the monuments solidified that power, as the interests of the ethnic groups were so closely associated with the interests of the city. Each year the monuments are rededicated on a day associated with that group, with city officials recognizing the group's contributions as they speak from the steps of city hall with the flags of both their homeland and America raised high behind them. Each year the relationship with the ethnic group, the collective memory of the city, and the American nation is reconfirmed.

Ethnicity and cultural pluralism emerged as positive ideas in the 1970s. Despite later battles over the incorporation of ethnicity into the Lowell National Historical Park exhibits, in the early planning stages of the National

Curtis LeMay, Armand Mercier, and Armand LeMay at the Franco American Monument in front of Lowell city hall at the annual rededication, June 24, 1996.

Park in Lowell ethnicity was a key concept.[58] While the National Park was negotiating how the history of ethnic groups would factor into the story of Lowell, local people created ethnic monuments with local funds that they dedicated at locally attended ceremonies. It appeared as though the two interpretations of the past, the federal and the local, were on two separate and quite different tracks.

In 1974 the first of the overtly ethnic monuments, the Franco American Monument, was dedicated on the front lawn of city hall. It was no accident that the monument was dedicated when Armand LeMay, a Franco American, was mayor. According to LeMay, he saw a large school bell in the attic of a municipal building and arranged to have it sold to the Franco American community for one dollar. He had a monument designed for the bell and "received permission from the city council to put the monument in front of city hall." The Franco American Committee created the language for the monument.[59] The mayor and his son, Curtis LeMay (later a city councilor), dug the

five-foot-deep foundation by hand. The senior LeMay commented on the permanence of its placement: "You will never move it. You couldn't move it if you wanted to." Franco American children in Lowell contributed twenty-four cents each to help pay for the monument. The monument was meant, said LeMay, to be not just a memorial for all the Franco American people—living, dead, and those to come—but to commemorate their contributions to culture, language, and especially to the city of Lowell.[60] Every year a ceremony is held by the monument to remember what the Franco Americans have done for Lowell.[61] Typically, the mayor reads a proclamation from the steps of city hall officially declaring it Franco American Day, the Canadian flag is raised, the Lowell High School band plays "Oh Canada," there are speeches by city politicians in both English and French, and selected Franco Americans, perhaps a city councilor or a former mayor, lay a wreath at the monument.

Once the Franco American Monument was in place, there was a flurry to create other ethnic monuments in visible, politically significant spaces. Within three years, the Polish community erected a cenotaph in front of city hall, just opposite the Franco American Monument.[62] According to Pauline Golec, a Polish historian in Lowell, the idea for the Polish Monument came from the Franco American Monument.

It is difficult to say whether the Polish Monument would have been erected if the Franco American one was not in place. However, the Franco American Monument certainly inspired the Polish community to lobby for a spot in front of city hall and to plan for their own monument. [The] location was important to many members of the [monument] committee and to many members of Polonia. It was and is a source of pride, a validation of feelings that members of Polonia had contributed significantly to the city of Lowell, their home by virtue of birth and/or choice. The location is also highly visible, a spot where the Polish Monument and all that it signifies can be seen by many.

The monument honors all Polish Americans of Lowell, past, present, and future.[63]

There was tremendous disagreement within the Lowell Polish community as to whether the symbol of Poland, the eagle, should include a crown. At the time the Poles were still under communist rule and the crown was from the precommunist days of the monarchy. For some the crown symbolized the monarchy, for others it was a symbol of anticommunism. The crown sometimes appeared on Polish flags, but not always. After much discussion,

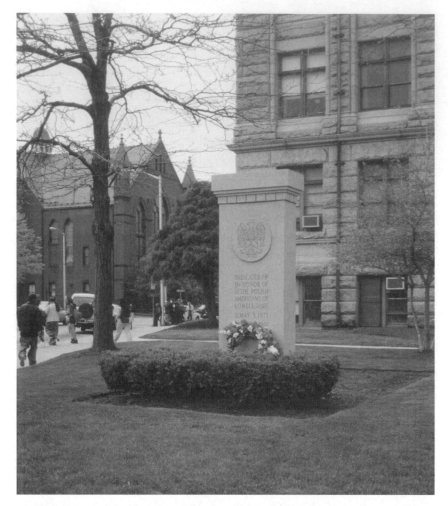

The Polish Monument in front of Lowell city hall, May 1999.

a decision was made on January 3, 1977, to have an eagle without a crown, "as that was the symbol in use in Poland at the time." Nineteen years after the Polish Monument was dedicated, and some two years after Poland had become independent of Soviet rule, a crown was quietly added to the eagle.[64] Thus, not only did the monument become a symbol of Polish ethnicity in Lowell, but it became contested ground over the meaning of the real Polish nation.

Like the Franco American Monument, a wreath is laid in front of the Pol-

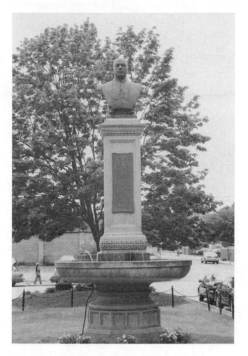

The Cardinal O'Connell Monument,
Cardinal O'Connell Parkway, Dummer
Street, July 1997.

ish Monument annually on Polish Constitution Day or the Sunday falling closest to May 3.[65] The Lowell ceremony takes place in front of city hall and includes speeches, raising of the Polish flag, and singing the Polish and American anthems.[66]

With the two most prominent places in front of city hall occupied by the Polish and Franco American Monuments, the Irish selected a location for their monument facing the side of the building and next to the 1918 Cardinal O'Connell Monument. While not explicitly dedicated to Irish immigrants, the Cardinal O'Connell Monument implicitly signifies the importance of the Irish in Lowell. On an axis aligned with the side door of city hall and parallel with both the railroad tracks and the canalway, the Cardinal O'Connell Parkway was once an important space in the center of city life.[67] A large bronze bust of Cardinal O'Connell sitting atop a carved granite basin, it is reminiscent of the busts adorning the top of the Vatican.[68] Situated in the middle of the parkway with the cardinal facing city hall, the mon-

The Irish Monument, Cardinal O'Connell
Parkway, Dummer Street, 1997.

ument commemorates not only one of Lowell's most successful religious fig-
ures, but also one of its powerful politicians. Although it is dedicated to one
man, in fact it serves as a monument to Irish Americans. In the November
1918 dedication ceremonies, which O'Connell attended, speakers claimed
that the monument commemorated not only his accomplishments but those
of Lowell's Irish population. Superintendent of Schools Hugh J. Molloy, after
praising the cardinal, went on to say:

> The real greatness of the nation rests upon the simple faith and honest, sac-
> rificing lives of lowly, virtuous, courageous men and women; and there is no
> great public occasion, no matter how splendid its character, on which this
> truth should be forgotten. Nor should this occasion be allowed to pass with-
> out the mention of the great part which Irish Catholic pioneers have played
> in the building up and [sic] the life of the city, state and nation, in times of
> peace and in times of the greatest stress; poor, oppressed, deprived of edu-

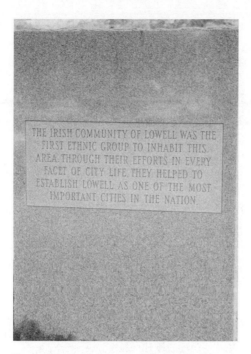

Rear of the Irish Monument, Cardinal
O'Connell Parkway, December, Dummer
Street, 1997.

cational advantages, harassed in their religious rights, they have maintained
and brought with them into the air of freedom an unshakable faith in God,
a strong and abiding love of learning, and a civic devotion which are unsur-
passed. This parkway, with its obvious suggestions will particularly memo-
rialize what they have done.[69]

The naming of the parkway was a subject of some controversy, "which
raged for several weeks in the newspapers." It was suggested to the Park
Commission that the newly broadened thoroughfare be called Whistler
Parkway in recognition of the fact that painter James McNeil Whistler was
born in Lowell. Because of Whistler's contemptuous attitude toward Low-
ell—he is reputed to have said that he refused to be born in Lowell—com-
mission members objected to naming the parkway for him. The names of
James B. Francis, a noted Lowell engineer, and Frederick Fanning Ayer, a
Lowell philanthropist, were also proposed. The city council decided that,

The Greek Immigrants Monument,
Cardinal O'Connell Parkway, Dummer
Street, 1997. Courtesy Jim Higgins.

"since the sector of the widened Dummer Street was likely to become per-
haps the most conspicuous avenue in Lowell, nothing could be more ap-
propriate than it should be named after the greatest man ever born in Low-
ell; and in the council it appeared to a majority, if not to all the members,
that this man was William, Cardinal O'Connell, born at Lowell, Dec. 8, 1859,
and educated, so far as his elementary schooling was concerned, in its
schools."[70]

In 1977 a monument was erected and dedicated explicitly to the Irish
Americans of Lowell who "helped to establish Lowell as one of the most im-
portant cities in the nation."[71] Occupying most of the front of the monu-
ment is a large Celtic cross, which has become a symbol of Irish ethnicity
in America.[72] An Irish Monument Committee was formed when Leo Farley,
an Irish American, was the mayor of Lowell. Marie Sweeney, a member of
the Irish Monument Committee, remembered that the mayor wanted some-

thing done to recognize the Irish because there were no monuments to them and they were "suffering from assimilation." Sweeney stressed that the monument was never intended to be located in front of city hall, but was meant to be placed near the cardinal and near the Acre. The Irish Monument Committee raised the funds for both the monument and the dedicatory event. The dedication began with a benediction at St. Patrick's Church and was followed by a procession to the monument with the Sacred Heart band. The dedication was attended by hundreds of people, including the bishop, the Irish consul, and local politicians.[73] Sweeney remarked that it was important to have a connection with the church and with Ireland at the dedication: "There was the connection with the homeland, the church, local politics, and regular people." During Irish Culture Week held annually in March, the Irish flag is raised at city hall, the audience sings the Irish anthem, and a wreath is laid at the monument.[74]

In 1983, at the opposite end of Cardinal O'Connell Parkway, an ethnic monument to the "early Greek immigrants" was erected. The back side of it faces city hall and the Irish monuments. The front faces the Acre, the first Greek neighborhood in Lowell.[75] A large Greek cross in incised in the front of the stone, a recognizable symbol of Greek ethnicity. Each year, in celebration of Greek Independence Day in March, a mass is held at the Holy Trinity Church, followed by a procession to the Greek American Veterans Monument and the Greek Immigrants Monument, where wreaths are laid. The ceremonies continue at city hall with the raising of the Greek flag and the playing of the Greek and American national anthems.[76]

The Italians were the last ethnic group to mark the city hall area with a monument. On Columbus Day 1987 the community dedicated a bas-relief in JFK Plaza, a large civic plaza and office building adjacent to city hall. The six-foot bronze sculpture references Italy's Campanile and the palazzo in the Piazza of Siena as well as the country's boot shape. It shows the mills in Lowell with figures of a young man and woman gazing into the future. About five feet wide, the sculpture has a boat shape, saluting the immigrants' travel to the United States.[77]

Not all of the monuments proposed for the area around city hall were erected. In the early 1990s Cambodian Lowellians went before the city council with a proposal to create a monument. The monument, which would have been of the four-sided head of a mythical figure that is an important symbol of peace in Khmer culture, was proposed to be located near city hall, close to the Acre, where most of the Cambodians then lived. The motion was

The Lowell Memorial Auditorium with the various war monuments on its front lawn, May 2000.

denied. In 1989 the city had passed a referendum adopting English as the official language of Lowell. An editorial in the *Lowell Sun* portrayed a tearful young Cambodian man learning English from a mustached professor who was using words like "scram," "leave," and "go" on his flashcards.[78] The English-language referendum was viewed by the local and national press as a hostile response to the resettlement of Cambodians in Lowell. A few years later the Lowell Historic Preservation Commission funded the creation of a Cambodian-inspired mosaic in a newly renovated park in the Acre. The park was renamed Menoram Park after one of the Cambodian words for peace and harmony. No statue was ever built anywhere near city hall. At the time, the Cambodian community lacked the political power to assert their ethnicity through the creation of monuments in highly visible civic space.

When one leaves city hall and follows Merrimack Street toward the confluence of the Merrimack and Concord Rivers, there appears the second great civic building in Lowell, the Lowell Memorial Auditorium, itself built as a monument after World War I. While the inside of the building houses a multitude of veterans' memorials, the lawn outside has come to be a concentrated environment of monuments to veterans from various wars. One large cannon, date unknown, rests prominently in front of the building, close to the bridge over the Concord River.[79] A large bronze doughboy, one of two

The Portuguese Monument on Back Central Street, part of a
series of three Portuguese and American war monuments at
the site, July 1997.

in the city, sits atop a granite base dedicated to the Spanish War veterans from 1898 to 1902. For many years the doughboy was the only exterior monument at the auditorium. At first, it was near the sidewalk, but later it was moved back on the lawn to accommodate other war monuments. Beginning in 1985, a series of monuments was dedicated on the lawn in front of the auditorium when veterans of particular wars began to agitate for recognition. The Korean War Monument was erected in 1985, the Vietnam War Monument in 1986, the World War II Monument in 1987, the Marine Corps Monument sometime in the mid-1990s, and the Women's Veterans Monument in 1997. With the exception of the Vietnam War Monument, which added the names of those Lowellians killed in the war in 1991 after much public controversy centering around who should be included,[80] the other monuments remember "all those who served" in a particular war. Like the ethnic monuments at city hall, these war monuments generally commemorate the deeds of groups in service to the nation, but the veterans' monuments refrain from any reference to ethnicity. The city recognizes its service to the nation through the ultimate sacrifice of its young to war. Thus at opposite ends of Merrimack Street, the primary axis of power in the city,[81] the Lowell Memorial Auditorium and city hall juxtapose carefully chosen monuments to the immigrant communities who helped to build Lowell with monuments dedicated to the protection of the nation state by the city's soldiers.

Ethnicity is more specifically expressed through allegiance to the nation in the form of ethnic war monuments located in the group's original neighborhood. These ethnic war monuments represent the result of a complex negotiation of ethnic loyalty and loyalty to the nation. In 1943 the Lowell Portuguese community erected a monument in a small park on Back Central Street, the heart of the Portuguese neighborhood, to the Portuguese Americans who died in World War II. Almost fifty years later two additional stones were added to the park and inscribed with the names of Portuguese Americans who died in other wars. In 1953 the Greek American Legion erected a monument in the Acre, formerly the Greek neighborhood, to "our departed brothers in arms." Club Passé Temps, a Franco American club, erected a monument to its members and veterans in 1977 in what was once Little Canada; and in 1988 the Polish community erected a monument to Polish Americans, who served in all wars, in front of a Polish club. The undated Swede Village Monument was dedicated to the men and women of Swede Village who served in World War II and located on the edge of Lowell's former Swedeville.

While the Irish appear to be one of the few ethnic groups without a war monument, former city manager and state representative Paul Sheehy described the World War I doughboy in the Acre as an Irish war monument. It was, he said, erected primarily in memory of an Irish boy killed in the war. The monument states that it is "Dedicated to / The Gallant Sons / Of the Acre / Who Made the / Supreme Sacrifice / in the World War / 1917–1919" and lists names that include Irish, Greek, and Franco American men.[82] This kind of war monument, which is both an ethnic and a neighborhood monument, represents a more subtle voice of ethnicity and patriotism. As most neighborhoods are associated with particular ethnic groups, monuments that do not explicitly reference ethnicity can be read as ethnic. Between 1919 and 1945 six neighborhood monuments were dedicated to the people from that section of Lowell who served in national wars, with some listing the names of the neighborhood soldiers who were killed in a particular war.[83]

Some of the neighborhood ethnic veterans' monuments are dedicated to an individual man who died in war. These are the most specific of the ethnic monuments, proclaiming the loyalty of the group to the nation through the sacrifice of this individual's death. These monuments personalize and localize the memory of the fallen ethnic martyr, and there are many such monuments in Lowell. The corner of Market and Suffolk Streets, deep in the heart of the Acre and minutes away from the Greek Holy Trinity Church, was named for Athanasios Michalopoulos in 1922. A monument in the shape of an obelisk was erected bearing the words "Private / Athanasios C. / Michalopoulos / Born 1895 / Killed in Action / France / July 1918 / He Gave His Life / To Preserve / Liberty and Freedom / MICHALOPOULOS/SQUARE." This quiet monument, nestled among the trees along the canalway, once again reinforces the loyalty of Greek Americans to America through the sacrifice of this man. Scottie Finneral died in the Persian Gulf on September 14, 1991, at the age of twenty-one from injuries sustained as a result of a helicopter crash. The first of the Finneral Monuments was created in 1992 in the greenway between two streets in his neighborhood. It reads "Scottie Finneral / Memorial / U.S. Navy Persian Gulf / September 14, 1991." Incised on the granite boulder is the image of a shamrock. In the mulched area in front of the boulder there is a small American flag, and sometimes there is also an Irish flag. In 1997 a second monument was erected to Finneral, this time outside of his neighborhood along the much-used Van den Berg Esplanade adjacent to the Merrimack River. The plaque's text creates a fuller portrait of Finneral in this much more public context, citing his pride in his family, in his Irish heritage, and in Lowell. It ends with an Irish prayer.[84]

The Scottie Finneral Monument, showing the Irish shamrock, Lincoln Parkway and Van Greenby Street, 1997. Courtesy Jim Higgins.

When the 1980's and 1990's waysides and the public art pieces were created, most people at the National and State Parks, and at the Preservation Commission were unaware of the sheer volume of local monuments.[85] The National and State Park waysides and public art pieces were created in civic spaces without reference to the local monuments. They conceptually describe the chronological history of nineteenth-century Lowell, while the locally erected monuments remember ethnic groups, local men and boys, and, occasionally, women. Historical texts do not begin when memory ceases to function, as the cultural theorists suggested; rather history coexists, side by side, with a living, functioning memory. Yet history and memory have intermittent intersections. The overall structure of the waysides is based on a historical narrative about the city's past and what constitutes significant events and ideas in that past. It includes quotations from written texts, photographs, and graphics from nineteenth-century Lowell. The National Park has constructed, thoughtfully I would argue, an official version of the past. It has also had an impact on local memory. The number of local monuments erected tripled in the 1970s and has remained consistently high throughout the 1980s and 1990s, all during the National Park's tenure in Lowell. The local

monuments offer a different sense of the past, one that insists on the ethnic past and on the mixing of memory and power.

Local memory has been incorporated into the "official" history of Lowell in the form of some exhibits and oral-history videos in the major National Park museums. When collected as a body of oral documents, the personal memories of individual ethnic Lowellians who once worked in the textile mills reveal strong patterns in their responses to industrialism. They constitute a form of collective memory of the industrial experience. These documents offer an insight into the ideas and actions of Lowell workers and, by comparison with oral histories of industrial workers elsewhere, help us understand the ways that all American workers negotiated nineteenth- and twentieth-century industrialization. Yet it has been difficult, despite strong efforts by various historians both local and national, to fully integrate such memory into the telling of Lowell's history.

The collective memory of most families, and certainly most Lowell families, is preserved through oral tradition, family artifacts, and the emotional significance of place. Within oral tradition, historical and nonhistorical chronologies coexist, with family experiences woven in and through chronologically established national events.[86] People live daily with the associative memory of their family histories and narratives built over time within the community. While in school they also learn about "history" events disassociated from their lives, objectified, organized, and so often depersonalized. Emotionally significant objects in the home have value within the context of the family, but artifacts in the historic house or museum have some unarticulated historical value separated from the worlds of the visitors. Markers on the landscape tell people what sites are important, what is historical, and, hence, what is worth noticing by enshrining and segregating them from ordinary places.[87] The places of importance to families are rarely marked in such a way. Most people move daily between these different experiential worlds, these different ways of knowing the past. One is the more abstracted past of the community and the nation; the other is the more personalized past of those who are known, through narrative, through family sites of memory, through objects passed down over time, and more recently, through local monuments. These worlds do intersect at the moments when national events impact a person's life, when the past is close enough to be remembered and discussed, and when the landscape, carefully observed, is marked with representations of both the abstractions of history and the power of local ethnic groups.

It is the responsibility of history to pay great attention to the places where it intersects with memory. Absent the letters from the mill girls, which gave a human voice to the feelings and thoughts of the young Yankee women who first worked in Lowell's mills, who could have imagined the combination of pride, independence, ill health, and anger that these women experienced? Absent oral histories from twentieth-century mill workers, who would imagine the sense of self-worth work gave to some people, combined with their shame at being called "mill rats"? Still absent from the intersection of history and family memory in Lowell is the story of the poor and the working classes who did not work in the mills and the women who shopped and cooked for their families. Still absent is the story of those who struggled with their own identity inside the strong class structure in Lowell, who left the city and who returned to engage the Lowell class struggle once again. Still absent are the multiple meanings of the three-room tenement.

II

THE GENDER
OF MEMORY

Long before I knew that society had strong ideas about the proper roles for women, and women's relationship to the public sphere, my grandmother and my mother shaped my construction of gender. They did not mention the word *gender* or specifically instruct me on the qualities a woman should possess, although my mother came closer to that in her later years. Instead they told me stories of their lives and the lives of the men and women they knew, and they implicitly held themselves up as models for me to emulate. How they told me what they knew was as significant as what they told me.

The agency of the women in my family, as in much of Lowell, was exercised primarily in the private and semiprivate spheres of the home, the extended family, and the neighborhood. The memory of these women and their memories are preserved through stories. These memories were a chronicle of everyday existence and a vernacular history of our family and of the city. The stories also linked narrative and place. The places where the women lived and told stories became memory sites for my family, and, in the narratives themselves, the women created images of places in Lowell's past.

Catherine Barrett Cleary (second row from front, third from right) at St. Patrick's School, 1895.

I learned from census records that Nana's father came from Ireland via England in 1878 and her mother in 1879, while Grandpa's relatives came in 1849. There were a few other details I learned from written sources like church records, death certificates, and city directories. These documentary sources ultimately told me little about my family's past.[1] Everything we know about who we are and what we had done had to come from the stories. They were the expression of our collective memory. Nana's narratives were always slightly tragic, told with a wry humor, rooted in the complex relationships between family members and intimate friends, and strong on plot and social context. My mother had her own repertoire of stories. Hers were sadder than Nana's, partly as a result of her temperament and partly as a result of the turn her life had taken, but they were full of the same humor, detail, and nuance. When I learned in college that my friend's parents were artists, writers, musicians, and collectors, I wondered what, exactly, my family had ever done. Some years later I understood: they told stories on the Sunday visits, in the evenings, at Christmas, and in the summers. The stories were everything.

Embedded in the stories are snapshots of the past. Grandpa's mother had a little store on Suffolk Street in Lowell where she sold black aprons and candy to the mill workers. I learned much from this rare piece of informa-

tion about my great-grandmother. For as long as we can remember, the women in my family have worked in the mills or in their own small businesses, perhaps run out of their homes. I learned too that the mill workers sucked on the candies to relieve the strain on their throats caused by all of the cotton dust, creating a portrait for me of the many people in Lowell who struggled to breathe. Nana's parents must have married soon after arriving, as was the case with so many new immigrants. Nana was born in 1882 on Marion Street, in the heart of the Acre in Lowell where most of the Irish then lived. She was the oldest of six children and the only one who married. Her sister, Aunt Nan, became a nurse, graduating from St. John's Hospital School of Nursing. She had lived in the house reserved for nurses, and when it closed she moved into her own house. Did she buy it? I do not think my early family ever owned property.

"Before Aunt Nan went in training she worked in the mill. It could have been the Lawrence Hosiery. She met Helen O'Malley there. Helen lived in the St. Patrick's home, which was a boarding house. Aunt Nan invited Helen to live with them. So Aunt Helen lived at the house and later on when she retired from the mill, she kept house for Aunt Nan and Aunt Mary. In the end, after Aunt Nan died, it was just Aunt Mary and Aunt Helen at 959 Bridge Street. I always thought she was my real aunt."[2] It was years before my mother found out that Aunt Helen was not her aunt at all, but a friend of Aunt Nan's. This was part of how the Lowell I knew operated: people were often taken into the home, and friends of the family became like relatives.[3]

Nana's other sister, Aunt Mary, worked for the telephone company. She married briefly. My mother told me that someone overheard Aunt Mary screaming on her wedding night. The marriage must have been annulled. As in so many families, the "facts of life" were not discussed openly, or at all, and marriage was frightening for some women. This story brought me into the private world of Lowell Irish women's culture of two generations ago, where neither sex nor menstruation were mentioned, let alone explained or discussed.

Nana remembered her younger brother, Tom, with tenderness. Just after graduating from high school he played a game of tennis and sat in front of a fan to cool off. That, Nana told us, was how he developed pneumonia. Burning with fever, he lay in his bed singing "Oh Danny Boy" at the top of his lungs until he died. We were never allowed to sit in front of a fan or air conditioner when we were sweating. There was Nana's little brother, Andrew, who fell on a picket fence when he was four and died in his mother's arms,

and there was John, whom we knew as Uncle Jack, the only one of Nana's brothers who lived past the age of eighteen.[4] The youngest son in Irish families was supposed to become a priest; Uncle Jack became the first Dominican priest from Lowell. These stories brought me close to Nana's mother, my great-grandmother, as I imagined her losing two of her six children to infections, just as so many working-class and poor women have buried many of their children.

Nana had often told us that when she was sixteen years old her mother died, but she never said what her mother died from. On the death certificate it cites the cause of death as "menopause." After her mother's death Nana's father told her she would have to leave high school to work in the textile mills. Nana cried the whole night before she went to the mills. When her father brought her down to the mill, the hiring man asked how old she was. "Sixteen," her father said. "Take this girl back to high school," the man said. "She's too young to go to work." Because of this man Nana was able to complete another year of high school. Years later I told this to a ranger at the Lowell National Historical Park, and he said he would incorporate it into the interpretation of the Lowell mills as a counterpoint to the stories of the many hardened mill overseers. I thought of how much Nana must have wanted to complete high school to avoid the fifty-six-hour workweek in the mills, and I thought too of the many women I interviewed in Lowell who did not meet that particular mill manager and who, at the age of fourteen, began the ten-hour days in the weave rooms.

As the oldest girl in the family, Nana had to take care of everyone after her mother died. This she did, until she met Grandpa. Her sisters did not want her to marry, and they were rude to Grandpa. At some point Nana's family moved from the Acre to Centralville, the neighborhood they called home for the next one hundred years. Nana was, as she told me, "married from Hampshire Street." My mother later told me they married on Monday, October 11, 1911, because it was a holiday, and they could get the day off from work. Nana wore a brown suit. They would have married in St. Michael's, the Centralville Irish Catholic church.

When Aunt Mary and Aunt Nan visited Nana, both of them dressed up and stooped to wipe off the chair before they sat down. They did not bother much with their nieces and nephews, except for the oldest boy, Edward. The oldest boy held a special place in the hearts of my family. Aunt Nan and Aunt Mary bought Edward books and other small things. They were financially comfortable, while Nana struggled. When Aunt Mary died from a blood clot

on her way home from the phone company in 1960, she left Nana some money. Nana put it in envelopes and distributed it to her children, then grown with children of their own. "She didn't give it to me when I needed it, when you kids were young. It doesn't mean anything to me now," Nana said. That often repeated story reinforced the commitment to help family members in need. It was bordered by the other story of Nana taking the Bridge Street bus to Kennedy's Butter and Eggs in downtown Lowell. She stopped along the way to talk to friends and neighbors. As she greeted people, she gave them something from her bags, sometimes giving away most of her food. "Oh the poor X family, they could use a pound of tea," she said. Nana's relentless generosity was admired and resented. During the Great Depression, she sent food to neighbors. Sometimes she sent envelopes, which my mother suspected contained money. "The neighbors we gave to later bought houses. If Nana had saved some of that money, we could have bought a house too," my mother and my aunt told me. Yet later Aunt Dorothy sent baskets of food to friends, and my mother bought clothes for the sons and daughters of relatives who were struggling. The redistribution of wealth, even meager wealth, was a core value for many of the women in our family. Women often made up the early informal social-welfare systems in Lowell, which sustained the extended family, the ethnic group, and the neighborhood.

Nana was proud, my mother said, and she never borrowed. Financial independence was cherished. My mother spoke to me often of Nana's words: "Your dollar is your best friend." I later told the same to my children. And they would respond to me, "But I thought you said Nana said, 'Your mother is your best friend.'" Yes, I admitted, she did. These two phrases sum up much of the wisdom of the working-class family. In our family, as in much of Lowell, your mother is your best friend, and your dollar, your financial sense of self, is also your best friend.[5]

Each time I hear some of the stories that I can now hear only in my memory, I feel their power, although I am not sure exactly what some of them mean. In the middle of the night Nana is awakened by the sound of knocking three times on her front door. She gets up and goes down the stairs to open the door. No one is there. The next day her sister dies suddenly, and Nana understands that it was the angel of death who had come to warn her. There are signs and meanings in dreams. Dreaming of someone who had died meant bad news, and the closer the person was to you the worse the news. If a spoon was dropped a female would come to visit, and a knife meant a male. There was a pantheon of saints to help and protect us. St. Christopher protected us

when we traveled, and St. Anthony found lost objects for us. When Nana developed cataracts, I bought her a statue of St. Lucy, the patron saint of eyes, and the small plaster figure sat on Nana's dresser, eyes in her hands, for the rest of Nana's life. The store that sold religious statues was in the basement of St. Joseph the Worker Shrine in Lowell. Full of novenas, medals, statues, and the patron saints of all causes, it was otherworldly to me.

Much later, when my mother and I were working on our family history, we went to visit Uncle Charlie, Grandpa's last living sibling. Uncle Charlie was old and he did not say much. Without warning, he took my hand and made the sign of the cross where my thumb met my index finger. "My father's father was the seventh son of the seventh son," he told me. "He had special powers. He could make a mark like this and cure someone." Later, when I worked at the Preservation Commission, a Greek friend from Lowell told me that when his son was sick and none of the doctors could cure him, he asked his grandmother to help. She worked to free the boy from the evil eye by putting his clothes on backward, having him lie in the crib upside down, and cracking an egg so that the evil eye would appear in a bowl.

Intuition was highly prized. It was critical to be able to read a person's character, but it was also expected that one should be able to see warnings for the future. It was not until I left my family for college that I began to probe for the differences between intuition and intellect, separating myself through intellectual discourse from the beliefs of my family. I sensed that people frowned upon relying on one's intuition and on signs. Yet my intuitive sensibility resurfaces. When each of my aunts and uncles died, I had signs, small inexplicable experiences that I later saw as the modern angel of death knocking on my door. While I knew from Uncle Charlie that men could have special powers, it seemed to me that it was the women in my family who knew things, saw into the future in dreams, and could read a person's character and predict a person's actions. It was a combination of wisdom, learning through the stories, watching, and, in the end, intuition.

St. Michael's Church was an ever-present part of my family's life. All of Nana's children went to St. Michael's Catholic School. St. Michael's was not only a Catholic church, but, because Lowell was de facto segregated ethnically, it was an Irish Catholic church and school. If the nuns scolded one of the children, even unfairly, Nana scolded them again when they came home. Nana did not question the authority of the church. No one ever missed mass on Sunday morning, nor were they allowed to go to bed without kneeling and saying their prayers. Grandpa refused to attend the church. When the church

St. Michael's Church, Sixth and Bridge Street, summer 1997.

was building their school, Grandpa said they brought in scabs rather than hire union labor. A strong union man, he never forgave them. From this story I came to believe in the value of unions to protect the working person. In the 1980s I heard Lowell's working women cry in their living rooms when I interviewed them, thanking God for unions and the protection they provided.

We were not allowed to work on Sundays. Sunday was a day to go to church, eat a big dinner, and visit. It was a good time to tell stories, although all times were good for stories. We never phoned ahead of a visit—we simply showed up. Sometimes we visited other aunts and uncles, but for the most part we visited Nana and Dorothy. The teakettle was always full, and we were always offered a cup of tea.[6] When I was little I played with my cousins while my mother talked. Later I too sat at the kitchen table and drank tea and talked. Dorothy brought out cookies or banana bread or a sandwich from the pantry. Other relatives often dropped in while we were there. The conversation was about daily life, the new priest at the church, a letter from one of Nana's old friends, a funny mishap—Big Walter fixing the bathroom floor upstairs and stamping his foot through the ceiling of the pantry below. While we always spent Thanksgiving and Christmas day with our nuclear family, on holiday evenings we went to Dorothy's. There, the

Catherine Barrett Cleary (Nana) and John
Barrett (Uncle Jack) at the Dempsey's house
on Seventh Street at Christmas, circa 1962.

whole extended family gathered. The women brought and served food, and
Dorothy brewed huge pots of coffee. The children gathered in the den, the
men in the dining room, and the women in the kitchen. I came to see that
men and women inhabited this world, the world of my family, differently,
and gradually I began to understand that they must also inhabit the larger
world in separate realms.

Perhaps my mother's stories began when I was a child, when we lived in
New Jersey, but I only remember them in the evenings after we moved back
to Massachusetts when I was seven. She focused on the recent past, but
sometimes she would turn to the more distant past. "Did Nana ever get
mad?" I once asked her. She said

Not very often, but she could. When we lived at 848 Bridge Street, I remem-
ber coming home from nurses' training one day. I was young and thought I
knew it all. Nana was sitting in the kitchen with her best friend who lived
downstairs. I told them that I'd taken care of a young unmarried woman who
had a baby, and that we were all disgusted with her at the hospital. Without
thinking any more about it, I went upstairs to take a bath. Later that night
Nana came into my room. She was mad. She said, "Listen young lady, you did
a lot of damage today. My friend is probably downstairs crying her eyes out
tonight because of you. When she was sixteen years old, she didn't know the

facts of life and a baseball player [—was it a baseball player?—] came through town. She got pregnant and had a little boy. That boy later joined the circus, and she never hears from him. All these years she has kept that pain inside, and you brought it all out with your holier-than-thou attitude.

After that I made sure that whenever a young unmarried woman came into the hospital to give birth, I was compassionate and kind to her above and beyond the call of duty.

My mother told me stories of adoptions and illegitimate births that Nana had told her, swearing me to secrecy, just as Nana had done with her. They were stories about young women getting pregnant and the complex arrangements made to re-create identities for the mother, child, or father. There were enough of the stories to make me understand that in Lowell in Nana's time, and in my mother's time, it was not uncommon for young women to give birth out of wedlock, and it was a secret carefully guarded by the family (guarded from many, but not from the older women of the community who saw and told their daughters the actual genealogies as sto-ries passed down over the generations of women). One of my cousins learned that she had been adopted when she applied for Social Security at the age of sixty-five. Her parents were long dead, and there was no one to ask. This secret too I had known since I was a little girl, and I knew never to mention it. It often seemed to me that these stories, the ones that were told openly and the ones that were told in hushed tones, were the real history of Lowell, the history that mattered, and that only the women knew it.

My mother admired Nana's sense of humor, compassion, and tolerance. "She was very open-minded for her time," my mother said. "Off and on she would work in the mills, and she made friends with people from different backgrounds. Once she went to a Greek wedding, and another time she went to a Protestant wedding. At that time Catholics just didn't go to Protestant weddings." My mother shared these values with Nana, a mind open to new people and ideas, yet she struggled with the limits of tolerance. Who was too different to be admitted into the family—where did one draw the line?

My mother spoke so often of Nana and Grandpa and their lives in Low-ell. "She would never have the dinner ready when Grandpa came home from work. She would be downtown, and she'd run into some of her friends, and she would talk and visit. Then she'd realize the time and say, 'Oh Glory be to God, he's going to kill me. I'm late with his dinner again.' Grandpa would be mad. He'd say, 'It's the only thing I ask. I work hard all day and I just want a

hot dinner on the table when I get home at night.' But he never got it." My mother would laugh, seeing the humor in a gregariousness that kept Nana from following any schedule. "At night after she had cleaned up, they would go and sit on the steps outside. Grandpa built a bench for them to sit on. Grandpa would smoke his pipe, and Nana would sew or darn the socks. The other neighbors would sit out too and they'd visit." There were many stories from World War II, when my father was in the army and my mother and Billy, her first baby, lived with Nana and Grandpa. As my mother got older she returned more and more often to these stories.

> Grandpa could hardly breathe, but he had to work a few more years to get his Social Security. So Nana would pack his lunch, and Billy, who was about two at the time, would wait on the steps for him to come home. Grandpa never finished eating his lunch—he just didn't feel well enough to eat much. So Billy would open the lunch box and finish whatever Grandpa had left in there. One day Nana was thrilled because Grandpa had finished his whole lunch. When Billy opened the box he was furious: "What? You didn't save me anything? Nothing?" Grandpa felt like a heel for eating his own lunch. After that Nana would always put a little extra in Grandpa's lunchbox so he'd have something to give Billy when he came home. We could have given him something fresh from the kitchen, but he wanted it from the lunchbox.

While her story seemed to be about Grandpa and Billy, for me it was about Mum and Nana, and the wisdom and compassion of both women. My mother's story interwove the pain of Grandpa's struggle to breathe with the humor of Billy's indignation, World War II, an old man's need for the Social Security a few more years of work would bring, and a half-eaten sandwich.

Later in his life Grandpa sat with the other men on Bridge Street in front of the gas station, smoking and possibly drinking beer. My brother Billy remembered walking down to see him there. My mother only saw her own grandfather, Grandpa's father, one time. She remembered being in the car with her sister and four brothers, her father and Nana, in front of an apartment building on Hurd Street. Grandpa went in and brought out an old, drunk man. "Pa," Grandpa said, "I just wanted you to see my wife and my six children." The old man grunted and went back inside. Alcohol is the great plague of my Irish family. It is a scourge that has marched through every generation, laying the lives of both men and women to waste. This too is a part of the history of Lowell.

Grandpa was a fancy plasterer. He had learned the trade from his Uncle Dan, who, like many of the Irish, was in the building trades. He worked on big buildings, including the Empire State Building in New York City. At the time he made good money, my mother said, and they were the first on their street to own a car.[7] I wonder now what "good money" meant, and how they compared to other workers in the city. Grandpa's car was an open-touring Ford, and he never drove more than twenty miles an hour, although the speed limit was thirty-five. Nana always took her friend Mrs. Reed for a ride in the car because she worked hard all week in the mill. Against Grandpa's wishes, she also sneaked a neighborhood child into the car. "I have enough responsibility with our own six children," he said to her. And she nodded to the child and said, "Go ahead and get in. He won't notice you're there." The sense of community maintained by women meant sharing even the resource of a ride in the car.

When they went to the beach Nana packed corned-beef sandwiches, and by lunchtime they were soggy. My mother could smell the hot dogs cooking at a stand, "Oh, Pa, could I please have a hot dog?" "If I buy you a hot dog then I'll have to buy one for everyone," he said. "At ten cents each, I could buy a full tank of gas with the same money. Eat the good sandwiches your mother made for you." Years later she told him how she had longed for a hot dog. "Oh, Kathleen," he said to the now grown woman, "If I had known it meant that much to you, I would have bought it." There in that story was working-class common sense, frugality, kindness, and tragedy, a metaphor for all the stories that my mother told.

Not only did my mother's stories connect me with generations of relatives long dead, but they reached out to a large network of extended family and friends. Many in this network were not technically relatives, but were the brothers, sisters, nieces, nephews, and later grandchildren of my mother's sisters-in-law or brother-in-law. My mother followed their life stories and recounted them to me, just as their mothers were following my life story through my mother and sharing it with their children. The stories were a kind of live soap opera—who married who, had children, divorced, had other children, who died, who was at the wake, who had been to jail, and who had become the president of a company. In turn I shared with my mother the stories of my friends—who was in or out of love, whose parents had divorced, and what the millionaire grandfather had left his grandchildren. There was a tendency to form life-long friendships. My mother knew her best friend for sixty years. While they occasionally visited, they remained

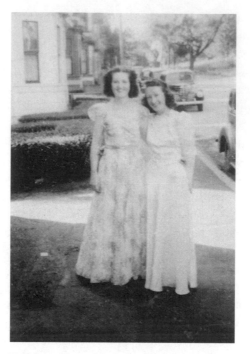

Kathleen Cleary Norkunas and Dorothy
Cleary Dempsey at Dorothy's wedding, 1940.

primarily connected to our family through their stories. Some of the stories were funny, but some were deeply tragic, and these too were shared within the family. Such long friendships and honorary membership in the family bespoke loyalty and devotion. It was also a closed circle, denying entry to anyone new.

Two years after my mother's death, I was awash in a wave of loneliness. I missed my mother, and I missed the stories she told me about my extended family. I realized that the older women relatives only told the stories to my mother. They would not tell them to me in the same way, or at all. My mother visited them and talked with them on the telephone. They had stable, committed relationships. I was an outsider to their telling of the stories, although they certainly knew that my mother shared those stories with me. Without her, without the transgenerational link between mother and daughter, I was cut off from all of their narratives, and from the connections embedded in the shared life stories.

While my mother held the thread of our family stories, it was Dorothy

Kathleen Cleary Norkunas and Dorothy Cleary Dempsey talking together at the kitchen table, June 1901.

who followed the lives of Lowellians at large. In later years when my mother once again lived in Lowell she visited Dorothy nearly every day. Dorothy caught my mother up on the news of the people they had once known. "You remember Mary Kelley?" she said, "She married Billy the Greek who ran the garage up on top of the hill. They had four children, the oldest became a teacher. He married the middle daughter in the Flanagan family, the ones from way down there on West Sixth Street. Well, they had two children, and the youngest is the one who won the Carney Medal at Lowell High last week." My mother nodded with a vacant look on her face and later told me, "She forgets, I haven't lived in Lowell all my life. I forget who these people are." In my mother's absence from the city she had lost track of many of the genealogies of those outside of our extended family, the connections between Lowell families, and the major events that marked those lives. On occasion my aunt noticed the vacant stare and became mildly annoyed at my mother. "Don't you remember?" she tersely prodded. The stories of our family, and the larger ripples of stories about the people of Lowell, were the history of Lowell to the women in my family, although they would never have called it history. The connections between people—what they did and where they moved—were the facts and stories that gave life to the city, and they drew all of this from their memories, shared and discussed over time. What they might have called history, events "out there," mattered insofar as they

impacted the lives in the Lowell stories. In the end these memories, this kind of history, was the only kind of history that mattered.

Through stories, my grandmother, aunt, and mother told me another history of Lowell, not of its institutions, wars, and economics, but of the personal lives of men and women, relations between people, intermarriage, unwed motherhood, and the struggle to make ends meet and to lead good lives. The stories of my grandmother's life, my mother's life, the lives of my aunts and uncles, my great extended family, as well as the milestones in the lives of ordinary people in Lowell document how larger historical events were faced, lived, and accounted for by Lowellians. They are a window into the daily lives and culture of ordinary people. The oral records of local people were preserved by women. Through these stories I learned what moral principles my mother's generation felt the world operated on, how much people deviated from those principles and were still loved, and how men's and women's paths intersected and diverged. I learned about loyalty—four brothers and two sisters who stayed friends for their entire lives, despite their disagreements—as well as the act of creating the vow of commitment and the scars of having it broken. In what seemed almost anachronistic outside of Lowell, I learned about children's devotion to their parents, but especially about a daughter's devotion to her mother.

At first, my husband was stunned by my close relationship with my mother. He said, "I thought the village women in Turkey were close to their mothers, but I don't think even they feel so attached." But I was not unlike the other women my age in Lowell. I talked to my mother nearly every day, she picked our children up from daycare, they spent the night at her apartment, she shopped for me, and she cooked dinners for us. We discussed everything, and she had an opinion on everything. When my family went on outings (picking apples or riding to the beach, down to Spaggs in Worcester to see what bargains they had, or into Quincy Market in Boston for Easter brunch), my mother came with us. My friend moved into the duplex adjoining her parents' home, and, after her son was born, she made a door in the wall between the two houses so that they could visit more easily. My cousin's mother shops for her, picks the children up from daycare, cleans her house, and does her laundry. The involvement is at so many levels, from the physical to the emotional, from the maintenance of connections to the maintenance of tradition. My mother was connected to her mother in much the same way.

My family's world first revolved around my grandmother and later the powerful figures of my mother and my Aunt Dorothy. It seemed to me that

all the women in my family were powerful because they managed the money in the house, made the important decisions, taught us how to act and what to believe, dispensed charity, and maintained social relations. With my mother as my role model, I grew up thinking of women as the authority figures to be loved and feared. In our household certainly, and even to some extent in my extended family, men were the quieter figures in the background. Perhaps because they were socially constrained from exercising power outside of the home, the women dominated the household. All of their energy, drive, and ambition was dispensed within the home.

Nana was a homemaker who worked occasionally in the mills, my Aunt Dorothy was a homemaker who sometimes worked as an aide in a nursing home, and my mother was a nurse. None of them ever held public office, spoke at a public function, appeared in the local newspaper, published or composed anything, or became the head of any organization. Yet they performed the thousands of small services that enabled the family to function, which ultimately enabled the industrial city to operate.[8] Nana, Dorothy, and my mother, by sending food and money to neighbors and taking working women and children with them to the beach, were organizing and managing a complex series of informal institutions that are the present-day equivalent of state-sponsored social services. Their actions were semiprivate and semipublic, but they were done without any thought of the impact on a local or national level. They represent hundreds, perhaps thousands, of women from Lowell who strove to be good citizens in the avenues open to women.

As a result of her divorce and her role as a female wage earner, a single mother, and the decision maker, my mother became more politicized as she grew older and changed many of her ideas about women's proper role in society. She felt forced to think about herself as a woman, and the social and economic constraints that society imposed on her because of her gender. Looking back, she realized she had chosen nursing from among the four career options open to women (the other three were teacher, clerk, and private secretary). She did not work outside the house when she was married. After her divorce, she was profoundly glad that she had a profession that allowed her to contribute to the support of her family. She demanded that her daughters have professions in the event that we might one day have to support ourselves, not yet foreseeing the importance of careers to women even in the context of marriage. Still, she criticized dominant women, commenting disparagingly, "She really wears the pants in that family," and looked down on men who could not stand up in the family, calling them "Mr. Milquetoast."

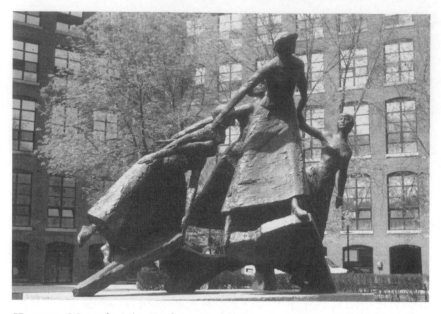

Homage to Women by Mico Kaufman, Market Street in downtown Lowell, May 2000.

Most of the women she knew were not divorced. She was the only one of her siblings who was divorced. She was caught between what she had been taught was a woman's place and the reality of her situation as a female head of household. She became an insider/outsider to her role as a Lowell woman. It was only when she was in her seventies, when the husbands of many of her women friends died and they themselves were once again single, that she too felt comfortable as a single woman. She learned through the evidence of her own life just how political the personal was.

If she was not ready to openly declare herself a feminist, my mother respected my feminism. When *Homage to Women,* the first of Lowell's public art pieces to recognize women workers, was dedicated in 1984, she sent me the clipping from the *Lowell Sun.* Later, my mother's best friend sent me an embossed medallion of the sculpture, which had a group of five women in simple dresses, leaning forward, almost in motion, touching each other's arms or hands, with serious, perhaps tired expressions on their faces. Seven-feet tall, the monument was known as the "mill girl statue." Initially sculptor Mico Kaufman said it commemorated the early female mill operatives, but he later enlarged its meaning to include all working women.[9]

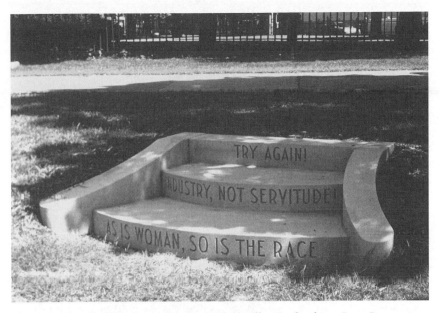

The stair piece from *Industry Not Servitude* by Ellen Rothenberg, Lucy Larcom Park in downtown Lowell, May 2000.

I did not know any of the women in the statue, for they are anonymous and speak not to the life of any one person, but to the idea of women as wage-earning workers. Both of my grandmothers had occasionally worked in the mills, but I never thought of the statue as representing them. For me it was of an earlier era, the era of the Yankee women workers, not ethnic women. Still I was moved that women were represented in a visible space in the historic district. I felt that something had happened and that the downtown had changed in an important way.

In the next fifteen years several other monuments and waysides to wage-earning women were erected in downtown Lowell. All were financed in whole or in part by state and federal agencies. The Lowell National Historical Park identified the story of nineteenth-century Yankee women factory operatives as one worth telling. These women are a distinct group, and their labor has been represented through statues, steles, inscribed text, and waysides. They are portrayed as early mill workers or labor organizers.

In 1996 *Industry Not Servitude,* a public art piece by Ellen Rothenberg, was dedicated in Lucy Larcom Park. It is composed of eight granite and metal pieces, each inscribed with the words of women who were part of the Low-

Stele for the Merrimack by Peter Gorfain,
showing the Native American woman, French
Street Extension near Suffolk Street,
December 1997.

ell Female Labor Reform Association, the first women's labor organization
in the country. On granite steps, for example, are the words, "Try Again! In-
dustry, Not Servitude! As Is Woman, So Is the Race," and on a large granite
clock is text about the ten-hour movement.[10] Rothenberg called the texts the
"voices of women whose history is largely unknown and uncommemo-
rated." At the dedication ceremony, Bud Caufield, then mayor of Lowell,
spoke about the importance of remembering the "women who gave them-
selves [to the mills] from sunrise to sunset for low pay." He remembered his

Detail from *Stele for the Merrimack* by Peter Gorfain, showing ethnic women mill workers.

own mother working in the mills; from her experience he realized how hard that kind of work was on people. He declared June 29, 1996, as Women's Role in the American Labor Movement Day for "the positive contribution made by the early women laborers of Lowell who distinguished themselves as fore-runners of women in America's workforce and advocated for the rights of workers." The mayor situated his mother in the historical context of work-ing women. He spoke as well of the women who advocated for the rights of all workers in the limited political arenas open to women.[11]

The images of working women appear on another sculptural piece in downtown Lowell, *Stele for the Merrimack*. In the late 1990s New York City artist Peter Gorfain created and installed a bronze stele in Lowell. The tall

obelisk is four sided, with each side telling some aspect of Lowell's transformation from a natural setting to a factory city. There are bas-reliefs of nineteenth- and early twentieth-century women in simple work dresses locking arms with men in work clothes. In one panel, two women in work dresses stand holding hands. Their image is taken from an old Lowell photograph of two French Canadian sisters working in the textile mills. Another panel is of a group of Irish women with shuttles. One woman appears with falling water behind her. She is the spirit of the Pawtucket Falls, reinforcing the close association of Native American women with nature. No text explains who the women are, and no one would know that the women were French Canadian or Irish, but the Native American woman is clearly set apart by her long hair and dress. The anonymous women as workers are in groups in a sisterhood of imagery much as they were when they occupied the boardinghouses of Lowell in the 1820s through the 1840s.[12]

Three of the waysides erected by the National Park in the late 1990s mention the early Lowell female labor force. The St. Anne's Church Wayside references the church built by mill agent Kirk Boott. It describes, in part, the mill practice of requiring all women workers, regardless of their religion, to attend the Episcopalian church.[13] A second wayside also recounts aspects of the lives of the early female factory operatives: "Lowell's first company-owned boardinghouses were built across the canal in 1823 to house young women workers from rural New England. . . . The companies hoped that a moral, clean, and safe boardinghouse environment would encourage parents to send their daughters to work in the mills."[14] The third wayside details the conditions of the early female factory operatives. It moves from a description of Yankee women to a reference to immigrants at the moment when ethnic women began to appear in the mills:

> Dozens of company-owned boardinghouses served as home for thousands of young, single women—Lowell's 'mill girls.' . . . Quarters were crowded, and rules were strict. Curfew was at 10 P.M., church attendance was mandatory, and improper behavior was prohibited. Still, the boardinghouse provided an atmosphere where workers shared experiences and forged bonds of solidarity. / As working and living conditions worsened, Yankee women resisted with strikes and petition drives. When their protests were ignored, they began to leave the mills. / Like the Yankee women before them, immigrants came to Lowell for mill work. They usually chose to live in ethnic neighborhoods rather than corporation boardinghouses.[15]

What do these monuments, created primarily by federal agencies, represent? They have changed the physical space of Lowell, and in so doing have changed the public memory of the city. In addition to their representation on the landscape, the Yankee female factory operatives are a central component of the "Working People" exhibit and are included in the Boott Cotton Mills Museum. Through research and representation, the Yankee female factory operatives, as a group, have become an integral part of Lowell's historic and civic identity.

It was a tiny plaque that first led me to think about what happens to the history of the city and the memory of an individual woman when her name is inscribed on the public landscape by local people. Lucy Larcom Park was designed by Frederic Law Olmsted, and it runs along the canal in the heart of the downtown, just outside the doors to Lowell High School. Given to the city in 1909, Lucy Larcom Park is named for the nineteenth-century female factory operative and poet. Ironically, no sign or plaque identifies the park as being named for Lucy Larcom, although the park has never been known by another name and is referred to locally as Lucy Larcom Park. I must have walked through the park hundreds of times before I noticed a small greenish bronze plaque under a large tree that was dedicated in 1932 to Lucy Ann Hill, founder of the Educational Club of Lowell.[16] I had never heard of Lucy Ann Hill. My colleagues at the National Park and the Preservation Commission had never heard of her. No one knew who she was. When I gave a talk to the Lowell Historical Society and asked the illuminati of Lowell history who she was, not one person knew. It took hours of research, combing through city documents and newspaper archives to learn something about her.

On May 20, 1932, nine years after Lucy Ann Hill died, the Educational Club of Lowell planted a Douglas fir tree to commemorate Hill and her founding of the club.[17] As the tree was being planted, Emma Brooks, the sole living charter member of the Educational Club, read comments on the life of Hill. Lucy Ann Hill began a reading club in Lowell in 1893. The membership increased so quickly that she "thought it best to have a regular women's club of Lowell," which she started at her home on Nesmith Street the following year. Hill was "an educator of prominence, being a teacher of various subjects and languages," and devoted much of her time to a private school in her home.[18] The Educational Club offered readings, essays, and discussions as well as classes in French, German, English, and literature at moderate prices to members.[19] In 1908 Lucy Ann Hill moved to Andover where she died on February 8, 1923, at the age of ninety-one.

Lucy Larcom Park showing the location of the Lucy Ann Hill Monument (under the large tree) and the *Industry Not Servitude* stairs (between the two trees); and a close-up of the Lucy Ann Hill Monument, October 1996.

Like my grandfather's mother, Lucy Ann Hill operated a business from her home. She was an educator and an intellectual who used the domain of the home as the site of her public activity as a teacher. Her home was a semipublic place for women to gather to learn languages and to discuss literature and ideas. She was a single woman who chose teaching from among the limited professional options open to most women at the time.

Of all the monuments in Lowell, this may be the most visible. It is located in the middle of the city in a park frequently used by Lowell High School students, locals, and visitors. Lucy Ann Hill represents women's service to the community—a rare locally constructed public statement about an individual woman. It is, however, the most anonymous: a public monument to a now unknown woman. Yet it was only because the monument existed that she became known once again; only because she was a part of the acknowledged past of Lowell that her biography was again public.

Like Lucy Ann Hill, the Boardinghouse Bricks identify the names of individual women and men. Created in the 1980s, the Boardinghouse Bricks are black and golden bricks set into the sidewalk near the site of the boardinghouses where working women lived. They bear the names and dates of women and some men who lived in the boardinghouses and worked in the Boott Cotton Mills. No accompanying text explains the names or dates, so in some sense they remain anonymous. Yet the women's names and dates exist in public space—"Sarah Quimby / 1838, Mary Bamford / 1840, Clarissa J. Rice / 1850"—thus permitting the possibility of one day filling in the details of their lives.[20]

After finding the monument to Lucy Ann Hill, I began to search the city for other monuments to individual women. Of the 252 monuments in Lowell, both federally funded and locally constructed, eight monuments are dedicated to individual women and two to a man and a woman.[21] Most of the monuments to individual women were created through local initiative. The first of the local monuments to mention a woman was the fountain donated to Lowell in 1914 by Mary Ann Sanders Tyler, and it was she who had her own name inscribed.[22] Two more monuments were created in the 1930s: the Lucy Ann Hill Monument in 1932 and the Sarah Ann Parker Monument, put up by the Daughters of the American Revolution in 1938 to recognize the birth of the "first white girl born in Chelmsford, now Lowell."[23] One monument was erected to an individual woman in the 1940s: the Rose Archambault Monument, created in 1942, remembers a woman for her tender charity to orphans.[24] Two were created in the 1980s: the Joan Sienkiewicz McGann

The Rose Archambault Monument adjacent to the Stations of the Cross behind the Franco American School, Pawtucket and School Streets, October 1996.

Plaque, which honors her for her community housing activism,[25] and the Bette Davis Plaque, located on the house in Lowell where the film star was born.[26] Two monuments were dedicated to individual women in the 1990s: the Agnes Davis Plaque, again recognizing a woman for housing activism,[27] and the Cheryl Berard McMahon Monument. Other monuments include the names of individual women (among the names of donors of land) or mention the word women ("the men and women who served in the Armed Services").[28]

In the mid-1990s several monuments to ordinary women were created and placed in public parks in the hearts of several neighborhoods. Two are to a woman and a man. In 1995 the Paul and Therese Ducharme Monument was dedicated in a small public park. Remembered for their community service, the couple attended the dedication. It was their fiftieth anniversary.[29] The following year a monument to a mother and son was placed in the landscaped median strip in a residential neighborhood. Jacqueline Noonan was a waitress, the mother of twelve children, and a long-time resident of Lowell. The night after her son, Timothy, died, when the family was gathered around, she too passed away. Less than a year later, one of Ms. Noonan's sons, mourning the deaths of his brother and mother, petitioned the city to place

The Noonan Monument in the middle of a residential neighborhood and a close-up of the monument, July 1996.

a monument to them near their former place of residence.[30] In 1998 a polished pink granite monument was dedicated in a small parking lot in the Back Central Street neighborhood. It is dedicated to Cheryl Berard McMahan who died of cancer on Christmas day in 1987. Located across the street from McMahon's family home, the monument remembers her as a daughter, a sister, and the mother of four children.[31] These rare public monuments acknowledge ordinary women, integrating them into the identity of the neighborhood and, ultimately, into the history of the city.

One monument is a bridge between local and federal expressions of commemoration. In the early 1990s I received a phone call from a professional woman colleague in Lowell. Several women had set up a phone chain targeted at midlevel professional women. Each of us was asked to donate $200 to the Lowell Folk Festival and in return our names would be inscribed on a monument. I phoned my mother and we agreed that we would each take part. In a month the women raised $42,000, some $10,000 more than their goal. The polished granite monument was placed downtown next to *Homage to Women*. It was not dedicated to the idea of women or to the Yankee women workers, but to contemporary women for their "commitment to service" to the city of Lowell. "Lowell," the monument stated, "is a city rich in the value of its women."[32] When it was unveiled in the mid-1990s, my name and my mother's name were among the 208 women's names listed.

A national survey in Australia conducted from 1987 to 1988 revealed that there were more monuments to women than tour books and local histories suggested, but instead of being free-standing monuments in public parks or other open spaces they were in the form of plaques, seats, or drinking fountains. Women were memorialized collectively as pioneers, workers, and wives. Monuments to specific women began to appear after the 1960s as a result of the women's movement. While the number of monuments to women has not increased over the years, the categories have shifted from passive victims of disasters or servants to the community to local heroes in national history, pioneers, and workers. The individual women who are commemorated are recognized as "honorary men" in the male-dominated occupations of inventors, sports figures, and adventurers. They remain at the level of compensatory history. Although they are women in male domains, rather than women excelling in areas of special interest to women, feminist historians were able to bring these women to public attention and to give them a significance they did not before possess.[33]

IN LOVING MEMORY OF
CHERYL BERARD McMAHO
DAUGHTER OF LEO AND LESLIE
SISTER OF JOE AND MARCIA
MOTHER OF ERIN, RYAN, KATE AND MATTHE
SEPTEMBER 23, 1957 – DECEMBER 25, 1986

The Cheryl Berard McMahon Monument at the side of a car condo, or small parking lot, and a close-up of the monument, Walnut and Chapel Streets, May 1999.

Across America, the generic woman statue has come to stand not for individual women, but for women's roles. Statues of the pioneer woman were erected across America between 1874 and 1980. Inspired by a photograph of the Sacajawea statue in Portland, Oregon, Mrs. John Trigg Moss, a member of the Daughters of the American Revolution, began to work on a project to erect monuments to pioneer woman on what became U.S. Route 40.[34] Although professionally sculpted, Moss and her son designed the monument. The ten-foot-tall sculptures stand on bases, which bring their final height to eighteen feet. While the sculptures are identical, each of the bases is inscribed with different text, commemorating the pioneer woman. Eleven sculptures were eventually erected. The Madonnas of the Trail each wear homespun dresses and a sunbonnet. In their left arms each cradles a baby and their small sons cling to their skirts on the right side. They are holding a rifle and striding forward.[35] Vivien Rose found that the statues of the Madonnas of the Trail and other pioneer women fell into one of three categories: white women captured by Native Americans, Native American women, and white women settlers in the trans-Mississippi West. "Although some of the statues are intended to portray real women, they are in fact composites of ideas about women's essential contributions. What we have, then, are women's roles cast in bronze and stone."[36] These statues that represent women as mother and settler and the bronze statues of women in Lowell that represent them as industrial worker can be read as both transgressing the norm of female representation and maintaining it. While the figures introduce ordinary women into the commemorative landscape, and hence integrate them into a shared conception of the past, they represent women as generic or anonymous groups.

In the United States, women's history sites are a small percentage of the total number of significant American historical sites. Of the 1,942 National Historic Landmarks in 1987, forty were associated with women. Of the nearly 70,000 sites listed in the National Register in 1998, about 360, or under 4 percent, are related to women. In 1989 the National Park Service participated in a women's history landmark project to identify sites of importance to women's history. Page Putnam Miller described the frustrations involved in convincing the National Park Service that these particular sites demanded a different kind of consideration of how history had been experienced and how it could be marked. Few women's organizations owned their own buildings, and most of the buildings they had occupied had been radically altered over time. Because of the National Park's emphasis on the physical integrity

of the structure, notable people, and national significance, it was difficult to move beyond compensatory history that concentrated on the achievements of exceptional women who excelled in fields typically dominated by men.[37] Female-specific historical activities were devalued in favor of the experiences and accomplishments of men, with male deeds the measure of significance.[38]

War monuments are a case in point. Women were denied commemorative representation because they had not officially served the nation in war or politics. Men constructed monuments to mark their own patriotic deeds in the public sphere. Women, in the more constricted sphere of the home, embroidered images of obelisks and urn memorials using a visual grammar in which granite monuments stood for heroic men and willow trees for weeping women.[39] Only six of the fifty war monuments in Lowell mention women, and five of these were dedicated after 1986. In 1997 one monument was dedicated solely to women veterans. Speakers at the dedication noted that more than 1.8 million women served in the American armed forces in all wars and that of the 400,000 women who signed up for duty in World War II, not one was drafted. Another commented that women replaced men in various fields so that they could go fight.[40]

The landscape in Lowell is a sea of maleness. Men's names appear on buildings, roadways, squares, trees, waterways, and monuments, inscribing the landscape with masculinity. Monuments reinforce male dominance of public space. Valor is defined as a male province, as is history. In addition to the literal valorizing of males through monuments, there is an emphasis on male forms of memorialization. The obelisk is the quintessential male memorial form, an overtly phallic symbol of male power. More covert male ideals are embodied in the tremendous power of technology to conquer nature, which can be read as domination over the feminine.[41] Still other masculine ideas are prominent features in the memorials where the male hero is an athlete or a warrior.

What does it mean to exist in a sea of male references? In the 1970s Elaine Noble, then the first openly lesbian state representative in Massachusetts, led a series of evening seminars. She took her class into the Massachusetts State House, paused in the lobby, and asked the women in the group if they felt at ease and at home. There was a distinct feeling of discomfort, without a clear understanding of the source. She pointed out the gendered idiom of representation: the gallery of male portraits, the dominant color of brown everywhere, including the paneled walls, and the massive proportions of the fur-

niture. All of the visual cues reinforced the idea that women had no place in the building.[42] Some twenty years later, in an effort coordinated by the Massachusetts Foundation for the Humanities, bronze bas-reliefs of six women who played significant roles in the history of Massachusetts were incorporated into the State House. "Hear Us," the State House Women's Leadership Project, was inspired by the recognition that of the more than one hundred portraits, busts, statues, and murals on display in the halls of the state's most important political building, no women were represented, although statues of two women—Anne Hutchison, who was banished from the state, and Mary Dyer, who was hanged—are outside the building. The women who were selected were "all activists who devoted their lives to trying to change government policies and public perceptions," although their actions, "however courageous and controversial at the time," were later forgotten.[43] They were all involved in the major social movements of the nineteenth and twentieth centuries, and distinguished themselves by their leadership abilities, organizational skills, and commitment to bring about positive social change. While the women chosen "stepped outside of women's traditional sphere to collect signatures, lobby legislators, raise money, walk on picket lines, [and] demand the vote," they all operated in areas in which women took special interest.[44]

In 2000 two identical memorials were added to the Canadian landscape, one at Parliament Hill in Ottawa, Ontario, and the second in a public park in Calgary, Alberta.[45] Narrowly approved by the Canadian legislature, the Famous 5 sculpture commemorates five women who challenged Canadian law to redefine "person" to include women as well as men.[46] The sculpture is in a decidedly female idiom and remarkable not only because it occupies significant male commemorative space, but because it represents women in vernacular dress and pose, doing what women at a meeting might do: drinking tea. The five women are gathered near a table, teacups visible, in clothing of the 1920s. The teacups, dress, and physical positioning infer a social gathering without political import. At first glance the sculpture seems out of place on the landscape of power. The women have not borrowed from an imagery of larger-than-life males on horseback. They appear ordinary, like mothers or grandmothers; yet they are engaged in a powerful political meeting, for their actions changed the status of all women in Canada. Frances Wright, president of the Famous 5 Foundation, described them as wives and mothers. She wanted their ordinariness to reveal the capacity of women to do extraordinary things. "By having statues you show a society

the very people who have excelled in particular fields, so they can come and look at them and see they are not mythical, that they aren't gods, that they are ordinary flesh and blood folks."[47]

The monuments in Massachusetts and in Canada are a part of a movement that increasingly calls for a recognition of the contributions of women within women's domains. Putnam Miller noted the importance of women in architecture, the arts, community, education, politics, religion, and work.[48] Women's involvement in the suffrage movement, peace activities, social welfare, children's issues, and labor organizing are other areas of historical activity of significance to women. In 1994 the first Reclaiming Women's History through Historic Preservation conference was held in Pennsylvania. Women gathered to discuss women's history sites, the reinterpretation of sites to include women's history, and woman as preservationists.[49] In 1998 Public Law 105-341 established the Women's Progress Commemoration Act. The act created a commission "for the important task of ensuring the historic preservation of sites that have been instrumental in American women's history, creating a living legacy for generations to come." The law further directed the commission to identify sites of "historical significance to the women's movement."[50] In 1997 the National Park Service published a thematic issue of its periodical *CRM* entitled, "Placing Women in the Past," which explored the many ways women can be more fully integrated into interpretations of the past.[51] Some of the most interesting work in identifying women's historic sites is taking place on the Internet. Rather than marking actual sites, women are now able to mark virtual sites with relative ease.[52]

In writing about the eleventh century, Patrick Geary called women the bearers of tradition because they preserve the link between the living and the dead. Remembering and keeping alive the memories of men was a form of power for women in the eleventh century, just as it is for women today.[53] Rather than being remembered themselves, American women have acted in the role of rememberers. Women founded the American historic preservation movement, leading the effort to save a number of American national icons. Ann Pamela Cunningham was the central figure in preserving Mount Vernon, the home of George Washington. Women were the leaders in the preservation of the Orchard House and Monticello, as well as other national landmarks.[54] Both Patricia West and Gail Dubrow argue that women's historic preservation work was a respectable pathway for nineteenth-century middle-class women to enter the public domain and claim public power.

This leadership in historic preservation lasted until the early twentieth century when the preservation movement became professionalized. Architectural training, a field dominated by men, became the standard for authority in historic preservation, disempowering and marginalizing women.[55]

While women have not been well represented by monuments in Lowell, they have been active in preservation activities. The Daughters of the American Revolution erected at least three of the monuments in Lowell,[56] the Garden Club erected at least one monument, the Educational Club of Lowell was responsible for the Lucy Ann Hill Monument, and the Back Central Neighborhood Association, headed by a woman, has been involved in the creation or renovation of more than five monuments. Women have been involved in many of the committees that planned and developed monuments in Lowell.[57] Yet with little research available on the lives and contributions of ethnic women, few people in the city can identify a woman worth commemorating.

The lives of my grandmother, mother, and aunt were testimony to the fact that women were the keepers of the family's past and the past of much of the city. I knew that narrative was a gendered form of commemoration created over the kitchen table and accompanied by countless cups of tea.[58] I knew the power of the women in my family. I knew how vital women had been in the life of Lowell. I could not find, however, much evidence of my grandmother or my aunt on the landscape. The construction of gender that I came to understand from my family stories was far away from the construction of gender I saw on the landscape. My own memory sites, created through the stories and the tellers of those stories, remained private and silent. The other ethnic women who came to Lowell on the waves of immigration from Ireland, Greece, French Canada, Poland, Lithuania, mainland Portugal, the Azores, Puerto Rico, Colombia, the Dominican Republic, Cambodia, and Vietnam were nearly silent on the landscape. The importance of women's unpaid work in the home, the connections between women's work in the extended family, and the neighborhood and the ability of the industrial city to function were not a part of the city's public identity.[59]

The near absence of inscription to women on the public landscape seems woven around notions of what is worth commemorating in the public realm. To understand the public world and what is required to participate in it, I had first to understand what is excluded from the public and why that exclusion takes place.[60] I turned to feminist thinkers who wrote about the relationship between women and space to help me understand the dispar-

ity between the powerful presence of women in my memory, in the stories, and in the economic, political, cultural and educational life of the city, and their powerful absence on the landscape. Mary Ryan wrote of public space as a social construction that reflects the fundamental inequalities between men and women. The gendered use of space goes beyond the creation of commemorative public spaces and encompasses the entire design of the city. Yet commemorative spaces within the city are quite significant because they serve as symbols of the relationship between power, space, and gender. Ryan wrote, "Here in the public domain is the crucible of the community's prestige system where men are situated to establish status for both sexes." In public, men speak and act for the whole community, including women, issue pronouncements that pass as consensus, and presume to represent the common good.[61]

The many statues of women as worker in Lowell, for example, have never been used to represent all workers, but only female labor. Local union labor leaders use *The Worker,* the bronze statue of a man digging the canals of Lowell, as a site to commemorate labor, both the labor of men as well as the labor of women. On National Workers' Day union members lay a wreath at the foot of *The Worker* and hold a small ceremony in memory of all workers. The ceremony is never held near one of the female statues of women workers. Even a bronze male statue speaks and acts for the whole community in a way that statues of women do not.

Few in Lowell have questioned the absence of a female presence on the landscape: it just seems natural.[62] There are three hundred squares in Lowell dedicated to men, the great majority to male veterans. At the time of this writing, none of the named squares are dedicated to a woman.[63] The coordinator of veterans affairs for the city was intrigued when I asked him why there were no squares honoring women. "It never occurred to anyone. It never came up. But it would be a good idea," he replied. When poet Paul Marion attended the dedication of a square to his veteran father, he asked the assembled crowd when such a ceremony could be held to honor his mother. Marion said, "When are we all going to get together at the corner of Merrimack and John Streets to put up a plaque for my mother who worked for thirty years at Cherry and Webb? She was a person who contributed to Lowell's economic vitality, and there is no way to recognize that. There ought to be some comparable hero squares for the women of the community, some program that allows us to publicly remember the women in a systematic way."[64] A 1988 letter to the editor of the *Lowell Sun* encouraged

the city to "substantially honor other important figures in its past as they have Jack Kerouac." The author proposed that a committee be formed to select the "Top Ten of Lowell's All Time Most Valuable Players." He then went on to name his top ten list. They were all male. The committee he suggested to choose the names, however, was to be composed of both men and women.[65]

To borrow from Carolyn Kay Steedman, commemorative landscapes that privilege maleness "describe nothing at all but rather simply *are* the way the world is."[66] Feminist scholars had early challenged accepting inequalities between men and women as though they were natural and inevitable. They called for an examination of "the ways in which we are represented and represent ourselves within a range of cultural practices," and for an understanding of the ideological processes that legitimate and help perpetuate women's subordination.[67]

In *The Power of Place,* Dolores Hayden took an activist approach to the relationship between power, women, ethnic minorities, and the landscape. She not only looked for evidence of their presence on the landscape, she analyzed the meaning of its absence and introduced monuments and artworks to represent them. Eclipsing the argument of benign neglect, she voiced the indignation many feel about their exclusion from the realms of naming streets, monuments, walking tours, historic markers, and other historic and commemorative forms. She noted that one of the consistent ways to limit the economic and political rights of groups is to limit access to space. Public space can nurture a subtle and profound sense of what it means to be an American and act as a storehouse for social memory and identity. This power of place, this power of ordinary urban landscapes to encompass a shared history and a shared civic identity remains untapped for most ethnic history and for most women's history. Centuries of neglect of ethnic and gender history have generated a tide of protest in various cities throughout the nation. Everywhere the question is the same: Where are the landmarks for ethnic Americans and women? Working with public artists, the Power of Place project in Los Angeles created outside historic memorials to African American women and ethnic minorities, and the places that were of importance to them.[68]

Women's limited access to public space has been explained by the public/private paradigm, which has characterized much modern thinking about gender and space. Males are identified with the public realm and society, and fe-

males with the private domain, the home, and nature.[69] Women travelers in the early nineteenth century, for instance, while not out of place in public, found their behavior dictated by rules different from those of men. Women were under implicit pressure to act incompetent in negotiating public space and to seek male protectors. Failure to conform to those rules carried potential penalties for these women travelers.[70]

The public/male-private/female idea also influenced the development of public spaces such as the public parks in Hartford, Connecticut, in the early twentieth century. Competing concepts of the park were introduced by those who saw the park as a way to extend into public space the feminine values of the parlor and by others who envisioned a park system segregated by social status, age, and gender. Reinforcement for the latter position came after an incident in which a young girl selling newspapers on Hartford's public streets was raped. Legislation was passed denying women equal access to public space in order to preserve their chastity. One feminist argued that it would have made more sense to make the public space safer than to force females into seclusion.[71]

As in Hartford, class stratifies the public parks in Lowell. The parks in the elite neighborhoods were larger and more elegant, although some are now in disrepair. Fort Hill Park bordered the Victorian-designed Lowell Cemetery, which was also used as a recreation area. Both the North Common and the South Common bordered working-class neighborhoods and catered to mill workers. In 1903 Lowell's Committee on Commons was reorganized into the Park Department. The superintendent viewed parks as a necessity for all classes, but especially for the poor laborer and his family who could use the parks to escape from the hot and dusty streets.[72] Smaller parks in Lowell neighborhoods reflect the class identity of that neighborhood and often have basketball courts and swing sets. Neither Fort Hill Park nor Kittredge Park have basketball courts, again reflecting the division between recreation for the masses and contemplation for the elite. Like neighborhood bars, which ostensibly admit anyone but in fact look suspiciously at newcomers who enter, neighborhood parks are centered around the families who live in an area. Women can often be seen in the working-class parks during the day with their small children, and girls play softball in the parks as part of organized sports. Most often boys and young men play softball or pick-up basketball games, or visit with friends in the parks. Forty percent of Lowell's monuments are located in public parks, school fields, or playgrounds. Two of these are named after individual women and two mention women.[73] If

the public parks are a form of class-stratified and gendered space, this helps to explain why monuments to women do not appear here.

Gender and the regulation of women's behavior determined the design of Lowell from the beginning. The city was originally planned as an industrial enterprise around the mills and the mill workers.[74] The first Lowell mill workers were young Yankee women from rural New England. Their schedules were strict, and the physical arrangement of the early city was designed to reinforce those schedules. Their living spaces, the boardinghouses, were located immediately adjacent to their working spaces, the textile mills. The women moved from the boardinghouses to the mills, and from the mills to the boardinghouses at specific times of the day. In their limited "leisure" time they moved from the boardinghouses to the church, bank, and shops. When Irish immigrant men came to Lowell, they were spatially segregated from the Yankee women in their living spaces, inhabiting the Acre, and in their working spaces—they initially did not work in the textile mills but were the manual laborers who dug the canals.

Space was used by political leaders within ethnic communities as a subtle expression of the ethnic group's power, exemplified by Irish parade routes and later by Portuguese processions.[75] Within ethnic communities, space was used to define political alliances transported, for example, to America from Ireland.[76] The Irish neighborhoods and Irish ethnic institutions "enabled the Irish to exist in a partially separate sphere within the larger native American community," both physically and culturally.[77] As other ethnic groups came to Lowell they were also ethnically segregated into enclaves. Women from each of the ethnic groups existed within their own ethnic enclave, and many of them rarely moved outside of it, except to walk to work in the factories, where they re-entered a minienclave in the mill. One Irish woman commented that she was eighteen years old before she left her neighborhood.[78] Tensions developed between ethnic communities, and women were often afraid to walk through the area of other ethnic groups. Boys inhabited the public parks, throwing stones at boys with different ethnic backgrounds, but the women passed quickly through these contested areas.[79] According to the former director of the Lowell Museum, Lewis Karabatsos, "Women were not wandering around the streets. They did not go out alone, except to go to work, to shop or to visit, and even then they went with a friend. Women went to public parks and walked on the public streets, but never alone. If they went to the park it was usually for a city event and they went with their families. If they were walking alone it was just to get somewhere."[80] Because pub-

lic spaces are particularly forbidden to women after dark, when Ellen Rothenberg sculpted *Industry Not Servitude,* she hoped her piece would create a sense of a safe space for women where they could feel comfortable walking alone.[81]

There were differences in the way that women from the various ethnic enclaves experienced the space of Lowell, just as women from the different social classes in Lowell moved within the public space differently. Women from Greece in the nineteenth and early twentieth century came to Lowell to a male relative, who acted as her protector. Many Irish women traveled to the United States alone and lived in Lowell boardinghouses managed by someone from their village in Ireland, but they were not necessarily supervised by a male relative. Women from some ethnic groups were allowed to attend public dance halls, while others were forbidden to go to such public places for fear that they might fraternize with men from other ethnic groups.[82]

There were no narratives of fear in public spaces from the women in my family. My grandmother walked home from the movies alone or with a friend in the early 1900s, my mother walked home alone from St. John's Hospital in the 1930s, and my cousin Ann remembers walking alone in the city. But they likely walked in areas they knew. They had constructed a mental map of safe areas and areas that were out of bounds.

The *Winged Victory,* the single figurative monument to a woman in Lowell, is in the city's most prominent public space. The nine-foot-tall figure of a draped woman with wings, holding the wreath of victory in one hand and the harvest sheaf of peace in the other hand sits atop a seven-foot granite base just in front of the Ladd and Whitney Monument in the center of the city. Her left breast is bared and her right breast is visible beneath the thin, bronzed drapery. She is young, serious, and fertile.[83]

In 1866 wealthy Lowell entrepreneur James C. Ayer, lamenting the paucity of statues in America, "devoted some time to find a figure, either in marble or bronze, which I could present to our city as a commencement of this kind of ornamentation in Lowell."[84] He eventually found the image of Victory in a pair of statues, designed by the Prussian sculptor Rauch for the king of Bavaria, standing at the entrance to the king's palace in Munich. A replica was made for Lowell and, amid parades and speeches, dedicated on July 4, 1867, just two years after the dedication of the Ladd and Whitney Monument. According to Lowell historian Charles Cowley, writing in 1895, "the fitness of the combination of the two impressive symbols at once became ap-

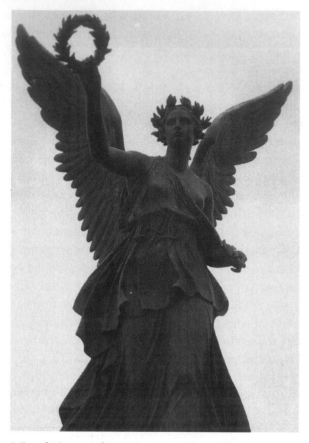

Winged Victory, July 1997.

parent . . . the cross [on the Ladd and Whitney Monument] stands for self-sacrifice, and the crown [on the *Winged Victory*] for the great reward which self-sacrifice brings." The new monument, he went on, acts to renew attention to both the martyred soldiers buried on Monument Square and the gloried cause they died for.[85]

The *Winged Victory* is a combination of the female as icon of civic virtue and as sexual symbol. In Lowell, as in much of the world, the female body acts as a device to pass meaning beyond women themselves to the civic values cherished by male citizens.[86] The *Winged Victory* does not refer to an individual woman, to the women of Lowell, or even to the notion of womanhood; rather it refers to the martyred men and the cause of the Civil War,

to the idea of male sacrifice, and to the notion of male heroism. Marina Warner, in writing about the female form, noted that daily we exchange goods, commodities, and ideas as status and identity symbols through the symbolic form of the female figure. Sculptors assume that abstract concepts of liberty, justice, or victory can be expressed by the female figure, although few think that real women have special claims to liberty, justice, or victory. The exposed breast, present on many allegorical female statues, stands for the abundance of nature as mediated by the state.[87]

The most famous sculpture in America of the female form used to express abstract ideas of liberty and justice is the Statue of Liberty in New York City. The idea of nationhood often finds expression in the female form. Marianne is the symbol of the French nation, not an individual woman. The revolutionary concept of republic or liberty tended to be a naked or bare-breasted female through the nineteenth century.[88] In writing about Palestinians exiled from their homelands, Susan Slyomovics found the image of the Palestinian peasant woman had come to embody the lost Palestinian Arab house, an idea that derived its power from the familiar image of the nation as a female body. Slyomovics wrote, "She represents the 'national allegory' of the lost Palestinian homeland in much literary and visual imagery as the feminine sphere reproducing, literally and figuratively, the nation."[89] A graphic representation of woman's body as colonized and colonizing agent appears at the principal train station in Marseille, France. On either side of the grand entrance to the station is a large stone sculpture of a woman reclining, her breasts and buttocks bared and eroticized. One woman's body represents France's "Colonies of Asia," while the other represents "Colonies of Africa."

Michel-Rolph Trouillot wrote that the important question to ask of the past is not "What is history?" but "How does history work? What makes some narratives powerful enough to be accepted as history? What silences other narratives?"[90] Yankee women wage earners and labor activists found their way into the public domain and public memory through the thoughtful research of outsider historians who revealed much about Lowell's past to the city insiders.[91] The exhibits at the National Park examine in detail the lives of the Yankee women workers, and the outside monuments publicly remember their role in the history of the city. A few, rare local monuments acknowledge ordinary Lowell women. But the ethnic middle-class women from immigrant families who have exerted so much power behind the scenes in Lowell and the ethnic working-class women who have maintained the so-

cial fabric of the household and community relations remain nameless in the streets, museums, and history books. I know only the names of the women whose memories are preserved for me in the stories recounted by my family and my family's friends in Lowell. Were the definition of contribution to the public good enlarged to include women's primary spheres of activity, the names of local, working- and middle-class women who made a difference to their communities might become a part of local history, and perhaps national history.

Women's underrepresentation in monuments speaks to the limitations they have long experienced on their movement in public space, particularly in the crucible of the community's prestige system, and the maintenance of the public/male and private/female realms in Lowell. Limited access to public spaces has meant limited access to public institutions. Women were excluded from participation in a number of significant spheres, like city hall, the saloons and coffee shops where much business was done, and organizations. Most of the women who entered public political life did so after the death of a spouse, taking over his elected office. Those few who do sit at the table with power brokers where decisions are made "cross over" and are no longer seen as women but as "one of the boys."[92] The corpus of monuments that does exist about women is not ideologically neutral. They speak to ideas about the public role of the female form and publicly sanctioned roles for women. Women are rememberers of male accomplishment. Their bodies are used to remember male war heroes, the nation, or as eroticized images of colonization, and their early preservation activities in the nation, an entry for many women into the public domain, were used to enshrine sites associated with male political heroes.

Middle-class women in Lowell have developed their own agency and their own realms where they exercise power. I thought about the many ethnic middle-class women I know who play vital roles in the cultural and political life of the city, but whose names rarely appear in the newspaper. They serve on boards of directors, but rarely as chairs, and do committee work but do not announce it at the public functions. They are the church managers, education coordinators, nurse practitioners, neighborhood association members, and volunteers. They serve as clerks and mid-level managers, and work in other support services where much of the actual labor is done. It is here that volunteers are coordinated, campaign contributions are solicited, and organizational details of major projects are implemented. Women organize the fund-raisers for the schools, monuments, festivals, and halfway

A women's eroticized body used to represent France's African Colonies, Marseille, France, July 2000.

houses; women organize the social services that permit the city to function. It is this infrastructure that is composed of middle-class women, the infrastructure that remains so invisible but so critical to the performance of the public roles occupied by men. As Carole Pateman observed, "Women have never been completely excluded from participation in the institutions of the public world—but women have been incorporated into public life in a different manner from men."[93]

A Daughters of the American Revolution report described the work of the Missouri Daughters in World War I, but it could stand as a metaphor for the work of women of Lowell. "All during the war, Missouri Daughters gave of their time freely and willingly to the Red Cross and War Relief Work, knitting sweaters and sox, collecting barrels and sacks of fruits and supplies, adopting French war orphans, and doing everything toward assisting the men in service, that was within their power to undertake."[94] When I asked my cousin Ann, "Why are there no monuments to women?" she answered, "I would imagine women always worked behind the scenes so when men went off to war they could do heroic stuff and all the heroic stuff women did was just expected, sort of like today. Most likely the women were just trying to make ends meet."[95] When asked if she could think of any local women

deserving commemoration, another Lowell woman thought of two people she knew: "She was like a saint. They both were. That's how I'd describe them. Both are selfless. They didn't even want people to know what they did. They should be commemorated someplace. They were so giving to people, to the whole parish, the school. They weren't in wars, but they should be re-membered."[96] Enculturated into a society that reinforced women's humility, service, and selflessness, the women "didn't even want people to know what they did" or they worked behind the scenes to "make ends meet." For these women, there is as yet no corresponding public place of memory or com-memoration.

These women are on the boundary between public and private. This boundary is slowly blurring on many fronts, as women increasingly move into realms once reserved exclusively for men, as men begin to inhabit roles and spaces once thought of as female, and as women continue to challenge assumptions about their roles in the public domain. With modernity there is a displacement of the traditional sense of an inside as an enclosed and pri-vate space established in opposition to an outside, public space. This is true for the technologies that define the space of the city—photography, news-papers, electricity, and advertising—as well as for boundaries defining media and the space of sound.[97] What, for example, constitutes private and what constitutes public space and activities: walking alone on a beach? a politi-cian's sexual life? a woman's body?[98] What is public and private space on the Internet, where narrative, space, and image are commingled? Is women's un-paid domestic labor private when it supports the economic foundation for their working husbands? Are family narratives private when they articulate periods in the cultural past of a city?

I wonder how I could remember Nana, Dorothy, and my mother in Low-ell and for Lowell. I imagine creating a small sign outside my grandmother's apartment on Bridge Street, perhaps with the words, "Catherine Barrett Cleary / She performed the tasks of daily life with humor and generosity / Beloved by her family and neighbors / She told wondrous stories of herself and her times / Personifying Lowell in her life as an occasional mill worker, mother, grandmother, friend, and citizen / She lived in this building and in the house next door for more than fifty years." Just outside the apartment where my mother died, in the small patch of grass below her window, I thought of placing a bouquet of flowers or a small sign with her name on it. Someone else soon occupied the apartment, the long peach drapes re-placed and the brick facade too impersonal to imprint with the memory of

Big Walter Dempsey and Dorothy Cleary
Dempsey in the yard of their house on
Seventh Street, circa 1972.

her life. I think of marking Dorothy and Big Walter's apartment on Bridge
Street, and their house some three blocks away. What would I say about their
quiet lives, which meant so much to our huge family and to their lifelong
friends and neighbors, but were virtually unknown to the larger city? There
is no marking of my grandmother or my aunt on street signs, plaques, stat-
ues, or monuments. Like most women, they are anonymous on the land-
scape. Their long physical presence in the city, their beliefs, and their way
of life has not intersected with or altered the exterior landscape, apart from
my knowledge of the sites associated with them.

What and who is worth commemorating on the Lowell landscape? If the
criteria for marking a man in a public park is his service to the youth of Low-
ell as a long-time basketball coach, then certainly a woman's contributions
to the neighborhood can also be marked. If women have worked in the pri-
vate and semiprivate realms, then it is those realms that must become a part
of public consciousness and a part of public commemoration.[99] The fluid

boundary between public and private can reach to women's economic, educational, social, and political activities so that they are understood as being at the center rather than the periphery of the city. Women—individual, actual women—can speak in public on behalf of the community. Her body will not be used as a symbol of male heroism, the nation, or colonialism, but to represent her personhood and her deeds.

Marking women on the landscape will acknowledge their contributions to Lowell publicly. Some women will be commemorated for distinguishing themselves by their leadership, their organizational skills, and their commitment to bringing about positive social change. Others will be remembered as representative of ordinary women's lives or for having made a mark in realms specific to women. When women's names appear on streets, rivers, parks, bridges, buildings, federally funded public art, and small local monuments, then the landscape will represent a more fully shared civic identity for men and women. Perhaps then women's actions will not be circumscribed by public space, but they can walk freely throughout the city in daylight and in darkness.

Monuments cannot replace narrative, but neither can narrative replace monuments. The stories are one form of power derived through memory, the monuments another. Yet there is a clear relationship between gender, memory, place, and history. Collective memory seeks material reality in a concrete place in space, a symbol that binds it to place.[100] The places described in the narratives of my family and countless other families and the places where the women told the stories are powerful sites. These sites, and others like them, can be powerful collectively if they represented not only individual memory but the history of Lowell.

III

RELOCATING THE MEMORY
OF THE DEAD

I do not remember the first time I entered a cemetery. As a child I was afraid of the bodies I knew lie under the soil, and I held my breath as we drove by. My aunt's sister had a son who died suddenly at age seventeen, and she found it comforting to live near the place where he was buried. They lived in a part of Lowell we never went to. I considered it far away from us. My sisters and I thought it frightening to live so close to a loved one's body. After my grandmother died, I went to the cemetery on a bitterly cold and windy January day. It was just before my fourteenth birthday, and I remember grief, but little of the physical place of her burial. Nana had chosen a flat stone for Grandpa ten years earlier, so that it would be easier for the grounds people to mow the grass. In a small restaurant years before she died, she stacked up the plates on our table to help our waitress because, "the poor thing must be tired." Nana identified so completely with the working classes that she imagined their fatigue and tried to spare them any extra labor.

My mother introduced me to the idea that certain cemeteries were historical and hence worth visiting. We read the epitaphs on the older grave markers and admired the gravestones of the powerful and the wealthy. In her

The Norkunas Monument in the Polish and Lithuanian Cemetery, where Martha
and Joseph, my Lithuanian grandparents, and their daughter, Sophie, are buried,
May 2000.

Lithuanian grandmother's grave. Not only were the names on the stones dif-
ferent from those in St. Patrick's, but the look of the landscape was slightly
different, with small bushes on either side of most of the stones and a large
area of unused land in back of the graves. I thought of the story my mother
used to tell us when we were little about how her older brother teased her
when she started going out with my father. "Doff your hats, everyone," Ed-
ward said when they drove by the Polish cemetery, "This is where Kathleen
will be buried one day." She said she was annoyed with him, but she always
laughed when she told the story. It was, of course, a derisive comment, for
the Irish to be buried apart from their own was an unwelcome idea. In the
end, the bonds of ethnicity will prove stronger for my parents than the bonds
of marriage. My mother is buried in St. Patrick's Cemetery, and my father
will be buried across the street in the Polish and Lithuanian cemetery, next
to his mother. In Lowell, tradition born within the ethnic family governs
how and where a person lives and how and where a person dies and is
buried.

 After my mother's death, the cemetery changed for me again. It became
a more intimate place that I came to know well and feel comfortable in
through my repeated visits to her grave. Like my grandmother more than a

half a century before me and my sister, I turned to the cemetery to assuage my grief in the first year after my mother's death. My visits were not to keep her memory alive or out of familial obligation—she had already made it clear that regular cemetery visits were not something my family was ritually required to do. I went to keep my connection to her alive by being close to the place of her physical remains. Just after she died I bought a plot for four near her, because the old cemetery was running out of space, and I feared that if I waited I could not be buried in St. Patrick's. My husband has conflicted feelings about being buried in that plot. Always an outsider to Lowell, he may choose to be buried in Istanbul, next to his parents. Once again, the ties of family, ethnicity, and where one belongs will in death supercede the bonds of love and marriage. Perhaps these places in St. Patrick's Cemetery will become memory sites for our children. I do not know if they will chose to be buried there, aligning themselves with the literal remains of their mother's family, or go to Turkey to be close to their father's family. They may, instead, decide to create a sense of belonging to a new place. I like to imagine that they will return to Lowell.

When my Irish ancestors came to Lowell in 1847 the first Irish Catholic church in Lowell, St. Patrick's, was already sixteen years old. St. Patrick's Cemetery, the first Catholic cemetery in Lowell, formally opened in 1832, although the date on one of the stones indicates that there was a burial there three years earlier. Had they come to Lowell and died prior to 1832, they would have been buried on consecrated ground in Boston.[3] In most towns the burial ground was behind the Catholic church, close to both the church and the faithful. But in Lowell, "no closer land was available" so St. Patrick's Cemetery opened on an acre of land on the outskirts of the city.[4] St. Patrick's was very much a working person's cemetery, and, in the early days, there was no charge to be buried there.[5] It was also an Irish cemetery. French Canadians, although Catholic, were not welcomed in St. Patrick's Cemetery, just as they were not welcomed in most Irish Catholic churches in Lowell. The French Canadian priest, Father Andre Garin, purchased land outside of Lowell for a summer residence for the oblate fathers, but it was instead used as a cemetery. St. Joseph's Cemetery (for the French Canadians) opened in the 1890s, and Father Garin was the first to be buried there in 1895.

For the members of my family it was critical to be buried on consecrated ground, or ground blessed by the archbishop of the diocese. The Catholic church considers the burial of the dead a sacred act in addition to being a social responsibility. At one time, non-Catholics were not buried on conse-

crated ground. If a husband were a non-Catholic he would have been denied burial in St. Patrick's and would have had to be buried in another cemetery, apart from his wife. As long as my family had been burying their dead in St. Patrick's Cemetery, we were unaware of the Suicide Gate. If a person had committed suicide, had a bad marriage, or was known as undesirable, and hence not entitled to a Christian burial, a determination made by the church, he or she was brought into St. Patrick's Cemetery through the Suicide Gate and buried in the corner of land that was unconsecrated.[6] My grandmother had a stillborn child in 1918. Perhaps that baby was buried in the unconsecrated area reserved for the unbaptised. While Nana told the story of the baby's birth, she never mentioned its burial.

In my family, remembering the dead was important, but it was done through stories and not through regular visits to the cemetery. The dead and the living commingled not through the placement of stone reminders of the dead but through endless narratives. It was as though the dead were among us, as a part of the conversation of daily life, equal with the living. Molly Haskell, in reviewing the films of Paul Cox, wrote that his heroes lived in houses "where their mothers died, breathing in the erotic musk of ancestral heirlooms, communing nightly with hallucinatory memories as real and vivid as daytime conversations. Cemeteries, funerals, the legacies and possessions of the dead are featured prominently in Mr. Cox's pictorial scheme, not to eclipse the living but to assert their place in the continuum."[7] Most monuments outside of the cemeteries in Lowell are put up within two years after the person's death. Beginning in the nineteenth century, but especially in the twentieth century, Lowell men were remembered through the creation of a series of stones, one in the cemetery and a second one in the city, in the midst of the deceased's community. But for our family, the memory of the dead lived among us in "hallucinatory memories as real and vivid as daytime conversations." After the first year of visiting the monument over the body of our dead inside the cemetery, there was no second stone in a Lowell neighborhood.

By 1840 Lowell had three cemeteries: a burying ground at School and Branch Streets, the Old English Cemetery, and St. Patrick's Cemetery, originally called the Catholic Burying Ground. In 1841 the Lowell Cemetery was dedicated. Created not to alleviate a need for burial space, but as a place for walking and enjoying nature's beauty, it was an exclusive cemetery that charged fees for burial.[8] On its forty-five acres it had gently winding paths,

avenues named for famous men, and a small lake, since removed. "Hospital lots" were reserved for charity cases. The beautiful site forms the southeastern slope of Fort Hill Park and runs to the banks of the Concord River.[9] In 1846 the Lowell city council voted to have a new public burial ground laid out next to St. Patrick's Cemetery. It was named the Edson Cemetery, after the rector of St. Anne's Episcopal Church. With its level terrain and geometric paths, it too was in marked contrast to the landscaped beauty of the Lowell Cemetery.[10]

The Lowell Cemetery was inspired by the 1831 creation of Mt. Auburn Cemetery in Cambridge, Massachusetts. Mt. Auburn is America's first and most famous rural cemetery. In addition to acting as a place of internment, Mt. Auburn was designed as a public park. Most city governments, including Lowell, were not yet willing to spend public funds to create parks, so they looked to the rural cemeteries to serve some of that function.[11] There was an emphasis on social hierarchies in the rural cemetery, with family plots fenced off, often with ornamental cast-iron railings.[12] Since the beginning of English settlement in New England, the standard places of burial had been in the middle of towns, in churchyards, or on town commons, all places close to the living.[13] Owing to a rapidly increasing population, old graveyards had become overcrowded and unsanitary. By the nineteenth century, both in Europe and in the United States, people began to believe that cemeteries in the center of densely populated cities posed a serious health menace. There was a return to the idea that the dead should not commingle with the living, and cemeteries were moved to the outskirts of the city.[14] When the large cemeteries in Lowell were established, there was no thought of locating them in the center of the community. They were located on the outskirts of the city, far from the daily life of the people.

In 1845 the mayor of Lowell, Elisha Huntington, recognized that the city needed open public spaces beyond those of the Lowell Cemetery. The city purchased ten acres of land from the Locks and Canals Corporation to establish the North Common and twenty acres to create the South Common. Located at either end of the city they were supposed to act as a respite from urban life.[15] In fact they did serve as gathering places for the people of Lowell and as recreational areas. It was on the South Common that Fourth of July festivities were held, and on the sloping hills that city children went sledding in winter.[16] Neighborhoods grew up around both Commons, and they became little more than open fields with some trees so that when Fort Hill

Park was established in 1886, it was called Lowell's first park.[17] Despite public protests, in the latter half of the twentieth century schools were built on some of the land in each of the Commons, substantially shrinking the size of the Commons. Over time the city of Lowell established a series of small public parks in the neighborhoods.

When Fort Hill Park was created, two granite gateposts marked the principal entry. Originally a brass plaque was mounted on each gatepost, and on it were the words, "This park was presented to the City of Lowell in 1886 by Emily and Elizabeth Rogers, daughters of Zadoc Rogers, who bought 247 acres of farmland in the area in 1805."[18] Today the brass plaques are missing, and only the words "Rogers / Fort Hill Park" are incised directly into the stone gateposts.[19] Some eleven years after Mary Ann Sanders Tyler donated Tyler Park to Lowell in 1893 she placed a public drinking fountain on its edge and inscribed her name around the lip. In 1907 a stone monument marked the donation of Coburn Park, a small neighborhood park, to the city of Lowell. When Shedd Park, a large area of land adjacent to the Lowell Cemetery, was donated to Lowell it too had inscribed gateposts: "Shedd / Playground / A Gift to the / City of Lowell / By / Freeman Ballard Shedd / A.D. 1910." These inscriptions on stone were among the first monuments located in city parks, and they recognized the donors of the land.

In 1919, when the city dedicated a series of granite monuments to World War I veterans, it placed them in public parks. In the next five years five more monuments were placed in public parks. After World War II seven veterans' monuments were located in public parks. In the 1960s at least three monuments to Vietnam War veterans were dedicated in public parks. Beginning in 1966, new kinds of monuments began to appear in public parks, dedicated not to veterans, but to children, athletes, coaches, priests, and politicians. Over the course of the next thirty-five years more than forty of these new monuments were dedicated in Lowell's public parks.

Prior to the 1980s, the city most often used polished granite stones as monuments. These stones look like the gravestones found in the working-class cemeteries in Lowell. They are the same size as gravestones, many are mounted on granite bases, and they are polished and incised. They vary in color and design,[20] and some have a base while others are placed directly on the ground. Apart from their epitaphs any one of them could be found in a cemetery. Many of these stones are surrounded by a fence made of galvanized steel or aluminum, like the black wrought-iron fencing commonly found around family plots prior to the 1930s.[21]

After 1980 the city began to use incised boulders rather than polished granite stones for public monuments. Because the boulders were much less expensive than the polished granite stones, the city could afford to erect many more monuments. The average granite boulder is about three-feet wide by two-feet high, irregular in shape and has incised letters across the front, often painted black. Placed directly on the ground, rather than on a granite base, they may sink slowly back into the earth.[22] When people request a monument, they are now "conditioned" to ask for a boulder rather than a polished stone, but they still ask for the monument to be surrounded by the wrought-iron-looking fence. The Parks Department, which handles all monument placement, tries to honor the public's wishes, despite the fact that fences are a maintenance problem. There was some concern that people might feel less honored by having a boulder placed on a site, rather than a polished granite stone, but the commissioner of parks, recreation, and cemeteries, Tom Bellegarde, thought the boulders looked more natural and that they did not take away from what the city was trying to accomplish.[23]

Nearly every civilization commemorates important events with stone monuments. The use of headstones as grave markers is thought to date to protohistorical time.[24] The polished, cut stones represent a stronger cultural intervention in the creation of a memorial site. They are stone, but stone that has been worked by skilled craftspeople. The boulders are more natural and hence have a more raw appeal. From a distance, you would not at first know that the boulders were monuments. Coming closer you see that they are surrounded by mulch and have small evergreens on either side, and that is a signal that they are more than simple stones.

Like the stones themselves, the plantings around the monuments use the vocabulary of the cemetery. The majority of the monuments have a small shrub planted on either side of the stone. Gold-tipped juniper or dwarf Alberta spruce are the shrubs most often used. They "bounce off the stone nicely," they are indestructible, and they grow slowly.[25] Bushes, shrubs, and trees represent the regenerative powers of nature. In the graveyards of the Middle Ages the constant greenness of the yew and holly trees symbolized the resurrection; every plant carried special meaning and power. Evergreens, symbols of immortality, were thought to ward off evil spirits. Some species of evergreens are so commonly associated with burial grounds that they have become known as the cemetery tree.[26]

There is mulch around most of the monuments in the city. Mulch holds the moisture, but most importantly, it keeps the weeds under control. No

The Centralville Veterans Monument at the
intersection of Bridge Street and the VFW
(Veterans of Foreign Wars) Highway, July
1996.

grass or weeds grow within the circle of mulch. The people in the community have mixed feelings about the mulch—some love it and others feel it takes away from the commemorative area. The mulch of preference is hemlock. A newer, spray-painted mulch is becoming popular, but because of its artificial, slightly gaudy look, it has not been officially adopted.[27] Although not common in Lowell, many communities practice grave scraping, literally scraping all weeds and grasses off of the grave. Some trace its origins to Africa, while others have found evidence of European grave scraping. It was a way to keep the cemetery clean and symbolized a reverence for ancestors.[28] Mulch also defines the boundary of the space for those monuments without a fence.

In the cemetery, bodies are buried under or near existent trees. Outside of the cemetery, a lone tree is often planted in memory of someone, and a granite stone is placed under the tree. The tree, particularly the oak, is the symbol of strength and continuity, and of the individual as a member of the

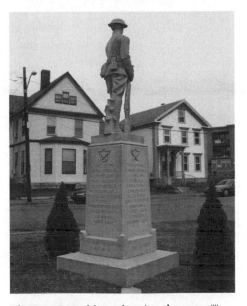

The Acre Doughboy, showing the cut-off
tree stump by his right leg, Fletcher and
Willie Streets, 1997.

community.[29] A lone flagpole and flag, the symbol of civic strength and con-
tinuity, may replace the single tree behind the monument. Some monu-
ments, both in and out of the cemetery, incorporate a granite tree stump to
indicate the life cut short. While trees represent vitality and self-regenerative
power, they also have a richly ambiguous status well suited to commemo-
rating the dead. The tree is in some sense both living and dead, with its inner
rings resembling the dead and its outer rings carrying life-sustaining nour-
ishment from its roots to the tips of its leaves.[30] Through the tree the dead
are thought to continue living.[31]

There are dates on some of the Lowell monuments, just as there are dates
on every cemetery monument, but unlike the monuments in the cemetery
that carry the birth and death dates of the interred, the dates on the civic
monuments do not always refer to death. In fact it is often unclear what the
dates refer to. In a cemetery one can walk through time, always aware of
when the dead had lived. The monuments outside of the cemetery are out-
side of time, without reference to chronology.

Charles McInerney was missing in action in
World War II. The Charles Thomas
McInerney Monument shows the lone flag
behind the monument in lieu of a tree,
Main and Massassoit Streets, December 1997.

Most of the stones to groups do not include names, but the stones dedi-
cated to an individual or to several people always include their names. More
than half of these stones reference dedication or memory.[32] The text "in
memory and honor of" promises that, although the person is no longer pres-
ent, they will live on not only in the memory of the living but in a state of
honor, respect, or affection.[33] This, then, is a public record of the covenant
between the living and the dead, and a promise that the living have made
to certain of the deceased.

While it is not always clear what qualities the deceased possessed that are
worthy of commemoration, many texts proclaim him as a worthy person or
a model for the community to emulate. "He set a standard for all young peo-
ple to follow" or he had "great courage."[34] A quality that is often highlighted
is a man's "service to the community," but the language of service is not used
for women.[35] Dedication to the youth of the community is highly valued.[36]

Love has many voices in these texts, with the living remembering the dead, "in loving memory," or the dead proclaiming their love for the nation through their deaths, "Greater Love No Man Hath, Than To Give His Life."[37]

The spirit of the dead is invoked to "live on" through transference to the living: "His spirit of sensitivity will live on in us" or "A life that touches the heart of others goes on forever." Inanimate space is personified as missing the dead. Michael Perry was in the air force when he was killed in a car accident at the age of twenty-two. The epitaph on his monument describes a small public park that misses him: "To Show How He Would Love to Say, / To All The Kids 'Come On Let's Play' / Stands This Memorial In Memory Of / Him. This Park He Enjoyed Felt The / Loss Of Him. All His Warmth And / Kindness Touched Those He Knew, / Here This Monument Was Placed / For Everyone To View."[38] Many of the monuments use the language of mourning. Here the living are primary, and it is their grief that is specifically articulated in the texts. "Beloved by all who knew him," speaks to the pain of loss. The text on several recent monuments is much more like standard cemetery epitaphs. The inscription on the Cheryl Berard McMahon Monument, dedicated in 1998, is indistinguishable from one in the cemetery, listing the deceased's birth and death dates and those who mourn her.[39]

There are few images on the stones. Except for crosses, which function as ethnic symbols, religious imagery is absent.[40] This sets the stones apart from those in the ethnic Catholic cemeteries and in the city cemeteries, where religious imagery abounds. On war monuments the eagle often appears. Like recent cemetery stones, the monuments sometimes include an image that defined the deceased, like a football, landscape, or Irish flag.

As a child, and later as a cultural historian working in downtown Lowell, I did not know that there were bodies interred under the Ladd and Whitney Monument in the heart of the city. No language on the monument itself infers interment. Most citizens or visitors to Lowell do not know that bodies are buried beneath this monument. Yet I knew from the moment I began to work downtown, and perhaps had a sense of it even as a child, that this was the most important monument in the city. Like the monuments to martyrs once placed in or adjacent to the church in the center of town, this monument is located on an island of land in front of city hall. Beneath the large granite obelisk are buried the bodies of the first two New England soldiers killed in the Civil War. A local newspaper reported, "The bodies of Luther C. Ladd and Addison O. Whitney, which had previously been buried at their

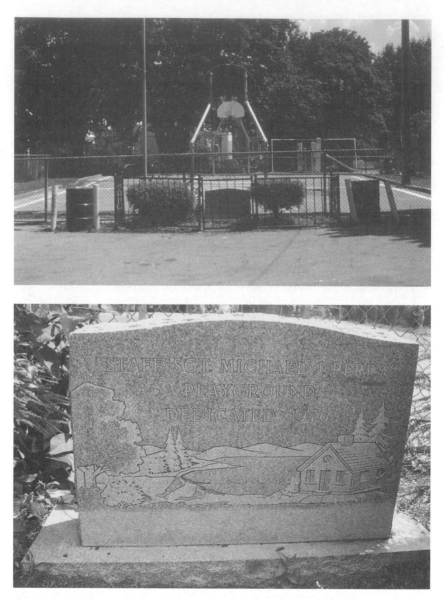

The Michael Perry Monument in front of a small park on Dover Street, and a close-up of the monument, August 1996.

The Ladd and Whitney Monument, where two soldiers are buried, 1997. Courtesy Jim Higgins.

respective home towns in New Hampshire and Maine, had been brought to Lowell and reinterred in special metallic coffins under the 28-foot granite monument which was erected in the triangle at the junction of Merrimack and Moody Streets."[41] Luther Ladd and Addison Whitney, who were interred in their home states, temporarily reinterred in Lowell while awaiting the dedication of the monument, were interred for the third and final time in 1865 in the political heart of the city.[42]

Both Ladd and Whitney had worked in Lowell,[43] and together with Charles Taylor of Boston and Sumner Needham of Lawrence, were killed in Baltimore on April 19, 1861.[44] The dedication of the monument in Lowell was to have taken place on April 19, 1865, "the fourth anniversary of the day the martyrs fell," but was postponed when Abraham Lincoln was assassinated.[45] On June 17, 1865, the anniversary of the Battle of Bunker Hill, itself commemorated in Boston by a tall obelisk, the Ladd and Whitney Monu-

ment was dedicated at a large public event. The dedicatory speeches and even a quotation on the monument itself are replete with the language of the martyred. On the reverse plinth of the monument is a quotation from John Milton's *Samson Agonistes:* "Nothing is here for tears, nothing to wail / Or knock the breast; no weakness, no contempt, / Dispraise or blame, nothing but well and fair / And which may quiet us in a death so noble."[46] On Monday, April 19, 1909, the name of Charles A. Taylor was added to the monument.[47] Shortly after the Ladd and Whitney was dedicated, James Cook Ayer commissioned the *Winged Victory* to stand at the front of Monument Square to complete the commemoration to the Civil War martyrs.

Over the years there have been efforts to remove or relocate the two monuments to accommodate new city designs, but they have never been successful. Old postcards show that the area around the monuments was once larger, cannons have been removed, and wrought-iron fencing has disappeared, but the monuments have remained in their original locations for 135 years. Today curbing, grass, and flowers surround them.

In the 1960s a quiet but important change was made to Monument Square. One hundred years after the dedication of the Ladd and Whitney Monument, a third monument was added to the memorial space. A new road was created adjacent to the monuments and named Arcand Drive. A boulder with a brass plaque was placed to the right of the Ladd and Whitney. It is dedicated to Donald Arcand, who died in the Vietnam War in 1965. Like the first two martyrs to die in the Civil War, Arcand was the first Lowell martyr to die in Vietnam. The two monuments form endpoints between two of the most divisive wars in American history.[48] Unlike Ladd and Whitney, Donald Arcand is not buried beneath his public monument, although it is impossible to know from its placement if he is interred there or not.

In the Middle Ages exhortations to martyrs showed their suffering in graphic prose and offered the hope of the resurrection as protection against that suffering. The custom of placing the bodies of martyrs under altars meant that Mass came to be celebrated over "the blood of martyrs."[49] In Lowell, soldiers are the civic martyrs. Their monuments indicate their deaths but not their pain. Civic memorialization is their reward for the fragmentation of their bodies and for their premature deaths. In the act of heroic death they achieve an eternal incorruption of memory. Rather than a literal resurrection of the body or the sacred resurrection of the soul, they are granted a triumphal resurrection of memory in the face of dismemberment, loss of body, or burial in a distant land. They are spoken of in the language

of martyrdom. The bodies of Ladd and Whitney were placed not under a sacred altar, but under a civic altar. When dedicated, the speakers stressed the obligation of those remaining to safeguard memory and to honor it. Even the original date of dedication was changed to honor one of America's greatest civic martyrs—Abraham Lincoln. In death the martyred soldiers are represented as whole and intact, belying the physical reality of their actual deaths.

Prior to World War II the "cult of the fallen soldier" exalted the youth of the fallen hero. By placing memorials to them in public spaces, their sacrifice was elevated in status. Once the memorials became shrines of national worship and there were civil pilgrimages to them on appointed days, they were transformed into symbols of the strong and immutable nation.[50] Their martyrdom was a critical ingredient in their transformation into a national symbol.

The aspect of commemorative monuments to martyrs is continued in the inscriptions. Surprisingly, not all of the war monuments contain the word *sacrifice,* nor does the word always pertain to the soldier fallen in war.[51] Police and priests are called martyrs for the sake of the people. Franco Americans who worked in the mills of Lowell are also called martyrs, perhaps because of the severe hardships they endured, or perhaps the language may be interpreted as martyrdom to the cause of industrial capitalism.[52]

The only other monument in Lowell that contains the remains of the people it commemorates is in front of St. Patrick's Church.[53] It is a large, rectangular granite monument raised slightly above the ground. On it are inscribed the words, "In Memoriam / Rev. Timothy O'Brien / 1791–1855 / Rev. John O'Brien / 1800–1874 / Rev. Michael O'Brien / 1825–1900 / Natives of Ballina / County Tipperary, Ireland / Requiescat in Pace." The three Irish brothers, priests of St. Patrick's Church, were not buried in St. Patrick's Cemetery but in an older location, in the heart of the Irish community.[54]

Like the Ladd and Whitney Monument and the Arcand Monument, representing secular martyrdom in the civic heart of the city, the bodies of the O'Brien brothers represent the fusion of the sacred with the civic polity. Marc Augé wrote that European war monuments in the center of town derive their particular efficacy from being in a place where the intimacy between the living and the dead was once expressed in more everyday fashion. Villages reveal the layout of medieval times, when the church, surrounded by the cemetery, lay at the center of active social life.[55] Such is

the case in Lowell at the only two sites where bodies are interred outside of the cemetery.

Just as most Lowellians are unaware that bodies are buried under two of the monuments in public space, neither would they know that no bodies are interred under any of the other monuments in Lowell. Because the monuments throughout Lowell are identical in form and design to cemetery monuments, some may think that these too mark the places of bodies throughout the city of Lowell. While other city structures are written on, chipped, or knocked over, the monuments are rarely disturbed. Tom Bellegarde, the commissioner of parks, recreation, and cemeteries, said,

> With all of the graffiti we have in the parks and all of the swears, profanity, and schwastickas, and for whatever the reason, the [kids] do not, knock on wood, they do not vandalize any of these stones. As you know, a lot of our stones aren't gravestones. They are like rounded flat face stones. So I don't know what it is, but they do not bother them. The playgrounds get it, the flagpoles get it, they steal the flags when they can steal them, but the actual stones are never tipped over. . . . Some people may even think there is a body under some of these [monuments]. But I think that there is already some understanding that they leave the stone alone. They destroy the tennis court, and they throw rocks in the pool, but they are leaving these things alone. Even though they don't know who it is and some of them may have come and read the inscription and they didn't even know what it means, but they know that this is something special and they leave it alone. . . . We are getting vandalism, but there is some kind of unwritten rule or something is hitting home with these kids.[56]

The stones throughout the city mark the second memorial space for an individual. The first space is thought by some to be a more private space. Ryan McMahon died in 1988 at the age of nine from a brain tumor. That fall the school he attended planted a single purple plum tree in his memory. In January his father's colleagues at the Policeman's Union dedicated a stone memorial in front of the tree in the schoolyard. His mother explained, "The monument and tree are kind of sacred territory. Everybody knows you're not supposed to go near the monument. The school wanted to do the tree, and it was Ryan's tree. The monument actually made it permanent." Although she associates that monument with her son, the cemetery monument where

The Ryan McMahon Monument with a purple plum tree behind it and bushes to either side, St. Margaret's School at the corner of Parker and Stevens Streets, October 1996.

his body is interred is more private, and she and her family go to his grave at the cemetery every Sunday.[37]

The monuments throughout the public land of Lowell mark the space apart from the body. They are the empty sepulchers or tombs. The Polish Monument, erected in 1977 just in front of city hall, is in the shape of a ceno-taph, a standardized form in the repertoire of monuments. The word *ceno-taph* comes from the Greek *kenos* for empty, plus *taphos* for tomb. It is a monument to all of the deceased persons whose remains are interred else-where. Here in Lowell is the tomb to the Poles, those many nameless persons who immigrated to America and whose bodies are buried elsewhere, which has come to stand for all of the immigrant Poles. In the Tomb of the Un-known Soldier in Washington, D.C., the body of one unknown soldier stands for all of the missing soldiers in war and ultimately for the nation. "In a number of countries, a 'Tomb of the Unknown Soldier' was built, seeking to push back the boundaries associated with anonymity, and proclaiming, over

a nameless body, the cohesiveness of a nation united in a common memory."[58] The tombs, completely empty or empty save for the one unidentified body, radiate the atmosphere of the actual burial place of the many.[59]

The ethnic markers are the mass cenotaphs, mass corpseless graves, which have been returned to the very heart of the city. They contain the memory of all members of the group who have lived and died in the city. Here the tombs are to the imagined community of ethnics, an ethnic nation within the larger American nation, rather than to a single unknown soldier who stands for the union. All of the monuments in Lowell, with the exception of Ladd and Whitney and the O'Brien brothers, are literally cenotaphs.

The monuments function as sites of public bereavement. Marking the spot where the dead are symbolically brought home, the space of the monument creates a place where the community can grieve collectively, legitimating individual, family, and community sorrow. [60] The monuments also act as sites to collectively acknowledge public honor. Just as war memorials are sites of symbolic exchange where the living admit that their degree of indebtedness can never be fully discharged, so too do the civic monuments offer themselves as sites of indebtedness to civic acts of courage, service, and fidelity.

The disposal of the deceased is a universal practice. But the marking of the dead in civic space moves beyond funerary practices. The proliferation of monuments throughout the civic landscape of Lowell is a rejoining of the cemetery with the living without the pollution of the corpse. A new kind of postmodern cemetery has been created in Lowell, with grave markers in small intimate corners of neighborhoods. In this new cemetery, memory can be venerated and mourned without the pestilence of the corpse. Rather than creating a cemetery as a park, as was done in the nineteenth-century rural cemetery movement, in the twentieth century Lowell has created parks as cemeteries. The commemorative function has been taken on by a site that does not contain the body, allowing the dead to be symbolically brought home. Monuments to women are a small percentage of this new cemetery in the city. For women the site of memory, the place where the living and the dead commingle, is not on the landscape but remains rooted in narrative.

The space of the monuments is that which is set apart as more than mundane. While the public parks as a whole are not marked space, the areas immediately around the stones use the language of the cemetery to identify a space that resembles the consecrated grounds of the cemetery.[61] The pol-

ished cemetery stone, the boulder, the plantings, the iron fences, and the mulch: these are not the design elements of grand monuments like the Lincoln Memorial or the Washington Monument, but familiar symbols of the place where the dead are buried. The polished granite and the boulders bespeak the primeval power of stone, with the evergreens recalling the regenerative powers of nature.[62] These symbols communicate directly to those who encounter them—even youth prone to violence do not disturb them. These are not spaces found in nature thought to be inherently imbued with sacred qualities, but spaces that are culturally designed and constructed in reference to the burial sites.[63] It has become profound space on the landscape associated with the memory and hence the spirit of the deceased. The beliefs of a community are shaping the landscape.[64] Through epitaphs and placement the monument is an expression of the city's need to redefine the modern male martyr and the ideals worth dying for.

It is in civic space that ideas about the proper relationship between the living and the deceased male are being renegotiated by bringing the memory of him, absent the corpse, back into the heart of the city and the neighborhoods. It is in the space of narrative that ideas about the relationship of the living with the deceased female are revealed, absent not only the corpse but the stone monument itself.

IV

THE CHANGING
RELATIONSHIP OF
MEMORY AND PLACE

There was never a time in my life when I was not returning to Lowell. From the moment I could understand my mother's and my grandmother's stories, Lowell lived vibrantly in my imagination—Nana getting married from Hampshire Street and the picket fence where Nana's brother Andrew fell to his death—as much as those specific places we belonged to—Nana's apartment and Dorothy's house. As a child I knew that Lowell meant Nana, and the aroma of her apartment, and it meant my Aunt Dorothy, Big Walter, and my cousins Little Walter, Jacky, Ann, and Brian. In the beginning I did not know that it was a city. I only knew that each year we drove the four hours from New Jersey to Nana's and Dorothy's. Even though my mother and father had left the city, it was always the place we went to. Lowell was the seat of tradition, holidays, and summer.[1]

My memories of Lowell begin with my childhood visits to Nana's apartment. I cannot drive by her apartment without reseeing her at the window, waving goodbye to us. When I close my eyes I can hear myself calling "hel-loooo" as I slowly climbed the long flight of stairs to the hallway outside her apartment and reenvision her sunny kitchen, Nana at the table with her giant

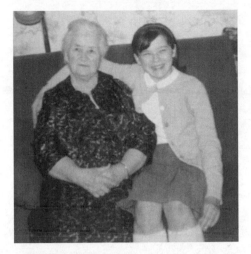

Nana and me at Dorothy's house, circa 1965.

cup of tea. The tea was milky and sweet. Nana got me a little glass, counting out teaspoons of tea from her cup to my glass—one, two, three, four, five. I thought she was sharing her tea, but she was teaching me to count.

I walked down the hall with her to the back-porch balcony where she hung out the clothes, and I gazed down on what seemed like a mysterious jungle of trees below. Did the peach tree down there really result from her tossing a seed from the balcony? Or was it I who tossed the seed? She kept the clothespins in the pocket of her apron or in a little bag on the line. I was forbidden to go to the balcony alone, increasing its mystery for me. There is a sound too from that time. It is the clothesline at my Aunt Dorothy's apartment. She is leaning out of the window, pulling clothes in from a pulley strung between her building and the tenement just across the yard. I could not take my eyes from it. It screeched, maybe from the pulleys being rusty, as she pulled the clothes—were they white and billowing, or did I add to my visual memory of the clothesline over time? So many of my memories of the women in my family are associated with the clothesline.[2]

The memories of Nana were preserved for me in the unchanging nature of her tan building with the four green doors, hers the second from the left. Years after Nana died they put siding on. It was shinier but still tan, and the doors still green. I was almost disappointed that the chipped paint was gone, but relieved that the window where she waved to us remained so much the same. I sensed that any change in the appearance of the site would change

A clothesline much like the one that Dorothy had at her apartment when I was a child, April 1992.

my memory and my ability to remember. Nana's apartment cannot be anything but that place of my childhood, the scent and Nana at the window. As many times as I have driven by that building, it can never be anything but Nana's home.

Some of the pictures I have in my mind, Nana created for me through her richly detailed stories. I was spellbound by the stories. I relived with her my Uncle Frank's return from World War II, his gift of a trip to New York City for her and Grandpa, and the shock of discovering upon her return that my brother, Billy, had been diagnosed with polio; as a young girl unknowingly eating her mother's ox-tail soup that she had so despised and then asking for seconds; the party Aunt Nan had for Uncle Jack; the altar cloth Nana spent two years making for Uncle Jack when he was a missionary in China and how the Chinese communists had used it for a horse blanket during the revolution; Aunt Nan pulling a long green strand of mucous from her throat as she lay dying of pneumonia in her bed at home.

These are the "received memories" from Nana, told and retold, and rooted in sites of Lowell. I've formed vivid pictures based on the narratives, just as

Nana's apartment building at 834 Bridge Street, June 1981.

vivid as if I'd been there myself, that are barely distinguishable from memory. They have created a past that is not mine at all and yet is my own, for they link me to generations of my Lowell family. These are the layers of the past for my family, and these are the stories and images that came to mean Lowell. Lowell could never be *just* a place, because it embodies these stories so that I am barely able to separate place, narrative, and memory. Neither can I separate history. I search for the place where history intersects with the sense of place, narrative, and memory that I have of Lowell, but I am not sure where to find it.

This is the essence of what is called collective memory: memory built within a community of people, stories retold year after year to listeners awaiting each detail, in order to know the past and to make meaning of it. This collective memory, as I know it, is intimately linked to place. Each story is connected to a site in Lowell, and each site brings forth multiple stories of the past. The sites and the stories they embody have remained constant, but as my life has changed I understand them in different ways.

Over time the web of stories I knew expanded, and I came to see other places in Lowell as family landmarks and sites of memory. Downtown Lowell is where the Thom McCann Shoe Store used to be where my father began

his career in the shoe business and where he worked when he first met my mother; the Brighams where my Aunt Doris was a waitress for forty-two years; and the apartment building where as a child my mother remembered the actors and actresses departing for the nearby theater, their faces heavily made-up. The movie theater used to be downtown, where Nana met her friends to see movies and get a free china plate. So was the Woolworth's where my mother worked as a cashier when she was in high school and Kennedy's Butter and Eggs where Nana always shopped. There in front of Kennedy's Butter and Eggs I think of the story that my mother told me about Nana that symbolizes for me loyalty, the politics of doing business, and, once again, the importance of being known in the community of Lowell. It was World War II, many items were rationed, and Nana stood in a long line waiting to buy butter. My mother wanted the butter for Billy, who was only two years old, but the store ran out of butter before Nana entered.

> Every once in a while there would be a sale, and Nana would hear about the sale, and she would get in line. Butter was rationed, and I remember one day she said, "Oh butter, there's a sale on butter." She went off all the way downtown and got in a long, long line. She got into all the lines, anything that was on sale, Nana didn't mind waiting an hour and a half in line. So I went with her one day. We were in line at the Kennedy's Butter and Eggs store. Then the policeman came out and said, "Butter's all gone. Break up the line." So Nana said, "Come on, we'll go in." I said, "No need of going in, the butter's all gone." "Come on, we'll go in anyway." So we went in the store, and she spoke to the girl. The girl knew her because she had always traded in that store. She said to the girl, "I'd like a pound of coffee, a pound of tea." The girl said, "Okay." When we got outside, Nana said, "I got the butter." The regular customers they would take care of.[3]

The clerk had put aside butter for her long-time customers, and she had quietly slipped a pound into Nana's bag. Nana knew she would do this.

As a child my whole knowledge of Lowell was confined to the small area in Centralville between Nana's house on Bridge Street, Bridge Street itself, Dorothy's Bridge Street apartment, and later her house on Seventh Street, not three blocks from her old apartment. There were occasional trips downtown. My mother took us to Lemkins, a fancy dress store, to choose a dress for the holidays, making us feel special and privileged to shop there. Years later the building that once housed Lemkins became my office at the Low-

Bridge Street over the Bridge Street Bridge, showing the apartment where my parents first lived, summer 1996.

ell Historic Preservation Commission. On other days we went together to the Palmer Restaurant. I ate lentil soup there. It was thick and delicious, and I never had it anywhere else. I do not know why those outings have such an emotional hold on me, perhaps because the Palmer was small and slightly dark, and my mother seemed relaxed there. In the 1990s the building burned down. I felt a clutch at my heart, as though the disappearing place, fire to ashes, burned my memory.

Just past the taxi stand where my cousin, Ann, used to work as a dispatcher while she went to Lowell State Teacher's College is the Bridge Street Bridge. Whenever I come to the Bridge Street Bridge, the entrance to Centralville, I know that the memories and memory markers will intensify, physically and emotionally. Just over the bridge all the landmarks of my family's life are juxtaposed in a deep and complex tangle of time and space: the Dunkin Donuts where Mum and Daddy had a cup of coffee together twenty-five years after their divorce; the first apartment they shared together just after they were married; Dorothy's three-room tenement; the Blue Dot Candy Shop; the house where Mum was born, the house Nana was married from, the apartment where Mum lived with Nana and Grandpa while my father served in

World War II, and where Billy waited on the steps for Grandpa to bring him the remains of his lunch.

When my parents separated and my mother moved back to Massachusetts, my relationship with Lowell became stronger. It was around this time that Aunt Dorothy, Uncle Walter, and my four cousins moved from their three-room tenement to a big house some four blocks away, still, of course, in Centralville. Dorothy's new house became the focal point of my family's life. The stories of the past continued, re-creating for me whole scenes with people I now felt close to but had never met. As I grew older I developed my own storehouse of memories triggered for me now by Dorothy's great house. For weeks every summer I stayed at Dorothy's, playing with my cousins and the neighborhood children. We watched television, something my mother never allowed, played Monopoly, and had pillow fights. I collected cans on the streets to recycle and used the money to buy Dorothy a quarter pound of snowflakes from the Blue Dot Candy Shop for her birthday every August.[4]

That house was not only the focal point, but the heart of memory for our huge family. I can still see all the men in our family playing poker and throwing all the pennies on the floor for the kids to gather in the morning. I can see the women in the kitchen drinking coffee and talking. There is the coffee pot, always, always, in the same spot on the kitchen table. There is the metal plant hanger I made for Dorothy after I learned to weld, the signed photo from President John F. Kennedy, the vases Uncle Jack brought home from China—familiar objects in a terrain of memory.[5] There were always projects, like Dorothy and my mother making root beer in their cellars, calling each other to check its progress. Down in the cellar years later I found a forgotten bottle used, I was sure, to make the root beer. There is the styrofoam St. Patrick, the stuffed reindeer, and the wreath made from pinecones. I see these objects as heirlooms, produced by the hands of the women of our family. Inside and out, that house is a powerful site. Everything there stayed the same for me, locked in a sea of changelessness.

Each time I crossed the Bridge Street Bridge and passed my family's landmarks, I was struck by their power to evoke my memory. Not just Lowell, but Centralville, that specific, special place within the city, was where I returned, week after week, year after year. After I finished college I was always living somewhere else, so there was a constant going away and coming back, reseeing places with slightly altered eyes each time. Maybe the going away and coming back intensified the memories so that those places never became

Big Walter at the door of his house on Seventh Street, waiting to welcome us or to say goodbye, June 1981.

just buildings to me. My mother moved a great deal too: from the towns surrounding Lowell (Chelmsford to Bedford) when we were in school, within Bedford, and then to apartments in and around Lowell. For seven years she lived in North Billerica on the road leading out of Lowell, on Old Billerica Road, but Dorothy complained that the twenty minutes it took to get there made it too far away. My mother found an apartment back in Centralville, not five minutes from Dorothy and my Aunt Doris. With each move my mother made, mementos from inside the house were dispersed, small pieces of memory from the past now gone. The "house" meant the one in New Jersey, for it was always that upper middle-class life that was in the process of being dismantled, object by object. I learned to steel myself against the erosion of memorabilia, to try and disconnect objects from emotion, and to define home as my mother and not the place. Yet I was deeply attached to those objects that remained from a life my mother had cherished. The blond mahogany dining-room set went to Dorothy's house, where it remains. The dressers are mine now, as are the Danish modern end tables—not furniture I would have chosen but I cannot let them go. The wheat dishes are mine too—Uncle Jack's gift to my mother for the New Jersey house so many years ago.

The memento shelf in Dorothy's front hall
on Seventh Street, December 1997.

When I became a professional in Lowell, I developed a new relationship
with my memories and the spaces. I was the person who observed and doc-
umented the culture of Lowell, who could enter into any space armed with
tape recorders and cameras. I was supposed to enter spaces I was unfamil-
iar with, I was supposed to ask questions about what things meant, and I was
supposed to be able to articulate insights into the culture of Lowell. After I
began working at the Preservation Commission, downtown became for me
the place where I was the cultural affairs director. Every building in the area
that I once walked in while working at the Preservation Commission has a
memory for me of politics, negotiation, imagination, failure, triumph, or
some combination of them all. In some ways I have several personas in Low-
ell, and there are multiple Lowells for me: I am the person who inhabited the
physical and perhaps more importantly the political space of the downtown,
I am the nonpolitical researcher entering ethnic cultures apart from my own,
and I am the person who crossed the bridge into Centralville, back to the

physical and cultural space of my family. Lowell is the past of my family linked together through my memory and the sites of Centralville. Lowell is my knowledge of "the other" learned through the oral testimonies I collected from more than sixty in-depth interviews with people from many ethnic and religious communities in the city. And Lowell is the professional, historical, and political world of the Lowell National Historical Park and the Lowell Historic Preservation Commission.

I cannot make a chronology of my memory sites in Lowell. Like the terrain of memory, much of the physical place of Lowell is an emotional landscape. St. Michael's Church, once the site of Nana's devotion and Grandpa's unionism, the place of family baptisms and confirmations, and the site of countless family photographs at countless rite-of-passage events, is both a site of family history and a place of profound lived experience. Inside the church there is the indelible image, stronger in my mind's eye than any actual photograph, of the cold January day when my mother, almost stooped, wearing her brown coat, and walking beside her brother, Edward, followed Nana's casket up the main aisle. Almost twenty-five years later I walked beside my sister, Patty, up the same aisle behind my mother's casket.

Ten months after my mother's death I moved away from Lowell. I did not move away because of her death, but because my husband had accepted a position at the University of Texas, although I often wondered if I could have left had she been alive or endured in Lowell without her. In those intervening months, I found myself driving to her apartment, because memory deeply embedded in the body does not easily change. Each store and restaurant brought fresh memories of our shared lives. The landscape was alive with the memory of her absence. Even the landscapes of the living were altered, and I found that my visits to Dorothy's, without Big Walter and my mother, were different in ways I could not understand. Over the course of the next six years Dorothy left the space of my cherished aunt and moved into a more powerful, but less affectionate, quasi-mother role. As she and I changed, so too did my emotional attitude to her house. My new feelings battled with my attachment to the house as the locus of my memories of my childhood and my family's past in Lowell.

Returning to Lowell for the first time after my mother died was different from any of the many returns I had made in the past. Without my mother the notion of the home place was absent, and I felt the deep need for home without having a site of emotional attachment. I realized how much the meaning of place, the connection to family through narrative, and my un-

derstanding of the past were derived from the living presence of my mother. Memory was embodied in the space of my mother as well as in the visions she had created for me of the past, and the associations between memory and place that she had forged. I was afraid to go back, adrift in the question of where did I belong. I now stayed at Dorothy's house, instead of at my mother's. I must have tried to re-create in Dorothy's house a new home place for myself, but the transference was impossible for both of us. The eccentricities of place and people that had once charmed me now haunted me. The first time I stayed at Dorothy's house, I noticed that many of the mechanical things had simply stopped working. Neither Dorothy nor my cousin, Walter, could drive, the rotary phone made it impossible to navigate touch-tone menus, pipes leaked, water seeped through walls, and small courtesies, extended to the visitor, were slowly ebbing away.

I returned again in the fall and the next summer, always hoping we would rediscover our former relationship, where she was the beloved aunt and I the cherished niece. With that hope I went home for Christmas in 1997, this time bringing my children. I violated deeply held rules of how Christmas in Dorothy's nuclear family was done, rules I did not know because I had always spent Christmas day with my mother. I used the wrong dishes. I invited an outsider to dinner. In a moment of anger, Dorothy looked at me and said, "This isn't your home—remember that." When I said goodbye four days later, we cried. I kissed her cheeks, so like Nana's, so like my mother's, and for two seconds I closed my eyes and I imagined I was once again kissing my mother's cheeks. I was saying goodbye to Dorothy, to my mother, and to the idea of Lowell as home. I never saw Dorothy well again. When I next went home, Dorothy had suffered a stroke and was at a nursing home. Three weeks after I visited her there, she died. I never knew what had changed. Without my mother and Big Walter, Dorothy and I could not be the same. Without my mother and the Dorothy of my childhood, neither the present nor my memory of the past was what it had once been.

The next generation, my cousins, have opened their arms to me in welcome. They have tried to create a sense of me being able to come home by opening their home to me. I navigate the landscape in a new way, without clear pathways, but aware that there has been a great change. The sites of memory are still there. Physically they are much the same. But many of the people whose stories made that landscape come alive for me are gone, and I see that the sites are from a time that is receding farther into the past. Nana, my mother, and Dorothy have taken with them not the stories themselves—

for these I know—but the telling of the stories. I try to see the connections between place, memory, and the stories that continue to fill me in the world I now inhabit and to evolve another, different relationship with the physical landscape of Lowell, so dependent on my emotional relationship with the past. I try to understand what part of my family memory is my own and what belongs to Lowell as I slowly try to build a new sense of the city and where I belong in it.

In 1960 cultural geographer Kevin Lynch published *The Image of the City.* Nothing in the city is experienced by itself, he wrote, but in relation to its surrounds and to the memory of past experiences. Every citizen has had long associations with some parts of the city, and these images are soaked in memories and meanings.[6] There is a series of public images of any given city, held by significant numbers of its citizens. These elements are how people navigate the city and they are how people understand the city—both its physical layout and its cultural meaning. It is not just the individual who is connected to spaces in the city. Marc Augé writes that a group's identity is often based on space, and that social relations are inscribed in space. People defend against threats to their space in order to ensure that their language of identity retains a meaning.[7]

The physical landscape of Lowell is alive with the meaning of its history. There in the physical layout is the early emphasis on industrial production.[8] Water is at the core of the identity of the city. It enabled the production of food, transportation, and power. The Merrimack and Concord Rivers are the two great running, curving waterways that drew people to the lands in and around them. The environmental and, in many ways, the industrial heart of the city lies within the Merrimack at the thirty-two-foot drop known as the Pawtucket Falls, which was once a salmon run on land inhabited by Pennacooks and later was the incentive for the Boston Associates to create their textile empire in Lowell. The industrialists built a series of curved and linear canals feeding off of the water from the Merrimack River. They then built mills adjacent to the river and along the canalways, orienting the city around the ability of water to supply power to the mill complexes. The rivers, the canals, and the mill complexes allowed the industrialists to achieve their goal of creating the first fully integrated cotton textile production operation in America.

The physical layout of the city changed over time, much in the way Gerald Danzer described the changing of public parks. In the early era of the

walking city, there were squares, commons, parade grounds, and landings. From the 1850s to the 1890s streetcar cities built large central parks and parkway networks. Between 1890 and 1930 the neighborhood park and citywide park systems emerged at the height of the streetcar cities. The impact of the automobile on parks began to be felt in the 1920s and continued up to the present.[9] Railroad tracks were laid to deliver products in and out of the city, and later streetcar tracks were laid for an internal city transportation system. Housing for workers started appearing near the mills. Initially many dwellings were boardinghouses or multifamily tenements. Single-family houses were compact, built close to one another with small or nonexistent yards. Because people walked or used public transportation, neighborhood streets were often narrow, and few of the houses had driveways. This is still the landscape of Lowell, although it actually describes the economy and culture of an earlier era. It is, in the words of Peirce Lewis, a "pre-leap" landscape. In describing his axioms for reading the landscape, Lewis noted the corollary of historic lumpiness: most major cultural change occurs in great, sudden historic leaps, and after these leaps the landscape is likely to look very different than it did before. There will, however, be a lot of pre-leap landscape left lying around, even though its reason for being has disappeared.[10]

A major social and economic change began in Lowell in 1926 that left an indelible impact on the land and people, creating the pre-leap landscape of today.

> Then in 1926 came a wave of [mill] closings. The Hamilton Company went into receivership, followed by Suffolk, Trement, and Massachusetts Mills. The Appleton Company moved production to the South, and operations at the Saco-Lowell Shop (formerly the Lowell Machine Shop) shifted north to Maine. By the mid-1930s, of Lowell's first large mills, only the Merrimack, Lawrence, and Boott were still in operation.
>
> The Depression came early to Lowell and stayed. By 1936 total textile employment had dropped to 8,000, only slightly more than it had been a century earlier. Many mills stood empty; others housed a number of small manufacturing firms. Entire mill complexes were demolished, or sections lopped off, to reduce taxes. Parts of Lowell looked like a war-ravaged city.[11]

The city had begun the process of deindustrialization long before the phenomena had a name. Its economy was transformed from textile production and related industries to something more difficult to define. For many years

no new thriving industrial or other economic structure replaced textile man-
ufacturing. The pre-leap landscape of empty and abandoned mill buildings
dominated the city. Just as no one quite knew what to do with the economy,
no one quite knew what to do with the huge empty mill complexes. Discount
stores occupied some buildings, and smaller production companies occu-
pied parts of other mills, but most remained empty. Over time, even the
stores that occupied the mills closed.

A new language developed around the pre-leap landscape. Ordinary
speech became a memory of past places. People gave directions by where
things used to be. "You go down by where the Giant Store used to be and
take a left way up past where the Greek tailor used to be." "You go all the way
up Merrimack Street, way past where the Brighams used to be, and just be-
fore you get to where the Bon Marché used to be you take a left and go by
where the Palmer Restaurant used to be and you'll see the Roy Garage." "It's
just up Plain Street past where the Sears used to be." As the city had a history
of having street signs taken down and consequently few streets were identi-
fied by name, landmarks, and especially former landmarks, became the iden-
tifying marks when giving directions. Only people with a long memory of
Lowell could easily follow these directions, but even outsiders learned
enough key landmarks in the pre-leap landscape in order to get around the
city.[12]

Finally, many Lowellians wanted to destroy the huge hulks of abandoned
brick. They wanted to fill up the canals that had become refuse dumps. The
physical remains of the textile era had come to symbolize the failed prom-
ises of industrialization. By removing them from the city, so too would the
people remove the painful memories of their depressed industrial past.

A surprising thing happened in the early 1960s when a city debate erupted
over the fate of a row of boardinghouses known as the Dutton Street Row
Houses. Although it later reversed its position, the *Lowell Sun* supported
demolition, stirring up a feeling of "working-class revenge," which pitted
working-class city residents and officials against elite preservationist groups
who wanted to preserve a glorified look at the paternalistic era of Lowell's
history. "The newspaper joined a prominent city councilor in arguing that
the row houses were 'a part of our history that should be forgotten.' "[13] Res-
idents were also concerned about federal intervention in local affairs and the
displacement of the poor and elderly resulting from urban renewal. By Au-
gust 1966 the row houses were gone, as was the adjacent Franco American
neighborhood of Little Canada. But the controversy "laid the groundwork

for future preservation efforts" by making a distinction between historic preservation and the urban renewal that had caused so much local pain. At the same time, it showed that locals could work with federal interests to the benefit of the community and demonstrated that an uncritical view of the Lowell past could, and would, be opposed. Once locals were convinced that there would not be a whitewashing of the harsh conditions of industrial capitalism by outsider historians, the idea began to take root that the history of the city could be presented to the public, in both its successes and its price in human suffering. When Lowell residents testified in Congress in support of the creation of the Lowell National Historical Park, they spoke of the need to memorialize the immigrant worker along with the famous and the firsts of Lowell.[14] They hoped that the landscape would not be used a second time to foreground the benefits of industrialization.

With the advent of the Lowell Heritage State Park, the Lowell National Historical Park, and the Lowell Historic Preservation Commission in the 1970s, the landscape of Lowell changed once again. The complicated challenge was how to transform the nineteenth-century landscape, which was based on maximizing production, to the twentieth-century idea of maximizing consumption, including the consumption of history. The answer, in the end, was the conversion of the inside of everything into something new and the outside of everything into something old. Rather than creating new buildings, the federal agencies began to peel away layers of time to reveal the buildings' nineteenth-century facades. The abandoned mill buildings were reconstructed and new uses were found for them, like apartments for the elderly and for families, art galleries, offices, restaurants, and even television stations. In a strange twist on the postindustrial landscape, the new buildings that were added to the landscape were built to resemble the nineteenth-century mills to create a harmony of style throughout the downtown.[15] Lowellians experienced a sense of relief at the polished, renovated look of the downtown, while always remaining wary of any effort to erase their local culture by elite or outsider historians and preservationists.

Historic preservation became a physical memory of industrialization in Lowell. Individual places in the Lowell landscape became sites to describe historical events with historical summaries narrated at the canalways, mill complexes, and boardinghouses. Structures once on the verge of demolition became of national historical significance, both because of their physical integrity and because they served as a vehicle to tell the story of the American industrial age. At one point historic preservationists had to argue for the

preservation of the city's smokestacks. How, they claimed, could the city tell the story of American industrialization without the very icon of the industrial age, the smokestack? The smokestacks were in great disrepair, and it would cost nearly $60,000 per smokestack to fix them. This was a dilemma in the city, pitting the practicality of the residents against their wishes to preserve their history. How could one spend $60,000 on a nonfunctional smokestack? Yet how could one allow them to crumble into ruins?[16] The pre-leap structures that had seemed to so scar the landscape became symbols of the industrial past and were needed to tell a story that was now worth telling.

While the National Park was busy preserving abandoned mill buildings as sites of history, the people of Lowell were quietly creating small significant sites of memory and history throughout the city. They placed upon the landscape pieces of granite and bronze—elements that signify permanence or at least duration, and imply the strength of memory over time. Yet these stone and metal forms may also imply the diminution of memory and power, because monuments are moved and changed. The siting of a monument and changes to the site are keys to the meaning of the monument. The relationship of a monument to its place is expressive of ideas about the changing status of memory, the marking and sometimes the mourning of territory, and the cleansing of violence. Some monuments are created in neighborhoods to express communal grief over the premature loss of one of the community, but they also express the ethnic identity of the place. Monuments are used throughout the city to define ethnic neighborhoods, with some groups competing over the same space. Sometimes it is the memory of the lost neighborhood that is marked with a monument, but it is always the territory of the ethnic neighborhood that is marked. For some groups, the lack of an extant monument in a specific site reveals much about their lack of access to power. Unable to mark their own ethnic space, others mark space describing their visions of what made the group worth remembering.

Most monuments are placed in areas that are difficult to access, begging the question of who are they for and why are they erected? Many are placed not in a site where an event occurred, but based on the association that the living have about the dead, so that the location of the monument continues to evoke the memory of the deceased. The monuments of remembrance for those violently killed are not placed on the site of violence, but on the sites associated with the deceased. They work to cleanse the memory of the violent death.

A change in the location of the monument reveals changes in the memory, status, or power of a person or group. A monument may be moved from an obscure location to one of great prominence, or the reverse may occur; a monument may be relocated from the space of a small group to a larger but depersonalized space. There is such a demand for space to be named and marked with a monument that a great confusion results in the marking and remarking of space over time.

Almost every public park in the city and most of the schoolyards have one or more monuments. The monuments are typically located along the periphery of the parks, in corners facing outward, adjacent to a parking lot or along a major axis in the park, even if the axis has long since lost its importance. Secondary or subspaces within the park, such as baseball diamonds, often also have monuments or plaques and will also be marked along the edge. Newer monuments in small parks may be placed more centrally, with a small path leading up to and encircling it. Asked why the monuments were placed in neighborhood parks or schoolyards, family members respond by saying it is because that is where the person went to school, played ball, or spent a lot of time.

While the naming of space has always been important in Lowell, since the 1980s there has been a dramatic increase in the interest in naming a space and marking that space with a monument. There are more names waiting to be memorialized than there is available space. This has led to the subdivision and renaming of spaces in order to accommodate all the names. The naming of smaller and smaller spaces within larger named spaces, and the renaming of spaces is confusing, especially when people continue to refer to the space by the older, known names. Most of the public parks in Lowell are named, and most have a monument carrying that name. Later sections of the park, such as baseball diamonds, are named for someone else and marked by monuments, and corners of the larger park are named as memorial areas, again with monuments. Thus the generational memory of places in Lowell is experiencing a series of fractures as the demand for the dedication of space increases.

Tom Bellegarde, commissioner of parks, recreation, and cemeteries in Lowell, explained the modern fascination with naming and the confusion it sometimes causes.

> We started with naming parks, and then when we started running a little short on parks, we started going with things that we were building. It might have

been either new or fairly new, such as a playground. We have named playgrounds, we have named basketball courts, we have named tennis courts, we have named islands, circles, and squares. It is kind of difficult because we do have seventy parks in the city. In some of these parks, there might be four different people that have tied into them in some fashion. Bailey School is a brand new school that was dedicated after Gertrude Bailey. There are baseball and softball fields in the area, and the park next to the Bailey School, we used to call Dailey Park, because you had the Dailey School, the Bailey School and we called it the Dailey Park. The people in the neighborhood called it Highland Park, and now because of the fact that we spent ten years and we have dedicated several things over there, you got the Bailey School, which is dedicated after Gertrude Bailey, you got the Dailey School that was dedicated back in the 1950s after a principal at that school, you got Loucraft Field, which is named after someone that served as one of the founding coaches in the [Little] League, you have the Lacosta Field, and then you have the Fowler Complex, which was named after [a man] that officiated the [baseball] games for twenty-five years. That is one little park area, and there are five names attached to it.

Stratham Park, which is on Stratham Street for one hundred years, will always be known as Stratham Park to [the old timers]. However, we have named it Donohue Park. It becomes very confusing sometimes. Donohue was a war veteran and we rededicated it. You have Little Leaguers that are now adults that always knew it as Stratham. It is one of those habits that are hard to break. The new generation calls it Donohue, but that is where the glitch is. You got people asking for permits to these fields and depending on where they are on the timeline, they are asking for three or four different names to the same field. It makes for an interesting operation here.[17]

One of the great anomalies of the local monuments is how numerous they are and yet how invisible. No one seems to notice them. I asked people if there were any monuments in Lowell, and they cited the most obvious—the Ladd and Whitney in the center of the city and *The Worker* statue on Market Street. Most were surprised when I told them that there are more than 250 monuments in Lowell. Many of the monuments are located in sites that are difficult to access. One does not normally stumble upon them in daily life. It takes a small amount of effort to go to them, and then it takes yet another effort to stoop and read the inscriptions. Some monuments are more present and absent than others. The Rourke Bridge Plaque on the Rourke

Bridge is visible to every car that passes over its busy span, yet none can stop to read the text, dates, or names on the bronze plaque.[18] The Elmer Rynne Monument is located on a little-used road behind the tennis courts in Shedd Park, at an angle facing away from the courts. Absent curiosity, few would normally come upon the monument.[19] Perhaps the monuments are located apart from principle areas so that they are not easily accessible or so that they do not become overly familiar objects on the landscape, but require commitment, interest, and even devotion in order to interact with them.[20]

Most of the waysides, the bronze and stone plaques that synopsize some aspect of the historical past, are site specific. Their text and images refer to an event, historical epoch, person, or building that was associated with that particular place. The Middlesex Canal Wayside begins with the words "Middlesex Canal / 1793–1853 / At this location canal boats pulled by horses car- / ried freight and passengers between Boston and the / Merrimack River at Lowell before the days of railroads."[21] The wayside is located along the route of the canal it describes. A second wayside, Birth of an Industrial City, describes the site where the Merrimack, the largest of Lowell's mill complexes, once stood.[22]

Most of the monuments are not concerned with specific sites—nothing of note happened at that place, and the deceased may never have set foot there. Some appear almost arbitrarily placed: the Lucy Ann Hill Monument was placed in Lucy Larcom Park not because Hill had an association with the park but likely because the park was also named for a woman; the trees in the South Common marked with a small granite monument dedicated to the men and women who served in the Persian Gulf had no inherent connection with those soldiers or with the people in the Persian Gulf.[23] Other monuments have a tangential relationship to their place. Raymond and Timothy Rourke were both politicians active in securing funds for transportation in Lowell; Elmer Rynne was a tennis champion and ran a sporting goods store. The location of these monuments was based on the associations the living have about the deceased and the memories that they evoke. They are located near the places where the person was once known, or the places are associated with the things he or she once did.

Perhaps the monuments are ultimately not meant to be read, but only to be noticed as symbols of general valor. Fleeting glimpses of the stone or plaque can be had, but the specifics remain unknown. When I asked children in neighborhood public parks if they knew there was a monument in their park, they all said, "Yes." When I asked who the monument was dedi-

The William T. "Billy" Callery Monument at the corner of B and Stevens Streets, May 1999.

cated to, they did not know. When I asked if they would mind if the monument was removed, they were adamant that the monument should remain. The monuments had become for them symbols of good deeds and of important, even if undefined, service to the community, and they did not want that recognition disturbed.[24]

The monuments in the public parks represent localized and individualized expressions of ethnicity, power, and loss. They appear at thresholds to the neighborhoods, aligning themselves along boundary lines between sections of the city. In the Highlands section of Lowell, the park once known as Highland Park is now called Callery Park after the second Lowell boy to be killed in Vietnam. He died on February 22, 1966, on Washington's birthday. A Lowell attorney, Louis Saab, who had known Billy Callery and lived in the neighborhood, was moved by the young man's death and organized the dedication of a monument, together with the Veterans of Foreign Wars. It was dedicated in the summer of 1966 at a huge ceremony. Governor John Volpe flew in by helicopter for the dedication, and the mayor of Lowell and other dignitaries attended. The monument is located in a corner of the park in the area once known as the "beauty spot."[25] Callery's sister, Sheila, goes to the cemetery to remember her brother, and whenever there is a new child in the

family they bring the child to the park to tell them the story of Billy, "to bring them up."[26] Surrounded by a wrought-iron-looking fence and several small bushes, the inscription honors William T. Callery and all veterans from the Highlands neighborhood who served their country.[27]

At the opposite corner of the park, on a diagonal axis with the William T. Callery Monument, is another stone monument. It is dedicated to Daniel W. Newell Sr. for "his many years of love and devotion to the children of Lowell."[28] It is facing outward, with its back to the playground. Like the Callery monument, the Newell monument is made of granite and surrounded by a fence, bushes, and mulch. Newell "died unexpectedly" at his home on June 28, 1985.[29] Bill Kelley, secretary to the mayor, remembered Danny Newell as having lived in the Highlands and as being "big in helping youth programs in Lowell, Little League, up at Callery Park."[30]

The three baseball diamonds in the park are also marked with plaques high on the fences near each of the home plates. The first plaque was dedicated to John L. Zabbo, who died of leukemia at the age of ten on April 26, 1971. Zabbo grew up in the Highlands and was just starting to get active in baseball. He was the first person to be commemorated on a plaque in the newly created baseball fields. He had never played ball in those fields, and the family does not go there to remember him. For about ten years after his death there was "some sort of public commemoration there" when everyone still remembered him, but now no one knows who John Zabbo is or was. While his brother remarked, "He's just a plaque on a backstop," children in the neighborhood identify the field with the Zabbo name.[31] A second plaque was dedicated to Donald Conroy, who died of an illness at the age of forty-two on August 26, 1973.[32] His wife felt he was commemorated because "He did so much for the children. He put in quite a few years with the children. He helped them all." The plaque was organized by a group of coaches, mostly Irish. Mrs. Conroy often goes by the plaque, and it has great significance for her.[33] The Conroy plaque was dedicated in 1974, at the same time as a plaque to another coach, John J. Barrett. Barrett died unexpectedly in April 1973 at the age of thirty-nine. He had served as the treasurer of the Callery Park Baseball Little League.[34]

In the schoolyard just across the street are two more monuments, both to children who attended the school. One is along a walkway, and the other is in a corner of the park facing inward toward the school. One remembers Ryan McMahon, who died of cancer, and the second is dedicated to Sean Cullen, who drowned.[35]

Some local people remember Billy Callery. He used to play in the park, went to school and played ball with people from the neighborhood. Others remember that he was killed in Vietnam. The younger ball players no longer remember Billy Callery, but they know that the park is named Callery and that each of the baseball diamonds in the park is named for some other local person. They do not know that one of the baseball fields is named for a ten-year-old boy who died of leukemia. But they know that the park has a name, and the name means someone cared about that park or that it is dedicated to someone who "must have done something good."[36]

Many of the neighborhood monuments, while ostensibly representing war, athletes, or service to youth, can be read as marking the ethnic neighborhood. The people remembered by the monuments were from that neighborhood, although who they are and what they did may be forgotten over time. The ethnic names on the monuments identify the area as Irish, Greek, or Portuguese. Callery Park is located in St. Margaret's Parish, in the Highlands, and much of the immediate neighborhood is Irish. The stones are as much about marking the Irish ethnicity of the neighborhood, and a sense of belonging and being insiders, as they are about any individual person.

While none of the monuments to baseball heroes, coaches, civil servants, and politicians in St. Louis Park mention ethnicity, they are dedicated to Franco Americans. St. Louis Park is in a Franco American neighborhood, once part of Little Canada. The four monuments in the park are dedicated to Harry Allen, an outstanding softball pitcher,[37] Henry LeClair, who once worked for the Lowell Parks Department,[38] Albert Cote, who was a coach in the St. Louis field for many years,[39] and Gus Coutu, who was a former city councilor and died suddenly of a heart attack.[40] Once again the monuments mark the area as ethnic.

The John E. Sheehy Monument on the border of the Merrimack River is another of the Irish monuments in Lowell. John Sheehy died at the age of forty-nine in 1974. A life-long resident of Lowell, he was a prisoner of war in Germany in World War II, and later worked as the mayor's secretary and in the assessor's office in city hall. Mayor Leo Farley (the same person who was mayor when the Irish immigrants' monument was created) made a motion to create a monument to Sheehy, and a year after his death the newly restored park along the Merrimack River was renamed Sheehy Park. A heart-shaped monument was dedicated in the park in 1975. Paul Sheehy, John's brother, is himself named on one of the University of Massachusetts at Lowell buildings. Paul Sheehy helped to secure funding for the riverside park and

fondly remembers that area, for it was there that as children he and his brother played football and baseball, swam, and played in the fields. He said, "That was our neighborhood."[41] While the monument has personal significance for the Sheehy family, it also highlights the area as being important to the Irish.

Monuments to priests are located throughout the ethnic neighborhoods. French, Irish, Portuguese, and Polish priests are marked, although more monuments are dedicated to Irish priests than to the priests from any other ethnic group. Six public monuments commemorate Irish Catholic priests.[42] The first of the Irish Catholic monuments to priests is the Cardinal O'Connell Monument erected in 1918 on the border of the Acre. The most recent monuments are two plaques remembering the early pastors of St. Peter's Church, the second Irish Catholic church in Lowell. Once located inside the church, they were moved to the sidewalk after the much-contested demolition of the church. Now they stand as public monuments not only to these Irish priests, but also to the former Irish neighborhood that once surrounded the church.[43]

The larger than life statue of Father Andre Garin was dedicated in 1896, the year after his death. It is located in what was once Little Canada, outside the St. Jean Baptiste Church.[44] After his death a monument was dedicated in the Franco American neighborhood of Pawtucketville to the Rev. Roland R. Bourgeois, for his "devotion to youth." In the 1990s, in the Portuguese section of Lowell, a monument was erected to Father Joseph T. Grillo, the long-time pastor of St. Anthony's Portuguese Church. Two monuments were erected to Polish priests, describing the split between Polish Roman Catholics and Polish National Catholics. A monument outside the Polish National Catholic Church was erected to Father Franciszek Hodur, the organizer of the church, in 1954. In 1998 a plaque was placed on the Holy Trinity Polish church center, located in the middle of the Lowell Polish neighborhood, to Msgr. Alexander Ogonowski, the pastor of the church for fifty-one years.[45]

Unlike the more generalized monuments to ethnicity surrounding city hall, the neighborhood monuments remember specific men and boys who were part of the lived memory of that Lowell neighborhood or ethnic group. Over time, as the memory of the named man fades, these monuments become less and less personal and individualized, and they represent valor and service to the community. They also represent the borders of the ethnic neighborhood. The importance of the siting of a monument is clear when

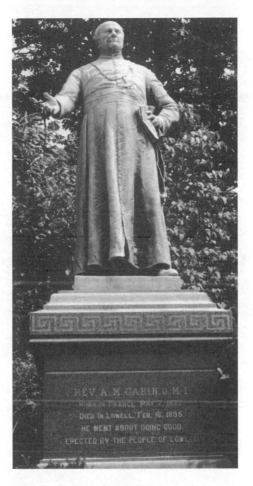

Rev. Andre Garin Statue, Merrimack Street,
August 1996.

I imagine erecting a monument to an Irish Lowellian in a Franco American
neighborhood, or doing the same to a Greek in an Irish section of the city.
A monument to someone from outside the neighborhood and from outside
the ethnic group cannot easily occupy another's ethnic space.

Several of the monuments mourn a loss of place, when two ethnic commu-
nities were cut apart to create housing projects adjacent to the downtown.
Older residents still lament the 1930s' loss of the Greek community that once
existed in the Acre, just as Franco Americans mourn the 1960s' destruction

Father Grillo Park and a close-up
of the monument, Back Central
Street, July 1997.

of Little Canada. The Greek tenements were razed to create one of the nation's first urban housing units under the Works Progress Administration (WPA). Parts of Little Canada also became public housing. Although outside observers had, at various times, described housing in both communities as substandard, residents mourned the loss of the sense of community they had once experienced in the tenements.[46] The reaction of both ethnic groups reveals the sustained grief for places that cease to exist and the emotional consequences that result when bonds between people and places are broken.[47]

The Little Canada Monument is located on the outskirts of the downtown, just beside the ruins of former mills on the border of what was once Little Canada. It is on private property surrounded by a fence and evergreen bushes. The monument itself is a stone from one of the last blocks of apartment houses to be torn down in the Franco American neighborhood. The language of dedication written on the stone links place and a people, specifically articulating the lost streets. "On this site grew the heart of the / Franco-American community. Hard working French Canadians came to fill the mills of Lowell and build a tradition of faith, generosity, and pride. This stone comes from one of the last blocks of large wooden apartment houses to be torn down." The monument then lists the streets of Little Canada.[48] This last stone has come to stand for the place, Little Canada, "the heart of the Franco-American community" and in turn for the collective memory of its residents. The monument represents a nation within a nation—French-speaking Canadians who helped to build America through their hard work in the mills of Lowell. It is sited on the border of the former Franco American community so that the place of the monument and the memory of the community it represents are one.

The Acre neighborhood has served as the point of entry for nearly all of the ethnic groups to settle in Lowell and remains symbolically important to many of these communities. The Acre received its name when Yankee mill owners designated an undesirable acre of land as the settlement area for the Irish men they had brought to Lowell to dig the canals. The Irish inhabited the area for decades, building St. Patrick's Church in what is considered the heart of the Acre. As time passed many of the Irish moved to other sections of the city. In the 1880s Greek immigrants settled the Acre and built the first Greek church in Lowell, the Holy Trinity Greek Orthodox Church. The two churches stand just across from each other, on either side of the Western

The Little Canada Monument, Aiken Street,
July 1996.

Canal. The Greeks remained in the Acre through the 1930s when the WPA
housing project displaced their community.

 While there are no monuments specific to the former Greek community
in the Acre, the two major Greek monuments, one to Greek immigrants and
the other to Greek veterans, are located at the two borders of that commu-
nity where the housing project replaced the Greek tenements. The Irish Im-
migrants Monument and the Irish Cardinal O'Connell Monument are also
located on the border of the Acre. Unlike the Greek monuments, the two
Irish monuments face city hall, a long-time seat of Irish political power. The
Early Greek Immigrants Monument, also located on Cardinal O'Connell
Parkway, faces away from the Irish monuments and away from city hall. The
duel between Greek and Irish monuments in the Acre continues in the North
Common, the large public park in the Acre. In the center of the North Com-
mon is a granite boulder dedicated to the Irish Carney family, while on the

The Cardinal O'Connell Parkway, showing the location of the Cardinal, and the Irish and Greek monuments on either end of the parkway, Dummer Street, April 1992.

periphery of the park are two monuments dedicated to Greek American soldiers.[49]

The Worker is at another boundary line between the Acre and the downtown historic district. It is located in a plaza area used to orient tour groups in the Lowell National Historical Park. The monument depicts a bronze man in work clothes, using a huge iron bar to move granite canal stones. It is a fountain and includes a text panel that describes laborers walking to Lowell from Charlestown, Massachusetts, and the hard labor they endured digging the city's canals.[50] The fountain "celebrates workers and their contribution to industrial and human heritage."[51] It is, however, well known locally that the men who came to Lowell from Charlestown to dig the canals were Irish,[52] and the monument, which never actually mentions the Irish, is considered by some to be one of Lowell's most important Irish monuments.

The Acre remains tremendously important in the imaginations of the Greek and Irish communities, because it marks a time when the tightly knit ethnic enclave meant shared space as well as shared tradition.[53] The two groups competed not only over the literal space of the Acre, but over the ownership of who most powerfully inhabited that space in the later narratives of immigration to Lowell. This rivalry was made concrete through the

placement of monuments on opposing sides of the Cardinal O'Connell Parkway, with their backs to each other. Their placement mirrors the locations of the Greek and Irish churches in the Acre and the monuments in the North Common, and re-creates the sense of contested terrain as both groups symbolically lay claim to the memory of the Acre as the American homeland.[54]

Both space and memory are politicized in different ways at different times. Most monuments to the deceased are dedicated within one or two years after death. When there is a long delay between date of death and date of dedication, it may mean that the creation and location of the monument may be about more than commemorating the deceased. In 1998 a monument was dedicated to a Vietnam War veteran in the Back Central Street Portuguese neighborhood. The inspiration for this monument was markedly different from other Vietnam War monuments in Lowell. Walter LeMieux, whose mother was Portuguese, grew up on Mill Street in the Back Central Street neighborhood. His father died when he was eleven, and he assumed many household responsibilities. When he was nineteen, he was drafted into the army and sent to Vietnam, where he died on March 9, 1967, three months before his tour of duty was to end. On November 11, 1987, his mother, together with Representative Chester Atkins, laid a wreath at the newly dedicated LeMieux Square sign at the foot of Mill Street. Some seventy-five people attended the dedication, including politicians, family members, and VFW members.

In the 1990s neighbors became concerned about an abandoned house on Mill Street. It had become a code violation, and street people were going into the house and lighting fires. The house was torn down, and the lot remained empty for three years. The adjacent neighbor, Joe Camara, wanted to make the lot into a park, but knew he needed to give the city a reason to create a park there. When he looked up and saw the LeMieux Square sign at the foot of the street, "I said to myself, 'That's the answer.' " He spoke to the family about naming a new park for LeMieux and they agreed. Working with the Back Central Neighborhood Association, he went to the city to have the park created, with a monument, to Walter LeMieux. The dedication of the park took place on September 27, 1998. It included speeches, the raising of the American, POW, and Portuguese flags, the playing of the American and Portuguese national anthems, a twenty-one-gun salute by the VFW, and the playing of Taps by the Portuguese band. Because LeMieux's mother died on the anniversary of her son's death in 1991, his sisters, brother, and niece represented the family.[55]

The early Vietnam War monuments were dedicated in the 1960s, shortly after the soldiers' deaths. In the case of the Vietnam War Monument dedicated in 1998, a space was identified and a neighborhood veteran was used to create the political will needed to transform the space from an empty lot to a park. The memory of LeMieux, while honored by the monument and the small park, was also an important tool in the neighborhood beautification program.

Not everyone in Lowell has the same access to space and power. There is a strong sense of ethnic absence on the landscape. Apart from a temporary planter in a small park, there are no monuments or public sites of memory to anyone from Vietnam, Puerto Rico, the Dominican Republic, or Colombia. While there are some squares named for Jewish Lowellians, there are no monuments recognizing their contributions to the city, nor are there any indications of Lithuanians in Lowell. There is also a conspicuous absence of monuments to Cambodians, despite the fact that, between 1980 and 1990 Cambodians came to represent 25 percent of the population in Lowell. Yet forms on the landscape not identified as monuments act as reminders of the presence of these ethnic others, like the pagoda that dominates the Cambodian "mall," the small Cambodian grocery stores, the bodegas selling candles and statues to Spanish speakers, and signs and school literature printed in Khmer, Spanish, Vietnamese, and English.

There is only one monument to an African American, despite the fact that there is a small African American population in Lowell. The Julian D. Steele Monument is located in front of a public housing project, although it is impossible to know from the text on the stone that Steele is African American. One of the opportunities to mark the importance of African Americans to the nation would have been in the form of Civil War monuments. There are only two existant monuments identified as dedicated to the Civil War (the Ladd and Whitney, 1865, and the *Winged Victory,* 1967), and both are silent on the major issues of the Civil War. The Lincoln Monument, erected in Lowell in 1909, may be read as a third Civil War monument.[56] This was a time when many monuments to the Civil War were erected, coming as the last of the Civil War veterans were dying.[57] Paid for by the "pennies of school children," the Lowell Lincoln Monument was also dedicated by children. News reports of the dedication highlighted the presence of an African American child, who symbolized all of the enslaved peoples granted liberty through Lincoln's Emancipation Proclamation.[58] While the monument ostensibly commemorates Abraham Lincoln, it can be read as asserting the

The Lincoln Monument at the intersection
of Lincoln and Chelmsford Streets, July 1997.

unity of the nation and as reaffirming a moral victory: "With Malice Toward
None / With Charity for All / With Firmness in the Right / As God Gives Us
to See the Right / Let Us Strive on to Finish / The Work we are in."[59] The
words "Let us Strive on to Finish the Work we are in" seem to echo the Get-
tysburg Address: "It is for us the living, rather, to be dedicated here to the
unfinished work which they who fought here have thus far so nobly ad-
vanced." This can be read as a commitment to the ideals of unifying the
American nation or as standing firm on the emancipation of enslaved peo-
ples. Nowhere, however, are there images of African Americans or explicit
text referencing emancipation.

It is not surprising that African Americans are absent from the Lowell
monuments most closely associated with the Civil War and the emancipa-
tion of enslaved peoples. It was not until the 1870s that African Americans
began to appear on major public monuments in the United States, because
public sculpture itself failed to be emancipated. Emancipation came to be
inscribed not on the bodies of African Americans but on the body of Abra-
ham Lincoln.[60] In the competition for the right to speak in public space, the
work of African Americans in building America and in building a sense of

community in cities such as Lowell has not found expression in the form of monuments.

Unlike monuments to other ethnic groups in Lowell, which were created and sited by the groups themselves, the monuments to Native Americans were put up by others. There are a total of six monuments to Native Americans in Lowell, and two more just outside the boundary line.[61] The major entryways in the southeastern part of the city are marked with Native American monuments, as is the most northwestern entry point, with the remaining monument located next to the environmental heart of the city—Pawtucket Falls.[62] They mark the sites where Native Americans were converted to Christianity.

In addition to the monuments, many places in Lowell are named for Native Americans.[63] Native American names in the Lowell area derive from people who were part of the Pennacook Confederacy, and they include the Wamesit and Pawtucket. The Wamesit lived at the point of land between the Concord and Merrimack Rivers; the Pawtucket lived across the Merrimack along the falls that bear their name.[64] Lowell's earliest place name was Wamesit, one of seven "Praying Villages" or Christian Indian towns.[65] Two streets today carry the name of Wamesit, and the falls on the Concord River were once known as the Wamesit Falls.[66] The Pawtucket Falls was an important gathering place for the Pennacooks.[67] The word *Pawtucket* is said to mean falling water.[68] Several streets in Lowell bear the name of Pawtucket, as does the Pawtucket Canal and one section of the city, Pawtucketville, which combines references to Native Americans and Franco Americans. Most of the street names that bear witness to the Native American presence in Lowell no longer convey particular meanings apart from their Native Americaness: Agawam, Chippewa, Monadnock, Ottawa, Pentucket, Shawmut, and Wachusett.[69] There is a disassociation between the places named for Native Americans and the memory of the actual people who once fished the rivers or walked the land. While both the river and the principal street in Lowell carry the name Merrimack, as did the first mill complex and the valley where Lowell is located, few have a clear sense of how these named places and the people who once spoke the name are connected. Some say *Merrimack* is a Native American word for sturgeon; others claim it means swift rapids, or deep river, or strong place. Poet Paul Marion entitled his book of Lowell poems *Strong Place* in reference to the translation of the word Merrimack as strong place and the idea of Lowell as a place of strength.[70]

There are two monuments to Passaconaway, the leader of the Pennacook

The Passaconaway Monument in Edson
Cemetery, 1997. Courtesy Jim Higgins.

Confederacy in Lowell. The first of these, dedicated in 1899, is a large statue.
It refers to him as a great warrior, who was both a friend of the white man
and who embraced Christianity.[71] The statue is located inside the gates of
Edson Cemetery, although Passaconaway's remains are not interred there.
The Daughters of the American Revolution placed a bronze plaque on a rock
to honor Passaconaway on June 11, 1935, near the Pawtucket Falls. The plaque
honors Passaconaway for accepting Christianity under the preaching of John
Eliot near the spot in 1648.[72] While there are no monuments to Pas-
saconaway's son and successor, Wannalancit,[73] one street bears his name.
Sometime in the 1960s or 1970s the Suffolk Mill was renamed Wannalancit,
perhaps by its then owner, Ted Larter.[74] In the 1930s a cast-iron wayside was
erected in front of the church where John Eliot preached to the Pennacooks
and Wamesits, and established a village of "Christian Indians." The wayside
was part of a series created by the Massachusetts Bay Tercentenary Com-
mission.[75] In the 1930s the Daughters of the American Revolution created a

plaque near a large tree. The Pow-Wow Oak was reputed to be the site of peace conferences and councils of war. The plaque gives equal time to describing the tree as having witnessed American soldiers marching off to fight in the Revolutionary War.[76]

In other areas of the United States, Native Americans have had more success at recasting the meanings of the sites that have already been memorialized. New memorials were authorized at Little Bighorn and Wounded Knee, for example, granting both sides an "equal honor."[77] There are sites in Lowell assumed to be associated with Native American dwellings or religious ceremonies, but they have not been marked. No recasting of the existent markers, located in sites of importance to the Anglo vision of the Pennacooks, has been attempted in Lowell.[78]

Many of the Lowell monuments are connected in some way with violence. They serve as public spaces to mark and lament loss. Not one of these monuments articulates a connection with violence, although each is a result of some kind of violent act. In writing about how Americans mark sites of violence, Ken Foote noted the strong connection between sites and tragedy. "Reading" these sites offers insights into the ways in which societies come to terms with violence and tragedy.[79] We remember where we were when traumatic events happened. People remember where they were standing when they first heard of the assassination of President Kennedy, for example, or the September 11 attacks on the World Trade Center towers, although that place had nothing to do with the event, but rather was connected to our first knowing of it. The new genre of ephemeral monuments that is evolving in the United States in response to acts of random violence—spontaneous outpourings of letters, flowers, personal objects, teddy bears, and jewelry—strive to cleanse the site where the violent act took place. None of the monuments associated with violence in Lowell cleanse a site where actual violence has occurred. Instead they act to cleanse the memory of violent acts by marking the site where the deceased once worked, played, or went to school.

The war monuments do not mark sites where death took place—Germany, France, Japan, Korea, and Vietnam—but where the living once walked, played, or passed. Each war was commemorated differently in the Lowell monuments. This is a result, in part, of how that war was received and evaluated by the nation; the memorial traditions observed at the time of the war and in the years following it; and the ways in which controversial wars were later negotiated and marked on the landscape.

The Pow-Wow Oak and a close-up
of the wayside, Clark Street,
May 1999.

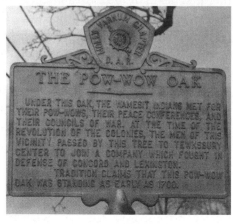

In the 1920s and 1930s the city erected nine monuments to World War I soldiers. They were dedicated to individual soldiers or to groups of soldiers from a neighborhood. They listed the names of the deceased and were located in neighborhoods. The World War II monuments, erected in the 1950s just after the war, and again in the 1980s and 1990s when WWII veterans were beginning to die, were not dedicated to individual men but to ethnic and neighborhood soldiers: "Dedicated in Memory of Polish Americans / Who Served in all Wars," for example. Half of them list the names of the deceased. Again they were located in the neighborhoods. Four of the six Vietnam War monuments were created between 1965 and 1967, and were dedicated to individual soldiers in large neighborhood parks or downtown. Two large monument complexes to all wars and to all Lowell soldiers were created in the 1980s and 1990s. In one, a stone text singles out the tragedy of one Lowell soldier's death: he was a prisoner of war in Hiroshima, Japan, the day the atomic bomb was dropped.[80]

Two monuments erected in the 1990s lament the loss of life to violence. Both monuments were specifically dedicated to peace, and both were inspired by great acts of violence in the community. On June 14, 1996, city and school officials dedicated a monument to peace in a Lowell schoolyard with the text, "Dedicated / To the Students of / Pawtucketville Memorial / And Dr. An Wang Schools / 'Whose Efforts at Promoting Peace by Example / Will Continue Through Life Confident / That They Can Make a Difference' / June 14, 1996." The monument and small park created around it were an effort to encourage children to negotiate resolutions to arguments rather than resorting to violence, and was accompanied by the inauguration of a school conflict resolution program. Not mentioned on the monument, but indicated by a school employee and mentioned by city residents, is the connection of the monument to the deaths of three Cambodian school children who had attended the elementary school and who had been shot and killed by their mother's boyfriend.[81]

A second monument to peace, or against violence, was dedicated on October 23, 1997. David McHugh was a counselor at the Sullivan School. He fell while intervening in a fight between two students and was kicked in the head by one of the students. Shortly afterward he began to have seizures and months later he died. Both McHugh's injury and death were widely reported in the local press, and his funeral was attended by hundreds of people. The monument, located just outside the front doors of the Sullivan School, references Eleanor Roosevelt's admonition to actively work for peace: "McHugh

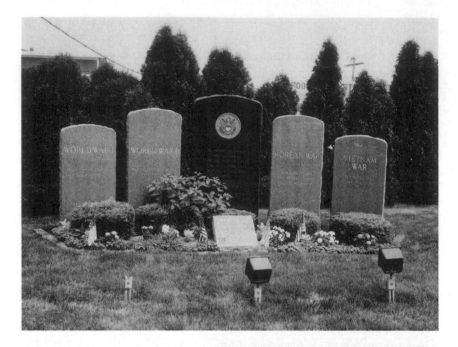

The Centralville Veterans
Monument and close-up of the
Normand Brissette Stone, July 1997.

The McHugh Peace Garden outside of the Sullivan School on Draper Street, December 1997.

/ Peace Garden / Dedicated Oct 23, 1997 / It isn't Enough to Talk / About Peace / One Must Believe in It / and Work at It / Eleanor Roosevelt." The two monuments were a response to the grieving school and city communities, although neither monument mentions the deaths of the children or the counselor. Both were located in the schoolyards associated with the deceased to cleanse the memory of violence.

Siting the monuments in very visible locations is an indication of a certain status. Sometimes a monument is intentionally placed in a prominent location. The Civil War monument to Ladd and Whitney is in the middle of downtown Lowell. While urban-renewal projects occasionally threatened relocation of the monument, it was never moved and the projects were built around the monument. At other times a monument is located in a place that itself changes, becoming more or less important. While monuments imply permanence, some do get moved over time, and the monuments assume a different status in their new locations.

In May 1980 a small realistic sculpture of a kindly policeman bending to help a young boy was dedicated on a landing just outside the front door of

The fountain in John F. Kennedy
Plaza next to Lowell city hall and a
close-up of the Police Monument,
April 1992.

the main Lowell police station in John F. Kennedy Plaza adjacent to city hall.[82] Named the Christos G. Rouses Memorial, for a police officer who died in the line of duty, the memorial was also "Dedicated to Lowell Police Officers / Who Paid the Supreme Sacrifice / During the Performance of their Duties." Occupying a much more visible and prominent position in the center of JFK Plaza was a circular decorative cement area with a fountain in the middle. The fountain had mechanical problems and was ultimately removed. In 1992 the police statue was relocated to the cement area that once held the fountain and was landscaped. New names were added to the memorial, and it was rededicated. On the landing where the Police Monument once stood, a monument to Lowell folk festival volunteer John Green was dedicated in 1994, during the opening ceremonies of the festival.[83] In 1997, when four policemen were killed in an accident on a hunting trip, their names were added to the Police Monument in a public ceremony. Ultimately a new small granite stone was added to what can now be called a memorial area. Each year on Policeman's Day the memorial area is rededicated. The Police Monument is enlarged as, over time, the community of police experiences trauma or loss. A humble monument on the landing outside the police station thus became a major city monument when it was moved into the place of the former fountain in the center of a large plaza. Although located close to its original site, the monument's new siting projected it into a prominence that it did not before possess. Visually, the whole plaza has become a memorial area to the police.[84]

There are five monuments located on the South Common. One honors a young soldier who died in Vietnam, both a plaque and a rock monument remember a long-time local baseball coach, a third lists those in power when the Common was renovated, and a fourth, located adjacent to a line of trees, remembers those who served in the Persian Gulf conflict. On adjacent streets, two other monuments recognize a local politician and Christianized Native Americans.[85] The fifth and oldest of the South Common monuments, the Crotty Circle Monument, is at the intersection of a main thoroughfare and a smaller but also busy street. It is surrounded by several trees and faces outward from the park, angled slightly toward the main street. It does not appear to be oriented to anything, and is both difficult to access and to read. It remembers George E. Crotty, a "courageous soldier" from World War I and a "faithful public servant" to the city in the years after the war. It reads, "Crotty Circle / In Memory of / 1896 George E. Crotty 1934 / Enlisted April 26, 1917 / Served Overseas with Battery F, 26th DIV. A.E.F. / Honorably Dis-

(Above) John F. Kennedy Plaza with the Police Monument relocated to the center of the former fountain, August 1996; (right) the John Green Monument on the landing where the Police Monument once stood, August 1996.

The Police Monument with an additional
stone, May 1999.

charged April 29, 1919 / Courageous Soldier / Faithful Public Servant / Dedicated by a Grateful City, Nov. 11, 1937." The monument's reference to a circle left a clue to its former siting and its former meaning.

Crotty was born in Lowell on September 15, 1895. During World War I, he served in Battery F of the 26th Division of the American Expeditionary Forces in France. After two years he contracted a lung and heart affliction and was sent home. He ran for the Lowell city council in 1921, and, although he was defeated, he remained active in local politics. He was appointed superintendent of soldiers' benefits, and later superintendent of public welfare and outdoor relief, and superintendent of the Chelmsford Street Hospital. He died suddenly on August 15, 1934. On September 21, 1937, the city council passed a resolution that the "Rotary Traffic Circle about to be constructed at the intersection of Appleton and Thorndike Streets be designated and known henceforth as the 'George E. Crotty Circle.'" The superintendent of streets had written a letter of support for the naming of the new traffic circle, citing Crotty's "excellent military service," the "humane and kindly" way that he performed his official and civic responsibilities, and "the fact that

he was so closely identified with the neighborhood where this new rotary traffic circle is to be constructed." On November 11, 1937, Armistice Day, a monument was unveiled to Crotty in the center of the traffic circle at Thorndike and Chelmsford Streets, a prominent location at the intersection of two main streets.[86]

In the fall of 1960 Crotty Circle was part of a large renovation project. The intersection was completely changed to include the meeting place of several major streets and the relocation of the railroad depot. It then became a major thoroughfare into Lowell. It is not clear exactly when the Crotty Circle Monument was moved, but it is likely that it was moved during this renovation. According to the director of the veteran's affairs office at city hall, monuments to veterans are rarely moved; rarer still is the dismantling of a monument.[87] The Crotty Circle Monument was relocated to a little-seen corner of the adjacent public park. Once visible, although not readable, to a wide public through its prominent location, it became nearly invisible in its new, isolated location. Its symbolic importance was vastly diminished, although its new location offered traces of evidence of what it might once have signified.[88]

With a clear eye, it is possible to read history upon the landscape, and to see the shadows and memories of former uses and former inhabitants. At first glance the placement of two monuments, each dedicated to an official in the water department, seems perfectly in keeping with 1980s' and 1990s' monument siting, but the landscape holds clues to their earlier meanings. They are located on a small green island between the water department building parking area and a busy street. The text on the Edward J. Tierney Monument reads, "Edward J. Tierney / Deputy Commissioner of Public Works / In Charge of Water / Sept. 12, 1960–July 2, 1984 / Served 48 Years for the Lowell Water Dept." The text on the Joseph C. Flynn Monument reads, "Joseph C. Flynn / Deputy Commissioner in Charge of Water / July 9, 1984–May 19, 1989 / 42 Years of Service / To the City of Lowell Water Department."

Dan Tine, an employee of the water treatment plant, had taken it upon himself to move the monuments in 1996 because "no one could see them. [We] wanted to dress the area up so [we] brought them out into the light." The monuments had previously been located about twenty-five yards away in a small parklike space that is now overgrown with grasses and weeds. Although outside and close to the busy public street, the park had the look of the intimate space of the staff of the water department. In the grassy area

The Edward J. Tierney and Joseph C. Flynn Monuments, after they were moved out of Tierney's Grove, face the street on either side of a long hedge, October 1996. A close-up of the Tierney Monument, 1997. Courtesy Jim Higgins.

Wooden retirement sign of a former water
department employee in Tierney's Grove,
July 1996.

were wooden boards nailed to trees. A man's name and a date were written
on each board. Tine explained that whenever a man retired, he used to put
his name and year of retirement on a board and nail it to a tree. At the entry
to the parklike space, facing the water department garages, was a long, rec-
tangular, and slightly irregular wooden sign that read, "Tierney's Grove." Far-
ther back in the park was a picnic table and a covered area. Tine described
the picnics that the men used to have in the area and noted that there had
not been one in Tierney's Grove in the six years he worked at the water de-
partment.

 After the small park space was closed, the retiring employees stopped
hanging the wooden boards on the trees and, instead, began to hang up their
shirts on a rack inside a large garage building at the water treatment plant
complex, according to Tine, "just like the Celtics." Gerry Dunn, another
water department employee, explained that the Grove was put together a
year after Tierney died. The men lined the Grove with old fire hydrants.
There were small oak trees, flowers, and yew trees. Someone mowed the grass
and watered the flowers weekly. It was great, he noted, for the morale of the

Tierney's Grove, where the Tierney and Flynn monuments were once located, July 1996.

workers. He spoke with great fondness of Joseph Flynn, the man who became commissioner of the water department when Edward Tierney died. When Flynn retired there was a large party at the Grove, with steak, lobster, games, and prizes for the kids. The monument to Flynn was dedicated at that time. Flynn spoke at the dedication, saying the people at the water department were like a second family to him. When the next executive director came to power, he abolished the parties at the Grove, citing concerns about people drinking too much and liability for the city.[89]

The monuments were once a part of Tierney's Grove, the intimate space of the water department workers. Within that space was the suggestion of class differences between workers and managers, with the simple wooden signs representing the workers and the polished granite monuments representing management. But both kinds of monuments also suggested a community of men (only one woman now works at the plant), remembering themselves and each other through the placement of markers upon a private, albeit city-owned, landscape. When that space was no longer used for water department celebrations, it lost its meaning to the community; so too did the monuments. No longer active links in the collective memory of the community of workers, the monuments became abandoned wooden signs

and stones. The Tierney and Flynn monuments were then made public through their relocation to the street, and in the process depersonalized and separated from the wooden boards that they were once a part of. By May 1999 even the Tierney's Grove sign had been taken down.[90]

The power of a monument and the memory it embodies are affected by the changes in its location in space. Space is used to revalue memory and create new determinations of the importance of a memory. When the memory of a person fades, the monument representing that memory is relocated to a nearly hidden, less-significant space. Over time, space tells of the diminution of memory. M. Christine Boyer wrote that twentieth-century urban theorists demanded that places and monuments generate meaning across generations and inscribe civic conduct on the landscape. This opened the possibility that the forms could fail to generate meaning, and instead generate memory loss by decentering the spectator.[91] Perhaps some monuments are moved because they now represent memory loss as new generations do not know who was commemorated. But rather than losing meaning, absent particular memories of the individual, the monuments come to represent the ethnic neighborhood and generalized ideas of valor and service to the community. Sometimes monuments are moved and become more or less visible and powerful; sometimes the place around the monument changes and that results in a change in the meaning of the monument. The siting of the monuments is never inconsequential. The place of the monument is, in some sense, always in the process of becoming pre-leap. The original siting, the original context for the monument, and the changes in that context reveal over time the community's changing relation to memory and meaning.

Place was critically important to the telling of the history of Lowell. The destruction of a set of structures, the Dutton Street Row Houses, sparked the idea that understanding the past was deeply connected to preserving certain places. The National Park uses specific sites to recount the history of Lowell. It was on this very site that the first fully integrated cotton textile mill once stood, on this very site that a boarding house for female factory operatives once stood, and on this site we can see the reconstructed home of a mill agent. The connection between site and the telling of history is so critical that aspects of the past will often be omitted or added, depending on what sites are available to tell that part of the story. In Lowell it was this site that helped to propel the selection of the city for a National Park, because so

much of the nineteenth-century landscape—the pre-leap landscape—remained.

Konstanty Gebert wrote about the significant absence of memorials to the Holocaust in places that would have been commemorated in Poland had historical criteria alone been taken into account. But history was not the prime determinant. The physical remains of the past played a powerful role in deciding what could be memorialized where, or what a memorial would mean in an altered landscape. The Warsaw Ghetto Uprising Memorial in Poland was built facing a gate that no longer existed. According to Gerbert, because of urban renewal, the monument was deprived of its specific point of reference, and the original meaning of the site was lost.[92] Had the past place of Lowell been dramatically altered, there would have been no national retelling of the city's history.

The National Park also altered the place of Lowell. Those altered places reflect and form both the memory of the past and the history being written about Lowell. The National Park used pre-leap landscapes to rewrite the contemporary landscape, taking everything back to tell the history of the nineteenth century. The pre-leap landscape remains, for the daily life of Lowellians, somewhat difficult to integrate into twenty-first century demands of technology, living spaces, business, and leisure. The nineteenth-century landscape in some ways reflects the nineteenth-century culture that lingers in the city, because the city is in many ways culturally pre-leap. Much of the culture of the ethnic enclave remains in Lowell, long after the enclave itself has mostly disappeared; much of the worldview of the industrial working class remains long after the industries themselves have closed.

Place is also of the deepest importance to my memories. I can imagine Nana's life, and the point at which my life was a part of hers, more powerfully in the presence of the place of her apartment. I am surprised and yet comforted by the continued existence of so many of the places where Nana, Dorothy, and my mother lived, worked, and visited. I do not have to remember or imagine the city that they once inhabited: it exists much in the same form now as it did then. Yet, without the active participation of the people who once lived in that landscape, its meaning has changed for me. With the deaths of Dorothy and especially my mother I am not sure I remember the past in the same way or that I see our shared landscape as I once saw it with them. I too exist in a pre-leap landscape in Lowell—the emotional pre-leap landscape of an extended family network that no longer exists. I walk in a landscape that has the power to elicit memory of past people

and narratives, but is no longer directly connected to my present life. I do not want the physical symbols of my family to be destroyed or the space to be occupied by new, different structures, yet changes in my sense of the past take place despite the preserved family landscape.

The meanings of the past are so intimately tied to place that even the slightest alteration impacts memory and visions of history. Yet freezing a place in time cannot cause memory and history to stop changing. Place, memory, and history move together, point and counterpoint, nuanced one by the other, intellectually and emotionally. The historic landscape, the local monuments, and my family narratives are testimony to this.

CONCLUDING
THOUGHTS

"For it seems to me that the best ethnography is
an ethnography of the role of the imagination in
culture. . . . It is an ethnography that seeks to
know and account for the power certain images
have to capture the imagination in a particular
culture at a particular time."

James Fernandez[1]

Like the battlefields where Americans of various ideologies come to compete for ownership of powerful national stories and to argue about the meanings of war, heroism, and sacrifice, there are key sites in every city where citizens compete for the right to assert their identity and power.[2] Much of the space of Lowell is concerned with issues of power, the negotiated relationship between the individual and the nation, gender and power,

the right to speak for the community in public space, and the ability to express ethnic identity without challenging the ethnic group's commitment to the American nation. The ethnic monuments that encircle city hall, the seat of political power in Lowell, assert the power of the Franco Americans, Polish, Irish, Italians, and Greeks to mark themselves and to mark their ethnic homelands. The meaning of these powerful monuments is reasserted annually through ethnic ceremonies and rededications. Yet loyalty to the ethnic nation may not be proclaimed unilaterally—it must be paired with proclamations of loyalty to America. In a careful balancing of representations of power, the ethnic monuments at city hall are on an axis with the nonethnic war monuments in front of the Lowell Memorial Auditorium, which recommit the city to the service of the nation through the sacrifice of its young. There is also the lack of power portrayed by the absence of monuments to African Americans, Cambodians, and the people from Latin America and Puerto Rico. Less-powerful ethnic groups in Lowell are not represented on the landscape or, as is the case with Native Americans, they are represented by non-Native Americans.

Trees are present at the site of many of the monuments. The tree contains within it both life and death as the living outer layers surround the "dead" wood of its core. It represents both body and memory, and the past and the immediate present. By certain associative processes, trees can excite the moral imagination concerning the health or disease of corporate bodies, bodies corporeal, and bodies politic as it were and are thus powerful imaginative devices.[3] I have looked at monuments as representations of the body in Lowell: the literal corporeal body, the ethnic body, the gendered body, the body politic, and the body of the nation. The presence or absence of the literal body plays an important role in the cultural implications of the monuments. No one knows that there are no bodies under the majority of the stones, just as no one knows there are bodies under two of the stones. It is the empty tomb or cenotaph to Lowell's immigrants that has come to represent one idea of the martyr in modern society, becoming powerful by the absence of all of the bodies it represents. Monuments marking the violence of war incorporate statues that present the body intact and in ideal form as a winged female or as a somber young soldier.

All of the monuments are to some extent about loss. They are also about the move from private grief to public mourning. The vocabulary of the cemetery—stones, fencing, mulching, and trees—is used to change the public landscape into something else. Stones have form and great substance, but

they are as well the locus of spirituality and the connecting place between the living and the dead. Stone formed in the shape of an obelisk, one end set on the ground and the other piercing the sky, for example, is a phallic symbol, but it is as well an ancient symbol of the link between heaven and earth. Stone has long had a great power over the imagination. The power of the spaces immediately around the monuments is achieved in part by the ability of the imagination to invoke the spirit of the dead in the place where the body is not.

Once a stone has been placed over the body in the cemetery, what does it mean to place a second stone, closely resembling those found in the cemetery, in the midst of the community on public lands, in neighborhood parks, or in the historic district? Cemeteries were once located quite close to the living. Over time it was thought disease resulted from this cohabitation, and the cemetery was moved to the outskirts of the city. In Lowell the monument, absent the body, has been reintegrated into the life of the community, relocated to the intimate corners of neighborhood public parks and to the downtown civic areas, so that the living and the dead once more commingle. These monuments are a new cemetery in the heart of the city, absent the pestilence of the corpse. Much has been written about the body as metaphor for illness in relationship to AIDS, as the nation, and as a site of memory and inscription.[4] Here, it is the very absence of the body that is crucial to the moving of memory back into the heart of the community.

It is also the absence of the body that explains the second memorial stone that moves the memory of the deceased from the private, individualistic realm to one more public. Once the stone has been enacted on public lands, the site must come to stand for more than the memory of the deceased, because that has already been marked. Within the everyday context of an ordinary park, a site of valor, common good, communal grief, the civic martyr, or ethnic identity and power is created.

I have made an effort to theorize the relationship between a culture and the system of monuments created by the people in a city. It concerns the intersections of personal and collective memory, male and female memory, the ethnic voice and the nation state, and the living and the memories of the dead. The monuments, abstract ideas expressed through objects with a material existence, are a complex set of physical symbols. In some sense the inner life of the culture has been exteriorized by placing the monuments on public lands throughout the city.

Pierre Nora wrote of *lieux de mémoire,* or places of memory. Such places exist between memory and history, and have meanings that are constantly changing. The *lieux de mémoire* stop time, block the work of forgetting, establish a state of things, immortalize death, and materialize the immaterial, "just as if gold were the only memory of money—all of this in order to capture a maximum of meaning in the fewest of signs." *Lieux de mémoire* have a capacity for metamorphosis and an ability to endlessly recycle their meaning.[5] Just as Nora worked to decode national memorials in places of memory in France in order to understand the past in the present, I have tried to decode the vernacular landscape of representation, the *lieux de mémoire,* in Lowell, in order to see how the past of memory and the past of history find expression in the present.

The local monuments have a complex content and involve ongoing decisions about their meanings and importance. A monument may be rededicated and a new meaning ascribed to it. Its relationship to the community may change in other ways. This is most clearly in evidence when a monument is moved or the city changes around it. A leap of some sort has been made, and the monument leaps with the change or becomes a part of the pre-leap landscape. I wonder what the wall of names remembering the Vietnam War dead will mean in the generations to come when there is no one alive who knew them. I wonder too what the Lowell monuments will come to mean, these personal expressions dedicated to one individual, when no one in Lowell remembers them.

Individually, and as a group, the monuments question the assertions of an objective, historical time. There is no abstract reordering of time and place. Like memory, they often ignore chronology. Monuments from widely separated time periods coexist in the same space. The memory of the person in the past is created in the space of the present, with the past and present conjoined in the physical space of the monument.[6] The locally erected monuments are almost wholly unconcerned with the nineteenth century. Only six of the extant monuments were erected before 1900. The remainder were erected in the twentieth century and refer to twentieth-century Lowell. The personal, local monuments are almost like memory itself, relying on small-group collective memory to identify the person, trusting that he will be known in his community. These breaks and discontinuities in space express continuity in time—the endurance of memory.

In pondering what it means for a culture to remember, Maria Sturken thought that it provides cultural identity and involves the interaction of in-

dividuals in the creation of cultural meaning. It is, she wrote, a field of cultural negotiation through which different stories vie for a place in history. When personal memories of public events are shared, their meanings change and this separates individual memory from cultural memory. History is like a still photo with explanatory text; memory is like a film with dialogue. Yet, she noted, personal memory, cultural memory, and history do not exist in neatly defined boundaries, because objects of each move from one realm to another.[7]

There was an effort in Lowell to portray the history of this city and to incorporate, to some extent, the memory of living people into the presentation of the past. The effort was honorable, but incomplete in part because it remained tied to the nineteenth century. Twentieth-century memory was too alive, and it seemed impossible to find a physical form to encompass it. The city continues to live on with the rich ethnic- and class-based memory coexisting beside the history exhibitions. The difficulty of integrating memory into the reconstruction of the history of the city can be read on the landscape itself. The National Park waysides and public art are independent of the local monuments. They are two separate physical and conceptual tracks. The waysides and public art are closest to history in that they are abstractions and interpretations of the industrial past often situated on specific sites. The local monuments are about the twentieth century and about local ethnic people. These monuments do not remain static over time; they crumble and are replaced,[8] they are moved, they are rededicated or forgotten, they are decorated with bushes, flowers, cannons, and flags, or they are stripped of accompanying material culture and left to stand alone.

With a few exceptions, the memory of women does not reside in public monuments in Lowell. Even the trope of the park as the postmodern, corpseless cemetery is essentially devoid of the female presence. Among the monuments to children who tragically or accidentally died, there are none to females. Among the many monuments to adults who died suddenly, prematurely, or accidentally, there are only two to women. Women are not mourned publicly in this cemetery in the city. The bodies of women are buried in the actual cemetery, a semiprivate realm associated with emotion and the feminine. Here visual images of women predominate through statues of females with their heads bent in sorrow, arms outstretched, or their bodies reclining tragically. Here the female form is used to express grief and mourning over the graves of both sexes. Perhaps actual women cannot be separated from the material body, and that is why the new corpseless ceme-

tery in the heart of the city does not include them. While generalized images of the female form are used to represent liberty or the nation, an actual woman's body does not yet publicly stand for the nation in the same way that an individual male king or male soldier is synonymous with the nation-state.

Women in the city are powerful, but it is a different kind of power that is not represented on public lands. This power is evidenced by my own narratives, which describe the roles my grandmother, mother, and aunt played in the life of my family. Women's ability, through narrative, to remember the past is itself a form of power. Like other women of Lowell, their agency was exercised in the home and neighborhood, two infrastructures that support the city. They gave shape to the major institutions in the city, family, economy, society, and culture, but were constrained from movement in public space in the broadest sense of that term: the physical space of the city and the space of public leadership, acknowledgment, and valor.

Each time I return to Lowell, I go to different parts of my own past and the past of my family. Anton Shammas wrote about someone he knew who was going on a trip, not just somewhere but home. The difference, he wrote, was that you can go back to a place that you have lived, "but you go home to a place that even though you may have never seen it in your life, still, it is as if you had; a place that is the other, deep end of the pool of your created, acquired, and invented memories."[9] I am a stranger to Lowell, the person who observed and worked on the construction of a history of the city that sometimes departs from and sometimes intersects with the lived experience of most Lowellians. I am, however, the most intimate of insiders, for I am the person who can go to this place of Lowell that is the deep end of my created, acquired, and invented memories. I can reach back into my family's memory of Lowell more than 150 years and find them coming to the Acre, dying of pneumonia, sending food to neighbors, eating soggy corn-beef sandwiches, caring for the less fortunate, and coming together for Christmas and the great summer cookouts. Throughout all of it I keep alive the memory of who we are through the stories. Make no mistake, we are no one important to history. We acquired no wealth, power, or position, and, because we only occasionally worked in the mills, we are not a part of the telling of Lowell's industrial past.

With the creation of this book, I add another level to the person I am in Lowell and to Lowell: I am the one who remembers the stories and the sites,

and who writes it down. I am both the observer and the observed, the insider and the outsider. In reconstructing the self of others, you go to the sites where they once lived in order to gain a deeper understanding of them and their context. My daughter and I visited the house of Louisa May Alcott to understand her better as a woman and writer, and ultimately to see her as a part of American culture in a particular era. I have gone to my sites of memory in order to reconstruct parts of the past of myself, my grandmother, mother, and aunt. I have gone to the sites of memory and history marked upon the landscape through monuments. I have looked at sites of memory, my own personal sites, the sites of a monument in a neighborhood marking the place where a man once coached baseball, and the sites marking the places where the great mill complexes once stood as a way to understand how ideas about the past intersect with ethnicity, class, and gender. I have looked for the delicately shaded lines, the boundaries, the small and large points of sometimes wild intersections between the memory of a single person and the history of a city.

The landscape has been my guide. Just as the National Park uses landscape to create a narrative about Lowell's past, I have used landscape to evoke the memory of my past. I have tried to create a physical map to navigate the monuments and an intellectual map to explain them. I used my family's stories to create a map of the culture of Lowell, with its complex rules, class structure, politics, and obligations. And I have used the map of my memory, complete with its intersections with my imagination, my knowledge of history, and my understanding of how history can be constructed to re-create the sites of those stories and the people who told them.

If I could freeze a memory of my grandmother, mother, and aunt by creating plaques inscribed with their stories about their lives in Lowell, would they live into the future and become a part of the city's history in a way they otherwise would not? If you live as long as you are remembered, could I cause them, the people who gave meaning to the stories and the places of the Lowell I know, to live longer if they were remembered in stone?

APPENDIX I

SURVEY FORM

Monument Number:_____

Monument Name:_____

Last Modified:_____

Fieldwork Information Date Recorded:_____ Recorded By:_____

Location/Address:_____

Dedication Date:_____

Text:_____

Monument Description (including materials, condition, and plantings):_____

Setting (what is the social context of the piece, i.e. neighborhood in terms of ethnicity, surrounding buildings, public spaces, etc.):_____

How accessible is the piece by foot, by car?_____

What is the orientation of the piece (compass direction and what it faces):_____

Interview Material:_____

Map:_____

Photographs:_____

Follow-up Contacts:_____

Research Information

Ownership:_____ Public_____ Private_____

Date of Construction:_____

Date of Dedication:_____

Date of Rededication:_____

Designer/Sculptor:_____

Was the monument altered (dates)?_____

Was the monument moved (where, when, why)?_____

Was there ever another monument on the same spot? What happened to it?_____

Biographical information about names mentioned on the monument:_____

What organization/individual commissioned the piece?_____

What funds were used to pay for the piece?_____

Who or what organization owns the land the piece is on?_____

What ceremonies were associated with the dedication of the piece?_____

Have any other ceremonies been associated with the piece since its dedication
(annual ceremonies, other commemoratives)? Describe:_____

Who is responsible for annual ceremonies? For taking care of the monument?
For the plantings?_____

Is there a special date associated with the monument?_____

Was there any opposition to the piece?_____

Contact Names (who may have more information about the piece):_____

Sources used to compile this information:_____

Questions suggested by research information:_____

Research information recorded by:_____

Date:_____

APPENDIX II

LIST OF MONUMENTS

No.	Name	Location
1	Armory Park Monument	Westford and Grand Streets
2	Early Greek Immigrants Monument	Cardinal O'Connell Pkwy
3	Cardinal O'Connell Monument	Cardinal O'Connell Pkwy
4	Irish Immigrants Monument	Cardinal O'Connell Pkwy and Merrimack Street
5	Rogers Canon	city hall/library
6	Polish Monument	Merrimack and Worthen Streets (city hall)
7	Franco American Bell Monument	Merrimack and Worthen Streets (city hall)
8	Police Monument	JFK Civic Center Plaza
9	*Italian Settlers*	JFK Civic Center Plaza
10	Firefighters Monument	Coburn and Moody Streets
11	Arcand Drive Monument	Monument Square
12	Ladd and Whitney Monument	Monument Square
13	*Winged Victory*	Monument Square
14	Boston and Lowell Memorial Track	Lucy Larcom Park
15	Merrimack Street Depot Wayside	Merrimack Street

No.	Name	Location
16	Drive Pulley Wayside and Big Wheel	Shattuck and Middle Streets (removed)
17	*The Worker* statue and wayside	Shattuck and Market Streets
18	Head of Middlesex Canal Wayside	Van den Berg Esplanade
19	*The Jack Kerouac Commemorative*	Eastern Canal Park
20	WWII Monument	Memorial Auditorium
21	Spanish American War (Dough Boy)	Memorial Auditorium
22	Korean War Monument	Memorial Auditorium
23	Auditorium Cannon	Memorial Auditorium
24	Vietnam War Monument	Memorial Auditorium
25	Elmer Rynne Monument	Shedd Park
26	Portuguese Veterans Monument	Charles and Central Streets
27	Meetinghouse Hill Plaque	Summer and Favor Streets
28	Frank Purtell Monument/Plaque	South Common
29	South Common Plaque	South Common
30	John Green Monument	JFK Civic Center Plaza
31	Liberty Tree Park Plaque	Arcand and Moody Streets
32	Victorian Garden Wayside	Middle and Shattuck Streets
33	Grannis Bridge Plaque	Lucy Larcom Park and French Street
34	*Human Construction*	Central Street
35	*Pawtucket Prism*	Lower Locks
36	*Lowell Sculptures 1, 2, and 3*	Boardinghouse Park
37	Lucy Ann Hill Monument	Lucy Larcom Park
38	Friends of Kittredge Park Bricks	Nesmith and Andover Streets
39	Greek American Vets Monument	Broadway and Dummer Streets
40	North Common Mall Plaque	Hancock Avenue
41	Carney Field Monument	North Common
42	Peter V. Tsirovasiles Monument	North Common
43	Pawtucketville Veterans Monument	Pawtucket Blvd and Mammoth Road
44	Rev. Dennis J. Maguire Monument	Mammoth Road and Woodward Street
45	Joseph C. Flynn Monument	Pawtucket Blvd at Water Dept
46	Jack Campbell Monument	West 5th at Campbell Park
47	Pollard Library Plaque	Merrimack Street at Pollard Library
48	Rev. Bourgeois Monument	University and Gardner Streets
49	Joseph McNamara Placard	West Meadow Field
50	Ronald LeBlanc Monument	West Meadow Field
51	Crotty Circle Monument	Summer and Thorndike Streets
52	Pawtucket Boulevard Monument	Pawtucket Blvd, Magnolia, and Dunbar Streets

No.	Name	Location
53	Sampas Pavilion Wayside	Pawtucket Blvd, Magnolia, and Dunbar Streets
54	Michael Rynne Wayside	Pawtucket Blvd at Bathhouse
55	Lowell City Seal	Market Street
56	*Homage to Women*	Market Street
57	Tribute to Education Plaque	Kirk and Paige Streets (Lowell High)
58	High School Addition Plaque	Kirk and Paige Streets (Lowell High)
59	Raymond Sullivan Plaque	Kirk and Lee Streets (Lowell High)
60	Lincoln Monument	Chelmsford and Lincoln Streets
61	John L. Durkin Monument	Chelmsford and Short Streets
62	Ricky Mulligan Monument	Plain Street and Avenue C
63	George W. Flanagan Plaque	Plain Street and Avenue C
64	Coburn Park Monument	Chelmsford and Stevens Streets
65	Mr. and Mrs. Thomas F. Dalton Bench	Stevens and Fleming Streets
66	Thomas Whalen Placard	Gage Field, Beacon Street
67	Ryan P. McMahon Monument	St. Margaret's School, Stevens Street
68	Daniel W. Newell Sr. Monument	Wilder and Parker Streets (Callery Park)
69	Donald J. Conroy Plaque	B Street (Callery Park)
70	William T. Callery Monument	Stevens and B Streets (Callery Park)
71	John Zabbo Plaque	Parker Street (Callery Park)
72	John J. Barrett Plaque	Wilder and Parker Streets (Callery Park)
73	Robert J. Loucraft Placard	Westchester and Campbell (BaileySchool)
74	Joseph M. DeCosta Placard	Westchester and Campbell (BaileySchool)
75	Quinn Holmes Bridge Placard	Nesmith Street (Hunts Falls)
76	Glacial Oval Monument	Academy Drive and Westford Streets
77	Sean A. Cullen Monument	St. Margaret's School, Stevens Street
78	Mary Ann Sanders Tyler Fountain	Westford and Park Streets (Tyler Park)
79	Middlesex Village/WW II Monument	Baldwin and Middlesex (Hadley Field)
80	Middlesex Canal Wayside	Middlesex Street (Hadley Field)
81	In Loving Memory Plaque	Middlesex and Pratt (Hadley Field)
82	David Michael Scullin Monument	Morey and Shaw Streets
83	Fort Hill Park Gate	Fort Hill Park at Rogers Street
84	William P. McCarthy Fire Station	Pine and Stevens Fire Station

No.	Name	Location
85	Bob Gallagher Monument	Shedd Park (upper)
86	Farrell/Cahill/Perrin Monument	Shedd Park (lower)
87	Walter "Gator" Gresco Monument	Shedd Park (lower)
88	Shedd Park Gates	Shedd Park (lower)
89	Saint Joseph the Worker Shrine Wayside	Lee Street
90	Eastham Circle Plaque	Rogers and Laurel Streets
91	James A. Donohue Monument	Stratham Road Playground
92	Victory Park Monument	Lawrence and England Streets
93	Charles Gallagher	Thorndike Street at train station
94	Tim Rourke Monument	Alumni Field at Rt. #38
95	Cawley Stadium Monument	Douglas Road behind Alumni Field
96	Father Kirwin Monument	Lawrence and Greenwood Streets
97	John J. O'Donnell Monument	Gorham Street at Butler School
98	Peter Deschene Fire Station	West 6th Street
99	*Passaconaway*	Gorham Street in Edson Cemetery
100	Swede Village WWII Monument	Gorham Street at Edson Cemetery
101	Matthew Ventura Field	Manning Field at Boston Road
102	Charles Thomas McInerney Monument	Main and Massassoit Streets
103	Lord Overpass Placard	Appleton, Chelmsford, and Middlesex Streets
104	Scottie Finneral Monument	Lincoln Parkway and Van Greenby Street
105	Vugaropolous Bridge Placard	Pawtucket and Middlesex Streets
106	Walker Street Pump Station Plaque	Sheehy Park, Pawtucket Street
107	John E. Sheehy Monument	Sheehy Park, Pawtucket and Walker Streets
108	Pawtucket Canal Wayside	Francis Gate Park on Pawtucket Street
109	The Great Gate Wayside	Francis Gate Park on Broadway Street
110	Vallee Monument	Thorndike and Highland Streets
111	Persian Gulf Trees Monument	South Common at Thorndike Street
112	Glory of God Cornerstone	South and Appleton Streets
113	O'Donnell Bridge Plaque	Varnum and Mammoth Streets
114	Julian D. Steele Monument	Gorham and Shaughnessy Streets
115	John Barry Gannon Fire Station	Mammoth Road
116	O'Keefe Circle Monument	Back Central Street at Hosford Square
117	Armenian Fathers Monument	Gorham Street and Sheraton Way
118	University of Lowell Plaque	University Avenue
119	Centralville Soldiers WWI Monument	Bridge Street and VFW Highway

No.	Name	Location
120	Centralville Veterans Monument	Bridge Street and VFW Highway
121	Ecumenical Plaza Plaques	Suffolk and Jefferson Streets
122	William E. Potter Monument	Pawtucket and Broadway
123	St. Michael's Bell	Bridge and 6th Streets
124	Leo J. Farley Monument	McPherson Playground at Bridge Street
125	Polish American Veterans Monument	Coburn and Hildreth Streets
126	Peace Park Monument	West Meadow Road at Schools
127	$500 Reward J. Butler	Aiken Avenue and Hovey Street
128	Martin "Mickey" Finn Field Placard	Gage Field at Boylston Street
129	Kearney Bridge Plaque	Suffolk at Jefferson Street
130	George McDermott Monument	Beacon and 6th Streets (reservoir)
131	Commonwealth Plaque	Hunts Falls Bridge at Nesmith Street
132	*Agapétime*	Lower Locks/Middlesex College
133	Bette Davis Plaque	Chester Street
134	Centralville Memorial Park Monuments	Aiken Street
135	Little Canada Monument	Aiken and Hall Streets
136	*Father Andre Garin*	Merrimack Street and St. Jean Baptiste
137	Acre WWII Doughboy Monument	Fletcher Street
138	Michalopoulos Monument	Market and Suffolk Streets
139	George P. LeGrand Monument	Broadway and Fletcher Streets
140	Pow-Wow Oak Wayside	Clark Road near Merriam Street
141	Women Working Monument	Market Street
142	*Debussy Sculpture*	University of Mass., Lowell, at Wilder Street
143	Shedd Park Field House Monument	Shedd Park (lower)
144	Rourke Bridge Plaque	Pawtucket and Wood Street
145	*Industry Not Servitude*	Lucy Larcom Park
146	Veterans All Wars Monuments	Aiken Street at VFW
147	Father Grillo Park Monument	Central and Chapel Streets
148	George F. "Mike" Haggerty Monument	Cawley Stadium at Rt. # 38
149	Raymond Sylvain Monument	Alumni Field at Rt. #38
150	Leo Fortier Marine Corps Monument	Memorial Auditorium
151	Joke Plaque	E. Merrimack at Eastern Canal
152	Pearl Harbor Plaque	E. Merrimack and Concord River Bridge
153	Spindle City Corps Monument	Westford and Grand Streets
154	James Kalergis Monument	Transfiguration Church off Fletcher Street
155	McOsker Circle Monument	Harris, Chauncey, and D Streets

No.	Name	Location
156	Passaconaway Monument	Mammoth Road and Varnum Street
157	Jack Bowers Monument	Westchester and Campbell at Bailey School
158	Thomas Crowley Monument	Lincoln Parkway and Campbell Drive
159	Central Street Plaques (2)	Central and Merrimack/Central and Prescott
160	Koumantzelis Monument	Behind the Bartlett School
161	Koumantzelis Monument (2)	Behind the Bartlett School
162	Noonan Family Monument	Washington Parkway and Florence Road
163	Harry Allen Monument	Lakeview Ave and VFW at St. Louis Field
164	Henry J. LeClair Monument	Lakeview Ave and VFW at St. Louis Field
165	Albert W. Cote Monument	Lakeview Ave and VFW at St. Louis Field
166	Edmond "Gus" Coutu Monument	Lakeview Ave and VFW at St. Louis Field
167	Highland Veterans WWII Monument	Plain and Houghton Streets
168	Michael J. Perry Monument	Dover Street near Grover Street
169	Korean War Bridge Placard	School and Rock Streets
170	John E. Cox Bridge Plaque	Bridge Street and VFW Highway
171	James W. Oliveria Monument	Behind Prince Spaghetti
172	Frank Ryan Monument	Gorham Street at Shaunessy School
173	Franciszek Hodur Monument	Lakeview Avenue at St. Casimir's Church
174	Paul and Therese Ducharme Monument	Woburn Street and Commonwealth Ave
175	Joseph R. Ouellette Bridge Plaque	Aiken Street at VFW Highway
176	Alumni Memorial Library Plaque	University Avenue
177	Water Treatment Plant Plaque	Pawtucket Blvd at water plant
178	Water Treatment Plant Plaque	Pawtucket Blvd at water plant
179	Edward J. Tierney Monument	Pawtucket Blvd at water plant
180	Fathers O'Brien Monument	Suffolk Street at St. Patrick's Church
181	National Register Monument	Suffolk Street at St. Patrick's Church
182	The Brick Vault Wayside	Between Shattuck and Dutton Street
183	"Are You There Mr. Watson?"	Between Shattuck and Dutton Street
184	Page's Clock Plaques	Merrimack Street
185	Boardinghouse Bricks	French and Foot of John Streets

No.	Name	Location
186	Rose Archambault Monument	Pawtucket St. behind Franco Street American School
187	Pawtucket Gatehouse Wayside	School Street on gatehouse
188	Pawtucket Turbine Engineering Wayside	School Street at Pawtucket Falls
189	Sheep Rock	Lowell Dracut State Forest
190	Sixth Street Water Bldg Plaque	Beacon and Sixth Streets
191	Mack Building Wayside	Shattuck Street
192	Ippolito Monument	Pawtucket Street behind Franco American School
193	Rock Plaque	Varnum Avenue and Tower Street
194	Garrison House Monument	Riverside Street
195	Veterans Memorial Bridge Plaque	Near Riverside Street
196	Women Veterans Monument	Memorial Auditorium
197	The Blond Tiger Placard	French and Aiken Streets
198	McHugh Peace Garden Monument	Draper Street at Sullivan School
199	Scottie Finneral Monument (2)	Van den Berg Esplanade
200	*Stele for the Merrimack*	French Street Extension
201	Mahion Webb Dennett Plaque	Memorial Gate Lowell Textile Institute (no longer exists)
202	Andre Garin Residence Plaque	Kirk Street
203	McCall Circle Monument	Off Andover Street
204	Blacksmith Shop Wayside	Gatekeepers house, Pawtucket Falls
205	Joan Sienkiewicz McGann Plaque	Julian Steel Housing Project
206	Chris Boughner Plaque	McPherson Playground, Hildreth Street
207	William "Billy" Trainor Court Plaque	LaGrange and Marion Streets
208	Thomas Burke Firehouse Plaque	Old Ferry Road
209	Coburn School House/Mission Rock	Pawtucketville
210	Archie Kenefick Plaque	Stackpole Street
211	Agnes Davis Community Center Plaque	Chelmsford Street
212	Arthur Sweatt Monument	McPherson Playground, Bridge Street
213	Old Worthen Plaque	Worthen Street
214	Lowell Trade School Plaque	Lowell High School
215	Eric Paul Dumont Monument	YMCA parking lot, Thorndike Street
216	Richard "Sliver" Clement Monument	198 South Street, Bishop Markham Village
217	Whipple Tree Inscription	Moore and Whipple Streets
218	National Historic Civil Engineering Plaque	Lower Locks

No.	Name	Location
219	Spindle City Corps Monument (2)	Back Central Area
220	Sarah Parker Plaque	Pine Street, Dumeral Condos
221	*Soccer Statue*	Shattuck Street
222	Frederick Fanning Ayer House Wayside	Pawtucket Street
223	Joseph Geary Monument	Douglas Road at Reilly School
224	Walter LeMieux Monument	Mill Street
225	Cheryl Berard McMahon Monument	Walnut and Chapel Streets
226	Club Passé Temps Veterans Monument	Moody Street
227	Msgr. Alexander Ogonowski Plaque	High Street on Holy Trinity Church
228	Tremont Wheel House Wayside	Not erected
229	Middlesex Canal Wayside	Not erected
230	St. Peter's Pastors Monument/Plaque	Gorham Street near Highland Street
231	Rev. Michael Ronan Monument/Plaque	Gorham Street near Highland Street
232	*The Indian Maiden*	Not erected
233	Louis Centore Bridge Plaque	Bridge adjacent to Lowell Connector
234	Dewey Archambault Towers Plaque	657 Merrimack Street
235	Irish Labor Wayside	Lucy Larcom Park
236	St. Anne's Church Wayside	Merrimack Street, St. Anne's Church
237	Life on the Corporation Wayside	Lucy Larcom Park
238	Birth of an Industrial City Wayside	French Street
239	Mill Agents Wayside	Kirk and French Streets
240	Harnessing Waterpower Wayside	Boott Mills
241	In the Shadow of the Mills Wayside	French Street at Boarding House Park
242	The Rule of the Bell Wayside	Foot of John Street
243	Evolution of a Millyard Wayside	Foot of John Street
244	The Mills Move South Wayside	Off Bridge and East Merrimack Streets
245	The Concord River Wayside	Lower Locks off East Merrimack Street
246	The Venice of America Wayside	Lower Locks off Central Street
247	Industrial Canyon Wayside	Pawtucket Canal walkway
248	Lowell Machine Shop Wayside	Off Dutton Street near Market Mills
249	Unsafe Mills Wayside	Off Central Street at Lower Locks
250	Locomotives of Lowell Wayside	Behind Shattuck Street
251	Street of Lightning Wayside	Merrimack and Dutton Streets
252	*Pawtucket Falls Island Project*	Northern Canal Island

APPENDIX III

❧ ❧

CLIMBING THE
TENEMENT STAIRS

As a kid I heard the relatives on both sides chatting in cut and spliced Canadian-American Franglais French, their tongues waggling strings of words so fast I caught each third phrase, then patched in conversational sense. They sat at the maple table drinking coffee, whiskey, tea, beer, tonic—rattling on about Little Canada, the packed tenement life between the canal and the river, and the Centralville of St. Louis de France parish, just this side of the Dracut frontier woods. When my Franco-American mother was a girl in Centralville she would not cross the Aiken Street Bridge to the enclave she considered low-class French, but still wound up with my father, a Cheever Street product from the blocks of Little Canada.

I heard stories about Français of the Honey Wagon making rounds to collect pig swill. During the '36 Flood, he herded his swine onto the porch, then up to the first, second, and, finally, third floor as water crested halfway up the block in Rosemont Terrace. And there was the time my grandfather's store burned. Expecting some poker-playing friends one night after he closed, he kept the oil heater lit. He and his chums drank a good time, then headed home across the river's ice. As soon as he sat down, a neighbor rushed over with the news that his market was in flames.

On Saturday a boy would pick up bean pots and deliver them to the bakery where they were retrieved the next morning for a big bean breakfast before or after Mass, depending on the family's level of devotion. Kids walked the canals during drain-downs, scouring muddy beds

for treasure. The same kids stole cloth from the ragman's wagon when he stepped inside to do business. They sold his stuff back to him on the next corner. The same kids scooped fresh water shrimp from the Merrimack and boiled them with potatoes on the rocks for a feed. These French Canadian-American folks had marathon card games, moving from house to house. New Year's Day meant pork pie and noise and sweets.

When she was young my mother was scalded in a cooking accident. My father climbed a set of tenement stairs in Little Canada to see a man known to have healing power, a medicine man, seventh son of a seventh son. She recovered and testified to this.

The North American carpenter Joseph Marion came to the States in 1881. His son Doda, born in Quebec, married in Lowell and died here in 1946. His grandson Wilfrid, the one with the store, is alive in his 90s. His great grandson, Marcel, my father, a man with a trade, was born and died in Lowell. My two brothers, Richard and David, an artist and a scholar, married teachers, Florence and Dianne. Their kids expect a college education. Doda's wife, Rosalba, was a mill operative in Lowell a hundred years ago. For the moment, our Marions can't reach back farther than merchant Nicolas marrying Marie Gueric in Normandy in 1665. He died in the New Old World of Quebec.

My mother sold coats and dresses in a downtown department store for twenty-five years. When I was a kid, my father, brothers, and I drove her to South Station in Boston, where she boarded a silver rail car bound for a retail training program at Charles of the Ritz in Manhattan. We thought it was her big career break. She came home a day early with the flu, and got on with her life. I found the training manual years later while cleaning out her bureau.

We've traced her side, Roy and LeRoy, to 1638 in Normandy, where Louis LeRoy married Ann Le Maistre in St. Remi de Dieppe. Her line comes through Nicolas and Jeanne, Nicolas II and Madeleine, Étienne and Marie, Pierre and Hélène, Antoine and Angélique, René and Marie, Damase and Marie, Philippe and Antoinette, and Joseph and Cecile Berube Roy, wed in St.-Jean-Baptiste Church in 1916, down to my mother, Doris. She died here this year. The two lines converge at the bend in the river. All the pieces aren't in place—all the poor scramblers who lived and had kids and died. I'm naming the names as I go.

Paul Marion (1989)

From Susan April, Paul Brouillette, Paul Marion, and Marie Louise St. Onge, *French Class: French Canadian-American Writings on Identity, Culture, and Place* (Lowell, Mass.: Loom Press, 1999).

NOTES

INTRODUCTION: ASKING QUESTIONS

1. I transcribed the text on each monument, wrote a physical description of it, as well as a description of its location and social environment, and photographed it. Each time I returned to Lowell, I visited either all the monuments, or selected categories, and rephotographed them.

2. The Web site will be hosted by the Lowell Historical Society (http://ecommunity.uml.edu /lhs/) and linked to Lowell Parks and Conservation Trust (http://www2.shore.net/~mltc/ demo/TEXT/NEARTRUST/landstrust/lowell.html). Searchable terms: Lowell monuments.

3. I stumbled upon a wayside "graveyard" on one of my trips to Lowell. Across from Francis Gate, a National and State Park site, was a pile of granite pillars, many of them used to repair the canal walls. Among the granite pieces were two pillars with waysides on them, both lying on their sides. The State Park employees said that there had been two other waysides, but they had been removed. The waysides had been created some years ago but had never been installed, because the projects they described had not been completed. By coincidence I discovered the fate of one of the unused waysides. In September 1997 I phoned Adrian Luz, a monument maker in Lowell. He told me he had been given a granite pillar with text on it and had been asked to create a new monument. He removed the text and replaced it with a new text plaque about Scottie Finneral, a young Lowell man who was killed in the Persian Gulf War.

The new monument was located on the Van den Berg Esplanade, a walking path along the Merrimack River.

4. Diane Brown, "Lured by Monuments' Mystery," *Boston Globe,* August 4, 1996, Northwest Weekly, 11.

5. Martha Norkunas, *Lowell Monuments* (Lowell, Mass.: Lowell Historical Society, 1997). This brochure is available at the Lowell National Historical Park bookstore, Market Street, Lowell, Mass., 01852.

6. Carolyn Kay Steedman, *Landscape for a Good Woman* (New Brunswick, N.J.: Rutgers University Press, 1986), 16, 24, 147.

7. Ruth Behar, *The Vulnerable Observer* (Boston: Beacon Press, 1996). See also Ruth Behar and Deborah Gordon, eds., *Women Writing Culture* (Los Angeles: University of California Press, 1995).

8. Karen McCarthy Brown, *Mama Lola: A Vodou Priestess in Brooklyn* (Berkeley: University of California Press, 1991), 12; Kirin Narayan, *Storytellers, Saints, and Scoundrels: Folk Narrative in Hindu Religious Teaching* (Philadelphia: University of Pennsylvania Press, 1989); Kirin Narayan, "How Native Is a 'Native' Anthropologist?" *American Anthropologist* 95 (1993): 671–86; Kathleen Stewart, *A Space on the Side of the Road* (Princeton, N.J.: Princeton University Press, 1996). See also Kamala Visweswaran, *Fictions of Feminist Ethnography* (Minneapolis: University of Minnesota Press, 1994).

9. Regina Bendix, correspondence with the author, September 2001.

10. Timothy Rourke, a state representative from Lowell who died in a car accident at the age of twenty-nine, for example, is mentioned on three monuments in Lowell.

1. INSIDE THE MEMORY OF CLASS AND ETHNICITY

1. Years later, my father's sister showed me a copy of my grandfather's passport. It is dated 1911, written in Russian, and issued in Lithuania.

2. Z. Bauman, *Modernity and Ambivalence* (Cambridge, Mass.: Polity, 1991), 60; and Anthony Giddens, "Living in a Post-Traditional Society," in *Reflexive Modernization,* ed. Ulrich Beck, Anthony Giddens, and Scott Lash (Stanford, Calif.: Stanford University Press, 1994), 81.

3. The immigrants each developed infrastructures to support their communities. The church, synagogue, or temple was, and for many still is, a central institution. Ethnic religious groups created death-benefit societies to protect their members. Absent health insurance, immigrants raised funds for the less fortunate among them. Drugstores became another central feature of the ethnic neighborhood, serving as post offices, employment bureaus, and dispensing local news. It was through the ethnic link that people found work in the textile mills, with entire floors and entire subspecialties composed of people from one ethnic group. Information derived from my 1983 interviews with former Lowell textile workers for the documentary *And That's How We Did in the Mill: Women in the Lowell Textile Mills* and from my interviews for the Lowell Folklife Project, The American Folklife Center, Library of Congress, summer 1987.

4. There are three video installations at the "Working People" exhibit: *Coming to Lowell* (3 minutes, 40 seconds), *Lowell Yesterday* (3 minutes, 4 seconds), and *Lowell Today* (5 minutes, 22

seconds). The segment referenced in the text is from *Coming to Lowell*. All segments were produced by Chedd-Angier Production Company, Watertown, Massachusetts, 1989.

5. One of my Cambodian American colleagues, realizing my predicament, good-naturedly served me and motioned for everyone to begin eating.

6. It took me several years of attending meetings in the Lowell Cambodian community to make contacts and form professional friendships. Many of my colleagues also took an interest in the Cambodian Americans in Lowell and worked to establish a network of contacts. During this period, a number of leaders emerged from within the Lowell Cambodian American community, and they served a critical function as spokespeople for the Lowell Cambodian American people and as cultural liaisons between older Lowellians and the newer immigrants.

7. The books include George Chigas, ed. and trans., *Resolute Heart: Selected Writing from Lowell's Cambodian Community* (n.p., 1994), and James Higgins and Joan Ross, *Fractured Identities: Cambodia's Children of War* (Lowell: Loom Press, 1997).

8. *Rebuilding the Temple: Cambodians in America.* Produced by Lawrence Hott and Claudia Levin of Florentine Films. My thanks to David Tebaldi, executive director of the Massachusetts Foundation for the Humanities, for sending the film citation. The MFH was a funder of the film and David Tebaldi was a participant in the discussion in Lowell.

9. David Tebaldi, conversation with author, September 2001.

10. Interview for the Lowell Folklife Project, American Folklife Center, Library of Congress, summer 1987.

11. For a fascinating discussion of Lowell's neighborhoods, see George Kenngott, *The Record of a City: A Social Survey of Lowell, Massachusetts* (New York: Macmillan Company, 1912). His description of Lowell is hardly objective, but it offers an interesting analysis of the social stratification of the city in the early 1900s. Peter Blewett also writes of Lowell's neighborhoods in "The New People: An Introduction to the Ethnic History of Lowell," in *Cotton Was King: A History of Lowell, Massachusetts*, ed. Arthur L. Eno Jr. (Lowell, Mass.: Lowell Historical Society, 1976), 190–217. My thanks to Stephen Matchak for sending me a copy of the unpublished report he produced with funding from the Lowell Historic Preservation Commission, "Lowell's Neighborhoods: A Geographical Perspective."

12. *The Preservation Plan Amendment* (Lowell, Mass.: Lowell Historic Preservation Commission, 1990), 6.

13. The series of brochures published by the Lowell Historic Preservation Commission in conjunction with the temporary-exhibits program at the Mogan Cultural Center details the histories of the various ethnic communities and service organizations in Lowell and are available from the Lowell National Historical Park library.

14. William Yeingst and Lonnie Bunch describe the confrontations that resulted when the Smithsonian Institution curated an exhibit about civil rights, still very much alive in the memory of the museum's audiences. See William Yeingst and Lonnie Bunch, "Curating the Recent Past: The Woolworth Lunch Counter, Greensboro, North Carolina" in *Exhibiting Dilemmas: Issues of Representation at the Smithsonian*, ed. Amy Henderson and Adrienne L. Kaeppler (Washington, D.C.: Smithsonian Institution Press, 1997), 143–55.

15. Lewis Karabatsos, preface to *Surviving Hard Times,* ed. Mary Blewett (Lowell, Mass.: Lowell Museum, 1982), xii.

16. Mary Blewett, preface to *The Last Generation: Work and Life in the Textile Mills of Lowell, Massachusetts, 1910-1960* (Amherst: University of Massachusetts Press, 1990), xv.

17. Blewett, Karabatsos, and graduate students from the University of Massachusetts at Lowell conducted the interviews.

18. Robert Weible, former historian, Lowell National Historical Park, conversation with the author, November 2000. Weible, a "new social historian," believed in the value of oral testimony. Weible is now the chief historian for the Pennsylvania Historical and Museum Commission in Harrisburg, Pennsylvania.

19. The half-hour documentary was funded by the Theodore Edson Parker Foundation and the Massachusetts Foundation for the Humanities. Since its completion in 1984 it has become a part of the National Park's outreach program in Lowell and is regularly shown on Lowell cable television. It is available from the Lowell National Historical Park Visitor's Center, Market Street, Lowell, Massachusetts 01862, and from Kent State University's Media Center.

20. The title of the video project is *The Workers Remember,* and it was completed in 1994. It consists of four oral-history stations, each with a theme: Going to Work, Life in the Mills, Survival and Conflict: Unions and Bosses, and The Closing of the Mills. Consultants working for the media firm that produced the videos interviewed thirteen former mill workers, both men and women.

21. Over a period of many years, a number of historians argued that the National Park should acquire a tenement to interpret the story of the ethnic working people of Lowell. To many, the tenement seemed a major physical piece of the story that was missing. Absent this physical structure, it was feared that the story of the ethnic family would not be well interpreted. The National Park did not acquire a tenement.

22. Blewett, *The Last Generation,* xvii–xviii.

23. Bruce Laurie, "The Working People" exhibit review, *The Journal of American History* (December 1989): 874.

24. Thanks to Bob Weible for discussing this issue with me.

25. Robert Weible, letter to the editor, *The Journal of American History,* dated January 16, 1990.

26. Riding a boat through the canals and on the Merrimack River, visitors see a part of Lowell that most Lowellians have never seen. When I began my work at the Preservation Commission I took my mother on the mill and canal tour. It was the first time she had been on the canal or had seen Lowell from the river.

27. Bill Giavis, for example, once owned a store in Lowell. He now works as an artist, specializing in Lowell scenes, and sells his work at the Brush Art Gallery, a cooperative gallery funded by the Preservation Commission.

28. The discussions about what constituted public art in Lowell mirrored the conflict that Dolores Hayden uses to open her book, *The Power of Place.* She cites the debate in the *New York Times* between Louise Huxtable and Herbert Gans, in which the two effectively described

the gulf in understanding between historic preservationists coming from an architecture background and preservationists with a social-history perspective. Huxtable argued that the New York Landmarks Preservation Commission was correct in prioritizing the preservation of monumental buildings of aesthetic singularity. Gans retorted that there needed to be a broader approach to preservation that included ordinary buildings of importance to the social history of the neighborhood. One view privileged high-class art, and the other wanted to give equal weight to pieces that represented the lives of ordinary people. Dolores Hayden, *The Power of Place: Urban Landscapes as Public History* (Cambridge, Mass.: MIT Press, 1995), 3–6.

29. As the cultural affairs director, I was a member of the public art selection committee and oversaw federal funding of several of the public art pieces. Art professionals were hired to recommend artists to a board of federal and city employees and local community leaders. The artists who were chosen were paid $5,000 to come to Lowell, spend up to six months getting acquainted with the history and people of the city, and develop site-specific proposals referencing Lowell's past. The public art program became a battleground for debating issues of class and memory. The artists who came to the city were intelligent, dynamic, and sensitive to the complexities of Lowell. In many ways the program was remarkably democratic, taking art into the streets quite literally. Various open spaces in the city became galleries, showing the works of some of America's newest and most interesting artists. On the other hand, the public art program felt elitist to many, drawing on the expertise of art professionals who implied a sophistication, taste, and education that made them able to judge artistic quality in a way that the ordinary person could not. A climate of distrust developed between managers, politicians, and art professionals. Everyone involved wanted to "do the right thing for Lowell" but no one wanted to appear the fool—applauding the emperor's new clothes. It was at once the most egalitarian of projects, and the one that drew the sharpest class lines.

30. Paul Tsongas died of non-Hodgkin's lymphoma on January 18, 1997. Admired locally for his political power and his dedication to Lowell, when his hearse passed through the downtown, Lowell police, National Park employees, and construction workers at the Paul E. Tsongas Arena stood at attention on the city streets.

31. In 1989 the Patrick J. Mogan Cultural Center was constructed. It houses the "Working People" exhibit and the University of Massachusetts at Lowell Center for Lowell History, an archive of industrial and Lowell history. In 1996 ground was broken for the Paul E. Tsongas Arena, which formally opened on January 27, 1998, one year after his death.

32. M. Christine Boyer, *The City of Collective Memory: Its Historical Imagery and Architectural Entertainments* (Cambridge, Mass.: MIT Press, 1994), 59–64.

33. Marc Augé, *Non-Places* (London: Verso, 1995); Maurice Halbwachs, *On Collective Memory*, trans. FJ Ditter (New York: Harper and Row, 1980); Anthony Giddens, "Living in a Post-Traditional Society," in *Reflexive Modernization*, ed. Ulrich Beck, Anthony Giddens, and Scott Lash (Stanford, Calif.: Stanford University Press, 1994).

34. My understanding of collective memory and of the differences between memory and history are derived from reading Halbwachs's *On Collective Memory* and from interpretations of Halbwachs in Gerdien Jonker, *The Topography of Remembrance* (Leiden: E. J. Brill, 1995),

18–25, Boyer, *The City of Collective Memory,* 20–30, 133, and others, and Mary Douglas (in her introduction to the 1980 edition of *The Collective Memory*).

35. Boyer, *The City of Collective Memory,* 24 and 204.

36. Giddens, "Living in a Post-Traditional Society," 64–65 and 79.

37. Umberto Eco wrote that the heirs of mass production now mass produced space in an "aesthetics of serilaity." See Umberto Eco, *Travels in Hyperreality: Fall '95* (San Diego: Harcourt Trade Publishers, 1995). Henri Lefebvre saw in the postmodern world the repetition of spatial units, such as office space, shopping malls, and downtown spaces. See Henri Lefebvre, *The Production of Space,* trans. Donald Nicholson-Smith (Oxford: Blackwell, 1991 [1974]).

38. My Aunt Doris has a story that captures the long memory of Lowell. Doris's mother's cousin married Franky Herbert. As a child Doris went every Friday night with her Aunt Loretta to visit the Herberts. Loretta played cards with the women, and Doris went to the front bedroom to play with the four sisters. More than sixty years later, Doris saw one of the sisters in the grocery store. She often saw her there, but she knew the woman did not recognize her. After Doris's mother died, she discovered an old wedding photo among her mother's things. She knew it was a picture of Mrs. Hebert. One day in 1999, Doris, then in her early seventies, approached the Hebert sister in the grocery store. At first suspicious, the woman eventually remembered Doris. Doris explained about the photo and, later, brought it to the woman's house. The woman was overcome with emotion. It was the only extant photograph of her parent's wedding some seventy years earlier.

39. See Martha Norkunas and Yildiray Erdener, "Food, Culture, and the Grocery Store," *The Local,* October/November 1989. The *Local* is a Lowell cultural newsletter produced by the Lowell Office of Cultural Affairs.

40. My work in Monterey, Califorina, examined the political use of public history and tourist sites. Martha Norkunas, *The Politics of Public Memory* (Albany: State University of New York Press, 1993).

41. Jonker, *The Topography of Remembrance,* 25. Jonker writes of historians in France, but it may also be said of historians in the United States.

42. Saul Friedlander, *Memory, History, and the Extermination of the Jews of Europe* (Bloomington: Indiana University Press, 1993), vii–viii, 38.

43. Edward Linenthal, *Preserving Memory: The Struggle to Create America's Holocaust Museum* (New York: Penguin Books, 1997).

44. While I write about the creation of the Lowell National Historical Park and the Lowell Historic Preservation Commission in Lowell, in the 1970s the Lowell Heritage State Park was also created. The Lowell Heritage State Park was part of a statewide system of heritage parks envisioned by then Governor Michael Dukakis. While some of the State Parks were built, the system Governor Dukakis hoped for was never fully realized.

45. See Chapter 4 for additional information about the Massachusetts Bay Tercentenary Commission's wayside and the DAR monuments to Native Americans.

46. Thanks to Martha Mayo, director of the University of Massachusetts at Lowell Center

for Lowell History, for describing the kiosks to me. She could not remember the specific texts, but she could clearly remember the structures and several locations.

47. The text on the marker reads, "46. Lee Streets / Church / St. Joseph / The Worker / Shrine / The early Romanesque style church was / built in 1850 by a Universalist congregation. With the arrival of French Canadians / to work in the Lowell mills, it was bought / by Father Garin and converted to serve as / the first French church in the Roman Catholic Archdiocese of Boston. / This marker is part of the Spindle City Exploration: Bicycle and Walking Trails Project, / funded by the Massachusetts Bicentennial Commission to the Human Services / Corporation. / Special Assistance has been received from / City of Lowell, Lowell Bicentennial / Sesquicentennial / Commission, Massachusetts/ Bicentennial / Commission, Human Services / Corporation / National / Cultural / Park Program."

48. *Lowell Sun,* March 2, 1977, 12.

49. In "Morning of a New Day," William Truettner writes that historic paintings often tell as much about the political climate of the era when they were painted as they do about the time depicted. The author examines several paintings in the Smithsonian Institution's collections and shows how the meanings of the painting go well beyond their literal representations. William Truettner, "For Museum Audiences: The Morning of a New Day?" in *Exhibiting Dilemmas: Issues of Representation at the Smithsonian,* ed. Amy Henderson and Adrienne Kaeppler (Washington, D.C.: Smithsonian Institution Press, 1997), 28–46.

50. These waysides rarely mention vernacular dwellings or the cultural life of local ethnics. In the late 1990s a set of brochures was produced by the Lowell Historic Board, which, like the 1970's waysides, focuses on the homes of the elite. Titled "Lowell's National Register Neighborhoods," the brochures include information on the neighborhood's "Early Development," "Architectural Development," and a "Who's Who" section, which describes the wealthy people of that area. The brochures include the South Common Historic District, the Belvidere Hill Historic District, the Wilder Street Historic District, and the Washington Square Historic District.

51. Two plaques were created in Lowell in 1985 commemorating engineering landmarks. The Pawtucket Canal Wayside was created by the American Society of Mechanical Engineers, and the Harnessing Waterpower Wayside by the American Association of Civil Engineers. A third wayside, Middlesex Canal, was created in 1987 by the Middlesex Canal Commission. Probably in the early 1980s, the city government created two identical plaques on Central Street in Lowell, describing its importance to transportation.

52. The waysides are Merrimack Street Depot (1835), Drive Pulley (1908), The Worker (1821), Sampas Pavilion (Charlie Sampas, 1911–1976), Michael Rynne (1882–1959), Pawtucket Canal (1796), The Great Gate (1850), The Brick Vault (1852), Pawtucket Gatehouse (1852), Mack Building (1886), Lowell Machine Shop (1885), and Blacksmith Shop (1885). The four waysides that were fabricated but never erected are Swamp Locks, Lower Locks, Middlesex Canal (1803), and Tremont Wheel House (1844/1851).

53. In addition to these sixteen waysides, the Lowell National Historical Park erected nine

plaques in 1999 that identify and describe pieces in the Lowell Public Art Collection. The themes of the public art waysides are abstract, speaking to honor, strength, endurance, nature, and the meaning of work. They include *Industry Not Servitude, Lowell Sculptures 1, 2, and 3, The Jack Kerouac Commemorative, Agapétime, Pawtucket Prism, Human Construction, Homage to Women, Stele for the Merrimack,* and *Pawtucket Falls Island Project.*

54. Marty Blatt, then historian for the Lowell National Historical Park, was the primary author of the waysides, but nearly everyone at both the National Park and the Lowell Historic Preservation Commission reviewed the texts at some point. Thanks to Peter Aucella, Gray Fitzsimons, and Chris Wirth for providing me with copies of all National Park Service wayside text and graphics.

55. Paul Litt writes that the site-specific waysides in Ontario, Canada, tend to be concrete. He said, "Ideas, cultural trends, and other such nebulous phenomena are rarely suggested as plaque subjects." Paul Litt, "Plant Clio and Immutable Texts: The Historiography of a Historical Marker Program," *The Public Historian* 19, no.4 (1997): 14.

56. Ibid., 13.

57. John Bodnar, *Remaking America: Public Memory, Commemoration, and Patriotism in the Twentieth Century* (Princeton, N.J.: Princeton University Press, 1992), 14–19, 246, 247.

58. See Robert Weible, "Lowell: Building a New Appreciation for Historical Place," *The Public Historian* 6, no. 3 (summer 1984): 27–38.

59. The text reads (left side, SE base), "En L'Honneur / Des / Franco Americains / De Lowell, Mass. / Le 24 Juin 1974." and (right side, SSE base) "In Honor / Of the / Franco-Americans / of Lowell, Mass. / June 24, 1974."

60. I attended the June 24, 1996, Franco American Day ceremonies where I interviewed Armand LeMay about the creation of the Franco American Monument.

61. In fact, the ceremony was established before the monument was erected. In 1970 an annual Franco American Day was created in Lowell to coincide with the feast of St. Jean Baptiste, the patron saint of French Canadians in America.

62. The letter from then City Manager William Taupier to the Polish American Community, dated April 15, 1976, approving the creation of the monument reads, "It is with distinct pleasure that I have the opportunity to inform you on behalf of the City of Lowell that the Lowell City Council has gone on record authorizing the erection of a monument to be dedicated to the Polish American people. The Polish contribution to the City of Lowell is something that reflects the vitality of the City itself, and makes every citizen of Lowell proud to be associated with an ethnic group that has the pride and fervor that has been displayed time and time again by the Polish people of the City of Lowell. It is with great anticipation that I await the actual erection of the monument and formal dedication, which is so righteously deserved and so long overdue." My thanks to Pauline Golec for providing me with information about the Polish Monument.

63. The text on the Polish Monument reads, "Dedicated / In Honor of / The Polish / Americans of / Lowell / May 3, 1977 / Cześć Polonii." The Polish American Monument Committee of Lowell raised all of the funds for the monument.

64. Sometime after January 3, 1977, a letter arrived from the Kosciuszko Foundation, a center for Polish culture in New York City, indicating that there had been many historical variations on the eagle, and the official Polish eagle at the time did not have a crown, although some people did not approve of the crownless eagle, associating it with the communist regime. When the crown was added sometime around 1996, members of the Polish Monument Committee were not consulted.

65. Polish Constitution Day commemorates the signing of the Polish Constitution, which was the first written constitution in Europe and is celebrated in many Polonias throughout Europe.

66. Information about the Polish Monument is derived from my interview with Pauline Golec July 31, 1996, and from correspondence with Golec, dated September 7, 1996, and August 20, 1997.

67. Evidence of a more formal, grand use of this space may be found in historic postcard views of the parkway. Thanks to Lew Karabatsos for bringing the postcards to my attention and to architect Tom Rose for identifying the major physical axes in the city.

68. According to the 1937 *WPA Guide to Massachusetts: The Federal Writes' Project Guide to 1930s Massachusetts* (New York: Pantheon Books, 1983), "The Cardinal O'Connell Bust surmounts a granite bird bath in the middle of the Green, commemorating the fondness of St. Francis of Assisi for the winged creatures of god. The bust is an excellent likeness of the Cardinal, a native of Lowell" (page 264).

69. *Lowell Courier Citizen,* November 18, 1918, 1–2.

70. F. W. Coburn, Whistler and His Birthplace, A Study of the Contacts of James McNeil Whistler (1834–1903) and Other Members of the Whistler Family with Lowell, Massachusetts, at Which City He Was Born, and a History of the Whistler House, n d., pp. 101–3.

71. The text reads, (front panel) "Dedicated to the / Irish Americans / Of Lowell / 1822–1977." and (rear panel) "The Irish community of Lowell was the / First ethnic group to inhabit this / Area. Through their efforts in every / Facet of city life, they helped to / Establish Lowell as one of the most / Important cities in the nation."

72. The Celtic cross is a pre-Christian symbol of intricate knot work, which later came to combine both the image of the sun and the Christian cross. See David McKean, *The Cross and the Shamrock: The Art and History of St. Patrick Cemetery, Lowell, MA* (Lowell, Mass.: The Archives of St. Patrick Parish, 1997), 27.

73. The actual dedication of the monument was November 6, 1977, not, according to Sweeney, because the date was of special significance, but because the monument was ready at that time.

74. Thanks to Marie Sweeney for discussing the Irish Monument with me. Marie Sweeney, conversation with the author, September 22, 1997. Thanks also to Lew and Susan Karabatsos for providing additional information about the Irish Monument.

75. The text reads, (front panel) "Dedicated to the Early / Greek Immigrants by their / Grateful Progeny / 1983 / ΑΙΩΝΙΑ ΑΥΤΩΝ Η ΜΝΗΜΗ." and (rear panel) "Benefactors / Christos S. Tournas / Angelos D. Sakellarios / Peter S. Vulgaropulos / Elias Kolofolias."

76. *Lowell Sun,* March 25, 1983, 13; *Lowell Sun,* March 23, 1984, 9.

77. *Lowell Sun,* April 30, 1987, 33; *Lowell Sun,* June 12, 1987, 7.

78. *Lowell Sun,* October 30, 1989, editorial cartoon.

79. The cannon was moved once while I was writing this book.

80. *Lowell Sun,* May 17, 1986, 8; *Lowell Sun,* June 10, 1991; *Lowell Sun,* October 30, 1991; and *Lowell Sun,* November 8, 1991.

81. The offices of many of the most powerful organizations in Lowell are, or were, located along Merrimack Street. These include the offices of the National Park Service, the *Lowell Sun,* attorneys, the Lowell Plan and the Lowell Development Financial Corporation, and the Lowell Historic Preservation Commission. The two key department stores were located on Merrimack Street for years. City hall is at one end, next to the main police station and fire station; at the other end is the Lowell Memorial Auditorium. Close to the auditorium is the largest hotel in the downtown, Middlesex Community College, and, just up the street, Saints Memorial Hospital, once known as St. John's Hospital.

82. Paul Sheehy, conversation with the author, July 19, 1996. Thanks to Paul Sheehy for discussing the ethnicity of various Lowell monuments with me.

83. These include the Centralville Soldiers WWI (1919), the Acre World War I (1923), the Pawtucketville Veterans (1928), the Middlesex Village World War II (1943), the Highland Veterans (1944), and the Centralville Veterans (1945).

84. The text reads, "George Scott Finneral / Born Feb. 22, 1970 / Lowell, Massachusetts / Proud of His Family and Irish Heritage / Proud of His Religion and Country / And So Very Proud of Lowell / Killed in Action Persian Gulf / Sept. 14, 1991 / Until We Meet Again / May God Hold You in the / Palm of His Hand."

85. I make this observation based on my conversations with National and State Park employees and Preservation Commission employees when I began the documentation process for this project.

86. David Thelen and Roy Rosenzweig, *The Presence of the Past: Popular Uses of History in American Life* (New York: Columbia University Press, 1998). Thelen and Rosenzweig discuss the ways in which ordinary people learn and remember history. They found that people related to "history," national and international events, by the way in which it impacted their families. Steven Zeitlin, Amy Kotkin, and Holly Baker, *A Celebration of American Family Folklore* (New York: Pantheon Books, 1982), recount the ways in which genres of stories capture major themes in the American family.

87. Dean MacCannell, *The Tourist: A New Theory of the Leisure Class* (New York: Schocken Books, 1976), writes of the ways in which sites are enshrined on the tourist landscape.

2. THE GENDER OF MEMORY

1. There was only one object in our family that remained from my great-grandparents' generation. Nana's mother had worn a short, black velvet shoulder cape. I donated the cape to the Lowell Historical Society with whatever information I knew about my great-grandmother as a way of preserving the memory of her, a woman I had never met. Late in her life my

mother mentioned that she thought she had the tin whistle that Nana's father played. I was delighted, although surprised that she'd never mentioned it. But there was no whistle. That physical connection I could have had to him through the whistle was gone, the whistle lost long ago.

2. Kathleen Cleary Norkunas, interview with the author, September 28, 1991.

3. Ruth Meehan, another remarkable Irish Lowellian storyteller, has a narrative about the person who became like a relative in her family. Her grandmother had taken in a young attorney as a boarder. He courted Ruth's mother, but she ultimately rejected his offer of marriage. When Ruth's grandmother died, the house went to Ruth's mother, who had meanwhile married Doctor Meehan. The boarder, who by then called the house his home, continued to live there with Ruth's mother, her father, and later their children. Ruth and her siblings grew up calling the attorney "Uncle."

4. Thomas Barrett died on October 19, 1905; Andrew Barrett died on May 31, 1893. Thanks to Mary Jo Christian for researching these death dates.

5. Nana always had a few dollars put aside in her "foxy pocket" just in case. Years later, when I was the cultural affairs director at the Lowell Historic Preservation Commission, I told the executive director that I had put $10,000 from the cultural budget in the commission's foxy pocket, just in case some interesting projects came up over the course of the year. He stared at me. "Foxy pocket? We don't have foxy pockets in the federal government." But later he came to appreciate the set-aside funds for those projects that came up at unexpected times. Midyear he approached me, asking, "Do you have any money left in the foxy pocket?"

6. Years later my husband asked me why I filled the kettle to the top when it was it was only he and I at home. When he met my mother he noticed that her kettle was also always full. I knew then that Nana's kettle must have always been full too. We were waiting for visitors.

7. My mother was born on Jewett Street, a few blocks from the house where Nana had lived with her father and a few blocks from the house where her family eventually moved and stayed. When my mother died, two old women came to the wake. My Aunt Dorothy was so pleased to see them. They had been children together on Jewett Street, and she had not seen them for more than sixty-five years.

8. One specific informal economic organization managed by women was the precursor to modern credit cards. Nana ran one such credit organization. My mother remembered going around with Nana to collect one dollar a week from various families over a twenty-five–week period. The family could buy clothes from certain Lowell stores before they had paid the full twenty-five dollars if they belonged to a reputable club. My grandmother had excellent credit, and the stores always honored the people who belonged to Kitty Cleary's Club. Nana must have received some commission for the club, generating income for her family.

9. *Lowell Sun*, October 23, 1984.

10. Another of the pieces is a metal fence encircling a tree. Cut out of the fence are the words of a poem by Lucy Larcom written at the time of the Civil War. The poem describes weaving and a sense of social responsibility. The second verse reads, "Too Soon Fulfilled, And All Too True / The Words She Murmured As She Wrought: / But, Weary Weaver, Not To You / Alone

Was War's Stern Message Brought: / "Woman!" It Knelled From Heart To Heart, "Thy Sister's Keeper Know Thou Art."

11. The quotations from Ellen Rothenberg are from her Project Narrative, presented to the Lowell Public Art Committee as a part of her proposal to create *Industry Not Servitude*. Mayor Bud Caufield's remarks are from my notes of the dedication event. The quotation from the proclamation is from a copy I obtained from the mayor's office.

12. The image of the French Canadian weavers in the Boott Mills is from 1905 and can be seen as the frontspiece in Mary Blewett, ed., *Surviving Hard Times* (Lowell, Mass.: The Lowell Museum, 1982). The interpretation of the stele is based on a telephone communication with the artist, Peter Gorfain, July 31, 1996.

13. The section of the text that mentions women reads, "St. Anne's Church / Shortly after the Merrimack Mills opened in 1823, the owners built this church to help attract young women workers from rural New England villages and farms." Later the wayside includes part of a poem written by Lucy Larcom: "The church rose close to the oldest corporation and seemed a part of it . . . like a leaf out of an English story-book. / Lucy Larcom."

14. The full text reads, "Life on the Corporation / Lowell's first company-owned boarding-houses were built across the canal in 1823 to house young women workers from rural New England. / Neat rows of boardinghouses once lined the streets of Lowell. The companies hoped that a moral, clean, and safe boardinghouse environment would encourage parents to send their daughters to work in the mills. Life 'on the corporation' soon became a centerpiece of the acclaimed 'Lowell Experiment.' / Over time, as mill owners sought to cut costs, working and living conditions deteriorated. Workers resisted with strikes in the 1830s and agitation for a shorter work day in the 1840s."

15. The full text reads, "In the Shadow of the Mills / To the right stands a boardinghouse block built in 1837 for Boott Cotton Mills workers. Dozens of company-owned boardinghouses served as home for thousands of young, single women—Lowell's 'mill girls.' / This block was one of eight owned and managed by the Boott Corporation. Quarters were crowded, and rules were strict. Curfew was at 10 P.M., church attendance was mandatory, and improper behavior was pro-hibited. Still, the boardinghouse provided an atmosphere where workers shared experiences and forged bonds of solidarity. / As working and living conditions worsened, Yankee women resisted with strikes and petition drives. When their protests were ignored, they began to leave the mills. / Like the Yankee women before them, immigrants came to Lowell for mill work. They usually chose to live in ethnic neighborhoods rather than corporation boardinghouses."

16. The full text reads, "1932 / This Douglas Fir Tree / Planted by / The Educational Club / of Lowell / In Memory of / Miss Lucy Ann Hill / Founder."

17. The Rev. Isaac Smith of the Grace Universalist Church gave the dedicatory address at the tree planting, saying that her "vocation and avocation was that of planting the tree of knowl-edge and creative ideas and ideals in the minds of the young. . . . Lucy A. Hill believed we should ever be seeking for that knowledge which gives us power and those truths which will make us free. She organized the Educational Club for adult women to keep in touch with the ever growing knowledge of current events and human affairs." He went on to say that plant-

ing the tree in Lucy Larcom Park was appropriate as Lucy Larcom had no doubt inspired the noble work of Lucy Hill.

18. *Lowell Courier Citizen,* May 21, 1932, 1, 10.

19. The fee was $2, and rooms were open days and evenings. *Lowell City Directories, 1900-1908,* 416, 1125–26, 331.

20. The Cultural Affairs division of the Lowell Historic Preservation Commission conceived of the idea of creating bricks outside of the Mogan Cultural Center "remembering" the people, predominantly women, who had lived in the boarding houses along French Street and who had worked in the Boott Cotton Mills, which now houses the National Park's Boott Cotton Mills Museum. Names were selected somewhat randomly at ten-year periods. The named bricks are black plaques with raised gold letters and a gold frame. They are set into the red brick sidewalk along the Foot of John Street. They are very subtle. The feeling of discovery was intentional on the part of the Preservation Commission staff, so that visitors would come upon the names as they walked. Each name and date is on a separate brick. The names are "Sarah Quimby / 1838; Mary Bamford / 1840; Clarissa J. Rice / 1850; Experience Sargeant / 1850; Bridget Callihan / 1850; Silas W. Cheever / 1860; Agnes McDonald / 1860; Eliza Dodge / 1870; Patrick Kelley / 1870; Maggie Grimes / 1870; Alberta Bileau / 1880; Katie McGrath / 1880; George Gauthier / 1900; Mihran Pahigian / 1910; Karoline Alrzybala / 1910; Charles Demers / 1920; Emma R. M. Bilodeau / 1930; John O'Donnell / 1939." Thanks to former cultural affairs director Paul Marion for discussing the development of the Boardinghouse Bricks with me.

21. Monuments to individual women include the Bette Davis Plaque, the Rose Archambault Monument, the Lucy Ann Hill Monument, the Mary Ann Sanders Tyler Fountain, the Sarah Parker Monument, the Joan Sienkiewicz McGann Plaque, the Agnes C. Davis Community Center Plaque, and the Cheryl Berard McMahon Monument. Monuments to an individual man and woman include the Noonan Family Monument (mother and son) and the Paul and Therese Ducharme Monument (husband and wife). The McHugh Peace Garden Monument, while dedicated to a man, quotes Eleanor Roosevelt.

22. Inscribed on the rim of a granite fountain at the edge of a neighborhood public park are the words "Gift of Mary Ann Sanders Tyler 1914." The fountain is of Quincy granite, stands four-and-one-half-feet high, and was built by Gumb Brothers of Lowell. In a letter to the Board of Aldermen dated February, 1893, Mary Ann Sanders Tyler and her daughter, Susan Emma Tyler, offered 2.74 acres of land to the city of Lowell "for the free use and enjoyment of the inhabitants forever." The park was accepted in May of the same year. In 1894 Charles Eliot, of Olmsted, Olmsted, and Eliot, the architectural firm founded by Frederick Law Olmsted, designed Tyler Park. In 1914 Mary Ann Sanders Tyler purchased a drinking fountain for the park at the cost of $250 and donated it to the city. Mary Ann Sanders Tyler was born in Cambridgeport, Massachusetts, on January 17, 1823, and died at the age of 101 in 1924. Frederick William Coburn, *History of Lowell and its People* (New York: Lewis Historical Publishing Company, 1920), 438–39; *Lowell Sun,* October 7, 1914, n.p.; *Lowell Sun,* December 22, 1997, n.p.; *Lowell Sun,* May 26, 1924, 3.

23. Just off a principal street in the Lowell neighborhood of the Highlands is an apartment complex. Adjacent to the apartment complex is a small path that leads to the apartment's front

door. Invisible to any but those who walk the path is a small rock with a bronze plaque inset. It reads, "Birthplace of / Sarah Parker / First White Girl / Born in Chelmsford / Now Lowell / Born January 14, 1653 / Daughter of / Jacob Parker / First Town Clerk of / Chelmsford / Placed By / Lydia Darrah Chapter D.A.R. / May 4, 1938."

24. Behind a large brick building that was once an orphanage and is now the Franco American School is a square granite monument atop a granite base. It is the first stone one encounters before seeing a remarkable series of enclosed sculptures of the stations of the cross, culminating in a stone grotto with statues of Mary and stairs leading to a large crucifix on a hilltop. The grotto was dedicated on September 4, 1911. The monument was dedicated on Columbus Day, October 12, 1942. Written in French, it commemorates Rose Archambault, for her service to the Franco American orphans. It reads, "Patinoire / A La Mémoire de / Mme. Rose F. A. Archambault / Qui se survit dans sa tendre / charité pour les orphelins, / L'orphelinat reconnaissant fait / hommage de ce monument / du souvenir. Juillet 1942. "("Skating Rink. To the memory of Rose Archambault, who lives on in her tender charity for the orphans, a grateful orphanage pays tribute to her through this monument in her memory. July 1942" [author's translation].) On April 12, 1942, the Sisters of Charity of Quebec wrote in their record book that they had learned that morning the sad news that Madame Amédée Archambault, their friend and neighbor, had died at 6:30 in the evening. She had heart trouble for the last several years. She was a woman, they wrote, of great charitable works and the church was filled at her service. Rose Archambault lived next to the Sisters of Charity at 311 Pawtucket Street in Lowell on the second floor of the funeral home owned by her husband, Amédée Archambault. Her husband donated a skating rink and pool to the then Franco American Orphanage in memory of his wife. Pere Tardif, the chaplain of the orphanage, gave the benediction. The skating rink (patinoire) and pool were removed about 1987, hence the monument now commemorates a gift that no longer exists. Letter to the author from Sister Madeleine Gagnon, s.c.q. dated January 13, 1997; *Lowell Sun,* September 2, 1911; *Lowell Courier Citizen,* September 4, 1911; *Lowell Courier Citizen,* September 5, 1911; *Lowell Sun,* May 26, 1933; *Lowell Evening Leader,* September 2, 1936, 2–3; Mr. Archambault, interview with the author, summer 1996.

25. On the wall outside a community center in a housing project is a plaque to a former resident and housing activist, now deceased. It reads, "Joan Sienkiewicz McGann / Community Center / Dedicated / June 11, 1989 / Armand P. Mercier, Chairman Allen J. Regan / George R. Gagan, Vice Chairman Lawrence P. Doherty / Allen J. Merrill Michael E. McLaughlin, Ex. Dir." Former mayor of Lowell Tarcy Poulios remembered McGann as a radical who fought for tenants' rights in the public-housing project. She died after moving away from Lowell, and the community center was dedicated to her. Interviews at the Sac Club, Lowell, May 1999. Other information from an interview with William Flanagan, Lowell Housing Authority, May 5, 1999.

26. A bronze-looking plaque with gold letters and a gold frame sits high on the left front of the house at 22 Chester Street in Lowell. It reads, "Birthplace / of Bette Davis / Star of stage and screen / For more than fifty years / Born April 5, 1908." Above the birth date are two stars. It was shortly after Davis's death in Paris in 1989 that City Counselor Brendan Fleming proposed some kind of memorial to "bring to the attention of the public, not so much in Lowell,

but outside of Lowell that she is certainly one of our better-known citizens." Davis, an Academy Award–winning film star, was born in Lowell. Fleming's proposal met with derision, in part because he had opposed the funding of a memorial to Lowell writer Jack Kerouac on the grounds that he was an alcoholic and no example for the youth of Lowell, but seemed unconcerned with Davis as a moral example. Both the plaque and *The Jack Kerouac Commemorative* were created. "Fleming Eyes Memorial for Bette Davis," *Lowell Sun,* October 10, 1989, 11; "Council Approves Study of Memorial for Bette Davis," *Lowell Sun,* October 11, 1989, 13; "Bette Davis Memorial Planned," *Lowell Sun,* July 3, 1990, 5.

27. Agnes Davis was a long-term board member of the Lowell Housing Authority. At one time she lived in the housing project with her family. The plaque reads, "Agnes C. Davis Community Center / George W. Flanagan Development (MA 1-2) / Lowell Housing Authority / Armand P. Mercier, Chairman / Lawrence P. Doherty, Vice Chairman / Allen J. Merrill, Commissioner / Joseph Grenham, Commissioner / James A. Hall, Commissioner / Former Members / George A. Gagan / Allen J. Regan / James A. Milinazzo, Executive Director / Jeffrey J. Cook, Architects, Inc. / Pascucci Bros. Co., Inc., General Contractor / Funding for this work provided by: / U.S. Department of Housing and Urban Development / June 2, 1994." Interviews at the Sac Club, Lowell, May 1999. Other information from an interview with William Flanagan, Lowell Housing Authority, May 5, 1999.

28. Monuments that list the names of women among those commemorated include the 1939 Pawtucket Boulevard Monument, which recognizes the donation of land to the city and lists women among the donors; the Centralville Veterans 1945 Monument, which mentions women; *Homage to Women* in 1984; the Vietnam Monument in 1986; the WWII Monument in 1987; the Boardinghouse Park Bricks in 1988; the Kittredge Park Bricks in 1990; the Persian Gulf Monument in 1991; the Kalergis Monument in 1992; the Fortier Monument in 1993; the Centralville Veterans Monument (redoing the earlier monument) in the late 1990s; the Women Veterans Monument; three waysides (created in 1997) that specifically mention women; the Working Women of Lowell Monument in 1995 and *Industry Not Servitude* in 1996. The proposed Indian Maiden, a figurative statue, was not erected at the time of this writing.

29. The text reads, "Ducharme / Dedicated in honor of Paul R. and Therese M. / Ducharme for their selfless devotion / To family, God and the South Lowell community / Dedicated July 15, 1995." At the park's dedication the chairman of the South Lowell Park Committee proclaimed that "The park is dedicated to the Ducharmes for their lifelong commitment to the South Lowell community and to the St. Marie's parish in Lowell." Paul Ducharme taught religious classes at the church, as did Therese, and he worked with tenants on city-housing issues. Therese worked with exceptional children at a local camp. A proclamation issued by the mayor stated that the couple had "dedicated their lives to serving their family, church, community, and each other" and that they stood as "shining examples of all of the wonderful things Lowell had to offer; loyalty, faith and compassion." From a proclamation by the mayor of Lowell, July 15, 1995; "Park Is City Couple's Anniversary Gift," *Lowell Sun,* July 15, 1995; memo from Law Department to Thomas Bellegarde, Commissioner of Parks, Recreation, and Cemeteries, May 2, 1995; letter from Thomas Bellegarde to Michael Sullivan, April 28, 1995.

30. The text on the stone reads, "The Noonan Family / In Lasting Memory of Our Dedi-
cated / Mother Jacqueline, and Our / Loving brother Timothy / Dedicated 5-26-96" (incised
in football: 58). Interviews with Cynthia Noonan Dykes, Pam Noonan Gray, and Sheila Callery
Kearns by project researchers, August 1996, for the Lowell Monuments Project.

31. The text on the monument reads, "In Loving Memory of / Cheryl Berard McMahon /
Daughter of Leo and Leslie / Sister of Joe and Marcia / Mother of Erin, Ryan, Kate and
Matthew / September 23, 1957–December 25, 1987." According to neighborhood activist Bar-
bara Palermo, the community conceived of the idea of a small parking lot with rented spaces
for residents' cars. Concerned that the cars might be vandalized, community members asked
a neighboring man if he would keep an eye on the property. He agreed. In return the city
agreed to erect a monument to the man's deceased daughter. Barbara Palermo, interview with
the author, October 12, 1999; Cheryl Berard McMahon's father at the monument site, inter-
view with the author, May 2000.

32. The full text reads, "Women / Working for / Lowell / Since 1823, the women of Lowell
have made / lasting contributions to the economic, educational, / cultural and social devel-
opment of this city. / In 1992, the following women continued this / commitment to service
with their contribution / to the Lowell Folk Festival Fund. / Lowell is a city rich in the value
of its women." The monument then lists the names of all of the 208 women who made con-
tributions to the Lowell Folk Festival Fund.

33. Chilla Bulbeck, "Women of Substance: The Depiction of Women in Australian Monu-
ments," *Hecate* 18, no. 2 (October 1992): 12–13, 26.

34. There are many statues of Sacajawea, the Native American woman who guided the Lewis
and Clark expedition. In early 2000 the United States Mint introduced a coin dollar with the
image of Sacajawea on its face. *New York Times,* January 23, 2000, 2.

35. Helen Bartlett Morris, "The Madonna of the Trail," in *The Historic Treasure Chest of the
Madonna of the Trail Monuments,* ed. Fern Ioula Bauer (Springfield, Ohio: John McEnaney
Printing, 1984), 101.

36. Vivien Rose, "Women of the West: Sacajawea, Frontier Mother and Madonna of the Trail
Statues Coast to Coast" (paper presented at the 1996 National Council of Public History Meet-
ing, Seattle, Washington). Thanks to Vivien Rose for discussing her work with me.

37. Page Putnam Miller, "Landmarks of Women's History," in *Reclaiming the Past: Land-
marks of Women's History,* ed. Page Putnam Miller (Bloomington: Indiana University Press,
1992), 20. See also Marion Tinling, *Women Remembered: A Guide to Landmarks of Women's
History in the United States* (Westport, Conn.: Greenwood Publishing Group, 1986), and Lynn
Sherr and Jurate Kazickas, *Susan B. Anthony Slept Here: A Guide to American Women's Land-
marks* (New York: Times Books, 1994). To search for women on the National Register of His-
toric Places, see http://www.cr.nps.gov/nr/travel/pwwmh/intro1.htm.

38. Miller, "Landmarks of Women's History," 14, 18–20; Gail Dubrow. "Preserving Her Her-
itage: American Landmarks of Women's History" (Ph.D. diss., University of California, Los
Angeles, 1991), 93, 102.

39. Dubrow. "Preserving Her Heritage," 19, 24.

40. The Lowell Women's Veteran Monument was inspired by the national effort to create the Women in Military Service for America Memorial, dedicated in October 1997 at the entrance to Arlington National Cemetery, Virginia. The Lowell Women's Veterans Monument was dedicated on September 21, 1997, and sits amidst the many war monuments on the lawn outside the Lowell Memorial Auditorium. The text reads, "To Honor / All Women / Who Served Their / Country in All Wars." Joe Duceau, Lowell's veterans affairs coordinator and chair of the Women's Veterans Monument Committee, stated that women's efforts "have been neglected for too long and it's time we honored them for our freedoms." *Lowell Sun,* September 21, 1997, 13; *Lowell Sun,* September 22, 1997, 6.

41. Marita Sturken discusses the feminine nature of the Vietnam Veterans Memorial and the calls for an overtly phallic memorial, resembling the Washington Memorial. She also discusses the deep connection between maleness and technology in the Persian Gulf War in the chapter "Spectacles of Memory and Amnesia." Marita Sturken, *Tangled Memories: The Vietnam War, the AIDS Epidemic, and the Politics of Remembering* (Berkeley: University of California Press, 1997), 53.

42. I participated in Elaine Noble's seminar while an undergraduate student at Brandeis University in Waltham, Massachusetts.

43. Ironically, although one of the women honored, Florence Hope Luscomb, was born in Lowell, there is no plaque or monument to her in Lowell. For further information on "Hear Us," see http://www.mfh.org/specialprojects/shwlp/site/index.html.

44. Citations from newsletters and press releases about the project produced by the Massachusetts Foundation for the Humanities, South Hadley, Massachusetts, in 1998 and 1999. The project was managed by MFH Assistant Director Ellen Rothman and funded by the Commonwealth of Massachusetts ($118,000) and by private and foundation matching funds ($118,000). My husband and I were contributors to the project. The six women chosen included Dorothea Dix, advocate for the mentally ill and superintendent of nurses for the Union Army during the Civil War; Florence Hope Luscomb, suffragist, peace activist, and executive in the Massachusetts League of Women Voters; Mary Kenney O'Sullivan, union organizer and advocate of legislation to protect women and children in the workplace; Sarah Parker Remond, African American abolitionist who led a movement to desegregate Massachusetts public schools; Josephine St. Pierre Ruffin, founder of the Women's Era Club for African American Women and cofounder of the National Federation of Afro-American Women; and Lucy Stone, suffragist and editor of the *Women's Journal.*

45. Like the public art pieces created with federal funds in Lowell, these monuments are professionally sculpted pieces, recognizing women who advocated for social change. Both the Canadian and the Massachusetts pieces were sculpted by women. "Hear Us," was created by Sheila Levrant de Bretteville and Susan Sellers; the Famous 5 sculpture was created by Barbara Paterson.

46. The sculpture was also criticized because it celebrated women who "cautioned whites

to protect themselves against other races" and who supported the forced sterilization of mentally and physically challenged women. Ann Marie McQueen, "Honor Doesn't Add Up," *Ottawa Citizen,* October 19, 2000.

47. Frances Wright, president of the Famous 5 Foundation, quoted in the *Ottawa Citizen,* December 15, 1997, by Dave Ebner. I am grateful to Diane Dodd of the Parks Canada Agency for providing me with copies of articles about this monument. For further information see the Famous 5 Foundation Web site at www.famous5.org.

48. Putnam Miller, "Landmarks of Women's History."

49. Reclaiming Women's History through Historic Preservation, the first national conference, was held June 17–19, 1994, at Bryn Mawr College in Bryn Mawr, Pennsylvania. A second conference was held in Arizona, and in May 2000 the third conference was held in Washington, D.C. The conferences have done important work in assembling historians interested in the topic.

50. The commission's task was to provide the secretary of the interior with a list of sites deserving recognition and preservation and to recommend actions to preserve those sites, as well as to provide interpretive material at the sites. *NCC Washington Update,* 4, no. 27 (July 17, 1998) and 4, no. 44 (November 10, 1998), by Page Putnam Miller, National Coordinating Committee for the Promotion of History. Quotations are from the completed report entitled "Women's History Sites: The Other Half of the American Story," by the Women's Progress Commission, July 2001. My thanks to Barbara Irvine for sending me a copy of the report.

51. "Placing Women in the Past," *Cultural Resource Management* 20 (1977).

52. My thanks to Liza Stearns for providing me with a list of internet sites relating to women, history, and place. One site is of particular interest to marking women on the landscape. "Places Where Women Made History," can be found at http://www.cr.nps.gov/nr/travel/pwwmh/index.htm. Quoted text is from June, 2002.

"As part of the commemoration of the 150th anniversary of the first Women's Rights Convention held in Seneca Falls, New York, the National Park Service has developed this National Register of Historic Places travel itinerary, Places Where Women Made History. This itinerary focuses on 74 historic places in New York and Massachusetts associated with the varied aspects of women's history. You will learn about the accomplishments of many American women who made outstanding contributions to education, government, medicine, the arts, commerce, women's suffrage, and the early civil rights movement.

Places Where Women Made History offers several ways to discover women's contributions to the development of New York and Massachusetts. Each property features a brief description of the site's significance, and color and historic photographs. At the bottom of each page, the visitor will also find a navigation bar containing links to five essays: Women and Historic Preservation, Women in Art and Literature, Women and the Progressive Era, Women Professionals and Women and the Equal Rights Movement. These provide historical background, or "contexts," for many of the sites included here. Finally, with the public accessibility information provided for each site featured, travelers can print copies of the maps and property descriptions and visit the sites open to the public."

Under the link "List of Sites" is the "Lowell National Historical Park" (http://www.cr.nps. gov/nr/travel/pwwmh/womlist1.htm). "The Lowell National Historical Park, on the banks of the Merrimack River in Massachusetts, is one of many sites in the United States where the Industrial Revolution produced a new way of life for American women. In the 1820s, the Boston Association [sic] harnessed the power of the Merrimack River and built a series of mills and canals. By 1850, there were almost six miles of canals, 40 mill buildings, 320,000 spindles, and more than 10,000 workers. During that period the farmers of the newly settled west surpassed the New England farmers in productivity and the Boston Association tapped into that willing workforce. 'Mill Girls,' 18-to-35-year old women from rural farm families, were recruited and brought to Lowell to run spinning machines, looms, and dressers. The girls signed yearly contracts, lived in corporation owned and operated boardinghouses, such as the 1830s Boott corporation boardinghouse block. These young unmarried women worked 16-hour days, 6 days a week, with mandatory church services on Sunday and were paid once a month, earning $12 to $14 dollars. After paying $5 for room and board, the women had a disposable income of their own. The 'Mill Girls' also formed an early labor organization—Lowell Female Labor Reform Association (LFLRA), and with mill worker Sarah Bagley petitioned the state legislature for a 10-hour workday. Most of the young women stayed for an average of three years, eventually leaving for marriage, a move west, or a job with better conditions. The era of the 'Mill Girls' slowly came to an end in the mid-19th century with the influx of Polish, Irish and other immigrants willing to work for lower wages. Today, the Lowell National Historical Park uses the backdrop of historic mills and factories to interpret the early history of the women and men who worked and lived during America's Industrial Revolution."

A second link in the site (link to "Introduction," then "Historic Preservation" to come to http://www.cr.nps.gov/nr/travel/pwwmh/pres.htm) is "Searching for Women on the National Register of Historic Places," by Carol D. Shull, Keeper of the National Register of Historic Places. "Documentation on properties listed in the National Register of Historic Places is a rich source of information about the contributions of women in American history, architecture, archeology, engineering, and culture. The National Register includes properties associated with women—some famous and some lesser-known—who made outstanding achievements in fields as diverse as education, literature, science, business, industrial design, civil rights, sculpture, painting, philanthropy, medicine, religion, architecture, and many other endeavors. With nearly 70,000 listings by 1998, the National Register is the only source of information on historic places of national, state and local significance nationwide. It is the singular inventory that recognizes historic and cultural units of the National Park System, National Historic Landmarks (NHLs) designated by the Secretary of the Interior, and places nominated by States, federal agencies and American Indian tribes. A computerized index to listings, the National Register Information System (NRIS), contains about 45 data elements which can be queried individually or in a variety of combinations to find listings associated with women.

A search of significant persons field is among the most useful. When the queries for this analysis were made, the NRIS showed 9,820 listings associated with significant persons, 15% of the total listings. About 360 (under 4%) of these were women. Researchers can query the

names of women of interest and then use the NRIS record on each listing and the National Register or NHL file to obtain more detailed information."

53. Patrick Geary, *Phantoms of Remembrance: Memory and Oblivion at the End of the First Millennium* (Princeton, N.J.: Princeton University Press, 1994).

54. Patricia West's *Domesticating History* gives detailed case studies of women in the historic preservation movement nationally. Patricia West, *Domesticating History: The Political Origins of America's House Museums* (Washington, D.C.: Smithsonian Institution Press, 1999).

55. Dubrow, "Preserving Her Heritage," 87–89, and West, *Domesticating History,* 48–50.

56. The Pow-Wow Oak, the Passaconaway Rock, and the Sarah Parker Monument were all originally erected in the 1930s.

57. Women's names appear on most of the brochures associated with the monuments. The brochures list the committee members who worked on organizing, fund-raising, and planning the monuments.

58. The narratives within the different ethnic enclaves are remarkably similar. I have included in Appendix 3 a poem by Paul Marion that describes life in the French Canadian American community, so like the stories I heard in the Irish Lowell community: the tenement stairs, the visiting, and even the seventh son of the seventh son.

59. "The wage received for public 'work' presupposes a private world of women and unpaid labor." Carole Pateman, *The Disorder of Women* (Stanford, Calif.: Stanford University Press, 1989), 9.

60. Pateman, *The Disorder of Women,* 3.

61. Mary P. Ryan, *Women in Public: Between Banners and Ballots, 1825-1880* (Baltimore: Johns Hopkins University Press, 1990), 8–9. Thanks to Vivien Rose for bringing Mary Ryan's work to my attention. See also Daphne Spain, *Gendered Spaces* (Chapel Hill: University of North Carolina Press, 1992); and Doreen Massey, *Space, Place, and Gender* (Cambridge, Mass.: Polity Press, 1994).

62. In my September 6, 1996, interview with the commissioner of the parks, recreation, and cemeteries, Tom Bellegarde, he outlined why he thought there were few monuments to women. He also explained that, through outside pressure, this was changing: "Probably because of the fact that it has never been put on the table to us. . . . Probably because I would say 95 percent of the coaches and people who volunteer their time in the different sports are men. . . . As far as I know in the history of the city, Ellen Sampas was the only woman mayor. There were a few city council women over time. I think they are just now coming into the realm with soccer and with basketball. I think in the next few years you are probably going to see some. Maybe not for the city, but for the state. A lot of the women chose not to serve government or they keep a low profile. You know assistant coaches. I mean you can be an assistant coach for twenty years, but if you are behind a head coach for twenty years you are not going to get the recognition of a head coach. Now that [we have] equal opportunity with the different sports—lets face it, ten years ago the boys got this field, which was kind of nice and the girls got that field, which wasn't kind of nice. We have a mind set [for the last twelve to fourteen years] where we have to play fair with everything. All right, and that is the same with the poor area and with the rich area. You

have got to play fair. I think in the next ten years you are going to see [monuments to women] because women are moving up—they are in government now. They are moving up in sports."

63. Since the research for this book was completed, a square has been named for Florence Marion, a cultural activist in Lowell and sister-in-law of Paul Marion.

64. Joe Duceau, interview with the author, summer 1997; and Paul Marion, conversation with the author, May 6, 1999.

65. Whitman Pearson, letter to the editor, *Lowell Sun*, July 1, 1988, 9.

66. Steedman, *Landscape for a Good Woman*, 76–77.

67. Stevi Jackson and Jackie Jones, "Thinking for Ourselves: An Introduction to Feminist Thinking," in *Contemporary Feminist Theories*, ed. Stevi Jackson and Jackie Jones (Edinburgh: Edinburgh University Press, 1998), 1; Stevi Jackson, "Feminist Social Theory," in *Contemporary Feminist Theories*, ed. Stevi Jackson and Jackie Jones (Edinburgh: Edinburgh University Press, 1998), 12.

68. Hayden's *The Power of Place* is a significant work in the scholarship of space, power, ethnicity, and gender. Her earlier work also addresses issues of women, space, and power. See Dolores Hayden, *The Power of Place: Urban Landscapes as Public History* (Cambridge, Mass.: MIT Press, 1995), and Dolores Hayden, *The Grand Domestic Revolution: A History of Feminist Designs for American Homes, Neighborhoods, and Cities* (Cambridge, Mass.: MIT Press, 1981).

69. Michelle Zimbalist Rosaldo, "Woman, Culture, and Society: A Theoretical Overview," in *Woman, Culture, and Society*, ed. M. Z. Rosaldo and Louise Lamphere (Stanford, Calif.: Stanford University Press, 1974), 17–42.

70. Patricia Cline Cohen, "Safety and Danger: Women on American Public Transport, 1750–1850," in *Gendered Domains: Rethinking Public and Private in Women's History*, ed. Dorothy C. Helly and Susan M. Reverby (Ithaca, N.Y.: Cornell University Press, 1992), 117, 122.

71. Peter Baldwin, *Domesticating the Street* (Columbus: Ohio State University Press, 1999), 26, 114 17.

72. Alan Emmet, "Open Space in Lowell," unpublished paper in the Center for Lowell History, Lowell, Massachusetts, 1975, 22.

73. The Friends of Kittredge Park Bricks in Kittredge Park include the names of women, as does the monument in the South Common, to those who served in the Persian Gulf War. The Mary Ann Sanders Tyler Fountain is in Tyler Park, and the Paul and Therese Ducharme Monument is in Ducharme Park.

74. See my discussion of the space of the city generally in Chapter 4.

75. Sallie Marston notes that the nineteenth-century St. Patrick's Day parades in Lowell "served to remind the rest of society that the Irish, as a moral and political unit, had a legitimate claim to full participation in republican America." Sallie Marston, "Contested Territory: An Ethnic Parade as Symbolic Resistance," in *The Continuing Revolution: A History of Lowell, Massachusetts*, ed. Robert Weible (Lowell, Mass.: Lowell Historical Society, 1991), 214. I also observed the use of space to demarcate symbolic and literal territory in the form of Portuguese processions, outlining the boundaries of the Portuguese neighborhood, while documenting Lowell for the Lowell Folklife Project, Library of Congress, summer 1987.

76. Brian Mitchell, *The Paddy Camps: The Irish of Lowell, 1823–61*, (Champaign: University of Illinois Press, 1988), and in Marston, *The Continuing Revolution*, 216.

77. Marston, *The Continuing Revolution*, 217.

78. Interview conducted for the documentary, "And That's How We Did in the Mill." The interviews are available to the public at the Center for Lowell History, the University of Massachusetts at Lowell.

79. See Martha Norkunas, "The Ethnic Enclave as Cultural Space: Women's Oral Histories of Life and Work in Lowell," in *The Continuing Revolution: A History of Lowell, Massachusetts*, ed. Robert Weible (Lowell, Mass.: Lowell Historical Society, 1991), 323–39, where I discuss women's fears of walking in the ethnic space of other groups in the city.

80. Lewis Karabatsos, conversation with the author, January 26, 2000.

81. Ellen Rothenberg, conversation with the author, summer 1997.

82. Based on my interviews with Lowell women, especially Ms. V. Tsoumas and Ms. Barber, for the documentary "And That's How We Did in the Mill," summer 1983.

83. A second representational female sculpture is planned for an area adjacent to the Merrimack River. Sculpted by local artist Mico Kaufman, the "Indian Maiden" is another larger-than-life-sized bronze figure of a woman, this time in a leather dress, kneeling toward the river. She is performing a ceremony involving water. She is to be an anonymous woman who shows the Native American's close association with nature. In an effort to better represent Native American history in Lowell, the image of an unknown woman will represent nature (women/nature/fertility). Mico Kaufman has sculpted many of the pieces in Lowell and the surrounding towns. In this case, the sculpture is already completed, and Kaufman sought a buyer. The Lowell Heritage State Park, interested in Native American history in Lowell, offered to raise the money for the sculpture and identified a location. Richard Scott, superintendent of the Lowell National Historical Park, conversation with the author, May 1999.

84. Letter from James C. Ayer to the Honorable J. G. Peabody, mayor of Lowell, October 23, 1866.

85. In 1923 the badly deteriorated *Winged Victory* was replaced by Frederick F. Ayer, the son of James C. Ayer, with a replica "of the best bronze that it is possible to make in America and is due to stand weather conditions for all time." *Lowell Evening Leader*, May 9, 1923, 1.

86. Ryan, *Women in Public*, 28.

87. Marina Warner, *Monuments and Maidens: The Allegory of the Female Form* (New York: Atheneum, 1985), xix, 17, 291.

88. Eric Hobsbawm, "Man and Woman in Socialist Iconography," *History Workshop*, 6 (1978): 124. See also Maurice Agulhon, *Marianne into Battle: Republican Imagery and Symbolism in France, 1789–1880*, trans. Janet Lloyd (Cambridge, Mass.: Cambridge University Press, 1979).

89. Susan Slyomovics, *The Object of Memory: Arab and Jew Narrate the Palestinian Village* (Philadelphia: University of Pennsylvania Press, 1998), 199–201, 208.

90. Those narratives that do not make it into the historical canon are a part of the silence of the past. Silence, Trouillot argued, enters the process of historical production at certain critical points, for some things are noted and others are not; some things are archived and become

authoritative and others are not. An archival trail, a material trail—documents, monuments on the landscape, photographs, references in newspapers—is tremendously powerful. Historians create historical narratives based on previous understandings of the past, derived from archives. Absent a material trail it becomes difficult to establish events, biographies, actions, and difficult to create historical narratives. See *Silencing the Past: Power and the Production of History* for an account of the silencing of the Haitian Revolution. Even as the Haitian Revolution happened, Trouillot argued, it was systematically recast to fit narratives that made sense to Western observers and readers. He goes on to theorize the Haitian Revolution in terms of power and the production of history. Michel-Rolph Trouillot, *Silencing the Past: Power and the Production of History* (Boston: Beacon Press, 1995), 6, 25, 29, 55.

91. See Thomas Dublin, *Women at Work: The Transformation of Work & Community in Lowell, Massachusetts, 1826-1860* (New York: Columbia University Press, 1979); and *Farm to Factory: Women's Letters, 1830-1860* (New York: Columbia University Press, 1993).

92. I was once asked to attend a meeting of powerful men in the city on behalf of the Preservation Commission. When I entered the room, I encountered an air of hostility and felt distinctly uncomfortable. Only one other woman was at the table, a policy maker at the local college. When I later described the meeting to the head of one organization, he remarked that the other woman present wasn't really a woman—she was one of the boys, indicating that although she was technically female, she was still a member of the power elite. There are many stories of women in politics who learned to become "one of the boys" in order to exercise power.

93. Pateman, *The Disorder of Women,* 4.

94. Mrs. Frank Sayer Leach, Missouri State History of the DAR, in *The Historic Treasure Chest of the Madonna of the Trail Monuments,* ed. Fern Ioula Bauer (Springfield, Ohio: John McEnaney Printing, 1984), 83.

95. Ann Dempsey King, conversation with the author, January 1, 2000.

96. Sheila Callery Kearns, interview with project researchers for The Lowell Monuments Project, August 27, 1996.

97. Beatriz Colomina, "Battle Lines: E.1027," in *The Architect: Reconstructing Her Practice,* ed. Francesca Hughes (Cambridge, Mass.: MIT Press, 1996), 6.

98. Nannerl Keohane, preface to *Gendered Domains: Rethinking Public and Private in Women's History,* ed. Dorothy G. Helly and Susan M. Reverby (Ithaca, N.Y.: Cornell University Press, 1992), ix–xii.

99. Inspired by my work on gender, memory, and monuments, I began a project in Austin, Texas, to create monuments to women in the city. Entitled "Austin Women's Commemorative Project," we received funding from the Woodrow Wilson Foundation and the National Endowment for the Humanities. At a "think-tank" meeting held September 21–22, 2001, discussion centered around the criteria for honoring women through monuments. Some women argued that to be commemorated through a monument, the woman must have stepped outside the realm of the ordinary, while others maintained that a homemaker who did her job well could stand for the work of all unpaid homemakers and could also be publicly commemo-

rated. We are currently engaged in developing biographical sketches of Austin women, and in renaming streets and creating monuments to women—all on a Web site. Later, we hope to rename streets and create monuments on the real landscape.

100. See Halbwachs, *On Collective Memory.*

3. RELOCATING THE MEMORY OF THE DEAD

1. For a discussion of the monuments in the Lowell Cemetery, see Catherine Goodwin, *Mourning Glory: The Story of the Lowell Cemetery* (Lowell: The Lowell Historical Society, 1992).

2. George Merritt, superintendent of St. Patrick's Cemetery, interview with the author, August 20, 1987.

3. David McKean, *The Cross and the Shamrock: The Art and History of St. Patrick Cemetery, Lowell, Mass.* (Lowell: The Archives of St. Patrick Parish, 1977), 1.

4. George Merritt, interview.

5. Over time, as the lower and middle classes that had been ignored socially and politically gained power and influence in Lowell, their monuments and markers became more imposing and elaborate. Beginning in the 1920s, following the trend in cemeteries nationwide, curbing began to be removed from family lots, and raised beds were lowered to make the cemetery easier to maintain. The regrading was completed by 1946. St. Patrick's Cemetery is owned and operated by the archdiocese of Boston, and in 1950 its ties to St. Patrick's Church ended. In 1960 St. Mary's Cemetery opened in Tewksbury because St. Patrick's had run out of room. Today, sections of the cemetery resemble a classic "lawn" cemetery, with flat markers and large expanses of grass. Other areas allow upright monuments and plantings, but no objects may be left on the graves. McKean, *The Cross and the Shamrock,* 2–7; Merritt, interview.

6. Merritt, interview.

7. Molly Haskell, "Daring to Make a Love Story of Life's Last Chapter," *New York Times,* August 19, 2001, 9.

8. McKean, *The Cross and the Shamrock,* 2–7.

9. Alan Emmet, "Open Space in Lowell," unpublished paper, Center for Lowell History, Lowell, Massachusetts, 1975, 8.

10. Today there are three classifications of cemeteries: church-operated cemeteries, private cemeteries, which are lot-owned corporations, and public cemeteries. The Lowell Cemetery is an example of a private cemetery, while the Edson and Westlawn, built adjacent to the Edson, are public cemeteries. In addition to St. Patrick's Cemetery, there are other church-affiliated cemeteries in Lowell, many initially organized by an ethnic church. There are other small burial grounds in various areas of the city that the city of Lowell maintains, but they are not active cemeteries. The small cemeteries include those on School and Branch Streets, Hildreth Street, near the Lowell General Hospital, and on Mammoth Road. Merritt, interview.

11. Thomas Bender, *Toward an Urban Vision* (Baltimore: Johns Hopkins University Press, 1975), 82.

12. Stanley French, "The Cemetery as Cultural Institution: The Establishment of Mount Auburn and the 'Rural Cemetery' Movement," *American Quarterly* 26 (1974): 37–59.

13. Ibid., 38.

14. Philippe Aries, *Western Attitudes toward Death* (Baltimore: Johns Hopkins University Press, 1974), 69.

15. Bender, *Toward an Urban Vision,* 82.

16. My mother and my Aunt Dorothy told me stories of attending the Fourth of July festivities at the South Common and of sledding there in the winter. I made a point of taking our children sledding at the South Common so that they could do something that their grandmother had done in the same place.

17. Emmet, "Open Space in Lowell," 5–6, 20.

18. *Lowell Sun,* October 4, 1987, A5.

19. The name Fort Hill derives from the Native American fort built on the top of the hill in what is now the park.

20. Some have bronze plaques inserted onto the face. Four stones bear the laser image of the man they commemorate (John Green, Gus Coutu, Rev. Bourgeois, and George McDermott), three are obelisks (Ladd and Whitney, Centralville Veterans, and the Michalopoulos Monument), and one is in the shape of a heart (John E. Sheehy Monument).

21. The fencing around monuments in the public parks surrounds a single monument. The fencing in cemeteries was usually around a group of monuments from one family.

22. Adrian Luz, interview with the author, 1996.

23. Tom Bellegarde, interview with the author, August 6, 1996.

24. John R. Stilgoe, "Folklore and Graveyard Design," *Landscape* 22 (1978): 22–28.

25. Bellegarde, interview.

26. Stilgoe, "Folklore and Graveyard Design," 24; D. Gregory Jeane, "The Upland South Folk Cemetery Complex: Some Suggestions of Origins," in *Cemeteries and Gravemarkers. Voices of American Culture,* ed. Richard E. Meyer (Ann Arbor, Mich.: U.M.I. Research Press, 1989), 114.

27. Bellegarde, interview.

28. Terry G. Jordan, *Texas Graveyards* (Austin: University of Texas Press, 1982), 14; Jeane, "The Upland South Folk Cemetery Complex," 113, 122–26.

29. George Mosse, *Fallen Soldiers: Reshaping the Memory of the World Wars* (New York: Oxford University Press, 1990), 87.

30. Laura Rival, preface and "Trees: From Symbols of Life and Regeneration to Political Artifacts," in *The Social Life of Trees,* ed. Laura Rival (Oxford: Oxford International Publishers, 1998), xiii, 3, 27.

31. A woman being interviewed on National Public Radio (*National Public Radio News,* October 10, 2001), for example, explicitly stated that, in her view, if a tree were planted for a deceased man, he would "continue to live through the tree."

32. Seventy-seven of the monuments contain some form of the word *dedicate,* in the textual inscription, and seventy-three include a form of the word *memory* (in memoriam, in memory of, this memorial).

33. According to *Webster's II* dictionary, *dedicate* means "to address or inscribe to someone as a mark of respect or affection."

34. Six monument texts include the word *courage*. They are dedicated to two veterans, one priest, firefighters, an athlete, and the Franco Americans of the Little Canada Monument.

35. Apart from one monument to women, none of those to individual women specifically use the dedicatory language of service. Instead they list the women's relationships and those who mourn her, or make no reference to her accomplishments at all. Seven monuments are dedicated to men for their "service to the community." In four cases the word is used in conjunction with service to youth. Other monuments remember the man as having "left Lowell a better place" or "making Lowell a better place to live."

36. Fifteen of the monuments remember a man for his "dedication to the youth" of Lowell, usually in conjunction with a sports activity, or are dedicated to the children of Lowell by a group.

37. Eleven of the monuments contain text with the word *love* or *loving*. The deceased are remembered as having "a deep love for their fellow man" or "for his love and devotion to the children of Lowell." Some monuments invoke the love of God through the agency of a deceased pastor: "Lord Keep Us In Your Love."

38. The monument to Joseph Geary, which stands just outside of a basketball court adjacent to a school, relates Geary's life to the court. It reads, "Dedicated / To / Joseph P. Geary / 1901–1986 / Who Brought This Court to Life."

39. This monument is discussed in the context of gender in Chapter 2.

40. The Greek Immigrants Monument has a Greek cross and the Irish Immigrant Monument bears a Celtic cross, for example.

41. F. W. Coburn, "Tribute to Civil War Heroes 75 Years Old," *Lowell Courier Citizen*, June 17, 1940, 1, 4.

42. "Ladd and Whitney Monument Dedicated 53 Years Ago Present Month—Governor Present," *Lowell Evening Leader*, June 9, 1913.

43. Addison Whitney was born in Waldo, Maine, and worked in Lowell at the Middlesex Company for two years before his death. Luther Ladd was born in Alexandria, New Hampshire, and worked at the Lowell Machine Shop before his death. Ibid.

44. Sumner Needham was actually wounded on April 19, 1861, and died a few days later.

45. "Ladd and Whitney Monument Dedicated 53 Years Ago Present Month—Governor Present," *Lowell Evening Leader*, June 9, 1913.

46. The plaques to the individual soldiers bear the words, "Addison O. Whitney, born in Waldo, Me., October 30th, 1839 and Luther C. Ladd, born in Alexandria, N.H., Dec. 22nd, 1843. Marched from Lowell in the 6th M.V.M. to the defense of the National Capital, and fell mortally wounded, in the attack on their regiment, while passing through Baltimore, April 19, 1861. The Commonwealth of Massachusetts and the City of Lowell dedicate this monument to their memory, June 17, 1865."

47. The inscription reads, "Charles A. Taylor / Co.D. 6th M.V.M. / The First to Fall in Defense of the Union / Baltimore, April 19, 1861."

48. The Lowell city council, in a city council resolution, voted to declare October 15, 1969, "Vietnam Peace Day" and expressed the council's desire to "see an end to war in Vietnam." City Council Resolutions, 1964–1993.

49. Caroline Bynum Walker, *The Resurrection of the Body in Western Christianity, 200-1336* (New York: Columbia University Press, 1995), 45, 55. See also Caroline Bynum Walker, *Fragmentation and Redemption: Essays on Gender and the Human Body in Medieval Religion* (New York: Zone Books, 1991).

50. Mosse, *Fallen Soldiers,* 80, 89–90.

51. Of the eight monuments that contain the word *sacrifice* only five are to war veterans. The Police Monument recognizes the "supreme sacrifice" made by officers killed in action, the monument to the organizer of the Polish National Catholic Church, Franciszek Hodur, recognizes him for "his principles, loyalty / devotion and sacrifice," and the monument to Little Canada remembers the sacrifices of Franco Americans: "Nos coeurs n'oublieront jamais leur courage, leurs sacrifices, leur foi, leur fierté. 1875–1964" (Our hearts will never forget their courage, their sacrifices, their faith, and their pride).

52. Frances Early outlined the heartbreaking conditions of early French Canadian immigrants to Lowell who lived in poverty. Frances Early, "The French-Canadian Family Economy and Standard-of-Living in Lowell, Massachusetts, 1870," in *The Continuing Revolution,* ed. Robert Weible (Lowell, Mass.: Lowell Historical Society, 1991), 235–63.

53. David McKean, St. Patrick's Church historian, interview with the author, March 19, 2002; Mary Noon, interview with the author, fall 2000; St. Patrick's Church Rectory, interview with the author, fall 2000.

54. Citywide Irish processions typically begin or end at St. Patrick's Church, and traditional Irish celebrations are held there. While the city has other Irish Catholic churches, St. Patrick's, as the oldest Irish Catholic church in Lowell, lays claim to being the symbolic heart of Irish heritage.

55. Augé, *Non-Places,* 66.

56. Bellegarde, interview.

57. Carol McMahon, interview with the author, October 18, 1996.

58. Jacques LeGoff, *History and Memory,* trans. Steven Rendall and Elizabeth Claman (New York: Columbia University Press, 1992), 89.

59. Mosse, *Fallen Soldiers,* 99.

60. Jay Winter discusses war monuments specifically as sites of mourning. See Jay Winter, *Sites of Memory, Sites of Mourning: The Great War in European Cultural History* (Cambridge: Cambridge University Press, 1995), 93–94, 98, 114.

61. Kristin Ann Hass described the ways in which the tradition of leaving objects at the Vietnam War Memorial is derived from African, Mexican, Italian, and Chinese American funerary traditions "beyond the edges of white middle-class America." Kristin Ann Hass, "Seashell Monument and Cities for the Silent," in *Carried to the Wall: American Memory and the Vietnam Veterans Memorial* (Berkeley: University of California Press, 1998), 64–86. For a slightly different version of her analysis, see her dissertation, "Remaking the Nation with Purple Hearts and Fishing Lures: The Vietnam Veterans Memorial and American Memory" (Ph.D. diss., University of Michigan, 1994).

62. Clifford Geertz, "Ethos, World-View and the Analysis of Sacred Symbols," in *Every Man*

His Way: Readings in Cultural Anthropology, ed. Alan Dundes (Berkeley: University of California Press, 1968), 301–15.

63. David Chester and Edward Linenthal present a detailed analysis of sacred space in their introduction to *American Sacred Space.* David Chester and Edward Linenthal, introduction to *American Sacred Space* (Bloomington: Indiana University Press, 1995), 1–42.

64. Erich Isaac, "Religion, Landscape, and Space" *Landscape* 9 (1959–1960): 14–18.

4. THE CHANGING RELATIONSHIP OF MEMORY AND PLACE

1. Later my husband referred to Lowell as "the center," meaning it was the center of the world for me.

2. The clothesline plays a huge role in the imagination of children. A short film entitled *Clothesline* describes children's memories of walking among the sheets and the clean-smelling clothes on their mother's clotheslines. It is also a potent symbol of women and of women's work. *Clothesline,* produced and directed by Roberta Cantow, 33mm, Picture Start, 1981.

3. Kathleen Norkunas, interview with the author, June 1981.

4. Years later, when I had my first child and lived in California, Dorothy sent me a birthday card with $5 inside. She wrote that the money was for me to buy myself a quarter pound of snowflakes.

5. In addition to outside spaces named in memory of a person or family, so much of the interior of the home is set aside for remembrance. Many of the homes in New England have a parlor room that was once set aside for Sunday-afternoon guests and to wake deceased relatives. In this room are often housed many different kinds of objects that act as a remembrance. It may be furniture, souvenirs, or photographs passed down from one generation to another and valued because if its age and family associations. In a classic study of people's relationship with the objects in their homes, Csikszentmihalyi and Rockberg-Halton found that certain objects became meaningful because they acted as signs of important memories, relationships, past experiences, and links to future generations. Four-fifths of the people the authors surveyed cherished at least one object, particularly furniture or photographs, because it reminded them of a close relative. These objects came to embody a person's sense of self and the ties that bind people to each other in their lifetimes and across generations. Women especially felt a sense of responsibility for maintaining a network of social ties through the objects in the home. Mihaly Csikszentmihalyi and Eugene Halton, *The Meaning of Things* (Cambridge, Mass.: Cambridge University Press, 1981), 61–86.

6. Kevin Lynch, *The Image of the City* (Cambridge, Mass.: MIT Press, 1960), 1. See also Kevin Lynch, *What Time Is This Place?* (Cambridge, Mass.: MIT Press, 1972).

7. Augé, *Non-Places.*

8. Bender, *Toward an Urban Vision.*

9. Gerald Danzer, *Public Places* (Nashville: Association for State and Local History, 1987), 111.

10. Peirce F. Lewis, "Axioms for Reading the Landscape," in *The Interpretation of Ordinary Landscapes,* ed. D. W. Meinig (New York: Oxford University Press, 1979), 12, 23.

11. Thomas Dublin, *Lowell, The Story of an Industrial City: A Guide to Lowell National Historical Park and Lowell Heritage State Park, Lowell, Massachusetts* (Harpers Ferry, W.Va.: Division of Publications National Park Service, 1992), 82, 85.

12. My husband, who lived in Lowell for a mere four years, learned where many former mills and stores "used to be" in order to navigate the city.

13. Mary Blewett, "The National Park Service Meets the Working People of Lowell," *Labor and Community Newsletter* 1 (1979): 2–3.

14. Material in this paragraph is cited from Loretta Ryan, "The Remaking of Lowell and Its Histories: 1965–83," in *The Continuing Revolution,* ed. Robert Weible (Lowell, Mass.: Lowell Historical Society, 1991), 377–95.

15. The best example of a new building built to resemble the old is the Hilton Hotel, later called the Sheraton Hotel and still later called the Doubletree Hotel. Upon seeing it, an artist visiting the city once turned to me and said she was experiencing a confusion of time. Was this a new building made to look like an old building or a restored building made to look old but newer old? Kevin Lynch discusses the idea of a confusion of time on the landscape in *What Time Is This Place?*

16. My thanks to Chuck Parrott, chief historic preservation architect for the Lowell Historic Preservation Commission, for discussing this and other historic preservation issues with me.

17. Tom Bellegarde, interview with the author, August 6, 1996. While the Parks Department recommends names for public parks and the areas within parks to the Lowell city council, it has a great deal of power over that process. People write to Bellegarde and ask for something to be named after a relative or colleague, usually from their neighborhood. Either Bellegarde or the nominee contacts a city councilor, who brings the name to a vote at a city council meeting. The process is largely based on personal connections, memory, and politics. Bellegarde explained the role of politics in the process: "I think politics will always play a role in the memorials. I say politics—a French powerhouse of the 1980s that might have passed away that was very popular, well that is a good French voting block when the mayor of the city wants to be maybe [reelected] mayor or [elected to the] city council the next time. You get three hundred people to show up at [the memorial dedication]; well they remember that, [John Smith] hammered it through for them. So, from a political point of view, politics is always going to play a role in who gets [a monument]. I am not saying a politician elects a politician. It may be that woman soccer coach—she is the first woman soccer coach that gets it. You get the women's vote. So politics will always play a role in it. You know popularity goes along with that, if you are a popular guy. We always want to do the right thing too. I think it is something that the city should be doing, and I think from the person looking up to the city it is just a very touching time. I think it plays out well with city officials, and I think it is a good tool for the mayor, the manager, or the city councilors to do it. Even though you may not even know who he was, you think it is a nice touch, for his twenty-five years of service as a coach."

18. At some risk to my life, I walked on the bridge to get close enough to the plaque to record the text. I had never been able to stop my car on the bridge long enough to read the text and have never seen anyone else walking on the bridge in front of the plaque. The text on the

bronze plaque reads, "Rourke Bridge / Through a History of Public Service and / With a Deep Love for their Fellow Man / Raymond F. Rourke and Timothy M. Rourke / Sought to make Lowell a Better Place in / Which to Live / 1982." Inscribed around a shield at the top of the monument is "Enserpetit Placidam /svb Libertate Quietem."

19. Elmer Rynne owned a sporting-goods store and donated many items to local school children over the years. He was a well-known figure in downtown Lowell. His monument was originally planned to be sited in front of a more public tennis court, and the city actually placed a boulder in that location. I photographed the uninscribed boulder. The next time I returned to Lowell a different boulder had been installed in a less visible site, adjacent to another set of tennis courts, and the original boulder had been removed. According to Tom Bellegarde, site selection is a negotiated process between the family of the person named on the monument and the city parks department. The text on the monument reads, "Elmer P. Rynne / Tennis Complex / Tribute of a Grateful City / For His Generous Support / of Youth Athletics / Tennis Champion 1932 - 33 - 34 / Dedicated M.I.I.I.M."

20. In *The Texture of Memory*, James Young calls the interaction between observer and monument the dialogic character of monuments. James E. Young, *The Texture of Memory: Holocaust Memorials and Meaning* (New Haven: Yale University Press, 1993). See also James E. Young, ed., *Holocaust Memorials: The Art of Memory in History* (Munich: Prestel-Verlag, 1994).

21. The full text reads, "Middlesex Canal / 1793–1853 / At this location canal boats pulled by horses car- / ried freight and passengers between Boston and the / Merrimack River at Lowell before the days of railroads. / The Canal ran from Charlestown through what are / now Somerville, Medford, Winchester, Woburn, Wil- / mington, Billerica, and Chelmsford to Lowell. / The Canal was just over 27 miles mong. It was 20 ft. / Wide at the bottom, 30½ ft. wide at the surface, and 3½ ft. deep. There were 20 locks, 8 aqueducts, and 50 bridges." Below this text is a map of the canal route, and below that is the following text: "Route of Old Middlesex Canal Through Lowell." In the bottom left corner appear the words "Erected by Middlesex Canal Commission 1987."

22. The full text reads, "The Birth of an Industrial City / The Opening of the Merrimack Manufacturing Company on this Site in 1823 Marked the Beginning of America's First Great Industrial City. / View of Lowell, Benjamin Mather, 1825 / Whistler House Museum of Art / The Merrimack was the Largest of Lowell's Mill Complexes. By 1848 it Produced more than 7,000 Miles of Cloth each Year. Like its Parent Company in Waltham, the Merrimack Combined all of the Steps of Cloth Production under a Single Roof. No Longer were Carding, Spinning, and Weaving Performed in Separate Mills. This Integrated Manufacturing System Succeeded on a Large Scale for the First Time in Lowell. / When it Closed in 1958, the Merrimack was one of Lowell's Last Surviving Mills. It was Razed in the 1960s, a Victim of the Wrecking Ball. / The Landmark Clock Tower and Mills of the Merrimack, ca. 1875 / Lowell National Historical Park."

23. The text reads, "These Christmas Trees are / Dedicated to the Men and / Women Who Served in the / Persian Gulf / April 28, 1991 / Lowell City Manager James Campbell."

24. I conducted informal interviews with children whenever I was in neighborhood pub-

lic parks. Their responses were remarkably consistent. The children were most often boys and ranged in age from approximately nine to fourteen years old.

25. According to George Merritt, the local boys knew it as the "beauty spot" because it was the nicest spot in the park. George Merritt, interview with the author, summer 1996.

26. Louis Saab and Sheila Callery Kearns, interviews conducted by project researchers for the Lowell Monuments Project, August 27, 1996, and August 27, 1996. Other information from the *Lowell Sun* obituary of William Callery, March 3, 1966.

27. The text reads, "William T. Callery / Memorial Park / In Honor and Memory of / All Veterans from the Highlands / Who Have Served their Country / In Time of Need."

28. The text reads, "In Memory of / Daniel W. Newell, Sr. / June 1, 1921–June 28, 1985 / For His Many Years of Love and Devotion / To the Children of Lowell."

29. *Lowell Sun,* June 29, 1985.

30. Bill Kelley, interview with the author, July 31, 1996.

31. Frank Zabbo, interviews conducted by project researchers for the Lowell Monuments Project, August 26, 1996. The plaque text reads, "John L. Zabbo / Memorial Field / At Callery Park / Dedicated 1971 / His Spirit Will Live On."

32. *Lowell Sun,* August 27, 1973.

33. Beverly Conroy, interview conducted by project researchers for the Lowell Monuments Project, August 28, 1996. The plaque text reads, "Donald J. Conroy / Memorial Field / At Callery Park / Dedicated 1974."

34. *Lowell Sun,* April 21, 22, 1973. The plaque text reads, "John J. Barrett / Memorial Field / At Callery Park / Dedicated 1974."

35. A few streets away are two other monuments that mention only the name of a family. The McOsker Circle Monument is in the center of a traffic circle, and the Coburn Park Monument is in a corner of a small park facing the street.

36. Notes from informal interviews conducted with children in the park in the summer of 1996.

37. I am not entirely certain if Allen is Franco American, although he was a member of the Club Passé Temps. The text on his monument reads, "Harry Allen / King of Lowell / Softball Pitchers / June 17, 1923–April 3, 1980."

38. The text on his monument reads, "In Memory of / Henry J. LeClair / For his Dedication to / The City of Lowell."

39. The text on his monument reads, "Albert W. Cote / Little League Field / Dedicated April 23, 1989 / For 25 years of Service to / The Youth of Centerville [sic] / As Coach and Manager."

40. The text on his monument reads, "Edmond 'Gus' Coutu / In recognition of his Years of / Involvement as a Community Leader / In the City of Lowell."

41. Paul Sheehy, telephone interview with the author, July 19, 1996.

42. Irish priests commemorated include Cardinal O'Connell, Rev. Dennis J. Maguire, the O'Brien brothers, pastors of St. Peter's Church, Rev. Michael Ronan and Rev. William J. Kirwin, who is memorialized in a public park in his former parish.

43. Thanks to Mary Noon for discussing these monuments with me.

44. The base text reads, "Rev. A. M. Garin. G.M.I. / Born in France, May 7, 1822 / Died in Lowell Feb. 16, 1895 / He went about Doing Good / Erected by the People of Lowell." The 1937 *WPA Guide to Massachusetts: The Federal Writers' Project Guide to 1930s Massachusetts*, (New York: Pantheon Books, 1983) writes of the statue: "A fine bronze statue of heroic size, by Philippe Heber, it presents a tall, bareheaded, commanding figure, with strong but sensitive scholarly face" (p. 265). Father Garin is also memorialized in a 1990s plaque on a retirement home for priests on Kirk Street in downtown Lowell.

45. Only one minister received a plaque in Lowell: the Rev. Appleton Grannis, pastor of St. Anne's Episcopal church from 1912 to 1940. He is mentioned on a plaque on a small bridge near his former church. The text on the Rev. Roland R. Bourgeois Monument reads, "This Court is Dedicated to / Rev. Roland R. Bourgeois, O.M.I. / For his Devotion to Youth / 1973." The text on the Father Grillo Monument reads, "Father Grillo Park / In Memory of Father Joseph T. Grillo / Pastor of St. Anthony's Church 1923–1948 / Beloved by All Whose Lives He Touched / Dedicated June 30, 1996 / Back Central Neighborhood Association." The text on the Father Hodur Monument reads, "April 1, 1866 / Feb 16, 1953 / K S. Franciszek Hodur / Pierwsay Biskup Narodowego / Ordained to the priesthood / August 19, 1983 / Consecrated / September 29, 1907 / at Utrecht Holland by Bishop / of the Old Catholic Church / In Grateful Recognition / of his principles, loyalty / devotion and sacrifice / We dedicate this memorial to / our beloved organizer of the / Polish National Catholic Church / Bishops, Clergy, Laity / Donated by Stanley J. Maslanka / Dedicated May 1954." The text is divided into two parallel sections—one in English and the other side in Polish. The text on the Msgr. Ogonowski plaque reads, "In Memory of / Msgr. Alexander Ogonowski / Pastor of Holy Trinity / 1904–1955 / Born Sept. 18, 1877 / Ordained Sept. 8, 1900 / Died June 1, 1962 / Lord Keep Us In Your Love."

46. Blewett, "The New People," 190–217; and Kenngott, *The Record of a City*.

47. See Peter Read, "Remembering Dead Places," *The Public Historian* 18 (1996): 25–40; and David Glassberg, "Public History and the Study of Memory," *The Public Historian* 18 (1996): 7–23. See also Slyomovics, *The Object of Memory*, which is a part of the literature on the Palestinian lamentation for lost home and lost place.

48. The left side reads, "Aiken – Cabot – Cheever – Coolidge – Melvin." The top reads, "Le Petit Canada–Little Canada." The right side reads, "Montcalm – Pawtucket – Perkins – Suffolk – Tucker – Ward." The bottom reads, "Je me souviens!–Lest we forget!" On the second plaque on the stone are the words, "1977 / Erected by / The Franco-American People / and / The Oblate Fathers of / St. Jean Baptiste Parish."

49. The text on the Carney Field Monument reads, "Carney Field / In Memory of the Carney Family for Their / Dedication to the Youth of the Acre." The text on the Tsirovasiles Monument, located in a corner of the park, reads, "Greek American Legion / Peter V. Tsirovasiles / Memorial Park / In Honor and Memory of / All Veterans from the Acre / Who Have Served Their Country / In Time of Need / Post No. 1 Lowell, Mass." The second monument to a Greek soldier is located just outside the North Common, in front of the adjacent Greek Transfiguration Church. The text reads, "Dedicated to the Men and / Women of the Armed Forces / In Memory of / James G. Kalergis / Lieutenant General U.S. Army / 1917 / 1991."

50. For further information on the importance of labor monuments in America, see Archie Green, "Labor Landmarks: Past and Present," *Labor's Heritage* 6 (1995): 26–53, and Patricia Mooney-Melvin, "The City That Works: Remembering Labor's Struggle," unpublished paper presented at the 1999 meeting of the National Council on Public History, Lowell, Massachusetts. The National Park Service, through a cooperative agreement with the Newbury Library in Chicago, has conducted an extensive survey on American sites associated with labor called the Labor History National Landmarks Project. The research promises to be an important contribution to the marking of labor sites and includes sites associated with manufacturing, agriculture, mining, transportation, and women's domestic work. Thanks to Patricia Mooney-Melvin for sharing this information with me.

51. The full text reads, "The Worker / In 1821 Hugh Commisky led a / band of laborers on a trek from / Charlestown to Lowell. With muscle / and sweat they dredged canals in / the soil of rugged farmland. As / others joined in their toil a complex / waterpower system evolved, creating a new era of textile production. / When one generation had endured / and the clamor of manufacturing / increased, immigrants came by / the thousands seeking labor and / a better life. This fountain celebrates workers and their contribution to industrial and human heritage. / Lowell Heritage State Park / Lowell National Historical Park."

52. The Michael Rynne plaque on the bathhouse on the widely used Van den Berg Esplanade along the Merrimack River is another monument that can be read as Irish. Rynne is remembered for his strength, his service to the community, his extraordinary athletic feats, and his humanity. The text on the monument, in this case a plaque on a wall, reads, "Michael Rynne / Mike Rynne / born in Ireland 1882, died in Lowell 1959. Policeman, / humanitarian, father figure to many. / A great natatorial athlete, he won / the famous Boston Light Swim. Long / remembered for his "Believe It or Not" / feat, at 70 he towed a boatload of six / 200 lb. men across the Merrimack / River with his hands and feet tied. / A big man, yet gentle, he taught the / children of Lowell to swim so they / would not drown in the tempting / canals. One of Lowell's finest, in / every sense of the word. / Lowell Heritage State Park / Lowell National Historical Park." The twentieth-century American writer Jack Kerouac was deeply influenced by his Franco American upbringing in Lowell. *The Jack Kerouac Commemorative,* while claimed as a literary monument and hence belonging to Lowell and the nation, is also a symbol of the Lowell Franco American community.

53. Norkunas, "The Ethnic Enclave as Cultural Space," 323–39.

54. There is a joke told in Lowell about two older Lowellians looking out over Cardinal O'Connell Parkway. One says to the other, "Every morning a little Greek dog comes to the parkway." The other answers, "How do you know the dog is Greek?" "Because every morning he pees on the Irish Monument."

55. Joe Camara, interview with the author, May 1999. Camara guards the park carefully. On the other side of the park were small children playing in a cramped cement area, but they are not allowed to play in the park. Other information from the *Lowell Sun,* November 12, 1987, 21; dedication brochure for Lemieux Park and detail from Lemieux Park Dedication; correspondence between the Back Central Neighborhood Association and the Lowell Parks Department dated Febuary 5, 1997.

56. It is possible to read a fourth monument as a Civil War monument as well. John Jacob Rogers, a congressman from Lowell, obtained a Civil War cannon from a navy yard and had it erected outside of Memorial Hall, later renamed the Pollard Library. The text, which reads, "Dedicated to the / City of Lowell / By / John Jacob Rogers / 1915," does not indicate its status as a Civil War memorial. On the mouth of the cannon, however, are inscribed words indicating the cannon's origin: "Fort Pitt, PA 1862."

57. The Civil War Monument in front of the Capitol building in Austin, Texas, for example, was dedicated in 1904. It represents an entirely different view of the Civil War from those monuments found in the northern United States. See Sanford Levinson's discussion of the Austin monument in Sanford Levinson, *Written in Stone* (Durham, N.C.: Duke University Press, 1998).

58. One reference condescendingly referred to the child as "pretty." "Four pupils of the [Lincoln School] performed the work of drawing aside, at the proper moment, the national colors that veiled the monument. They were Misses Sophie Thuman and Mary Whelan, Master Chester Chase and little Master Earle Edmund, a pretty colored boy, aged six years." "Lincoln Memorial Unveiled in Lincoln Square," *Lowell Courier-Citizen*, June 1, 1909, 1.

59. The full text reads, "1809 + 1865 / Abraham Lincoln / February 12 1809 / April 15 1865 / Erected / By / The School Children / Of Lowell / February 12 1909 / 'With Malice Toward None / With Charity for All / With Firmness in the Right / As God Gives Us to See the Right / Let Us Strive on to Finish / The Work we are in.'"

60. Kirk Savage, *Standing Soldiers, Kneeling Slaves* (Princeton, N.J.: Princeton University Press, 1997), 17–19, 210. See also Kirk Savage, "The Politics of Memory: Black Emancipation and the Civil War Monument," in *Commemorations: The Politics of National Identity,* ed. John R. Gillis (Princeton, N.J.: Princeton University Press, 1994), 127–49.

61. The Wamesit Indian statue and plaque is on the Lowell-Tewksbury line and the Wannalancit wayside is just beyond the Lowell line in Tyngsboro.

62. The *Passaconaway* statue in the Edson Cemetery is at the border of Lowell and Chelmsford. The Meetinghouse Hill Plaque at the Eliot Church is located close to the Lowell Connector, which "connects" Lowell with the major interstate highways, Route 495 and Route 3. The Pow-Wow Oak Wayside is close to the border of Lowell and Tewksbury. The only monuments not located at an entry/exit point are the Passaconaway Rock and the proposed statue of the Indian Maiden, with both sites close to the Pawtucket Falls.

63. There are other Native American sites in the city, such as the caves on top of Fort Hill and the stones thought to be Native American located in Pawtucketville, but they are not marked. See John Pendergast, *The Bend in the River* (Tyngsborough, Mass.: Merrimac River Press, 1991).

64. "The Pennacook were probably the largest group [of Native Americans] east of the Connecticut River; they inhabited all of New Hampshire, much of western and southern Maine, eastern Vermont and northeastern Massachusetts. In the southern Merrimac [sic] Valley they were divided into several sub-groups such as the Naticook, Nashaway, Souhegan, Wamesit, and Pawtucket." Pendergast, *The Bend in the River*, 31.

65. Pendergast, *The Bend in the River*, 51; J. Frederic Burtt, "Passaconaway's Kingdom," in

Cotton Was King: A History of Lowell, Massachusetts, ed. Arthur L. Eno (Lowell, Mass.: Lowell Historical Society, 1976), 4.

66. John Goodwin, "Villages at Wamesit Neck," in *Cotton Was King: A History of Lowell, Massachusetts,* ed. Arthur L. Eno (Lowell, Mass.: Lowell Historical Society, 1976), 62.

67. "Along with the fishing, there were festivities, competitions, marriages and other ceremonies." Pendergast, *The Bend in the River,* 56.

68. This idea was the inspiration behind the public art piece by Michio Ihara called *Pawtucket Prism,* which references the water of the falls.

69. The name of the state itself, Massachusetts, is a Native American name, although few are aware of its derivation. "Roger Williams tells us that the name Massachusetts is an Indian word, meaning the blue hills." Isaac Taylor Canon of York, 1911, p. 406, quoting Roger Williams, Drake, *Book of the Indians,* bk ii, 18.

70. Pendergast, *The Bend in the River,* 36; Paul Marion, *Strong Place: Poems '74-'84* (Lowell, Mass.: Loom Press, 1976).

71. The full text reads: (front panel plaque) "Chief / of the / Penacooks / Great Warrior / And Friend of the White Man / Embraced Christianity / Died at the Age of 122 / Known as Aspinquid—The Indian Saint / Property of / Improved Ordre of Red Men / Of Massachusetts"; (in large raised letters on the second base) "Passaconaway"; (on a plaque on the left side at the base of the brass statue itself) "Dedicated by / Passaconaway Tribe No. 32 / IMPA-O-of-RM. / Dedicated August 19, 1899 / Manufactured by / Gumb Brothers—Lowell, Mass / Monument Com. AARON S. Thompson, P.S. / John L. Stevens P.S. / Milo Clifford Jr. Sag"; (on the side of the granite base) "Gumb Bros."

72. In the 1980s the bronze plaque was stolen. The Daughters of the American Revolution replaced it with identical text inscribed on a rock and rededicated the monument in the 1990s. The inscription reads, "Memorial to Passaconnaway / Chief of Pawtucket Indians / Near this Spot in 1648 He Accepted Christianity / Under the Preaching of John Eliot / Presented by the Molly Varnum DAR / Given to the City of Lowell / June 11, 1935."

73. Wannalancit means "breathing pleasantly." Pendergast, *The Bend in the River,* 59.

74. Lewis Karabatsos and Robert Weible, personal communication with the author, March 2000.

75. The monument text reads, "1630 [seal of Massachusetts] 1930 / Meetinghouse Hill / Site of Chapel Erected in / 1653 for John Eliot, the Apostle / to the Indians. Here he Preached to the Wamesit and Pennacook / Indians, Converting Many and / Establishing a Village of Chris- / tian Indians called Wamesit. / Massachusetts Bay Colony / Tercentenary Commission."

76. The plaque reads, "Molly Varnum Chapter DAR / The Pow-Wow Oak / Under this oak, the Wamesit Indians met for / Their Pow-wows, their Peace Conferences, and / Their Councils of War. At the Time of the / Revolution of the Colonies, The Men of this / Vicinity Passed by this Tree to Tewksbury / Center to Join a Company which Fought in / Defense of Concord and Lexington / Tradition Claims that this Pow-wow / Oak was Standing as Early as 1700."

77. Kenneth Foote, *Shadowed Ground* (Austin: University of Texas Press, 1997), 325-27.

78. Although Native Americans continue to live in Lowell today, the sites marked by monuments only reference those Native American leaders who are now well outside of memory.

79. Ken Foote described a continuum of sanctification, designation, reification, and obliteration. Sanctified sites commemorate heroic struggles, heroes, and martyrs, and offer some positive meaning to the community. Designated sites are meaningful, but less so. They are marked but not sanctified; they address minority causes and unforgettable events. When a site is reified, an accidental tragedy or act of senseless violence is put right. Rather than receiving a monument, the site is reintegrated into everyday activities. At the other end of the spectrum are sites of violence so odious to the community that they are obliterated, effacing all evidence of the tragedy. Foote, *Shadowed Ground*, 5–33.

80. The monument is one of a series dedicated to soldiers from various wars. It is located in a greenway at the edge of a Franco American, Polish, and Irish mixed neighborhood. Nearby is the second large complex dedicated to all Lowell soldiers. The full text reads, "Presented this Day, January 27, 1990 / to the / Brissette Family / In Honor and Loving Memory / Of their Brother / U.S. Navy Airman, / Normand Roland Brissette / Of Lowell, Massachusetts / Who Died while a Prisoner of War / At Hiroshima, Japan, the Day of the / Atomic Bomb, August 6th, 1945 / He will be Forever Young / For He Has Given us / His Tomorrow / Dedicated on Behalf of the / Centraville Memorial / Monument Committee / The Veterans of St. Louis / Parish and a Forever / Grateful Centraville / Community, Lowell / Massachusetts."

81. Interviews with school employees, summer 1996. The monument was taken down to accommodate new construction at the site in 1997.

82. The images of the policeman and the boy are decidedly masculine. They could be father and son, man and boy, or leader and successor. Absent is any reference to the female.

83. The text on the monuments reads, "John B. Green / 1931–1993 / 'Volunteer' / A People Person Who / Cared and Left Lowell / A Better Place For / All of Us." There is a laser image of Green on the monument as well as musical notes around his head and shoulders. John Green volunteered a great deal of time for Lowell projects, particularly the Lowell Folk Festival. He died in November 1993. The monument was dedicated the summer after his death. JFK Plaza serves as a major stage during the Lowell Folk Festival.

84. In a visit to Lowell in June 2002, I noted that the area around the Police Monument had been changed once again. The grass was removed and a fountain reinstated. Large black flagpoles now surround the entire fountain area.

85. The Vallee Monument is dedicated to a young man who died in Vietnam on July 26, 1966. The text reads, "Vallee Memorial Park / In Honor of the Late / Joseph L. Vallee / And / Other Veterans / Of the South End Area / Who Died in the Service / Of their Country / 1945 P.F.C. Joseph L. 1966." It occupies one corner of the South Common and faces the street. Some years later a plaque was dedicated to a man who coached baseball on the Common. A monument was later created to the same man. The text on both the plaque and the monument reads, "Purtell Field / In Honor of the Late / Francis 'Fronko' Purtell." The Purtell Monument is situated on an axis in the Common along an infrequently used walking path. It faces the center of the Common, and is not easily seen. It is also difficult to see the monument.

86. *Lowell Courier Citizen,* August 16, 1934, 1, 8; resolution from the Lowell city council dated September 21, 1937; *Lowell Sun,* November 11, 1937, 1, 6; letter from George LeGrand to the mayor and city council dated September 21, 1937.

87. Joe Duceau, interview with the author, July 1996.

88. At a point in time, a placard appeared in the new rotary circle. The placard is small and difficult to see. It reads, "Lord Overpass." The traffic circle is popularly called the Lord Overpass, so that the name has come to represent the place. Few people know that Lord was Raymond Lord, a former mayor of Lowell.

89. Dan Tine, interview with the author, summer 1996; Gerry Dunn, interview with the author, September 1998.

90. Another example of a monument moved to a more public and slightly less personal space is the monument to Chubby LeGrand. It was located in a small space on a sidewalk near the city barns in the Acre and was dedicated around the time LeGrand retired as the long-time commissioner of public works. Later, when a large supermarket was built near the barns, the monument was moved to a public corner and became less a part of the public works department, and more a city monument.

91. Boyer, *The City of Collective Memory,* 17.

92. Konstanty Gerbert, "The Dialectics of Memory in Poland: Holocaust Memorials in Warsaw," in *Holocaust Memorials: The Art of Memory in History,* ed. James E. Young (Munich: Prestel-Verlag, 1994), 121–23. Gerbert wrote that, for a time, alternative memory was expressed through ceremonies held at various memorial sites, infusing them with new and sometimes unexpected meanings. For a discussion of the resymbolization of the Lincoln Memorial, see Scott Sandage, "A Marble House Divided: The Lincoln Memorial, the Civil Rights Movement, and the Politics of Memory, 1939–1963," *The Journal of American History* 80 (1993): 135–67, and Savage, "The Politics of Memory," 127–49.

CONCLUDING REMARKS

1. James Fernandez, "Trees of Knowledge of Self and Other in Culture: On Models for the Moral Imagination," in *The Social Life of Trees,* ed. Laura Rival (Oxford: Oxford International Publishers, 1998), 84.

2. Edward Linenthal, *American Sacred Space,* 8–9, 16. See also Edward Linenthal, *Sacred Ground: Americans and their Battlefields* (Urbana: University of Illinois Press, 1991).

3. Fernandez, "Trees of Knowledge of Self and Other in Culture," 85.

4. Maria Sturken, *Tangled Memories: The Vietnam War, the AIDS Epidemic, and the Politics of Remembering* (Berkeley: University of California Press, 1997), and Susan Sontag, *Illness as Metaphor* (New York: Anchor Books, 1989).

5. Pierre Nora, "Between Memory and History: Les Lieux de Mémoire" *Representations* 26 (1989): 19.

6. As Jacques LeGoff observed, the basic material of history is time, and the past/present opposition is a construction. Jacques LeGoff, *History and Memory,* trans. Steven Rendall and Elizabeth Claman (New York: Columbia University Press, 1992).

7. Sturken, *Tangled Memories*, 1–5.

8. The Pawtucketville Veterans Monument, for example, was replaced and relocated three times since it was originally created.

9. Anton Shammas, "Autocartography," *The Threepenny Review* 16, no. 3 (fall 1995): 7–9.

SELECTED
BIBLIOGRAPHY

BOOKS, ARTICLES, AND UNPUBLISHED PAPERS

Agulhon, Maruice. 1979. *Marianne into Battle: Republican Imagery and Symbolism in France, 1789-1880*, translated by Janet Lloyd. Cambridge. Cambridge University Press.

Algeo, John. 1986. "From Classic to Classy: Changing Fashions in Street Names." In *Names and Their Varieties: A Collection of Essays in Onomastics,* edited by Kelsie B. Harder, 230–45. Lanham, Md.: University Press of America.

April, Susan, Paul Brouillette, Paul Marion, and Marie Louise St. Onge. 1999. *French Class: French Canadian-American Writings on Identity, Culture, and Place.* Lowell, Mass.: Loom Press.

Aries, Philippe. 1974. *Western Attitudes towards Death.* Baltimore: Johns Hopkins University Press.

Armour, Robert A., and J. Carol Williams. 1980. "Death in Popular Culture." In *Handbook of American Popular Culture,* edited by M. Thomas Inge. Westport, Conn.: Greenwood Press.

Augé, Marc. 1995. *Non-places.* London: Verso.

Baldwin, Peter. 1999. *Domesticating the Street.* Columbus: Ohio State University Press.

Bauer, Fern Ioula. 1984. *The Historic Treasure Chest of the Madonna of the Trail Monuments.* Springfield, Ohio: John McEnaney Printing.

Beck, Ulrich, Anthony Giddens, and Scott Lash. 1994. *Reflexive Modernization*. Cambridge, England: Polity Press.

Bender, Thomas. 1975. *Toward an Urban Vision: Ideas and Institutions in Nineteenth-Century America*. Baltimore: Johns Hopkins University Press.

Benjamin, Walter. 1955. *Illuminations*. New York: Harcourt, Brace & World.

Behar, Ruth. 1996. *The Vulnerable Observer*. Boston: Beacon Press.

Behar, Ruth, and A. Deborah Gordon, eds. 1995. *Women Writing Culture*. Los Angeles: University of California Press.

Bertram, Vicki. 1998. "Theorising the Personal." In *Contemporary Feminist Theories*, edited by Stevi Jackson and Jackie Jones, 232–46. Edinburgh: Edinburgh University Press.

Blewett, Mary H., ed. 1982. *Surviving Hard Times*. Lowell, Mass.: Lowell Museum.

———. 1990. *The Last Generation: Work and Life in the Textile Mills of Lowell, Massachusetts, 1910-1960*. Amherst: University of Massachusetts Press.

Blewett, Peter, F. 1976. "The New People: An Introduction to the Ethnic History of Lowell." In *Cotton Was King: A History of Lowell, Massachusetts*, edited by Arthur L. Eno Jr., 190–217. Lowell, Mass.: Lowell Historical Society.

Bloch, Maurice. 1998. "Why Trees, Too, Are Good to Think With: Towards an Anthropology of the Meaning of Life." In *The Social Life of Trees*, edited by Laura Rival, 39–55. Oxford: Oxford International Publishers.

Blunt, Alison, and Gillian Rose. 1994. "Introduction: Women's Colonial and Postcolonial Geographies." In *Writing, Women, and Space: Colonial and Postcolonial Geographies*, edited by Alison Blunt and Gillian Rose, 1–25. New York: Guilford Press.

Bodnar, John. 1992. *Remaking America: Public Memory, Commemoration, and Patriotism in the Twentieth Century*. Princeton, N.J.: Princeton University Press.

———, ed. 1996. *Bonds of Affection*. Princeton, N.J.: Princeton University Press.

Bogart, Michele, H. 1989. *Public Sculpture and the Civic Ideal in New York City, 1890-1930*. Chicago: University of Chicago Press.

Boyer, M. Christine. 1994. *The City of Collective Memory: Its Historical Imagery and Architectural Entertainments*. Cambridge, Mass.: MIT Press.

Brown, Karen McCarthy. 1991. *Mama Lola: A Vodou Priestess in Brooklyn*. Berkeley: University of California Press.

Bulbeck, Chilla. 1992. "Women of Substance: The Depiction of Women in Australian Monuments." *Hecate* 18, no. 2: 8–30.

Burtt, J. Frederic. 1976. "Passaconaway's Kingdom." In *Cotton Was King: A History of Lowell, Massachusetts*, edited by Arthur L. Eno Jr., 3–8. Lowell, Mass.: Lowell Historical Society.

Bynum, Caroline Walker. 1991. *Fragmentation and Redemption: Essays on Gender and the Human Body in Medieval Religion*. New York: Zone Books.

———. 1995. *The Resurrection of the Body in Western Christianity, 200-1336*. New York: Columbia University Press.

Chidester, David, and Edward T. Linenthal. 1995. *American Sacred Space*. Bloomington: Indiana University Press.

Chigas, George, ed. and trans. 1994. *Resolute Heart: Selected Writing from Lowell's Cambo-dian Community.* N.p.

Coburn, Frederick William. 1920. *History of Lowell and Its People.* New York: Lewis Histori-cal Publishing Company.

———. 1940. "Tribute to Civil War Heroes 75 Years Old." *The Lowell Courier Citizen* June 17, 1, 4.

———. 1988. Whistler and His Birthplace: December 8, 1933, to February 19, 1934. Edited by Edith Williams Burger and Liana De Girolami Cheney. Tweksbury, Mass.: P & J Printing.

Cohen, Patricia Cline. 1992. "Safety and Danger: Women on American Public Transport, 1750–1850." In *Gendered Domains: Rethinking Public and Private in Women's History,* ed-ited by Dorothy G. Helly and Susan M. Reverby, 109–22. Ithaca: Cornell University Press.

Colomina, Beatriz. 1996. "Battle Lines: E.1027." In *The Architect: Reconstructing Her Practice,* edited by Francesca Hughes, 2–25. Cambridge, Mass.: MIT Press, 1996.

Connerton, Paul. 1989. *How Societies Remember.* Cambridge: Cambridge University Press.

Coolidge, John. 1942. *Mill and Mansion: A Study of Architecture and Society in Lowell, Massa-chusetts, 1820–1865.* Amherst: University of Massachusetts Press.

Csikszentmihalyi, Mihaly, and Eugene Richberg Halton. 1981. *The Meaning of Things.* Cam-bridge: Cambridge University Press.

Danzer, Gerald, A. 1987. *Public Places: Exploring Their History.* Nashville: Association for State and Local History.

Deffontaines, Pierre. 1953. "The Place of Believing," *Landscape* 2: 22–28.

Doss, Erika. 1995. *Spirit Poles and Flying Pigs: Public Art and Cultural Democracy in American Communities.* Washington, D.C.: Smithsonian Institution Press.

Dublin, Thomas. 1979. *Women at Work: The Transformation of Work and Community in Lowell, Massachusetts, 1826–1860.* New York: Columbia University Press.

———. 1992. *Lowell, The Story of an Industrial City: A Guide to Lowell National Historical Park and Lowell Heritage State Park, Lowell, Massachusetts.* Harpers Ferry, W.Va.: Division of Publications National Park Service.

———. 1993. *Farm to Factory: Women's Letters, 1830–1860.* New York: Columbia University Press.

Dubrow, Gail. 1991. "Preserving Her Heritage: American Landmarks of Women's History." Ph.D. diss., University of California Los Angeles.

Duncan, James, and David Ley, eds. 1993. *Place/Culture/Representation.* New York: Routledge.

Early, Frances. 1991. "The French-Canadian Family Economy and Standard-of-Living in Lowell, Massachusetts, 1870." In *The Continuing Revolution,* edited by Robert Weible, 235–63. Lowell, Mass.: Lowell Historical Society.

Echo, Umberto. 1995. *Travels in Hyperreality: Fall '95.* San Diego: Harcourt Trade Publishers.

Emmet, Alan, S. 1975. "Open Space in Lowell." Unpublished paper, Center for Lowell His-tory, Lowell, Massachusetts.

England, Kim, 1991. "Gender Relations and the Spatial Structure of the City," *Geoforum* 22: 135–47.

Eno, Arthur L., Jr., ed. 1976. *Cotton Was King: A History of Lowell, Massachusetts*. Lowell, Mass.: Lowell Historical Society.

The Federal Writers' Project. 1983 (1937). *The WPA Guide to Massachusetts*. New York: Pantheon Books.

Fernandez, James, W. 1998. "Trees of Knowledge of Self and Other in Culture: On Models for the Moral Imagination." In *The Social Life of Trees*, edited by Laura Rival, 81–110. Oxford: Oxford International Publishers.

Foote, Kenneth E. 1990. "To Remember and Forget: Archives, Memory, and Culture." *American Archivist* 53: 378–92.

———. 1997. *Shadowed Ground*. Austin: University of Texas Press.

French, Stanley. 1974. "The Cemetery as Cultural Institution: The Establishment of Mount Auburn and the 'Rural Cemetery' Movement." *American Quarterly* 26: 37–59.

Friedlander, Saul. 1993. *Memory, History, and the Extermination of the Jews of Europe*. Bloomington: Indiana University Press.

Frisch, Michael. 1990. *A Shared Authority*. Albany: State University of New York Press.

———. 1994. "American History and the Structures of Collective Memory." In *Memory and History: Essays on Recalling and Interpreting Experience*, edited by Jaclyn Jeffrey and Glenace Edwall. Lanham, Md.: University Press of America.

Geary, Patrick. 1994. *Phantoms of Remembrance: Memory and Oblivion at the End of the First Millennium*. Princeton, N.J.: Princeton University Press.

Gebert, Konstanty. 1994. "The Dialectics of Memory in Poland, Holocaust Memorials in Warsaw." In *Holocaust Memorials: The Art of Memory in History*, edited by James E. Young, 121–29. Munich: Prestel-Verlag.

Geertz, Clifford. 1968. "Ethos, World-View, and the Analysis of Sacred Symbols." In *Every Man His Way: Readings in Cultural Anthropology*, edited by Alan Dundes, 301–15. Berkeley: University of California Press.

Giddens, A. 1994. "Living in a Post-Traditional Society." In *Reflexive Modernization*, edited by Ulrich Beck, Anthony Giddens, and Scott Lash. Stanford, Calif.: Stanford University Press.

Gillis, John R., ed. 1994. *Commemorations: The Politics of National Identity*. Princeton, N.J.: Princeton University Press.

Glassberg, David. 1996. "Public History and the Study of Memory." *The Public Historian* 18: 7–23.

———. 1996. "Patriotism in Orange: The Memory of World War I in a Massachusetts Town." In *Bonds of Affection*, edited by John Bodnar. Princeton, N.J.: Princeton University Press.

Goodwin, Catherine L. 1992. *Mourning Glory: The Story of the Lowell Cemetery*. Lowell, Mass.: Lowell Historical Society.

Goodwin, John. 1976. "Villages at Wamesit Neck." In *Cotton Was King: A History of Lowell, Massachusetts*, edited by Arthur L. Eno Jr., 57–65. Lowell, Mass.: Lowell Historical Society.

Green, Archie. 1995. "Labor Landmarks: Past and Present." *Labor's Heritage* 6: 26–53.

Gupta, Akhil, Ferguson, James. 1997. "Culture, Power, Place: Ethnography at the End of an Era." In *Culture, Power, Place,* edited by Akhil Gupta and James Ferguson, 1–29. Durham, N.C.: Duke University Press.

Halbwachs, Maurice. 1971. *La Topographie Légendaire des Évangiles en Terre Sainte.* Paris: Presses Universitaires de France.

———. 1980. *On Collective Memory,* translated by F.J. Ditter. New York: Harper and Row.

Harvey, David. 1989. *The Condition of Postmodernity: An Enquiry into the Origins of Cultural Change.* Oxford: Blackwell.

Hass, Kristin Ann. 1994. "Remaking the Nation with Purple Hearts and Fishing Lures: The Vietnam Veterans Memorial and American Memory." Ph.D. diss., University of Michigan.

———. 1998. *Carried to the Wall: American Memory and the Vietnam Veterans Memorial.* Berkeley: University of California Press.

Hand, Wayland. 1981. "The Evil Eye in its Folk Medical Aspects: A Survey of North America." In *The Evil Eye: A Folklore Casebook,* edited by Alan Dundes, 169–80. New York: Garland.

Handler, Richard, and Eric Gable. 1997. *The New History in an Old Museum: Creating the Past at Colonial Williamsburg.* Durham, N.C.: Duke University Press.

Hayden, Dolores. 1981. *The Grand Domestic Revolution: A History of Feminist Designs for American Homes, Neighborhoods, and Cities.* Cambridge, Mass.: MIT Press.

———. 1995. *The Power of Place: Urban Landscapes as Public History.* Cambridge, Mass.: MIT Press.

Henkin, David, M. 1998. *City Reading: Written Words and Public Spaces in Antebellum New York.* New York: Columbia University Press.

Henry, Marilene Patten. 1994. "Monumental Accusations: The Monuments Aux Morts as Expressions of Popular Resentment." Ph.D. diss., University of Virginia.

Higgins, James, and Joan Ross, *Fractured Identities: Cambodia's Children of War.* Lowell, Mass.: Loom Press, 1997.

Hobsbawm, Eric. 1978. "Man and Woman in Socialist Iconography." *History Workshop* 6: 121–38.

———, and Terrence Ranger, eds. 1983. *The Invention of Tradition.* Cambridge, Mass.: Cambridge University Press.

———. 1987. *The Age of Empire, 1875-1914.* London: Pantheon Books.

Howett, Catherine. 1977. "Living Landscapes for the Dead." *Landscape* 21, no.3: 9–17.

Hughes, Ellen Roney. 1997. "The Unstifled Muse: The 'All in the Family' Exhibit and Popular Culture at the National Museum of American History." In *Exhibiting Dilemmas: Issues of Representation at the Smithsonian,* edited by Amy Henderson and Adrienne Kaeppler, 156–75. Washington, D.C.: Smithsonian Institution Press.

Huntington, Richard, and Peter Metcalf, eds. 1979. *Celebration of Death: The Anthropology of Mortuary Ritual.* Cambridge, Mass.: Cambridge University Press.

Huyssen, Andreas. 1995. *Twilight Memories: Marking Time in a Culture of Amnesia.* New York: Routledge.

————. 1994. "Monument and Memory in a Postmodern Age." In *The Art of Memory: Holocaust Memorials in History,* edited by James E. Young, 9–17. Munich: Prestel-Verlag.

Isaac, Erich. 1959–1960. "Religion, Landscape, and Space." *Landscape* 9: 14–18.

Jackson, J. B. 1980. *The Necessity for Ruins and Other Topics.* Amherst: University of Massachusetts Press.

Jackson, Stevi. 1998. "Feminist Social Theory." In *Contemporary Feminist Theories,* edited by Stevi Jackson and Jackie Jones, 12–33. Edinburgh: Edinburgh University Press.

————, and Jackie Jones. 1998. "Thinking for Ourselves: An Introduction to Feminist Thinking." In *Contemporary Feminist Theories,* edited by Stevi Jackson and Jackie Jones, 1–11. Edinburgh: Edinburgh University Press.

Jameson, Fredric. 1991. *Postmodernism, or The Cultural Logic of Late Capitalism.* Durham, N.C.: Duke University Press.

Jeane, D. Gregory. 1989. "The Upland South Folk Cemetery Complex: Some Suggestions of Origins." In *Cemeteries and Gravemarkers: Voices of American Culture,* edited by Richard E. Meyer. Ann Arbor, Mich.: UMI Research Press.

Jeffrey, Jaclyn, and Glanace Edwall, eds. 1994. *Memory and History: Essays on Recalling and Interpreting Experience.* Lantham, Md.: University Press of America.

Jonker, Gerdien. 1995. *The Topography of Remembrance.* Leiden: E. J. Brill.

Jordan, Terry G. 1982. *Texas Graveyards.* Austin: University of Texas Press.

Joutard, Philippe. 1977. *La légende des camisards: une sensibilité au passé.* Paris: Éditions Gallimard.

Karp, Ivan, and Steven D. Lavine, eds. 1991. *Exhibiting Cultures.* Washington, D.C.: Smithsonian Institution Press.

Kammen, Michael. 1991. *Mystic Chords of Memory: The Transformation of Tradition in American Culture.* New York: Knopf.

Kazickas, Jurate, and Lynn Sherr. 1994. *Susan B. Anthony Slept Here: A National Guide to Women's Landmarks.* New York: Random House.

Kenngott, George. F. 1912. *The Record of a City: A Social Survey of Lowell, Massachusetts.* New York: Macmillan.

Keohane, Nannerl O. 1992. Preface to *Gendered Domains: Rethinking Public and Private in Women's History,* edited by Dorothy G. Helly and Susan M. Reverby. Ithaca, N.Y.: Cornell University Press.

Kerouac, Jack. 1976. *Doctor Sax.* Mattituck, N.Y.: Amereon Limited.

Lachin, Teresa, B. 1993. "War and Remembrance: The War Memorial as Cultural Artifact." Ph.D. diss., University of Maryland.

Laurie, Burce. 1989. Exhibit review of "The Working People." *The Journal of American History* December 1989, 874.

Lefebvre, Henri. 1991. *The Production of Space,* translated by Donald Nicholson-Smith. Oxford: Blackwell.

LeGoff, Jacques. 1992. *History and Memory,* translated by Steven Rendall and Elizabeth Claman. New York: Columbia University Press.

Leon, Warren, and Roy Rosenzweig, eds. 1989. *History Museums in the United States.* Urbana: University of Illinois Press.

Levinson, Sanford. 1998. *Written in Stone.* Durham, N.C.: Duke University Press.

Lewis, Peirce F. 1979. "Axioms for Reading the Landscape." In *The Interpretation of Ordinary Landscapes,* edited by D. W. Meinig, 11–32. New York: Oxford University Press.

Linenthal, Edward. 1991. *Sacred Ground: Americans and Their Battlefields.* Urbana: University of Illinois Press.

———. 1995. *American Sacred Space.* Bloomington: Indiana University Press.

———. 1997. *Preserving Memory: The Struggle to Create American's Holocaust Museum.* New York: Penguin Books.

Lipsitz, George. 1990. *Time Passages: Collective Memory and American Popular Culture.* Minneapolis: University of Minnesota Press.

Litt, Paul. 1977. "Pliant Clio and Immutable Texts: The Historiography of a Historical Marking Program." *The Public Historian* 19, no. 4: 7–28.

Lowenthal, David. 1975. "Past Time, Present Place: Landscape and Memory." *The Geographical Review* 65, no. 1: 2–36.

———, and J. Bowden Martyn, eds. 1976. *Geographies of the Mind.* New York: Oxford University Press.

Lynch, Kevin. 1960. *The Image of the City.* Cambridge, Mass.: MIT Press.

———. 1972. *What Time Is This Place?* Cambridge, Mass.: MIT Press.

MacCannell, Dean. 1976. *The Tourist: A New Theory of the Leisure Class.* New York: Schocken Books.

Marling, Karal Ann, and John Wetenhall. 1991. *Iowa Jima: Monuments, Memories, and the American Hero.* Cambridge, Mass.: Harvard University Press.

———. 1996. *Graceland: Going Home with Elvis.* Cambridge, Mass.: Harvard University Press.

Marston, Sallie. A. 1991. "Contested Territory. An Ethnic Parade as Symbolic Resistance." In *The Continuing Revolution: A History of Lowell, Massachusetts,* edited by Robert Weible, 213–33. Lowell: Lowell Historical Society.

———, and Michelle Saint-Germain. 1991. "Urban Restructuring and the Emergence of New Political Groupings: Women and Neighborhood Activism in Tucson, Arizona." *Geoforum* 22: 223–36.

Massey, Doreen. 1994. *Space, Place, and Gender.* Cambridge, Mass.: Polity Press.

Matchak, Stephen. 1989. "Lowell's Neighborhoods: A Geographical Perspective." Unpublished report, Lowell, Massachusetts.

Mayer, Arno, J. 1993. "Memory and History: On the Poverty of Remembering and Forgetting the Judeocide." *Radical History Review* 56: 5–20.

Mayo, James, M. 1988. *War Memorials as Political Landscape.* New York: Praeger.

McDowell, Linda. 1993a. "Space, Place, and Gender Relations: Part I: Feminist Empiricism and the Geography of Social Relations." *Progress in Human Geography* 17: 157–79.

———. 1993b. "Space, Place and Gender Relations: Part II: Identity, Difference, Feminist Geometries, and Geographies." *Progress in Human Geography* 17: 305–18.

McKean, David, D. 1997. *The Cross and the Shamrock: The Art and History of St. Patrick Cemetery, Lowell, Massachusetts.* Lowell, Mass.: Archives of St. Patrick Parish.

Meinig, D. W., ed. 1979. *The Interpretation of Ordinary Landscapes.* New York: Oxford University Press.

Melosh, Barbara. 1989. "Speaking of Women: Museums' Representations of Women's History." In *History Museums in the United States,* edited by Warren Leon and Roy Rosenzweig. Urbana: University of Illinois Press.

Meyer, Richard, E. 1993. "Strangers in a Strange Land: Ethnic Cemeteries in America." In *Ethnicity and the American Cemetery,* edited by Richard E. Meyer, 1–13. Bowling Green, Ohio: Bowling Green State University Press.

Miller, Page Putnam. 1992. "Landmarks of Women's History." In *Reclaiming the Past: Landmarks of Women's History,* edited by Page Putnam Miller, 1–26. Bloomington: Indiana University Press.

Mitchell, Brian. 1988. *The Paddy Camps: The Irish of Lowell, 1821-1861.* Champaign: University of Illinois Press.

Mooney-Melvin, Patricia. 1999. "The City That Works: Remembering Labor's Struggle." Unpublished paper presented at the 1999 meeting of the National Council on Public History, Lowell, Massachusetts.

Morris, Helen Bartlett. 1984. "The Madonna of the Trail." In *The Historic Treasure Chest of the Madonna of the Trail Monuments,* edited by Fern Ioula Bauer, 100–12. Springfield, Ohio: John McEnaney Printing.

Mosse, George L. 1990. *Fallen Soldiers: Reshaping the Memory of the World Wars.* New York: Oxford University Press.

Narayan, Kirin. 1989. *Storytellers, Saints, and Scoundrels: Folk Narrative in Hindu Religious Teaching.* Philadelphia: University of Pennsylvania Press.

———. 1993. "How Native Is a 'Native' Anthropologist?" *American Anthropologist* 95: 671–86.

Nora, Pierre. 1989. "Between Memory and History: Les Lieux de Mémoire." *Representations* 26: 7–25.

Norkunas, Martha K. 1993. *The Politics of Public Memory.* Albany: State University of New York Press.

———. 1991. "The Ethnic Enclave as Cultural Space: Women's Oral Histories of Life and Work in Lowell." In *The Continuing Revolution,* edited by Robert Weible, 323–39. Lowell, Mass.: Lowell Historical Society.

———, and Erdener, Yildiray. 1989. "Food, Culture and the Grocery Store." *The Local* October/November.

Pateman, Carole. 1989. *The Disorder of Women.* Stanford, Calif.: Stanford University Press.

Pendergast, John. 1991. *The Bend in the River.* Tyngsborough, Mass.: Merrimac River Press.

Portelli, Alessandro. 1991. *The Death of Luigi Trastulli and Other Stories.* Albany: State University of New York Press.

Rashid, Mahbub. 1998. "Reconstituting Traditional Urban Values: The Role of the Boundary in the Contemporary City." *TDSR* 9: 37–49.

Read, Peter. 1996. "Remembering Dead Places." *The Public Historian* 18: 25–40.

Rival, Laura. 1998. "Trees: From Symbols of Life and Regeneration to Political Artefacts." In *The Social Life of Trees*, edited by Laura Rival, 1–36. Oxford: Oxford International Publishers.

Rosaldo Zimbalist, Michelle, 1974. "Woman, Culture, and Society: A Theoretical Overview." *Woman, Culture, and Society*, edited by M. Z. Roasldo and Louise Lamphere, 17–2. Stanford, Calif.: Stanford University Press.

Rose, Vivien. 1996. "Women of the West: Sacajawea, Frontier Mother, and Madonna of the Trail Statues Coast to Coast." Unpublished paper presented at the 1996 National Council of Public History Meeting, Seattle, Washington.

Rosenzweig, Roy, and Elizabeth Blackmar. 1992. *The Park and the People: A History of Central Park.* New York: Henry Holt and Company.

Ryan, Loretta. 1991. "The Remaking of Lowell and Its Histories: 1965–83." *The Continuing Revolution*, edited by Robert Weible, 377–95. Lowell, Mass.: Lowell Historical Society.

Ryan, Mary, P. 1990. *Women in Public: Between Banners and Ballots, 1825-1880.* Baltimore: Johns Hopkins University Press.

Ryden, Kent, C. 1993. *Mapping the Invisible Landscape.* Iowa City: University of Iowa Press.

Sampas, Charles G., Leo Panas, and Nikitopoulos, Charles. N. d. *The First Greek Immigrants in Lowell, Massachusetts: A Photo Documentary, 1900-1940.* Lowell, Mass.: Greeks.

Sandage, Scott A. 1993. "A Marble House Divided: The Lincoln Memorial, the Civil Rights Movement, and the Politics of Memory, 1939–1963." *The Journal of American History* 80: 135–67.

Savage, Kirk. 1987. "The Self-Made Monument: George Washington and the Fight to Build a National Memorial." *Winterthur Portfolio* 22: 225–42.

———. 1994. "The Politics of Memory: Black Emancipation and the Civil War Monument." *Commemorations: The Politics of National Identity*, edited by John R. Gillis, 127–49. Princeton, N.J.: Princeton University Press.

———. 1997. *Standing Soldiers, Kneeling Slaves.* Princeton, N.J.: Princeton University Press.

Scott, Damon John. 1999. "Our Aboriginal Nomenclature: Temporal Spatial Patterns in the Adoption of Native American Names for Places." M.A. thesis, University of Texas, Austin.

Sellars, Richard W. "Vigil of Silence: The Civil War Memorials." *History News* 41: 19–21.

Senie, Harriet F., and Sally Webster, eds. 1992. *Critical Issues in Public Art: Content, Context, and Controversy.* New York: Harper and Collins.

Shammas, Anton. 1995. "Autocartography," *The Threepenny Review* 16, no. 3: 7–9.

Sherr, Lynn, and Jurate Kazickas. 1994. *Susan B. Anthony Slept Here: A Guide to American Women's Landmarks.* New York: Times Books.

Shils, Edward. 1983. *Tradition.* Chicago: University of Chicago Press.

Short, J. R., et al. 1993. "Reconstructing the Image of an Industrial City." *Annals of the Association of American Geographers* 83: 207–24.

Simmel, G. 1971. "The Stranger." In *On Individuality and Social Forms.* Chicago: University of Chicago Press.

Slyomovics, Susan. 1998. *The Object of Memory: Arab and Jew Narrate the Palestinian Village.* Philadelphia: University of Pennsylvania Press.

Sontag, Susan. 1989. *Illness as Metaphor*. New York: Anchor Books.

Spain, Daphne. 1992. *Gendered Spaces*. Chapel Hill: University of North Carolina Press.

Steedman, Carolyn Kay. 1986. *Landscape for a Good Woman*. New Brunswick, N.J.: Rutgers University Press.

Stewart, George, R. 1986. "A Classification of Place Names." In *Names and Their Varieties: A Collection of Essays in Onomastics*, edited by Kelsie B. Harder, 23–35. Lanham, Md.: University Press of America.

Stewart, Kathleen. 1996. *A Space on the Side of the Road*. Princeton, N.J.: Princeton University Press.

Stilgoe, John R. 1978. "Folklore and Graveyard Design." *Landscape* 22: 22–28.

Sturken, Marita. 1997. *Tangled Memories: The Vietnam War, the AIDS Epidemic, and the Politics of Remembering*. Berkeley: University of California Press.

Taylor, Isaac. 1977. *Words and Places: Or, Etymological Illustrations of History, Ethnology, and Geography*. Philadelphia: Richard West.

———. 1969. *Names and Their Histories*. Farmington Hills, Mich.: Gale Group.

Thelen, David. 1990. *Memory and American History*. Bloomington: Indiana University Press.

Thelen, David, and Rosenzweig, Roy. 1998. *The Presence of the Past: Popular Uses of History in American Life*. New York: Columbia University Press.

Thompson, Paul. 1988. *The Voice of the Past*. New York: Oxford University Press.

———. 1994. "Believe It or Not: Rethinking the Historical Interpretation in Memory and History." In *Memory and History: Essays on Recalling and Interpreting Experience*, edited by Jaclyn Jeffrey and Glenace Edwall, 1–16. Lanham, Md.: University Press of America.

Tinling, Marion. 1986. *Women Remembered: A Guide to Landmarks of Women's History in the United States*. Westport, Conn.: Greenwood Publishing Group.

Trouillot, Michel-Rolph. 1995. *Silencing the Past: Power and the Production of History*. Boston: Beacon Press.

Truettner, William, H. 1997. "For Museum Audiences: The Morning of a New Day?" In *Exhibiting Dilemmas: Issues of Representation at the Smithsonian*, edited by Amy Henderson and Adrienne Kaeppler, 28–46. Washington, D.C.: Smithsonian Institution Press.

Tuan, Yi-fu. 1974. *Topophilia: A Study of Environmental Perception, Attitudes, and Values*. Englewood Cliffs, N.J.: Prentice-Hall.

———. 1991. "Language and the Making of Place: A Narrative-Descriptive Approach." *Annals of the Association of American Geographers* 81: 684–96.

Visweswaran, Kamala. 1994. *Fictions of Feminist Ethnography*. Minneapolis: University of Minnesota Press.

Vovelle, Michel. 1992. *Idéologies et mentalités*. Paris: Éditions Gallimard.

———. 1983. *La ville des morts*. Paris: Editions du Centre National de la Recherche Scientifique.

Wagner-Pacifici, Robin, and Barry Schwartz. "The Vietnam Veterans Memorial: Commemorating a Difficult Past." *American Journal of Sociology* 97: 376–420.

Wallace, Mike. 1996. *Mickey Mouse History and Other Essays on American Memory*. Philadelphia: Temple University Press.

Walter, E.V. 1988. *Placeways*. Chapel Hill: University of North Carolina Press.

Warner, Marina. 1985. *Monuments and Maidens: The Allegory of the Female Form*. New York: Atheneum.

Weible, Robert. "Lowell: Building a New Appreciation for Historical Place." *The Public Historian* 6, no. 3: 31.

———., ed. 1991. *The Continuing Revolution: A History of Lowell, Massachusetts*. Lowell, Mass.: Lowell Historical Society.

Weisman, Leslie Kanes. 1992. *Discrimination by Design*. Urbana: University of Illinois Press.

West, Patricia. 1999. *Domesticating History: The Political Origins of America's House Museums*. Washington, D.C.: Smithsonian Institution Press.

Winter, Jay. 1995. *Sites of Memory, Sites of Mourning: The Great War in European Cultural History*. Cambridge, England: Cambridge University Press.

Yeingst, William, and Lonnie G. Bunch. 1997. "Curating the Recent Past: The Woolworth Lunch Counter, Greensboro, North Carolina." *Exhibiting Dilemmas: Issues of Representation at the Smithsonian*, edited by Amy Henderson and Adrienne Kaeppler, 143–55. Washington, D.C.: Smithsonian Institution Press.

Young, James, E. 1989. "The Biography of a Memorial Icon: Nathan Rapoport's Warsaw Ghetto Monument." *Representations* 26: 69–106.

———. 1993. *The Texture of Memory: Holocaust Memorials and Meaning*. New Haven: Yale University Press.

———., ed. 1994. *Holocaust Memorials: The Art of Memory in History*. Munich: Prestel-Verlag.

Zeitlin, Steven, Amy Kotkin, and Holly Cutting Baker, eds. 1982. *A Celebration of American Family Folklore*. New York: Pantheon Books.

Zelinsky, Wilbur. 1988. *Nation into State*. Chapel Hill: University of North Carolina Press.

———. 1994. *Exploring the Beloved Country: Geographic Forays into American Society and Culture*. Iowa City: University of Iowa Press.

Zerubavel, Yael. 1995. *Recovered Roots: Collective Memory and the Making of Israeli National Tradition*. Chicago: University of Chicago Press.

Zinsser, William. 1991. "I Realized Her Tears Were becoming Part of the Memorial." *Smithsonian* 22: 32–43.

SELECTED WEB SITES RELATING TO WOMEN (JUNE 2002)

American Women's Diaries [www.newsbank.com/readex/scholarly/wdiar1.html]

American Women's History: A Research Guide
 [frank.mtsu.edu/~kmiddlet/history/women.html]

Distinguished Women of Past and Present [www.DistinguishedWomen.com/]

GenderGap.com [www.gendergap.com]

Library of Congress, American Memory Project: Selections from the National American Woman Suffrage Association Collection, 1848–1921 [lcweb2.loc.gov/ammem/naw/naw-shome.html]

Library of Congress, Manuscripts Division, Women's History [lcweb.loc.gov/rr/mss/guide/women.html]

Links to Women's History in Archival Collections, Alabama to Missouri [www.lib.utsa.edu/Archives/links1.htm]

List of Women's Web Sites [www.DistinguishedWomen.com/sites.html]

Living the Legacy: 1848–1998 [www.legacy98.org] A site devoted to the history of the Women's Rights Movement.

Museum of Women's History [www.nmwh.org]

The National Women's History Project [www.cr.nps.gov/nr/travel/pwwmh/lrnmore.htm]

Notable Women Ancestors [www.rootsweb.com/~nwa] This site has created categories for ordinary people to honor the women in their own families.

Places Where Women Made History [www.cr.nps.gov/nr/travel/pwwmh]

Searching for Women on the National Register of Historic Places [www.cr.nps.gov/nr/travel/pwwmh/intro1.htm]

Women's Heritage [www.womensheritage.org/index2.html] and [www.womensheritage.org/trail/] Includes a proposed women's heritage trail of thirty sites in central and western New York State.

Women's History Celebration; The President's Commission on the Celebration of Women in American History [www.gsa.gov/staff/pa/whc.htm]

Women's Rights National Historical Park [www.nps.gov/wori]

Worcester Women's History Project [www.assumption.edu/html/academic/history/WWHP/front.html] One long-range goal is "Identifying and marking local historical sites significant in the history of women and developing a heritage trail."

INDEX